Canon® EO

60D

Digital **Field Guide**

Canon® EOS
60D
Digital Field Guide

Charlotte K. Lowrie

WILEY

Wiley Publishing, Inc.

Canon® EOS 60D Digital Field Guide

Published by
Wiley Publishing, Inc.
10475 Crosspoint Boulevard
Indianapolis, IN 46256
www.wiley.com

Copyright © 2011 by Wiley Publishing, Inc., Indianapolis, Indiana

Unless credited otherwise, all photographs Copyright © Charlotte K. Lowrie

Published simultaneously in Canada

ISBN: 978-0-470-64862-9

Manufactured in the United States of America

10 9 8 7 6 5 4 3 2

WILEY

About the Author

Charlotte K. Lowrie is a professional photographer and award-winning writer based in the Seattle, Washington, area. She has more than 25 years of photography experience, ranging from photojournalism and editorial photography to nature and wedding shooting. Her images have appeared in national magazines and newspapers, and on a variety of Web sites, including MSN.com, www.takegreatpictures.com, and the Canon Digital Learning Center.

Charlotte currently divides her time among maintaining an active photography business, teaching photography, and writing books and magazine articles. Charlotte is the author of 14 books, including the bestselling *Canon EOS 7D Digital Field Guide* and 11 other Digital Field Guides, and she co-wrote *Exposure and Lighting for Digital Photographers Only*. In addition, she teaches monthly online photography courses at BetterPhoto.com. Visit her Web site at wordsandphotos.org.

Credits

Acquisitions Editor
Courtney Allen

Project Editor
Kristin Vorce

Technical Editor
Marianne Jensen

Copy Editor
Lauren Kennedy

Editorial Director
Robyn Siesky

Editorial Manager
Rosemarie Graham

Business Manager
Amy Knies

Senior Marketing Manager
Sandy Smith

Vice President and Executive Group Publisher
Richard Swadley

Vice President and Executive Publisher
Barry Pruett

Project Coordinator
Kristie Rees

Graphics and Production Specialists
Ana Carrillo
Nikki Gately
Joyce Haughey
Andrea Hornberger
Jennifer Mayberry

Quality Control Technician
Robert Springer

Proofreading and Indexing
Melissa D. Buddendeck
Valerie Haynes Perry

This book is dedicated in loving memory to my Dad, who taught me to pursue excellence, and it is dedicated to God, an unfailing source of inspiration and insight.

Acknowledgments

Writing a book is a team project, and for this book, I had some of the best editors at Wiley. Kristin Vorce provided outstanding support and editing as the project editor. And Lauren Kennedy was an eagle-eyed copyeditor. Thank you Kristin and Lauren for your fine editing and for your encouragement despite a brief deadline. Thanks also to Carol Kessel and Courtney Allen, acquisitions editors, for their support.

Thanks also to Peter Burian, a great friend and photographer who contributed images to this book. Ellen Anon, another dear friend and excellent photographer offered sage advice for the nature photography shooting tips. Thanks also to my clients who graciously allow me to use their images in my books.

Contents

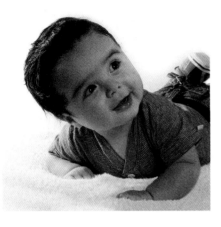

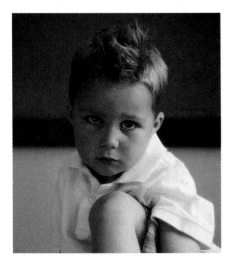

CHAPTER 3
Getting Great Exposures and Focus 51

CHAPTER 4
Using Color Options, Ambience
Effects, and Creative Filters 95

CHAPTER 5
Customizing the 60D 127

Introduction

Welcome to the *Canon EOS 60D Digital Field Guide*. This guide is designed to help you get the best pictures and the most fun from your new 60D. If you're new to digital photography, the 60D provides a doorway into the exciting world of digital photography. The camera is small, lightweight, and deceptively simple. But if you've browsed through the camera menus and screens, you know that there is a lot of power hiding behind the few straightforward buttons on the exterior. And you may be thinking how nice it would be if you knew how to use all the bells and whistles.

That's one of the objectives of this book — to guide you through the bells and whistles of the 60D. But getting the most from the 60D takes more than knowing what every button or option does. It's important to know when to use them in your everyday shooting. That's the second objective of this book — to help you know when to use the 60D's features and options in everyday shooting. And, of course, as I talk about using the 60D, it's inevitable that I also discuss photography in general — that's just part of learning the camera.

You don't have to be a technical wizard to use the 60D; that's one of its advantages. But it is good to know that the 60D sports some of the newest technologies in Canon's stable — technologies that help deliver excellent image quality. For example, the image sensor offers 18 megapixels that produce images that make beautiful prints at 11 × 17 inches and larger. The color out of the camera is lovely and exposures are consistent thanks in large part to Canon's newest metering system. This system uses a dual-layer metering sensor that reads both illumination and color from 63 zones and combines it with information from the autofocus system. You also get the latest iteration of Canon's venerable DIGIC processor, which has 14-bit processing for smooth tonal gradations, rich color, an expanded ISO range up to 12800, Live View shooting, and customization options.

This book assumes that you already own the Canon EOS 60D. The camera offers speedy performance at 5.3 frames per second during continuous shooting. With the addition of high-resolution 1920×1080 Full HD video, the 60D becomes a capable multimedia storytelling tool that opens new doors to creative expression. And for fun, you can choose from new Creative Filters and Ambience options to get unique images that you can print directly from the media card.

You may have a good sense of the power of the EOS 60D by now, but you may be using only a fraction of its features. This book is designed to be your one-stop, go-to resource. You'll learn not only what the camera features and options are, but also when and how to use them — without needing to refer to back the camera manual. You'll also get suggestions for setting up the camera for specific subjects and scenes using a combination of the 60D's features. My suggestions are just that — suggestions. You can use them as-is or as a jumping off place for your own settings. Either way, putting the camera's full power to work for you makes your shooting more efficient so you can concentrate on exploring subjects, lighting, and composition.

If you are new to digital photography or are returning after a long hiatus, be sure to check out the introduction to photographic exposure in Appendix A. I believe that any book about a camera should have staying power; in other words, it should be useful to you for as long as you use the 60D. With that in mind, the book includes both basic and advanced shooting techniques so that as you progress, you'll have more advanced techniques to explore.

You may be wondering if this is the type of book where you can skip around reading chapters in random order. You can, of course, read in any order you want, but be sure to read Chapters 1 through 4 early. These chapters provide the foundation for learning the camera, getting the best image quality, and getting great color. From there you can explore Live View shooting, video, flash, lenses, and specific shooting areas in any order.

Before you begin reading, know that the best way to learn the 60D and photography is to shoot, evaluate, and then shoot some more. Rinse and repeat. Carry the camera with you everywhere and use it. Be curious. Be fearless. Be passionate. And always look for the light.

The team at Wiley and I hope that you enjoy reading and using this book as much as we enjoyed creating it for you.

Charlotte

Postscript: Thanks to the many readers who have contacted me over the years. Your questions, suggestions, and ideas for previous books continue to influence the content of the books that I write today. I learn as much from you, I believe, as I hope that you have learned from me. Thank you, and keep the questions and ideas coming.

Roadmap to the 60D

This chapter is designed to help you become familiar with the 60D and offer you ways to make everyday use of the camera easier and faster. While reading about the camera is helpful, the best thing that you can do is shoot with the 60D often — every day, in fact — because using the camera is the shortest path to gaining mastery of it.

By now, you may already know that the camera fits easily and comfortably in your hand, and has just enough heft to make it feel substantial. The exterior of the camera belies the power under the hood. The 60D gives you high image resolution, the latest metering system from Canon, responsive performance, and full creative control as well as high-resolution video with manual control. All in all, the 60D makes shooting pleasurable and satisfying while delivering excellent still image and video resolution and quality.

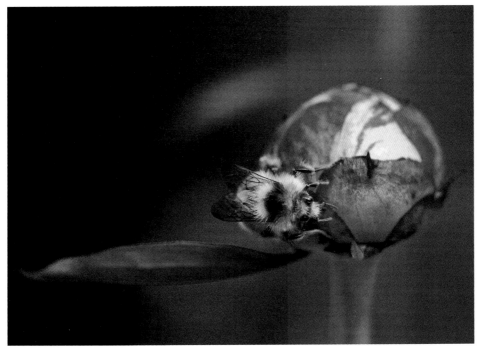

I had only seconds to capture this shot. I quickly switched to a wide aperture to both blur background distractions and to get a fast-enough shutter speed to freeze any movement by the bee. Exposure: ISO 200, f/3.5, 1/320 seconds using a –1/3-stop of Exposure Compensation.

Camera Controls Overview

Once you learn the overall design of the 60D, you can make camera adjustments more efficiently. The following sections provide methods for using the controls in logical and efficient ways.

The main controls that can be used together or separately to control most functions on the 60D are

▶ **Main dial and Quick Control dial.** These dials enable you to make adjustments for the four buttons located above the LCD panel. Just press the AF (Autofocus mode), DRIVE (drive mode), ISO (ISO speed), or metering mode selection button that is displayed as an icon, and then turn the Main or Quick Control dial to change the mode or ISO setting.

Main dial

1.1 The Main dial

Some camera menu screens, such as the Quality screen, also use the Main and Quick Control dials for selecting different values on the screen. And you can turn the Main dial to move among the camera menu tabs, and then turn the Quick Control dial to move to a menu option.

▶ **Multi-controller.** This eight-way control functions as a joystick when it is pressed in any of eight directions. For camera menus and the Quick Control screen, only the up, down, left, and right directions on the Multi-controller work. To activate the Quick Control screen, press the Q button, and then press left, right, up, or down on the Multi-controller to move to the option you want. Then turn the Quick Control

—Multi-controller
—SET button
—Quick Control dial

1.2 The Multi-controller, Quick Control dial, and SET button

dial or Main dial to make changes to most of the options. You can use the Multi-controller to manually select an AF point, move through images during playback, and move the autofocus (AF) frame or the magnifying frame in Live View.

NOTE These instructions are important because all the step-by-step instructions in this book assume that you can use these controls to navigate to menus and select options.

▶ **Setting (SET) button.** The SET button confirms changes you make to many menu items, and it opens submenus. On the Quick Control screen, you can select a setting using the Multi-controller, such as White Balance, and then press the SET button to display all the options for the setting.

Front of the camera

The front of the camera includes the nicely sculpted grip that increases steadiness and balance when handling the camera, as well as the controls that you use often. The front of the camera includes the following controls:

▶ **Red-eye reduction/Self-timer lamp.** When you use the built-in flash with the Red-eye reduction option turned on, the Self-timer lamp lights to help reduce the subject's pupil size. If the subject looks at the lamp, it reduces the appearance of red in the subject's eyes. In the two Self-timer/Remote control modes, this lamp lights and a beeper signals the delay countdown (either 10 or 2) to shutter release.

▶ **Remote control sensor.** This sensor works with the accessory Remote Controller RC-6, enabling you to remotely release the shutter up to 16.4 feet from the camera. Simply select one of the Self-timer/Remote control drive modes, focus, and then lock focus by pressing the Manual Focus (MF) button on the lens if the lens has an MF button. Then point the remote control at this sensor and press the transmit button to make the picture.

▶ **DC coupler cord hole.** This enables you to use household power when using the accessory AC Adapter Kit ACK-E6.

▶ **Depth-of-Field Preview button.** Pressing this button stops down the lens diaphragm to the currently selected aperture so that you can preview the depth of field in the viewfinder. The larger the area of darkness, the more extensive the depth of field will be. You can also use this button during Live View shooting. If the lens is set to the maximum aperture, the Depth-of-Field Preview button cannot be depressed because the diaphragm is already fully open.

▶ **Reflex Mirror.** As you compose an image, the reflex mirror reflects light from the lens to the pentaprism so you see in the viewfinder eyepiece what the imaging sensor captures. The viewfinder offers 96 percent frame coverage. In Live View shooting, the mirror is flipped up to allow a current view of the scene. If you are using Quick mode focusing, the mirror flips down to focus, thereby suspending Live View momentarily.

▶ **Lens mount and contacts.** The lens mount is compatible with Canon EF and EF-S lenses. EF-S lenses are compatible with only the cropped image sensor size of the 60D and other Canon EOS dSLR cameras. EF lenses are compatible with all EOS dSLRs. The lens mount includes a red index marker that is used to line up EF-mount lenses and a white index mount marker that is used to line up EF-S lenses.

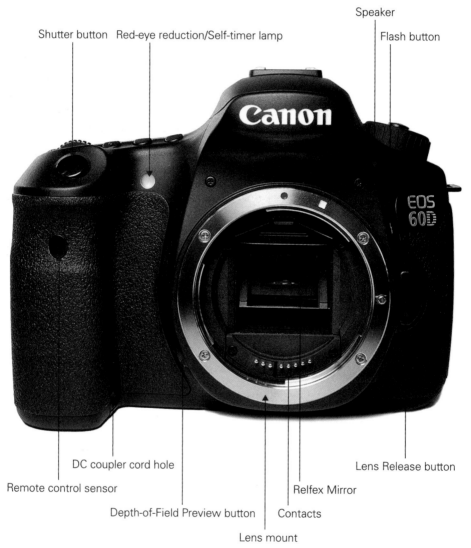

1.3 EOS 60D camera front

▶ **Lens Release button.** This button releases the lens from the lens mount. To disengage the lens, depress and hold down the Lens Release button as you turn the lens so that the red or white index mark moves toward the top of the camera.

▶ **Flash button.** In Program AE (P), Shutter-priority AE (Tv), Aperture-priority AE (Av), Manual (M), and Bulb (B) shooting modes, press this button to pop up and use the built-in flash. In automatic shooting modes, pressing the Flash button has no effect because the camera automatically determines when to use the built-in flash.

▶ **Microphone.** The built-in monaural, or single channel, microphone is used for sound recording when you're shooting movies. You can adjust the recording level manually from 1 to 64 levels, or you can have the 60D automatically adjust it. You can also adjust the built-in wind-cut filter to reduce the noise of wind while shooting outdoor movies. Alternately, you can disable sound recording.

Top of the camera

Dials and controls on the top of the camera provide access to frequently used shooting functions in addition to the hot shoe and diopter control.

▶ **Mode dial with lock button.** By pressing the lock button while turning this dial, you can select a shooting mode, which determines how much control you have over image exposures. Just turn the dial to line up the shooting mode that you want to use with the white mark to the right of the dial.

▶ **Hot shoe.** The hot shoe mounting plate with flash sync contacts is where you mount an accessory flash unit. The 60D hot shoe is compatible with E-TTL II autoflash with accessory Canon EX-series Speedlites, and offers wireless multi-flash support. When using a compatible EX-series Speedlite, the 60D offers flash configuration from the camera using the Shooting 1 menu.

▶ **Dioptric adjustment knob.** Turn this control forward or backward to adjust the sharpness for your vision by –3 to +1 diopters. If you wear eyeglasses or contact lenses for shooting, be sure to wear them as you turn the dioptric adjustment control. To make the adjustment, point the lens to a light-colored surface such as a piece of white paper or a white wall, and then turn the control until the AF points are perfectly sharp and crisp for your vision.

▶ **Focal plane mark.** This mark indicates the equivalent of the film plane and is useful in macro photography when you need to know the exact distance from the front of the image sensor plane to the subject.

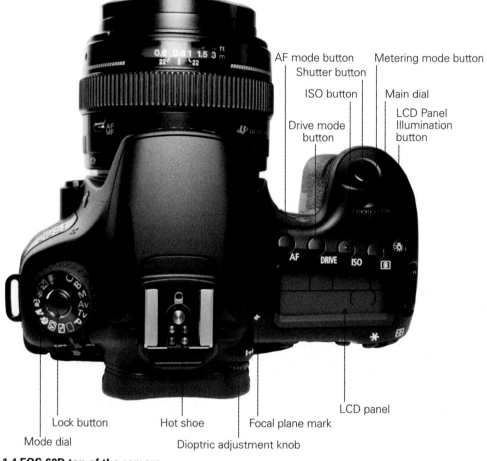

AF mode button Metering mode button
Shutter button
ISO button Main dial
 LCD Panel
Drive mode Illumination
button button

LCD panel
Lock button Hot shoe Focal plane mark
Mode dial Dioptric adjustment knob

1.4 EOS 60D top of the camera

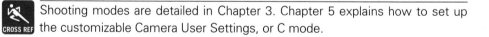

Shooting modes are detailed in Chapter 3. Chapter 5 explains how to set up the customizable Camera User Settings, or C mode.

▶ **LCD panel.** This panel provides a quick summary of the current camera settings as well as the battery status. It displays the drive, autofocus (AF), and metering modes, Picture Style, White Balance, Flash Exposure Compensation (FEC), shutter speed, built-in flash status, ISO, number of remaining shots, Self-timer countdown, Bulb exposure time, the Exposure Level meter, Auto Exposure Bracketing (AEB) and Flash Exposure Compensation amounts, the degree of change on the Electronic Level, aperture, and card writing status. In addition, this panel displays a variety of error messages and warnings.

▶ **AF mode button.** Pressing this button enables you to change the Autofocus (AF) mode to One-shot AF, AI Focus AF, or AI Servo AF mode. For all the buttons above the LCD panel, just press the button, and then turn the Main or Quick Control dial to change the mode.

▶ **Drive mode button.** Pressing this button enables you to change the drive mode using the Main dial. The drive mode options are Single-shot, High-speed Continuous (5.3 frames per second, or fps), Low-speed Continuous (3 fps), and Self-timer/Remote control (10- and 2-sec. delays).

▶ **ISO button.** Pressing this button enables you to change the ISO sensitivity setting using the Main dial in P, Tv, Av, M, and Bulb shooting modes. The ISO options are Auto (ISO 100-6400), 100, 125, 160, 200, 250, 320, 400, 500, 640, 800, 1000, 1250, 1600, 2000, 2500, 3200, 4000, 5000, 6400; with Custom Function I-3 turned on, you can choose H: 12800 as well.

▶ **Metering mode button.** Press this button to change the metering mode, and then turn the Main dial. The metering mode options are Evaluative (63-zone Through-the-Lens, or TTL, full-aperture metering), Partial (6.5 percent at center frame), Spot (2.8 percent at center frame), and Center-weighted Average.

▶ **LCD Panel Illumination button.** Pressing the LCD Panel Illumination button turns on a light that illuminates the LCD panel for approximately 6 seconds. This is a handy option for making LCD panel adjustments in low light or in the dark.

▶ **Main dial.** The Main dial selects a variety of options. Turn the Main dial to cycle through camera Menu tabs, cycle through AF points when selecting an AF point manually, set the aperture in Av shooting mode, set the shutter speed in Tv and M shooting modes, and shift the exposure in P shooting mode.

▶ **Shutter button.** When you press the shutter button halfway, the 60D simultaneously meters the light in the scene and focuses on the subject. Completely pressing the shutter button opens the shutter to make the picture. In High-speed or Low-speed Continuous drive mode, pressing and holding the shutter button starts continuous shooting at either 5.3 or 3 fps, respectively. In Self-timer modes, pressing the shutter button completely initiates the 10- or 2-sec. timer, and after the timer delay, the shutter fires to make the picture.

Back of the camera

The back of the camera includes minimal buttons and controls for a clean design and easy use. Here is a look at the back of the 60D:

AF point selection/Magnify button

Live View shooting/Movie shooting button

Viewfinder eyepiece and eyecup

AE Lock/
FE Lock/
Index/
Reduce
button

Power switch

Erase button

Access lamp

AF-ON button

LCD monitor

Menu button

Quick Control button

INFO. button

Quick Control dial

Playback button | SET button

Quick Control dial unlock (UNLOCK) button

1.5 Back of the EOS 60D

▶ **Power switch.** The power switch turns the camera off and on.

▶ **Erase button.** Pressing the Erase button during image playback displays options to erase the currently displayed image as long as it is not protected. Batches of images can be erased together by selecting and check-marking images.

▶ **Viewfinder eyepiece and eyecup.** The 60D viewfinder is an eye-level penta-prism with approximately 96 percent vertical and horizontal coverage. The focusing screen can be changed.

▶ **Live View shooting/Movie shooting button.** Pressing this button initiates Live View shooting, or video shooting when the Mode dial is set to Movie mode. In Live View shooting, the camera raises the reflex mirror to display a current view of the scene on the LCD monitor. In Movie mode, press the button once to begin recording a video, and press it again to stop recording.

▶ **AF-ON button.** In P, Tv Av, M, B, C, Movie, and Live View shooting modes, you can press the AF-ON button to focus just as you would by pressing the shutter button halfway. The AF-ON button is also referred to as the AF start button. Depending on how you like to work, the AF-ON button can be a more convenient way to focus. And you can use Custom Function IV-1, AF, and metering buttons to change the button used for focusing so that the AF-ON button functions for both focusing while a half-press of the shutter button initiates metering, as well as other combinations.

▶ **AE Lock/FE Lock/Index/Reduce button.** During shooting, pressing this button enables you to set and lock the exposure or the Flash Exposure at a point different from where you focus. During image playback, pressing this button displays four images at a time, and pressing it again displays an index of nine images on the LCD monitor. In Playback mode with an image magnified, pressing once, or pressing and holding this button, reduces the image magnification. When you are printing images, pressing this button reduces the size of the trimming frame.

▶ **AF point selection/Magnify button.** During shooting, press this button to manually select the AF point. During image playback, pressing and holding this button magnifies still images so that you can check focus or details in the image. To move around a magnified image, press the Multi-controller in the direction you want to move. During printing preparation, pressing this button changes the size of the trimming frame.

▶ **Menu button.** Pressing the Menu button displays the most recently accessed camera menu and menu option. To move among the menus, turn the Main dial or press left or right on the Multi-controller.

▶ **Quick Control (Q) button.** Pressing this button displays the Quick Control screen where you can change the most common exposure and camera settings.

▶ **Access lamp.** This light lights or blinks when any action related to taking, recording, reading, erasing, or transferring images is in progress. Whenever the light is lit or blinking, do not open the card slot door, turn off the camera, or remove the battery.

▶ **INFO. button.** During shooting, pressing the INFO. button displays the Info screen that details the current camera settings. On the Setup 3 camera menu, you can program the button to display the camera settings, the Electronic Level

to square horizontal and vertical lines with the frame, and/or to display shooting functions. Then you can press the INFO. button one or more times to display any of these. When playing back images, pressing the INFO. button one or more times cycles through four different playback display modes.

▶ **Setting (SET) button.** Pressing this button confirms menu selections, opens submenu screens, and, on the Quick Control screen, opens screens from which you can change settings such as Exposure Compensation and Exposure Bracketing.

▶ **Multi-controller.** The eight-way Multi-controller functions as a joystick when pressed in any of eight directions. During shooting, you can use it to select an AF point after pressing the AF point selection button, to move the AF point or magnifying frame in Live View shooting, or to select and set camera menu options. On the Quick Control screen, the Multi-controller provides access to primary shooting and exposure options. Press up, down, left, or right on the Multi-controller to move among the functions on the screen. To change a setting, turn the Quick Control or Main dial, or press the SET button to access the function's setting screen. When working with camera menus, the Multi-controller is used to set White Balance shift settings.

▶ **Quick Control dial.** The Quick Control dial selects the functions for the buttons above the LCD panel. When the camera menus are displayed, turning the Quick Control dial cycles through the options on each menu. When shooting, you can use the Quick Control dial to manually select an AF point after pressing the AF point selection button.

▶ **Quick Control dial unlock (UNLOCK) button.** Pressing this button temporarily unlocks the Quick Control dial so that you can use it to adjust camera settings and select menu options. You can lock the Quick Control dial on the Setup 2 menu. Enabling locking affects use of the Quick Control dial in P, Tv, Av, M, B, and C shooting modes. Locking the Quick Control dial helps prevent unintentional changes to Exposure Compensation and the aperture in M and Bulb shooting modes. But you have to remember to press the UNLOCK button when you want to temporarily use the Quick Control dial.

▶ **Playback button.** Pressing this button displays the last captured image. To cycle through images on the card, turn the Quick Control dial counterclockwise to view images from last taken to first, or turn the dial clockwise to view images from first taken to last. To change the playback display, press the INFO. button one or more times.

▶ **LCD monitor.** The 3-inch, 1.04-million dot LCD monitor is fully articulated so that you can turn it virtually any angle as well as away from the back of the camera to compose images with a 100 percent view of the image area. In addition, you can turn the LCD monitor inward to protect the LCD screen.

Sides and bottom of the camera

On one side of the 60D you find

▶ **Speaker.** The speaker provides audio when playing back videos. You can adjust the volume by turning the Main dial.

▶ **Media card slot door.** Opening the door reveals the slot for the SD/SDHC/ SDXC card. To eject the card, just push it once quickly to pop up the card. Do not open the card slot door when the access lamp is lit.

SDHC or SDXC cards rated as Ultra High Speed (UHS) provide the fastest image-writing speed. UHS cards enable a maximum write speed of SD Speed Class 10.

The opposite side of the camera houses the camera terminals under a rubber cover. The rubber cover is embossed with descriptive icons and text to identify the terminals.

Here is an overview of each camera terminal by rows.

▶ **External microphone IN terminal.** This terminal enables stereo sound recording with an accessory microphone that has a stereo mini plug (3.5mm diameter).

▶ **HDMI mini OUT terminal.** This terminal, coupled with the accessory HDMI (High-Definition Multimedia Interface) Cable HTC-100, enables you to connect the camera to an HDTV. If the images can't be displayed, use the AV cable provided in the 60D box. You cannot use the HDMI mini OUT terminal simultaneously with the Video OUT terminal.

▶ **Audio/Video OUT/Digital terminal.** Use this terminal when you want to connect the camera to a non-HDTV to view images and movies stored on the media card. Be sure to use only the supplied AV cable to make the connection. You can connect the camera directly to a computer to download images from the camera to the computer, or to a PictBridge-compatible printer to print images directly from the SD card.

▶ **Remote Control terminal.** This terminal connects with the accessory Remote Switch RS-60E3.

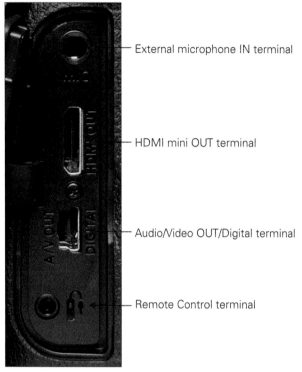

External microphone IN terminal

HDMI mini OUT terminal

Audio/Video OUT/Digital terminal

Remote Control terminal

1.6 EOS 60D terminals

The bottom of the camera houses the battery compartment cover and the tripod socket.

Lens Controls Overview

Lens controls differ according to the lens that you are using. In addition to autofocusing, you can also switch to manual focusing by setting the switch on the side of the lens to MF, or Manual Focus, on lenses that offer it. Manual focusing includes focus assist. As you adjust the focusing ring on the lens, the focus confirmation light in the lower-right side of the viewfinder lights steadily and the camera sounds a focus confirmation beep when sharp focus is achieved.

Although I cover lenses fully in Chapter 9, navigating the camera includes using the lens controls, so I include them here. Lens controls may include the following, depending on the lens:

▶ **Lens mounting index.** You match up the red or white mark on the lens with the red or white mark on the 60D's lens mount to attach the lens to the camera. Canon EF lenses have a red index mark and EF-S lenses have a white mark.

▶ **Focusing distance range selection switch.** This switch limits the range that the lens uses when seeking focus. For example, if you choose the 2.5m to infinity focusing distance option on the EF 70-200mm f/2.8L IS USM lens, then the lens does not seek focus at 2.5m and closer, and this speeds up autofocus. The focusing distance range options vary by lens.

▶ **Zoom ring.** Turning this ring zooms the lens to the focal length marked on the ring. On some older lenses, such as the EF 100-400mm f/4.5-5.6L IS USM lens, zooming is accomplished by first releasing a zoom ring, and then pushing or pulling the lens to zoom out or in.

▶ **Distance scale and infinity compensation mark.** The distance scale shows the lens's minimum focusing distance through infinity. The scale includes an infinity compensation mark that can be used to compensate for shifting the infinity focus point that results from temperature changes.

▶ **Focusing ring.** Turning the focusing ring enables you to manually focus or tweak the focus at any time on compatible lenses, even if you are using autofocusing. For lenses with an MF switch, you can switch to MF and turn this ring to focus on the subject.

▶ **Focus mode switch.** On the lenses that have this switch, you can choose either AF (Autofocus) or MF (Manual focus).

▶ **Image stabilizer switch.** This switch turns on or off Optical Image Stabilization. Optical Image Stabilization (IS) corrects vibrations at any angle or at only right angles when handholding the camera and lens.

▶ **Image stabilizer mode selector switch.** On some telephoto lenses, this switch enables image stabilization for standard shooting and stabilization when you are panning with the subject movement at right angles to the camera.

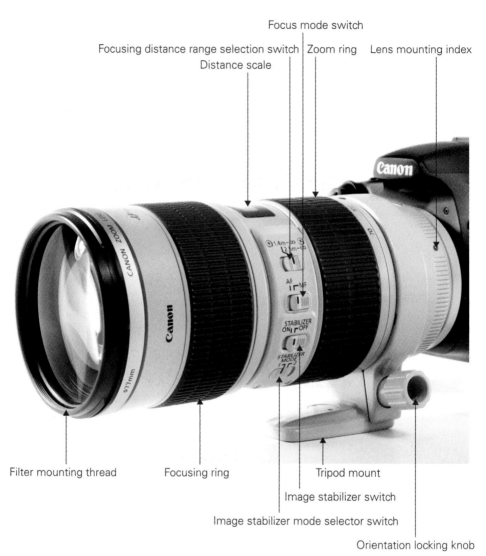

Focus mode switch

Focusing distance range selection switch | Zoom ring Lens mounting index

Distance scale

Filter mounting thread Focusing ring Tripod mount

Image stabilizer switch

Image stabilizer mode selector switch

Orientation locking knob

1.7 Lens controls, as shown on an EF 70-200mm f/2.8L IS USM lens

Camera Menus and Displays

While the exterior of the camera has key controls for camera adjustments, you'll also be able to verify most exposure settings by looking in the viewfinder. And for other camera adjustments, 14 camera menus provide more adjustment options. The Movie menus are not displayed until you switch to Movie shooting mode on the Mode dial.

Viewfinder display

The eye-level pentaprism viewfinder displays 96 percent of the scene that the camera captures. Figure 1.8 shows the viewfinder information and what each element represents.

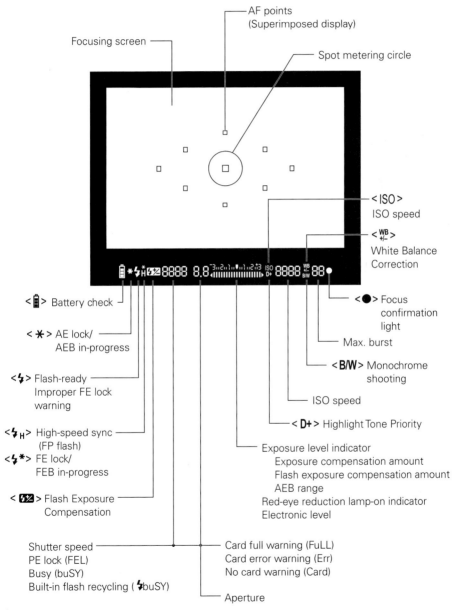

1.8 EOS 60D viewfinder display

The viewfinder includes nine AF points superimposed on the focusing screen, as well as key exposure and camera setting information.

Looking through the viewfinder during shooting allows you to verify that camera settings are as you want, or alerts you if they need to be changed. In addition, you are alerted when any exposure element you have chosen is beyond the exposure capability of the light in the scene.

Camera menus

The 60D offers 14 menus that appear as tabs and are categorized as Shooting, Playback, Setup, Custom Function, a customizable My Menu, and Movie. Accessing the menus is as easy as pressing the Menu button on the back of the camera.

The menus and options change, based on the shooting mode you select. In the automatic shooting modes, such as Creative Auto (CA) and Full Auto, the menus are abbreviated, and you can make only limited changes.

But in semiautomatic and manual modes such as P, Tv, Av, M, and B, the full menus are available. If you find a technique described in this book, but you cannot find the option mentioned on the menu, check the camera's shooting mode. By changing to a semiautomatic or manual mode, the option you need is displayed.

Table 1.1 through Table 1.14 show the full camera menus and options that are displayed in P Tv, Av, M, and B shooting modes.

To access the menus, just press the Menu button, press left or right on the Multi-controller to select a menu tab, and then press up or down on the Multi-controller to select a menu option. Then press the SET button to display the choices you can make.

Table 1.1 Shooting 1 Menu

Commands	Options
Quality	Large/Fine, Large/Normal, Medium/Fine, Medium/Normal, S1/Fine, S1/Normal, S2, S3, RAW, M (Medium) RAW, S (Small) RAW. You can also choose RAW+JPEG.
Beep	Enable, or Disable.
Release shutter without card	Enable, or Disable.
Image review	Off, 2 sec., 4 sec., 8 sec., Hold.
Peripheral illumination correction	Enable, or Disable.
Red-eye reduction	Disable, or Enable.

Commands	Options
Flash control	Flash firing (Enable/Disable), Built-in flash func. setting, External flash func. setting (available only with flash connected), External flash C.Fn setting (available only with flash connected), Clear ext. flash C.Fn setting (available only with flash connected).

Table 1.2 Shooting 2 Menu

Commands	Options
Expo. comp./AEB (Exposure Compensation/Auto Exposure Bracketing)	1/3-stop increments by default, up to plus or minus 5 stops of Exposure Compensation and up to plus or minus 3 stops of AEB.
Auto Lighting Optimizer	Off, Low, Standard, or Strong.
Picture Style	Standard, Portrait, Landscape, Neutral, Faithful, Monochrome, User Defined 1, 2, and 3.
White Balance	Auto (AWB), Daylight (Approximately 5200K), Shade (Approximately 7000K), Cloudy (Approximately 6000K), Tungsten (Approximately 3200K), White fluorescent light (Approximately 4000K), Flash, Custom (2500 to 10000K), K (Color Temperature 2500 to 10000K).
Custom White Balance	Set a manual White Balance.
WB Shift/BKT (White Balance shift/bracketing)	White Balance correction using Blue/Amber (B/A) or Magenta/Green (M/G) color bias; White Balance Bracketing using B/A and M/G bias.
Color space	sRGB, Adobe RGB.

Table 1.3 Shooting 3 Menu

Commands	Options
Dust Delete Data	Locates and records dust on the image sensor so you can use the data in the Canon Digital Photo Professional program to erase dust spots on images.
ISO Auto	Enables you to set the highest ISO used with the Auto ISO option. Max.: 400, Max.: 800, Max.: 1600, Max.: 3200, or Max.: 6400.

Table 1.4 Shooting 4 Menu

Commands	Options
Live View shoot.	Enable, or Disable.
AF mode	Live mode, (Face detection) Live mode, or Quick mode.
Grid display	Off, Grid 1, Grid 2.
Aspect ratio	3:2, 4:3, 16:9, 1:1.

continued

Table 1.4 Shooting 4 Menu *(continued)*

Commands	Options
Expo. simulation (Exposure simulation)	Enable, or Disable. For Live View shooting, choosing Enable provides a better representation on the LCD of how the final image will look.
Silent shooting	Mode 1, Mode 2, or Disable. For Live View shooting, these modes provide quieter shutter operation.
Metering timer	4, 16, 30 sec.; 1, 10, or 30 min.

Table 1.5 Playback 1 Menu

Commands	Options
Protect images	Options for marking and protecting all or selected images from being deleted.
Rotate	Choose to rotate the selected image clockwise at 90, 270, or 0 degrees by pressing the SET button.
Erase images	Select and erase images, All images in folder, or All images on card.
Print order	Displays options for selecting images to be printed.
Creative filters	Displays image with the option to apply Grainy B/W, Soft focus, Toy camera effect, Miniature effect.
Resize	Displays image so you can select options for reducing the image size in pixels; for example, M, S1, S2, or S3.
RAW image processing	Displays image with editing options for processing the selected RAW image, and then saving it as a JPEG file.

Table 1.6 Playback 2 Menu

Commands	Options
Highlight alert	Disable, or Enable. When enabled, overexposed highlights blink in all image-playback displays.
AF point disp. (display)	Disable, or Enable. Superimposes the AF point that achieved focus on the image during playback.
Histogram	Brightness, or RGB. Brightness displays a tonal distribution histogram. RGB displays separate Red, Green, and Blue color channel histograms.
Image jump w/(Main dial)	Options to move through images by: 1, 10, 100 (images at a time), Date, Folder, Movies, Stills, or Image Rating.
Slide show	Displays options to Setup and Start a slide show of images on the media card.

Commands	Options
Rating	Displays image with options to rate the image with 1, 2, 3, 4, 5 stars, or choose Off to not rate the image.
Ctrl (Control) over HDMI	Disable, or Enable.

Table 1.7 Setup 1 Menu

Commands	Options
Auto power off	1, 2, 4, 8, 15, 30 min., or Off.
Auto Rotate	On for camera and computer, On for computer only, or Off. Turns vertical images to upright orientation for the camera's LCD and/or computer display.
Format	Format and erase images on the SD card with the option to use Low level format.
File numbering	Continuous, Auto reset, Manual reset.
Select folder	Displays current folder(s) with the option to Create a new folder.
Eye-Fi settings	Eye-Fi transmission: Disable, or Enable, and connection information. This menu option appears only when an Eye-Fi card is in the camera.

Table 1.8 Setup 2 Menu

Commands	Options
LCD brightness	Seven adjustable levels of brightness.
Date/Time	Set the date (year/month/day) and time (hour/minute/second).
Language	Choose language.
Video system	NTSC, PAL.
Sensor cleaning	Auto cleaning (Enable, or Disable), Clean now, or Clean manually.
Lock (Quick Control dial)	Disable, or Enable. Prevents unintentional changes to Exposure Compensation and aperture setting in certain shooting modes.

Table 1.9 Setup 3 Menu

Commands	Options
Battery info.	View the battery type, remaining battery capacity, shutter count, and recharge performance.
INFO. button display options	Choose to include or exclude these options when you press the INFO. button one or more times: Displays camera Settings, Electronic level, or Displays shooting functions.

continued

Table 1.9 Setup 3 Menu *(continued)*

Commands	Options
Camera user settings	Register or clear camera settings to the C shooting mode.
Copyright information	Display copyright info., Enter author's name, Enter copyright details, Delete copyright information.
Clear all camera settings	Restores the camera's default settings, does not delete copyright information or change Camera User Settings (C-mode settings) or My Menu settings; this does not restore Custom Function to their original default settings.
Firmware Ver. (Firmware version number)	Displays the existing firmware version number, and enables you to update the camera's firmware.

Table 1.10 Custom Functions Menu

Commands	Options
C.Fn I: Exposure	Displays Custom Function for Exposure level increments, ISO increments, ISO expansion, Bracketing auto cancel, Bracketing sequence, Safety shift, and Flash sync speed in Av mode.
C.Fn II: Image	Displays Custom Function for Long exposure noise reduction, High ISO speed noise reduction, and Highlight tone priority.
C.Fn III: Autofocus/Drive	Displays Custom Function for Lens drive when AF is impossible, AF point selection method, Superimposed display, AF-assist beam firing, and Mirror lockup.
C.Fn IV: Operation/Others	Displays Custom Function for AF and metering buttons, Assign SET button, Dial direction during Tv/Av, Focusing Screen, and Add image verification data.
Clear all Custom Func. (C.Fn)	Restores all the camera's default Custom Function settings.

Table 1.11 My Menu

Commands	Options
My Menu settings	Select and save frequently used menu options and Custom Functions to this menu for easy access.

Table 1.12 Movie 1 Shooting Menu

Commands	Options
Movie exposure	Auto, or Manual.
AF mode	Live Mode, (Face detection) Live mode/Quick mode.
AF w/ shutter button during (movie recording)	Disable, or Enable.
AF and metering butt. (button) for (movie recording)	Set the function for the shutter button, AF-ON, and AE Lock (*) buttons during movie recording.
ISO speed setting increments	1/3, or 1 stop.
Highlight tone priority	Disable, or Enable.

Table 1.13 Movie 2 Shooting Menu

Commands	Options
Movie rec. (recording) size	1920×1080 (30, or 24 fps), 1280×720 (60 fps), 640×480 (60 fps), Crop 640×480 (60 fps).
Sound recording	Auto, Manual, or Disable, Rec. (recording) level, Wind filter (Disable, or Enable).
Silent shooting	Mode 1, Mode 2, or Disable.
Metering timer	4, 16, 30 sec.; 1, 10, or 30 min.
Grid display	Off, Grid 1, or Grid 2.

Table 1.14 Movie 3 Shooting Menu

Commands	Options
Exposure comp. (compensation)	Plus or minus 5 stops in 1/3-stop increments.
Auto Lighting Optimizer	Disable, Low, Standard, Strong.
Picture Style	Standard, Portrait, Landscape, Neutral, Faithful, Monochrome, User Def. 1, 2, or 3.
White balance	Auto (AWB), Daylight (Approximately 5200K), Shade (Approximately 7000K), Cloudy (Approximately 6000K), Tungsten (Approximately 3200K), White fluorescent light (Approximately 4000K), Flash, Custom (2500 to 10000K), K (Color Temperature 2500 to 10000K).
Custom White Balance	Set a custom white balance.

The Movie shooting menus also include all or abbreviated Shooting, Playback, and Setup menus as provided for still-image shooting.

Choosing Camera Options and Reviewing Images

The first step when you get a new camera is to set it up to your liking. That sounds easy enough, and you may have already set up your 60D. However, some options are particularly important — especially those that affect the image size and quality because they affect how large you can print your images. So even if you've set these options, be sure to review the image quality sections in this chapter. In addition, this chapter discusses a new 60D feature that enables you to edit and convert RAW images and save the edited image in JPEG format in the camera so that you can print the JPEG image from the media card. This chapter also details how to resize JPEG images in the camera, set the image aspect ratio, set up file numbering and folders, add your copyright to images, and use options

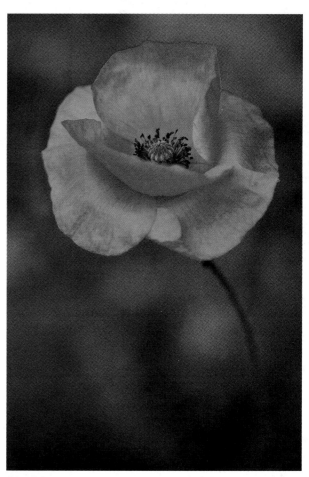

Careful camera setup helps ensure the best image quality, and you don't have to spend time tweaking settings when you're ready to begin shooting. For this shot, I chose RAW capture with my copyright embedded into the image file. Exposure: ISO 400, f/3.2, 1/640 second.

that make it easier for you to keep track of, review, and protect images from accidental erasure.

Choosing Image Format and Quality

One of the most important setup choices is choosing the image quality level. Only a few years ago, people routinely chose lower image resolution to get smaller file sizes so they could fit more images on the SD/SDHC card. Over time, media card prices have come down and larger capacity cards are now quite affordable. When you shoot at the 60D's high-quality settings with a 4GB SD/SDHC card, you can store 490 JPEG or 130 RAW images on the card. And when you use the high-quality settings, you can print images at 11 × 17 inches or larger. This is not to say that you'll print every image at this size, but when you get those one-of-a-kind shots that beg to be printed in a large format, you know that you gave a large-enough file to print it.

A related setup option is choosing the file format for capturing your images — either JPEG or RAW. The 60D offers a full menu of individual and combined choices for both JPEG and RAW capture. The next sections detail the advantages and disadvantages of each option to help you decide what works best for you.

JPEG format

JPEG is the most common file format used for digital images, and it is the default file format on the 60D. JPEG offers efficient, high-quality file compression that saves space on the memory card. JPEG also offers quick display of image files on the camera's LCD monitor and on the computer.

The small file sizes that JPEG produces allow you to store many images on the SD/SDHC card. To reduce image file size, JPEG compresses files and, in the process, discards some image data. The higher the compression level, the more image data is discarded and the smaller the image file size, and vice versa. Because of this loss of data, JPEG is known as a *lossy file format*. While data loss isn't ideal, data loss at a low compression level is typically not noticeable in prints.

> **TIP** If you edit JPEG images on the computer, and then save them as JPEGs, the data loss continues to occur. To preserve image data during editing, be sure to save JPEG images as TIFFs or in another file format before you begin editing.

Another advantage is that JPEG files can be displayed on any computer, regardless of the operating system; on the Web; and in e-mail without the need for special viewing programs or preprocessing. And with JPEGs, you get a finished file that you can print directly from the media card. That's because the 60D processes, or edits, the images before storing them on the SD/SDHC card. The processing includes setting the color,

contrast, and sharpness. By contrast, with RAW images, you can set color, contrast, and sharpness during image conversion on the computer.

 Choosing a Picture Style also affects the color tone and saturation, image contrast, and sharpness of images. And you can apply Ambience and Creative Filters that affect the final image. All are detailed in Chapter 4.

Another JPEG advantage is that it provides the 60D's maximum burst rates when you're shooting in High-speed Continuous drive mode. For example, shooting the highest-quality JPEG images, the burst rate is 58 shots at 5.3 frames per second (fps). Thus JPEG capture offers a definite edge for getting the fastest performance from the 60D.

JPEG has some disadvantages as well. The 60D offers two JPEG compression levels, and you can reduce the image-recording size from 17.9 to either 8 or 4.5 megapixels. The higher the compression and the smaller the image size, the more images you can capture in a continuous shooting burst, and the more images can be stored on the SD/SDHC card. But the higher the compression and smaller image size, the more the image quality suffers.

You can also resize JPEG images in the camera, a technique detailed later in this chapter.

Another consideration is that JPEG capture means loss of image data from in-camera conversion of the image's bit depth. Every 60D image is captured as a 14-bit file that delivers 16,384 colors in each of the three color channels: Red, Green, and Blue (RGB). Because the JPEG file format doesn't support 14-bit files, the 60D automatically converts JPEG images to 8-bit files with only 256 colors per channel. While the conversion from 14-bit to 8-bit is done judiciously, the fact remains that much of the image color information is discarded in the process.

Combine this data loss with the automatic in-camera editing and JPEG compression, and you get a file that has one-third or more of the image data discarded before it's written to the SD/SDHC card. Certainly the JPEG image files are smaller, but with the data loss, the files are not as rich as RAW files, and they offer less latitude and stability when you edit them on the computer.

However, for photographers who seldom edit images on the computer and want small file sizes with maximum portability, JPEG is the best option. But, for photographers who want to preserve all the rich image data that the 60D captures, RAW capture is worth exploring.

Should You Use the S2 and S3 JPEG Options?

On the 60D, you have two additional JPEG options: S2 and S3. Both options create images that are saved with low compression, but at very small sizes. The S2 option produces images at a diminutive 3.5 × 5.1 inches, a size that fits into a digital photo frame with no resizing needed in an editing program. The S3 option produces even smaller images that are ready for you to send in e-mail or to post on the Web. These are convenient options, but because you cannot shoot these small files in combination with a larger JPEG file size, you have to be certain that you will never want larger versions of your S2 and S3 images.

Personally, I would choose these options only with a RAW file option. If you shoot only JPEGs, then I recommend choosing a large JPEG file size and using an editing program that offers a one-click option to create Web-sized images from your large JPEG file.

RAW capture

RAW is the option to choose if you want the highest quality images the 60D can deliver. RAW is a designation for image files that are captured and stored on the SD/SDHC card with little in-camera processing and with no loss of data from compression or conversion. RAW files are not converted to 8-bit as with JPEG files, but rather they are captured and stored as 14-bit images. And unlike pre-edited JPEG files, the only settings the camera applies to RAW images are the aperture, ISO, and shutter speed.

With RAW, you can set or adjust key settings such as white balance, brightness, contrast, and saturation after the image is captured. This means that in addition to getting an image file that contains all the 60D can provide, you also get wide latitude when converting the RAW image.

Converting RAW images is done using Canon Digital Photo Professional (DPP), Adobe Camera Raw, Adobe Lightroom, or Apple Aperture where you adjust the image color, brightness, tonal range, contrast, and color saturation to your liking. If you use DPP, you can also apply a Picture Style, Auto Lighting Optimizer, and other options just as you would apply them in the camera.

 On the 60D, you can edit and convert a RAW image in the camera and save the resulting file as a JPEG, a technique detailed later in this chapter.

In addition, if images have blown highlights — areas where the highlights went to solid white with no image detail — you can recover some of that image detail during conversion. If an image is underexposed, you can brighten it during conversion. All the adjustments made during RAW image conversion are nondestructive, just as if you had made the adjustments in the camera.

When a RAW image conversion on the computer is complete, you have a robust file that you can save as a TIFF or in another file format. Having a robust file is important because when you edit the image in Photoshop or another image-editing program, virtually all the edits you make are destructive — whether you adjust levels or color balance or set a tonal curve. Less robust JPEG files can suffer *posterization*, or the loss of smooth transitions among tonal levels. By contrast, with RAW files, you begin with a rich 14-bit file that you can save as a 16-bit file in a RAW conversion program. A 16-bit file can withstand destructive image edits much better than an 8-bit file.

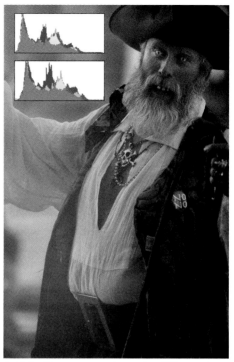

2.1 The histograms show the difference between this image as a RAW capture and as a JPEG. In the JPEG histogram at the bottom, the highlights spike indicates clipping, or discarding, of data. In the RAW histogram at the top, the highlights are well within range. This Seafair pirate was performing in a large amount of smoke from the pirates' last cannon explosion. Exposure: ISO 200, f/2.8, 1/1000 second.

In addition, you can opt to shoot using medium or small RAW image-recording options, both of which offer the same advantages as full-size RAW files, but at a smaller image size. The 60D offers M-RAW at 10.1 megapixels (16.7MB file), or S-RAW at 4.5 megapixels (11.1MB file).

RAW files have some drawbacks, however. First, RAW files lack the portability of JPEG files. You cannot edit RAW files on the computer unless you've installed Digital Photo Professional or another RAW conversion program, such as Adobe Lightroom or Camera Raw. Second, unless you enjoy working with images on the computer, RAW is not a good option because the files must be first converted, and then saved in

another format, such as TIFF. Third, RAW image file sizes are considerably larger than JPEG images.

When you know the advantages and disadvantages of JPEG and RAW capture, you are in a better position to choose whether you want to shoot JPEG or RAW images. You can choose to take advantage of both types of files and select the size for each type.

In-camera RAW image conversion

With the 60D, you now have the option to process RAW images in the camera, and save the images as JPEG images on the SD/SDHC card. Then you can print the JPEG files directly from the SD/SDHC card or simply have them available as a preprocessed JPEG file when you download images to the computer. This option sidesteps the need to convert RAW images on the computer. You can convert only full-size RAW images, not M- or S-RAW size images in the camera.

The disadvantage of in-camera RAW processing is that for the converted JPEG file, you have limited control over the RAW image conversion with no histogram to check for clipping — or discarding pixels during the conversion. The primary reason to shoot RAW capture is to have complete control over the final image. But the 60D retains the original RAW image unaltered on the media card so that you can still convert it in a conversion program to your liking.

However, during in-camera RAW conversion, you can change the brightness, white balance, Picture Style, use Auto Lighting Optimizer and adjust the setting, apply one of three levels of noise reduction (NR), set the size of the converted image, change the color space, apply Peripheral Illumination Correction, apply distortion correction, and correct chromatic aberration.

 Chromatic aberration is a lens phenomenon that causes different effects including a colored fringe on the edges of high-contrast objects as well as color flare or blur. See the Glossary for more details.

Here is how to convert a RAW image in the 60D and the adjustments that you can make.

 For all step-by-step instructions in this chapter, you can access the 60D camera menus by pressing the Menu button. Then turn the Main dial to select a menu tab, and then press up or down on the Multi-controller to highlight a menu option or turn the Quick Control dial.

1. **On the Playback 1 camera menu tab, highlight RAW image processing, and then press the SET button.** The 60D displays the first RAW image with the RAW [to] JPEG icon in the upper left.

2. **Navigate to the RAW image you want to convert, and then press the SET button.** To quickly locate a specific RAW image, press the Index button on the back right of the camera. Then you can press the Multi-controller to move through the index pages to find the image you want. The RAW image pro-cessing controls appear over-laid on the image.

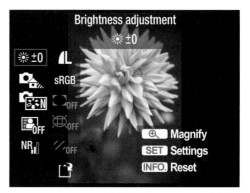

2.2 The RAW image conversion screen

3. **To select a processing option, press up, down, left, or right on the Multi-controller, and then press the SET button.**

4. **Turn the Quick Control dial or press left or right on the Multi-controller to select the setting, and then press the SET button to apply the change.** As you make adjustments, the image display reflects the changes.

 • **Brightness.** (Denoted by a sun and +/–0 icon.) This setting is adjustable up to +/–1-stop in 1/3-stop increments.

 • **White Balance.** (Denoted by an AWB icon.) You can choose a different White Balance option or choose the K (specific color temper-ature) option. If you choose K, turn the Main dial to set the color temperature.

 • **Picture Style.** (Denoted by a Picture Style icon.) You can not only choose a new Picture Style, but you can

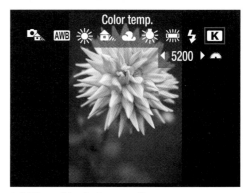

2.3 The white balance adjustment screen

also change the parameters for the Style. Press left or right on the Multi-controller to choose a style, and then press down on the Multi-controller to set the first parameter. The parameters from top to bottom are Sharpness, Contrast, Saturation, and Color tone.

- **Auto Lighting Optimizer.** (Denoted with a person and light/dark background icon.) Adjust this setting to automatically change the brightness and contrast of the image. Three levels are available, as well as an Off option.

- **High ISO speed noise reduction.** (Denoted by an NR and bar-graph icon.) You can choose to apply a Standard, Low, or Strong level of noise reduction to images shot at high ISO settings.

- **Image-recording quality.** (Denoted by a quarter circle and L icon.) Use this option to set the pixel count and image quality of the JPEG file that will be saved from the RAW image conversion. For Live View images shot at a specific aspect ratio, the resulting JPEG file will reflect that aspect ratio as well. You also set the aspect ratio to 3:2, 4:3, 16:9, or 1:1 depending on the option you choose.

- **Color space.** (Denoted by an sRGB icon.) This option enables you to choose either the sRGB or Adobe RGB color space. If you choose Adobe RGB, the appearance of the image on the LCD does not change because the LCD isn't compatible with Adobe RGB, but the print reflects the color space you choose. Color spaces are detailed in Chapter 4.

 NOTE The following options are available only if the image has the characteristics these options correct.

- **Peripheral Illumination Correction.** (Denoted by a rectangle with a vignette icon.) If you select the Enable option, it corrects the darkening of the four corners, or *vignetting*, in an image.

- **Distortion correction.** (Denoted by a grid icon.) This option corrects lens distortion, such as the barrel or pincushion distortion where the center of the image bows out or in, respectively, or other lens distortions that can happen with different lenses. If you correct the distortion, the edges of the image are cropped, making the image appear slightly larger, and making it potentially lower in resolution.

- **Chromatic aberration correction.** (Denoted by a rectangle of stripes icon.) Choose Enable to correct a lens phenomenon that bends different-colored light rays at different angles, causing color along the edges of elements in the image such as a purple or magenta fringe. To see the effect, press the Magnify button to enlarge the image, and then look at the edge of an object, especially one that has high contrast such as a tree limb against the sky. Press the Reduce button on the back of the camera to zoom out when you finish.

 If you don't like the adjustments, press the INFO. button to return to the original image settings.

5. **Press down on the Multi-controller to select Save (denoted by a curved arrow), and then press the SET button.** The Save as a new file screen appears.

6. **Press right on the Multi-controller to select OK.** The camera displays the folder in which the JPEG image will be saved and the file number.

7. **Press the SET button to confirm the file location.** The camera displays the original image. You can navigate to the next RAW image to convert, or lightly press the shutter button to return to shooting.

The best of both worlds: Shooting RAW and JPEG

To get the best of both worlds, you can choose to shoot both RAW and JPEG. You then have the advantage of getting a pre-edited JPEG file you can post online or print directly with no image editing. You also get a RAW file, either full size or smaller, that you can convert and edit. So when you get a great shot that you want to perfect in a RAW conversion program, or when you get a shot that needs some adjustments, the RAW file gives you the latitude to make adjustments.

One downside of shooting RAW+JPEG is the increased space needed on the SD/SDHC card. For example, on a 4GB card, you can store 100 full-size RAW and Large/Fine JPEG images. Whereas if you shoot only Large/Fine JPEGs, you can store 490 images on the card. If you capture both JPEG and RAW, the images are saved with the same file number in the same folder. They are distinguished by the file extensions of .JPG for the JPEG image and .CR2 for RAW, M-RAW, or S-RAW. RAW+JPEG capture also slows down the continuous high-speed shooting burst rate as shown in Table 2.1. (Estimates in Table 2.1 are approximate, and vary according to image factors, including ISO, Picture Style, and Custom Function settings, as well as card brand, type, and speed.)

Canon divides the image quality screen between RAW and JPEG options. You can select RAW options by turning the Main dial, and JPEG options by turning the Quick Control dial.

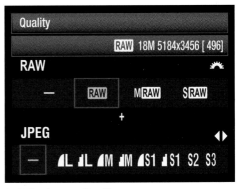

2.4 The image Quality screen

31

Table 2.1 Image Quality, Size Options, and Burst Rates

Image quality		Approximate size in megapixels (MP)	File size in MB	Maximum burst rate (4GB card)
JPEG	Large/Fine	17.9	6.4	58
	Large/Normal		3.2	300
	Medium/Fine	8	3.4	260
	Medium/Normal		1.7	1,930
	Small (S1)/Fine	4.5	2.2	1,500
	S1/Normal		1.1	3,100
	S2	2.5	1.3	2,580
	S3	0.35	0.3	10,780
RAW	RAW	17.9	24.5	16
	M-RAW	10.1	16.7	19
	S-RAW	4.5	11.1	24
RAW +JPEG	RAW + Large/Fine JPEG	17.9 each	30.9	7
	M-RAW + Large/ Fine JPEG	10.1 and 17.9	23.1	7
	S-RAW + Large/ Fine JPEG	4.5 and 17.9	17.5	7

To set the image format and quality, follow these steps.

1. **On the Shooting 1 camera menu tab, highlight Quality, and then press the SET button.** The Quality screen appears.

2. **Turn the Main dial to select a RAW option, or press left or right on the Multi-controller or turn the Quick Control dial to select a JPEG option.** If you want to shoot RAW+JPEG, choose a JPEG and a RAW option. Or, if you are shooting RAW+JPEG, and you want to stop capturing the RAW image, then select the minus sign for the type image you do not want to capture.

3. **Press the SET button.** The options you choose remain in effect until you change them.

Resizing JPEG images in the camera

If you print images directly from the media card, you'll appreciate the new 60D option to resize JPEG images on the card to a size and the aspect ratio you need for printing at standard print sizes. Alternately, you can use the resize option to have a JPEG image presized for display in a digital photo frame, or for posting on a Web site or sending in e-mail.

When you resize an existing image on the media card, it creates a new file, leaving the original JPEG intact. You can only resize JPEG images captured as Large, Medium, S1, or S2. RAW and S3 JPEG images can't be resized.

When you resize images, the aspect ratio and pixel count are set as well. The aspect ratio refers to the relationship of the image width to height. Standard print sizes have aspect ratios that may be different from the image's aspect ratio. For example, a 4 × 6-inch print has a 3:2 aspect ratio while an 8 × 10-inch print has a 5:4 aspect ratio. The resize option enables you to fit the image to the print's aspect ratio with varying amounts of cropping to make the image fit the paper size. To figure out the print size that each aspect ratio produces, multiply each number in the ratio by 2. A 3:2 aspect ratio translates to 6 × 4, or a 4 × 6-inch print.

You can resize the JPEG images as follows.

▶ Large can be resized to M, S1, S2, or S3.

▶ Medium can be resized to S1, S2, or S3.

▶ S1 can be resized to S2 or S3.

▶ S2 can be resized to S3.

You can also choose the resolution (or pixel count) and the aspect ratio as shown in Table 2.2. Aspect ratios can be set for Live View shooting on the Shooting 4 menu. Just select Aspect ratio, press the SET button, and then select the aspect ratio you want. Then when you begin shooting in Live View, nonprinting lines show the amount of the scene that will be in the final print based on the aspect ratio you chose.

Table 2.2 Aspect Ratio Options

Quality	Aspect ratio with megapixels (MP) or pixel count in parenthesis			
	3:2	**4:3**	**16:9**	**1:1**
M	3456 × 2304	3072 × 2304	3456 × 1944	2304 × 2304
	(8 MP)	(7 MP)	(6.7 MP)	(5.3 MP)
S1	2592 × 1728	2304 × 1728	2592 × 1456	1728 × 1728
	(4.5 MP)	(4 MP)	(3.8 MP)	(3 MP)
S2	1920 × 1280	1696 × 1280	1920 × 1080	1280 × 1280
	(2.5 MP)	(2.2 MP)	(2.1 MP)	(1.6 MP)
S3	720 × 480	640 × 480	720 × 400	480 × 480
	(350,000 pixels)	(310,000 pixels)	(290,000 pixels)	(230,000 pixels)

Nonprinting lines on the preview image show the crop for the 4:3, 16:9, and 1:1 aspect ratios. RAW images are saved at the camera's native 3:2 aspect ratio, but if you apply a ratio, it is appended to the RAW file. Then when you open the image in Canon Digital Photo Professional, the image is shown with the chosen aspect ratio.

To resize an L, M, S1, or S2 JPEG image, follow these steps.

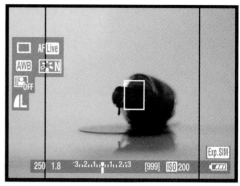

2.5 The black vertical lines on the left and right show the area of the image that will be cropped using a 1:1 aspect ratio. When you print the image, these lines do not print.

1. **On the Playback 1 menu, highlight Resize, and then press the SET button.** The image appears with the resize icon at the upper left. You can navigate to a different image if you want.

2. **Press the SET button, press right or left on the Multi-controller to select the size you want, and then press the SET button again.** The Save as new file screen appears.

3. **Press right on the Multi-controller to select OK.** A message appears noting the folder in which the image will be saved and file number.

4. **Press right on the Multi-controller to OK the message.** The original image appears. You can navigate to another image to resize.

Working with Folders and File Numbering

With the 60D, the camera automatically creates a folder in which to store images. However, you can set up additional folders for different scenes and subjects. This helps you organize images as you download them to the computer. Folders can contain up to 9,999 images, and when that number is reached, the 60D automatically creates a new folder.

Creating and selecting folders

One handy feature of the 60D is it enables you to create new folders on each SD/SDHC card to store images. The numbering sequence is straightforward, and starts with the default 100CANON folder and goes up to 999CANON. You can create new folders either in the camera or on the computer. Here are the folder guidelines using either option.

When image 9999 is recorded within a folder on the SD/SDHC card, the camera displays an error message, and you cannot continue shooting until you replace the SD/SDHC card, regardless of whether or not the card contains additional free space. This may sound innocuous, but it can cause missed shots. So if the camera stops shooting, try replacing the SD/SDHC card.

▶ **Creating folders in the camera.** Folders created in the camera are numbered sequentially, and begin with one number higher than the last number in the existing folder. The camera automatically creates folder 100CANON; therefore, if you create a new folder, the next folder name is 101CANON. When you create folders in the camera, the folder naming structure is preset and cannot be changed. If you insert a SD/SDHC card from another Canon EOS dSLR, the folder retains the folder naming from the other EOS camera until you format the SD/SDHC card in the 60D.

▶ **Creating folders on the computer.** You can also create folders on the computer for more flexibility in file naming. However, you must follow naming conventions. Each folder must be labeled with a unique three-digit number from 101 to 999. Then a combination of up to five letters (upper- and/or lowercase) and/or numbers can be added with an underscore. No spaces are allowed and the same three-digit number can't be repeated. So, you can create a folder named 102CKL_1, but not one named 102SKL_1.

Unlike image numbering, the 60D does not remember the last highest number when you insert a different media card and create a new folder on the card. And if you format the SD/SDHC card, the folders you created either in the camera or on the computer are erased along with all images. The only folder that isn't erased is the default 100CANON folder.

When you format the SD/SDHC card, all existing folders except 100CANON are deleted. Thus you need to create new folders after you format the card.

To view an existing folder or create a new folder, follow these steps.

1. **On the Setup 1 tab, highlight Select Folder, and then press the SET button.** The Select folder screen appears showing existing folders and the number of images per folder displayed on the left side and a preview of the first two images in the selected folder on the right.

2. **To create a new folder, turn the Quick Control dial to highlight Create folder, and then press the SET button.** The camera displays the Select folder screen with a confirmation message to create a folder with the next incremented number.

 If the Quick Control dial does not work, press the UNLOCK button under the dial, or press down on the Multi-controller.

3. Turn the Quick Control dial to select OK, and then press the SET button.
The Select folder screen appears with the newly created folder selected.

Choosing a file numbering option

Changing the way that the camera numbers files may not seem like a top priority to you, but you may find that one of the other file-numbering methods helps you delineate files in different shooting situations to make your workflow more efficient. Here is a look at each option and some of the shooting scenarios where each option could offer an advantage.

Continuous file numbering

Continuous file numbering is the default setting on the 60D, and every file is numbered sequentially beginning with 0001 through 9999. Image files are stored in the 100CANON folder located at the top-level on the SD/SDHC card.

The camera automatically creates the 100CANON folder. File numbering continues uninterrupted unless you insert a SD/SDHC card that has images stored on it. If the highest number on the card is higher than the last image number on the 60D, file numbering typically continues from the current highest-numbered image on the SD/SDHC card. That numbering continues even after you subsequently insert an empty formatted card. For example, although I had taken only 200 images with the 60D, when I inserted a SD/SDHC card from another Canon camera, the next image file number on the 60D was 4521, the next higher number on the SD/SDHC card.

Likewise, if a SD/SDHC card contains multiple folders with images in them, then the numbering sequence begins with the highest-numbered existing image in the folder that is being used. But if you insert a card that has a file number that is lower than the last highest file number taken on the 60D (stored in the camera's internal memory), the file numbering continues from the last highest file number recorded on the 60D. In short, the camera uses the last highest number from either the card or the number stored in memory.

Auto reset

As the name implies, this option resets image file numbering every time you insert a SD/SDHC card, and when you create a new folder on the SD/SDHC card. Using Auto reset, image file numbers reset to begin at 0001.

Auto reset is handy for keeping images organized by shoot when photographing different subjects or assignments on the same day. I create separate folders on the SD/SDHC card or cards, and then save images from different shoots to individual folders. Because the file numbers reset in each folder, it's easy to check each folder to see the number of images I've taken for the assignment. Additionally, it's easier to keep the images separate when I download them to the computer. Further, if you have enough SD/SDHC cards to use one card per scene or subject, Auto reset can help you organize images by SD/SDHC card.

But again, the Auto reset option isn't as straightforward as it seems. If you insert a SD/SDHC card with existing images stored on it, the camera uses the highest existing image number and continues numbering from there. So if you want Auto reset to reset to 0001, be sure to format the SD/SDHC card in the camera before shooting with it. In short, it pays to start a shooting day with an adequate supply of freshly formatted SD/SDHC cards, and to not swap SD/SDHC cards between cameras to make this and other file numbering methods work best.

Manual reset

This option seems to work around the limitations of the Continuous and Auto reset settings. By its name, it seems that you could force file numbering to reset for a fresh start. However, that's true only if the default 100CANON folder is empty. When you select Manual reset, the next image number is set to 0001. But if the folder has images in it, when you choose Manual reset, the camera creates a new folder, 101CANON, and starts image numbering at 0001 in that folder. That behavior is also true for SD/SDHC cards that have multiple folders with images in each folder.

When would you use Manual reset? I use it any time I want to quickly create a new folder and begin shooting at image number 0001. For example, if I'm shooting a wedding, and a member of the wedding party asks me to photograph his family during a break, I can select Manual reset and know that the family shots will be kept in a folder separate from the wedding image folder. Of course, I have to remember to switch back to the wedding folder when I go back to shooting the wedding.

After you choose to manually reset the file numbering, the 60D returns to the file numbering option that was in effect before the numbering was manually reset, either Continuous or Auto reset.

Follow these steps to set the file numbering option you want:

1. **On the Setup 1 tab, highlight File numbering, and then press the SET button.** The camera displays the three file numbering options.

2. **Highlight the option you want, and then press the SET button.** The option remains in effect until you change it, except for Manual reset, which creates a new folder if there are images in the current folder and in any other folders. If there are no images, then image numbers in the current folder begin with 0001. In both instances, the camera then returns to the previously selected file numbering option.

Miscellaneous Setup Options

There is a laundry list of setup options on the 60D that can make your shooting life easier and make the camera work better for you. You may have already implemented these settings, but in case you missed some, here is a list of helpful setup options.

General setup options

Within general options, I include options typically set only once, although there are some you may revisit for specific shooting scenarios. If you don't see a menu option in the following lists, it's because it appears in other sections of the book.

To change general setup options, press the Menu button, press left or right on the Multi-controller to choose a menu tab, and then follow the instructions in Tables 2.3 through 2.9.

Table 2.3 Shooting 1 Menu Options

Press up or down on the Multi-controller to select Menu Option	Press SET button to display Menu suboptions	Press up or down on the Multi-controller to select suboption, and then press the SET button
Beep	Enable, or Disable	Choose Disable for shooting scenarios where noise is intrusive or unwanted.
Release shutter without card	Enable, or Disable	Choose Disable to prevent inadvertently shooting when no card is inserted. The On setting is only useful when gathering Dust Delete Data.
Image review	Off, 2, 4, 8 sec., and Hold	Longer review durations of 4 or 8 seconds have a negligible impact on battery life except during travel, when battery power may be at a premium. I use 4 seconds unless I'm reviewing images with a client or subject; then I choose 8 seconds.

Table 2.4 Shooting 2 Menu Options

Press up or down on the Multi-controller to select Menu Option	Press SET button to display Menu suboptions	Press up or down on the Multi-controller to select suboption, and then press the SET button
Auto Lighting Optimizer	Disable, Low, Standard, or Strong	Enabling this option automatically corrects images that are too dark and/or images with low contrast at the level you choose. Using this option can mask the effects of exposure modification such as Auto Exposure Bracketing and Exposure Compensation.
Color space	sRGB, or Adobe RGB	Sets the color space to the smaller sRGB color space, or to the larger Adobe RGB color space. See Chapter 4 for more information on these options.

Table 2.5 Shooting 4 Menu Options

Press up or down on the Multi-controller to select Menu Option to select Menu Option	Press SET button to display Menu suboptions	Press up or down on the Multi-controller to select suboption, and then press the SET button
Grid display	Off, Grid 1, Grid 2	Choosing Grid 1 overlays a 3 × 3 grid on the Live View screen, and choosing Grid 2 overlays a 4 × 6 grid to aid in squaring up horizontal and vertical lines in the scene for better composition.
Aspect ratio	3:2, 4:3, 16:9, 1:1	In Live View shooting, the aspect ratio is shown with nonprinting lines indicating how JPEG images will be cropped to fit the aspect ratio. RAW images are displayed in the ratio, but are saved in the default 3:2 aspect ratio. You can apply the ratio to RAW images in Canon Digital Photo Professional. See details on aspect ratios earlier in this chapter.

NOTE To check current battery power, go to the Setup 3 menu tab, highlight Battery info, and then press the SET button. The Battery info screen displays the percentage of remaining capacity, the number of shots taken on the current battery charge, and the relative performance level of the battery's recharge in three levels. If you're using dual LP-E6 batteries in the BG-E9 grip, the screen displays battery information for both batteries.

Table 2.6 Playback 2 Menu Options

Press up or down on the Multi-controller to select Menu Option to select Menu Option	Press SET button to display Menu suboptions	Press up or down on the Multi-controller to select suboption, and then press the SET button
Highlight alert	Disable, or Enable	Choosing Enable causes areas of overexposure in the preview image to blink, alerting you to reshoot using negative Exposure Compensation if the blown highlights are in a critical area of the image.
AF point disp. (display)	Disable, or Enable	Choosing Enable displays on the preview image the AF point used to set focus.
Histogram	Brightness, or RGB	Choosing the Brightness displays a histogram showing the distribution and gradation of tones through the image, alerting you if exposure modification is necessary. Choosing RGB displays a histogram showing the distribution of color in the Red, Green, and Blue color channels, enabling you to evaluate the color saturation and gradation.

Table 2.7 Setup 1 Menu Options

Press up or down on the Multi-controller to select Menu Option	Press SET button to display Menu suboptions	Press up or down on the Multi-controller to select suboption, and then press the SET button
Auto power off	1, 2, 4, 8, 15, 30 min., and Off	Choose an option to determine the amount of time before the 60D turns off automatically. Shorter durations conserve battery power. Just press the shutter button halfway to turn on the camera again.
Auto rotate	On for the LCD and computer, On for the computer only, or Off	Choose the On option to automatically rotate vertical images to the correct orientation on the LCD and computer monitor, or only on the computer monitor. If you choose the first option, the LCD preview image is displayed at a reduced size. Choose Off for no rotation on the camera or computer.
Format		Formats the SD/SDHC card. It's a good idea to format cards often. Always format the SD/SDHC card in the camera and never on the computer.

Table 2.8 Setup 2 Menu Options

Press up or down on the Multi-controller to select Menu Option	Press SET button to display Menu suboptions	Press up or down on the Multi-controller to select suboption, and then press the SET button
LCD brightness	Choose from seven brightness levels	Watch both the preview image and the grayscale chart as you adjust the LCD brightness. As you adjust brightness, ensure that all tonalities on the grayscale chart are clearly distinguishable.
Date/Time		Set the current date and time.
Sensor cleaning	Auto cleaning (Enable, Disable), Clean now, Clean manually	Auto sensor cleaning happens automatically when you power the camera on and off, but if it bothers you, you can choose this option to Disable it. Clean now initiates sensor cleaning immediately. Clean manually enables you to clean the sensor using a blower or other sensor-cleaning products. Be sure that the battery is fully charged before manual cleaning.
Lock (Quick Control dial)	Disable, or Enable	In Program AE (P), Shutter-priority AE (Tv), Aperture-priority AE (Av), Manual (M), Bulb (B), and Camera User Settings (C) shooting modes, you can use this option to lock the Quick Control dial. That way, inadvertent changes are prevented for Exposure Compensation in P, Tv, and Av shooting modes, aperture changes during manual exposures, and aperture changes during bulb exposures. To temporarily unlock the dial, press the Unlock button below the Quick Control dial.

Table 2.9 Setup 3 Menu Options

Press up or down on the Multi-controller to select Menu Option	Press SET button to display Menu suboptions	Press left or right on the Multi-controller to select suboption, and press SET button
INFO. button display options	Displays camera settings, Electronic level, or Displays shooting functions	Choose one or all of the options to determine which screen is displayed by pressing the INFO. button. Camera settings displays the current exposure and camera settings on a static screen. The Electronic level displays a level on the LCD to help you keep the camera level. The level displays roll and pitch so you can check horizontal and vertical tilt in 1-degree increments. Shooting functions displays a summary of exposure and camera settings where you can activate the screen to change settings. This is also known as the Quick Control screen.
Clear all camera settings		Choose to reset the camera to the factory default settings for shooting, image-recording, camera, Live View, and Movie shooting settings.

Adding copyright information

Your copyright identifies your ownership of images. On the 60D, you can append your copyright information to the metadata that is embedded with each image that you shoot.

While including your copyright is a great first step in identifying ownership of the images you make, the process is not complete until you register your images with the United States Copyright Office. For more information, visit www.copyright.gov.

To include your copyright and the camera owner's name on your images, follow these steps:

1. **On the Setup 3 camera menu, highlight Copyright information, and then press the SET button.** The Copyright information screen appears.

2. **Highlight the option you want, such as Enter author's name or Enter copyright details, and then press the SET button.** A screen appears where you can enter the name or details.

3. **Press the Q button on the back of the camera to move to the bottom portion of the text entry screen, and then press left or right on the Multi-controller to move the cursor to the letter or symbol you want to enter.**

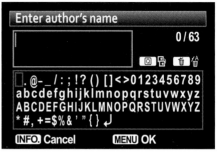

2.6 Enter author's name screen

4. **Press the SET button to enter the character or symbol.** The character appears in the upper area of the screen. To delete a character, press the Erase (trashcan) button. You can enter up to 63 characters, numbers, and symbols in the text entry area. You can cancel entering text by pressing the INFO. button.

5. **Press the Menu button when you finish to return to the previous screen, where you can choose to enter copyright details or the author name, whichever one you didn't choose in Step 2.** To display the copyright, go back to the Copyright information screen and choose Display copyright info.

Reviewing and Rating Images and Movies

These days, the ability to immediately see the last captured image is a given. Although image playback isn't the final judge on images, it's the best indicator to know when you need to adjust the exposure, tweak the color or focus, or modify the composition.

To view images on the 60D, press the Playback button to display the most recently captured image. If you're in Single image display, basic shooting information appears in a ribbon above the image. If you've turned on the Highlight alert and AF point display options, the preview image shows these as well, with localized areas of overexposure displayed as blinking highlights.

To move through images on the card, turn the Quick Control dial counterclockwise to view the next most recent image, or clockwise to view the first image. You can also press left or right on the Multi-controller to review images. You can change the playback display by pressing the INFO. button to cycle through each of these four image-playback displays:

▶ **Single image with no shooting information.** This display shows the image with no shooting information overlaid on the preview image. If you're showing subjects or friends the images you've captured, this display option provides a clean, uncluttered view of the image.

▶ **Single image with basic shooting information.** This default playback display gives the largest preview image and provides the shutter speed, aperture, folder number, file number, and image number relative to all images on the card.

▶ **Detailed information.** This display option shows the Brightness histogram with detailed shooting information, including the shooting mode, exposure and flash compensation, metering mode, white balance, file size, image recording quality, and the current image number relative to the total number of shots on the SD/SDHC card.

▶ **Shooting information with histograms.** This display includes a summary of exposure and camera settings along with a Brightness and separate R (Red color channel), G (Green), and B (Blue) histograms. The image preview is necessarily reduced in size to accommodate the additional information. With this display, you can check the tonal distribution in the Brightness histogram and the color distribution in the Red, Green, and Blue color channels, and verify key camera settings.

The playback displays changes for automatic modes, such as Portrait and Landscape modes, and for Movie mode.

 If you're new to using a histogram, be sure to read Chapter 3, where evaluating exposure using histograms is described.

To check focus and specific details within the image, you can magnify the preview image by pressing the AF point selection button on the top-right side of the camera back. Under this button is a magnifying icon with a plus sign in it. If you hold the button, the image magnifies to the maximum of 10X. You can then press the Multi-controller to move around the magnified image. Press and hold the Auto Exposure Lock (AE Lock) button to reduce the image magnification. Under this button is a magnifying icon with a minus sign in it.

 For details on playing back movies, see Chapter 7.

Rating images and movies

Rating images by one of five levels helps you find your favorite images quickly on the SD/SDHC card using the image jump technique detailed later in this chapter. You can also include rated images and movies when you create a slide show. In addition, you can sort images and movies in the ImageBrowser, a program provided on the EOS Digital Solution disk that comes in the box.

To rate images or movies, follow these steps:

1. **On the Playback 2 camera menu tab, highlight Rating, and then press the SET button.** An image appears on the LCD with a ribbon of rating options overlaid on the top.

2. **Turn the Quick Control dial to select the image or movie to rate, and then press up or**

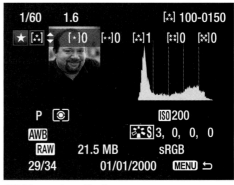

2.7 The rating display

down on the Multi-controller to select a rating. One or more stars appear to reflect the rating.

3. **To continue rating images, repeat Step 2, and then press the Menu button to exit the rating display.** The Playback 2 menu appears.

Searching for and moving through images and movies

When you need to find images or movies quickly on the SD/SDHC card, you have two options. First, you can display either four or nine images and movies as an index. Second, you can jump through images and movies by a specified number of images at a time, and by date, folder, movies, stills (still images), or image rating.

Here's how to use both options:

▶ **Display as an index.** To display images as an index, press the Playback button, and then press the AE Lock/Reduce button once for a four-image display or twice for a nine-image display. To go back to a four-image index, press the Magnify button. Then turn the Quick Control dial to select a single image, and then press the SET button to display only that image, or turn the Main dial to move to the next index screen.

▶ **Jump through images.** Select the Playback 2 camera menu tab, select the Image jump w/Main dial icon, and then press the SET button. On the Image jump w/Main dial screen, turn the Quick Control dial to select the method for jumping — 1 image, 10 images, 100 images, Date, Folder, Movies, Stills, or Image rating. (Turn the Main dial to select the rating level.) Press the SET button. Now press the Playback button to begin image playback, and then turn the Main dial to display the jump scroll bar and to jump by the method you selected. If you chose Date, you can turn the Main dial to display the date. If you chose Folder, you can select the folder in which to view images.

Protecting and Erasing Images and Movies

To ensure that your favorite images and movies are not accidentally deleted, you can add protection to them. Conversely, when you know that you do not want an image or a movie, you can easily delete it to free up space on the media card.

Protecting images and movies

Applying protection to images and movies helps prevent them from being inadvertently erased. The 60D provides handy ways to make protection faster by enabling you to protect not only individual images and movies, but also all images and movies in a folder, or all images and movies on the SD/SDHC card. Applying protection is much like setting a document on the computer to read-only status. Protected images can't be deleted using the Erase options detailed in the next section. And when you download protected images, you're asked to confirm that you want to move or copy read-only files, which indicates that the images have protection applied.

Protection is a handy way to clean up images and movies that you do not want. Simply add protection to the images and movies you want to keep; then when you choose to delete all images and movies on the card, only the images you have protected remain. This is handy, but is a technique you should use with caution to ensure you haven't forgotten to protect images or movies you intended to keep. Protected images are erased when you format the SD/SDHC card.

You can apply protection to an image by following these steps:

1. **On the Playback 1 menu tab, highlight Protect images, and then press the SET button.** The Protect images screen appears.

2. **Turn the Quick Control dial to highlight Select images, All images in folder, or All images on card, and then press the SET button.** If you chose Select images, then the last captured image appears on the LCD. A small key icon and the word Set appear at the top left of the image.

3. **Press the SET button to protect the displayed image, or turn the Quick Control dial to move to the image you want to protect, and then press the SET button.** A key icon appears in the information bar above the image to show that it is protected.

4. **To protect additional images, turn the Quick Control dial to scroll to the image you want to protect, and then press the SET button to add protection.**

If you later decide that you want to unprotect an image, you can remove protection by repeating Steps 1 to 3 and pressing the SET button to remove protection. When protection is removed, the key icon in the top information bar disappears. Alternately, you can go to the Playback 1 menu, select Protect images, press the SET button, and then highlight Unprotect all images in folder or Unprotect all images on card.

Erasing images and movies

With the 60D's large, high-resolution LCD monitor, evaluating images is more accurate than ever before. This makes it easier to decide whether or not an image is a keeper or one that you want to delete.

You can also review movies. For general reference, I'll use images to include both still images and movies.

The 60D offers two ways to delete images: removing one image at a time or check-marking multiple images and deleting all marked images at once.

It's often wiser to look at images on the computer monitor to evaluate the merits or faults before deleting them in the camera. If you erase images, they cannot be restored if you change your mind.

If you want to permanently erase a single image, just navigate to the image you want to delete during image playback, press the Erase button, highlight Erase, and then press the SET button.

To select and erase multiple images at a time, follow these steps (as you go through these steps, you can optionally choose to erase all images on the card or in a specific folder):

1. **On the Playback 1 menu tab, highlight Erase images, and then press the SET button.** The Erase images screen appears.

2. **Turn the Quick Control dial to highlight Select and erase images, and then press the SET button.** The last captured image appears.

3. **Press up or down on the Multi-controller to add a check mark that marks the current image for deletion, or turn the Quick Control dial to move to the image you want to mark for deletion.** Continue marking all the images you want to delete. A check mark appears on images marked for deletion. You cannot add a check mark to images with protection applied.

4. **Press the Erase button.** The Erase selected images screen appears.

5. **Turn the Quick Control dial to highlight OK, and then press the SET button.** The 60D erases the marked images, and the Erase Images screen appears.

Working with Eye-Fi Cards

One of the handiest ways to transfer images and movies to the computer is to use an Eye-Fi card that wirelessly transmits images to an online service or to your computer using a wireless local-area network. The card looks just like an SD/SDHC card but adds the wireless transfer capability as well as other features that work with the 60D.

 You can use Eye-Fi cards in the 60D, although Canon does not guarantee support of all functions on the card.

Depending on the Eye-Fi card, you can upload to your favorite networks with the proper ID and passwords. You first set up the Eye-Fi card on your computer to choose the network you want to use, and then you set up a folder for transferring images and movies to the computer. Then when you insert the Eye-Fi card into the 60D, media is automatically transferred as you shoot. In addition, the card controls the 60D's Auto power off function so that the camera's power remains on until the transfers are complete.

Newer Eye-Fi cards offer *endless memory*, a function that deletes the oldest images and movies that have been successfully transferred to the computer or network service to free up space on the card. You can set the card capacity point at which older images will be deleted to make space available. The concept of endless memory applies to the card, and it is endless only insofar as the amount of the space you have on the computer or network service. Newer cards also include geotags, hotspot location, RAW file transfer, and more. Card sizes range from 4GB to 8GB.

You need to verify that wireless transmissions are permitted in certain locations. Airports, hospitals, and some businesses do not permit wireless transmissions. In such areas, you can prevent the card from emitting a signal, even when no images are being transmitted, by removing the card from the camera.

To use an Eye-Fi card in the 60D, set up the card in the computer according to the manufacturer's instructions and insert it in the camera. Then follow these steps to set it up in the 60D:

1. **On the Setup 1 menu tab, highlight Eye-Fi settings, and then press the SET button.** The Eye-Fi settings screen appears.

2. **Press the SET button to select enable Eye-Fi trans. (transmission), and then press the SET button again.**

3. **Select Connection info., and then press the SET button.** The Connection info. screen appears.

4. **Verify that an Access point Service Set Identifier (SSID) is being used, and you can also check the Media Access Control (MAC) address.**

5. **Press the Menu button three times to exit.**

6. **Take the first picture.** The preview image is displayed. Thereafter, a transfer icon is displayed for images that have already been transferred. The 60D has four self-explanatory icons that indicate connection status, or you can press the INFO. button to see the status on the shooting settings display screen.

Getting Great Exposures and Focus

With the EOS 60D, you are perfectly poised to take great quick-grab shots by letting the camera set the exposure and focus automatically, to take slightly more control using Creative Auto mode, or to take full creative control using the semiautomatic and manual modes. If you're just learning about photography, the 60D has everything you need now and as you gain experience.

In this chapter, you learn about the 60D's shooting modes and how to get tack-sharp focus. You also learn techniques to modify exposures when you encounter challenging scenes and subjects. In addition, this chapter details how to select a drive mode that determines the number of photos you can get while shooting. All these controls are tools for realizing your creative vision with the 60D.

Keep a practiced eye out for the stunning pictures that surround you in everyday life. Exposure: ISO 200, f/8, 1/250 second with –1/3-stop of Exposure Compensation.

Working with Exposure

As you begin using the 60D, remember to set this goal for yourself: *Get it right in the camera.* It is too easy to see a problem with an image and think: "I'll fix it in Photoshop." But getting the best-possible exposure in the camera should be your first objective. Certainly you can polish many photos during editing, but seasoned photographers know that no amount of Photoshop editing can rival the beauty of a spot-on in-camera exposure.

Defining exposure goals

But what is a good exposure, and what does it look like? There are a couple of answers to the first question. Aesthetically, a good exposure captures and expresses the scene as you saw and envisioned it. Technically, a good exposure maintains image detail through the bright highlights (or the most important highlights) and in the shadows; displays a full and rich range of tones with smooth transitions; has visually inviting color; pleasing contrast; and, of course, tack-sharp focus.

Getting good exposures can be a challenge, but the fundamental goal of every release of the shutter button is to capture the best exposure possible given the light and the subject.

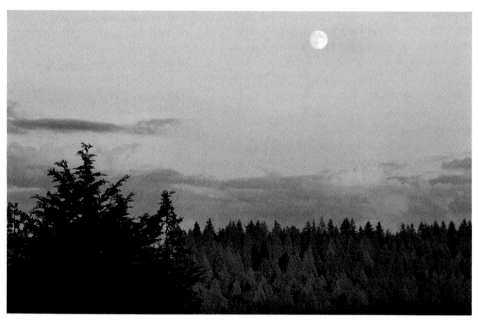

3.1 In this image, the exposure is excellent; it has great highlight detail and good shadow detail, and it has pleasing contrast. Exposure: ISO 100, f/8, 1/30 second.

Practical exposure considerations

Does that mean that every exposure will meet all the criteria of a good exposure? Not necessarily. Rather, the exposure ideally meets the photographer's creative vision or purpose for it. A classic example of an intentionally imperfect exposure is when a photographer overexposes a portrait of a mature woman to minimize facial lines and wrinkles. Although the exposure is intentionally imperfect, it flatters the subject and creates a pleasing image. Other examples of imperfect but acceptable exposures are photos of scenes where the range from highlight to shadow is so great that you can properly expose only the most important part of the scene (within a single frame).

Equivalent Exposures

For any exposure, different settings can produce the same, or an equivalent, exposure. For example, if the camera meters the light and suggests f/5.6 at 1/60 second as the ideal exposure at any given ISO setting, then there are other aperture and shutter speed combinations that are equivalent, or that provide the same exposure.

While the exposures are equivalent, the depth of field (DOF) changes. Both of the following images were shot at ISO 100 using the EF 24-70mm, f/2.8L Macro USM lens.

continued

continued

In the first image, the exposure is f/2.8 at 1/3200 second and the shallow DOF renders the background as a blur. The second image uses f/8 and the DOF is more extensive, showing more distinct detail in the background elements.

For any specific camera and lens combination, the number of possible equivalent exposures is fixed. To find that number, just multiply the number of shutter speeds by the number of possible lens apertures. As a simple illustration, consider a camera with nine shutter speeds (1/4 through 1/1000 second) combined with a lens that has nine full-stop aperture settings (f/1.4 through f/22). There are a total of 81 aperture shutter-speed combinations. Of the 81, a maximum of 9 equivalent exposures provide an accurate exposure for a given lighting situation.

In technical terms, *exposure* is a mathematical expression of a balance among light, intensity of light reaching the image sensor (aperture), sensitivity of the image sensor (ISO), and length of time the shutter is open (shutter speed). When you change one element, such as aperture (f-stop) or shutter speed, it represents a doubling (increase in a setting) or halving (decrease in a setting) of the light that reaches the image sensor or, in the case of ISO, of the sensor's sensitivity to light.

For example, changing the aperture from f/8 to f/5.6 doubles the amount of light reaching the sensor, while changing it from f/5.6 to f/8 halves the amount of light. Assuming that the ISO setting doesn't change, when you change the aperture, you have to make a proportional change in the shutter speed to achieve a proper exposure.

The starting point for calculating any exposure is metering, or measuring, the light in the scene, and the onboard light meter in the 60D takes this reading. From the reading, you or the camera can determine the exposure that's necessary for the amount of light in the scene. Depending on the shooting mode you choose on the 60D, you can control some or all of the exposure settings.

Choosing a Shooting Mode

Creative control begins when you choose a shooting mode, and the 60D offers modes ranging from full manual control to fully automatic shooting. As you encounter different scenes and subjects, choose the shooting mode that gives you control over the exposure element or elements that are most important to you. For example, if you are shooting a portrait in all but low light, the most important exposure element to control is the aperture so you can control the depth of field. And by controlling the aperture,

you can soften distracting background elements that pull the viewer's eye away from the subject. Thus Aperture-priority AE (Av) mode gives you that control. But if you are shooting a soccer match, you want control over the shutter speed to freeze the motion of players; that makes Shutter-priority AE (Tv) mode the best choice. For quick snapshots, you may want to let the camera control everything, so Full Auto mode is a good choice.

The 60D Mode dial segregates shooting modes by the amount of control or lack of control over exposure they offer you. Figure 3.2 shows shooting modes on the 60D Mode dial.

Movie mode

Basic Zone shooting modes
Full Auto
Flash Off
Creative Auto
Portrait
Landscape
Close-up
Spurts
Night Portrait

Creative Zone shooting modes
Camera User Settings (C mode)
Bulb
Manual
Aperture-priority AE
Shutter-priority AE
Program AE (P)

3.2 The Mode dial includes automatic, or Basic Zone, shooting modes as well as semiautomatic modes, Manual (M) and Bulb (B) modes, grouped as Creative Zone modes, and a customizable Camera User Settings (C) shooting mode, as well as Movie mode.

Semiautomatic, Manual, and Bulb shooting modes

The semiautomatic and Manual shooting modes, designated as the Creative Zone modes, give you the greatest degree of and creative exposure control in your images, whether your objective is manipulating the depth of field or controlling how subject motion is rendered in action shots.

It is also important to know that in these shooting modes, you have control over all the camera features and functions. For example, you can select the Autofocus (AF) mode and AF point. You can also set the drive mode, adjust the white balance, set the ISO, and modify the exposure using Exposure Compensation, Exposure Bracketing, and Auto Exposure Lock (AE Lock), or use Auto Exposure Bracketing (AEB). By contrast, Full Auto, Creative Auto (CA), and other automatic shooting modes allow little or no control over these camera settings.

The following sections summarize the semiautomatic, Manual, and Bulb shooting modes.

Program AE (P) mode

In P, or Program AE (Auto Exposure) mode, when you press the shutter button halfway, the 60D gives you its suggested exposure settings. If you want a different, but equivalent exposure using a different aperture and shutter speed, then you can temporarily change, or *shift*, the camera's suggested settings by turning the Main dial. For

example, if the camera initially sets the exposure at f/4 at 1/125 second, and you turn the Main dial one click to the left, the exposure shifts to f/3.5 at 1/200 second, which is equivalent to the initial exposure. Turning the Main dial to the right results in a shift to f/5 at 1/100 second, and so on.

An advantage of using P mode is that with a single adjustment, you can change the aperture to increase or decrease the depth of field, change the shutter speed to freeze or blur subject motion, or set a fast-enough shutter speed to handhold the camera. Exposure shifts are made in 1/3-stop increments by default. However, exposure shifts are temporary in P shooting mode. If you shift the exposure, and then release the shutter button without taking the picture within a few seconds, the camera returns to its original exposure. So the changes you make to exposure settings are used for only one image.

To use P mode, set the Mode dial to P, and then half-press the shutter button. The camera focuses on the subject, meters the light, and calculates the exposure. If you want to change the camera's suggested aperture or shutter speed, turn the Main dial to the left to make the aperture larger and the shutter speed faster, or to the right to make the aperture smaller and the shutter speed longer.

> **TIP** To change the shooting mode, be sure to hold down the Mode Dial lock button in the center of the Mode dial as you turn the dial.

Of course, exposure *shifts* are limited by the amount of light in the scene. If the shutter speed 30 and the maximum aperture are blinking in the viewfinder, the image will be underexposed. You can change the ISO to a higher sensitivity setting or use the built-in or an accessory flash. However, if you opt to use the flash, you cannot shift the exposure. Conversely, if the shutter speed shows 8000 and it, along with the lens's minimum aperture, blinks, the image will be overexposed. In this case, lower the ISO sensitivity setting or use a neutral density filter to decrease the amount of light coming into the lens.

Along with the ability to quickly change to an equivalent exposure, P mode gives you full control over all aspects of the camera, including setting the autofocus mode and AF point, setting the metering and drive modes, selecting a Picture Style, and modifying exposure using Exposure Compensation and AE Lock.

> **NOTE** At first glance, Full Auto and P mode may seem to be the virtually the same. However, P mode gives you full control over the AF point, white balance, metering mode, and so on. In Full Auto mode, you cannot change camera settings.

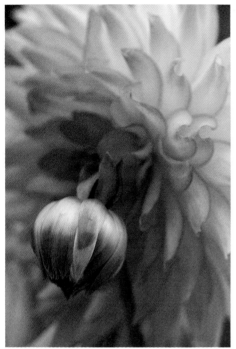

3.3 In P mode, the 60D's recommended exposure was f/4 at 1/320 second (ISO 100). The wide aperture results in a shallow depth of field, but I wanted more detail in the leaves above the dahlia bud.

3.4 I shifted from the recommended exposure to f/8 at 1/160 second (ISO 100), and was able to get more detail through the entire flower bud and its leaves.

Shutter-priority AE (Tv) mode

In shooting situations where your primary concern is controlling the shutter speed, use Shutter-priority AE (Tv) mode. In this semiautomatic shooting mode, you set the shutter speed and the camera automatically calculates the appropriate aperture based on the current ISO setting and the light-meter reading.

 Tv stands for Time Value, also referred to as Shutter-priority AE mode.

In everyday shooting, controlling the shutter speed determines how subject motion is rendered. By choosing a fast shutter speed, you can freeze a subject in midmotion. By choosing a slow shutter speed, you can show the subject motion as a blur. Thus, Tv is the mode of choice for shooting sports and action shooting, for rendering the motion of a waterfall as a silky blur, for moving the camera with the motion of the subject to create a streaked and blurred background, and for night shooting.

In addition, you can use Tv mode to lock in a shutter speed that is fast enough to hand-hold the camera and get sharp images — provided, of course, that that there is enough light in the scene to get a fast-enough shutter speed. For example, if you are shooting in moderate to low light with a non-Image Stabilized (IS) lens at a focal length of 150mm, then you can set the shutter speed to 1/150 second — a shutter speed that is fast enough to handhold the camera and get sharp images at this focal length. And in Tv mode, you are assured that the shutter speed remains constant as you continue shooting.

If you cannot get the shutter speed you need to handhold the camera, increase the ISO incrementally until you get a fast-enough shutter speed.

On the 60D, you can select shutter speeds from 1/8000 second to 30 seconds or switch to Bulb shooting mode. (Bulb mode is detailed in a later section.) To use Tv mode, set the Mode dial to Tv, half-press the shutter button, and then turn the Main dial to change the shutter speed. The camera automatically sets the aperture based on the current ISO and the light-meter reading.

For shooting sports or action, photographers often use Tv mode combined with AI Servo AF mode (the autofocus mode that tracks focus on a moving subject) and High-speed Continuous drive mode to capture the maximum number of images in a burst. Autofocus and drive modes are detailed later in this chapter.

© Peter Burian

3.5 Peter used a fast 1/800 second shutter speed to freeze the motion of the racers in this scene, and he created a visually powerful image by having the racers coming directly toward the viewer. Exposure: ISO 800, f/7.1, 1/800 second using +2/3 stop Exposure Compensation.

Using the Quick Control Screen

The Quick Control screen is a handy way to change the most frequently used camera settings. In P, Tv, Av, M, and B shooting modes, you can control the most commonly adjusted functions on the 60D, including the ISO, metering, and drive modes, AF point selection, white balance, Picture Style, exposure and flash compensation, and Custom Controls. In automatic shooting modes, a less detailed version of the Quick Control screen is displayed, and you can change only the Ambience effect, lighting type, and drive mode.

To display the Quick Control screen on the LCD monitor, press the Q button above the Quick Control dial on the back of the 60D. To make changes, press the Multi-controller to select the setting you want to change, and then turn the Quick Control or Main dial to change the setting. Press the SET button to display options you can select.

To show fractional shutter speeds, the 60D shows only the denominator of the fraction in the viewfinder. For example, 1/8000 second is displayed as 8000 and 1/4 second is displayed as 4. Shutter speeds longer than 1/4 second are indicated with a double quotation mark that represents a decimal point between two numbers or following a single number. For example, 1"5 is 1.5 seconds while 4" is 4 seconds (4.0).

The 60D alerts you if the exposure is outside the acceptable range in Tv shooting mode. If you see the maximum aperture blinking in the viewfinder, it is a warning that the image will be underexposed. You need to set a slower shutter speed or set a higher ISO sensitivity setting. On the other hand, if the lens's minimum aperture blinks, it is an overexposure warning. You need to set a faster shutter speed or a lower ISO sensitivity setting.

CROSS REF If you want to ensure that the exposure is correct in scenes where light changes quickly, you can enable Custom Function (C.Fn) I-6, Exposure Safety Shift. This function is useful in both Tv and Av shooting modes. Custom Functions are detailed in Chapter 5.

In the default 1/3-stop increments, the following shutter speeds are available (in seconds):

1/8000, 1/6400, 1/5000, 1/4000, 1/3200, 1/2500, 1/2000, 1/1600, 1/1250, 1/1000, 1/800, 1/640, 1/500, 1/400, 1/320, 1/250, 1/200, 1/160, 1/125, 1/100, 1/80, 1/60, 1/50, 1/40, 1/30, 1/25, 1/20, 1/15, 1/13, 1/10, 1/8, 1/6, 1/5, 1/4, 0.3, 0.4, 0.5, 0.6, 0.8, 1, 1.3, 1.6, 2, 2.5, 3.2, 4, 5, 6, 8, 10, 13, 15, 20, 25, 30

Shutter Speed Tips

Tv mode is handy when you want to set a shutter speed that is fast enough to handhold the camera and still get a sharp image, especially if you are using a long lens. If you are *not* using an Image Stabilized (IS) lens, then a handy guideline for determining the fastest shutter speed at which you can handhold the camera and lens and get a sharp image is 1/[focal length]. Thus, if you are shooting at a 200mm focal length, the slowest shutter speed at which you can handhold the camera and get a sharp image is 1/200 second.

If you are shooting action scenes and want a shutter speed fast enough to stop subject motion with no motion blur, the following guidelines provide a good starting point:

▶ Use 1/250 second when action is coming toward the camera.

▶ Use 1/500 to 1/2000 second when action is moving side to side or up and down.

▶ Use 1/30 to 1/8 second when panning with the subject motion. Panning with the camera on a tripod is a really good idea.

▶ Use 1 second and slower shutter speeds at dusk and at night to show a waterfall as a silky blur, to capture light trails of moving vehicles, to capture a city skyline, and so on.

You can also use a polarizing or neutral-density filter to capture moving water as a blur earlier in the day, both of which reduce the amount of light to give you a slower shutter speed. Besides reducing the light by 2 stops, a polarizer has the additional benefit of reducing reflections on the water.

Shutter speed increments can be changed from the default 1/3-stop to 1/2-stop increments using C.Fn I-1.

 Also in regard to shutter speeds, the 60D flash sync speed is 1/250 second or slower for Canon flash units.

In Tv mode, you have full control over camera controls such as autofocus and drive modes, AF point, Picture Style, and flash settings.

Aperture-priority AE (Av) mode

If you want to control the depth of field, whether the background details are shown as sharp or as a soft blur, then use Aperture-priority AE (Av) mode. In Av mode, you select the aperture (f-stop) that you want, and the 60D automatically sets the shutter

speed based on the current ISO and the light meter reading. The aperture, or f-stop, you select is one of the factors that control the depth of field. When you choose a wide aperture from f/5.6 to f/2.8 or wider, the resulting shallow depth of field renders background details as blurred. When you set a narrow aperture from f/8 to f/32, the resulting extensive depth of field renders the background details with acceptably sharp detail.

The range of apertures available to you depends on the lens that you are using. Each lens has a minimum and maximum aperture. And on zoom lenses, the minimum aperture may vary by focal length. For example, the EF 24-105mm f/4L IS USM lens has a minimum aperture of f/22 at 24mm, and f/27 at 105mm. The maximum aperture is f/4 at all focal lengths. On other lenses, the maximum aperture is variable, based on the focal length at which you set the lens.

To use Av mode, set the Mode dial to Av, turn the Main dial to set the aperture you want, and then half-press the shutter button to meter and focus. Turn the Main dial to the left to set a narrower aperture (f-stop) or to the right to set a wider aperture. The camera automatically calculates the appropriate shutter speed based on the light meter reading and the selected ISO.

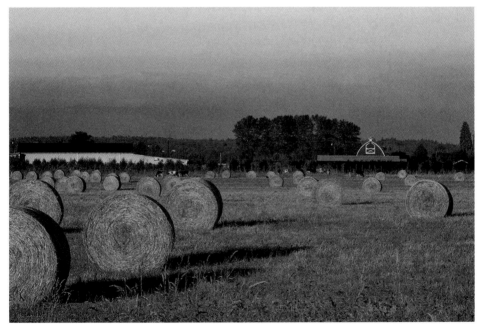

3.6 I wanted extensive sharpness from front to back in this scene to show both the hay and the red barn, so I chose a narrow f/16 aperture in Av shooting mode. Exposure: ISO 200, f/16, 1/400 second using –1 2/3-stops of Exposure Compensation.

Practically speaking, you can also control the shutter speed using Av mode, just as you can control aperture in Tv mode. For example, if I am shooting outdoors in Av mode and see a flock of birds coming into the scene, I can turn the main dial to switch to progressively wider apertures also while watching in the viewfinder until the shutter speed is fast enough to stop the motion of the birds in flight. The principle is simple: When I choose a wide aperture, the camera sets a faster shutter speed, and I can quickly get to motion-stopping shutter speeds by changing the aperture. The same is true for Tv mode, albeit by adjusting the shutter speed to get to the aperture you want.

In 1/3-stop increments, and depending on the lens you use, the apertures are

f/1.2, f/1.4, f/1.6, f/1.8, f/2.0, f/2.2, f/2.5, f/2.8, f/3.2, f/3.5, f/4.0, f/4.5, f/5.0, f/5.6, f/6.3, f/7.1, f/8.0, f/9.0, f/10, f/11, f/13, f/14, f/16, f/18, f/20, f/22, f/25, f/29, f/32, f/36, f/40, f/45

In Av mode, you have full control over all the camera settings, Picture Style, white balance, flash settings, and so on.

If you select an aperture and the exposure is outside the camera's exposure range, the shutter speed value blinks in the viewfinder and on the LCD panel. If 8000 blinks, the image will be overexposed. If 30 blinks, the image will be underexposed. If this happens, adjust to a smaller or larger aperture, respectively, or set a lower or higher ISO setting. If no lens is attached to the camera, 00 is displayed for the aperture setting.

You can preview the depth of field by pressing the Depth-of-Field Preview button on the front of the camera, located on the front right side of the camera near the lens. When you press the Depth-of-Field Preview button, the lens diaphragm stops down to the current aperture so that you can preview the range of acceptable focus. The more extensive the depth of field, the more of the foreground and background that will be in acceptably sharp focus and the larger the area of darkness in the viewfinder.

Manual (M) mode

As the name implies, Manual (M) mode enables you to set the aperture and shutter speed (and ISO). M mode is commonly used when you want to set the exposure by metering on a middle-gray area in the scene or by metering off a photographic gray card (a gray card is included in the back of this book).

In addition, Manual mode is best to use when you are using a predetermined exposure, such as when you are shooting fireworks or stars. It is also useful when you want a consistent exposure across a series of photos, such as for a panoramic series.

For all step-by-step instructions in this chapter, you can access the 60D camera menus by pressing the Menu button. Then press left or right on the Multi-controller or turn the Main dial to highlight the menu tab, and then press up or down on the Multi-controller to highlight a menu option or turn the Quick Control dial.

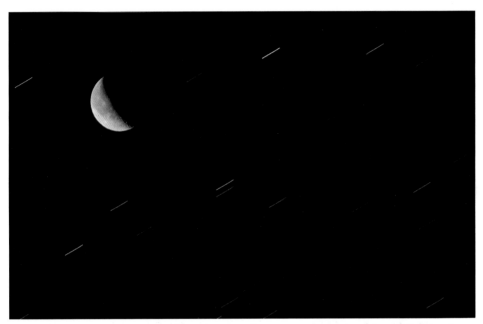

3.7 This image is a composite of two images: One moon shot using Manual (M) mode, and one star trails shot using Bulb (B) mode. The exposure for the moon image was ISO 100, f/11, 1 second. The exposure for the star trails was ISO 100, f/7.1, 2 seconds.

To use M mode, set the ISO that you want, and then follow these steps:

1. **Set the Mode dial to M and verify that the Quick Control dial on the back of the camera is unlocked.** Simply press the Unlock button below the Quick Control dial, or unlock it permanently by setting Lock (Quick Control dial icon) to Disable on the Setup 2 camera menu.

2. **Press the shutter button halfway to meter and focus on the subject.** Watch the exposure level meter at the bottom of the viewfinder as you change the aperture and shutter speed and note how far the tick mark is from the center point of the meter.

3. **Turn the Main dial to adjust the shutter speed, and turn the Quick Control dial to adjust aperture.** If you want to use the camera's recommended

exposure, which is based on the light meter reading, adjust the aperture and shutter speed until the tick mark is at the center of the Exposure Level meter. Alternatively, you can set the aperture or shutter speed to the exposure indicated by metering on a middle-gray card; or, if you have a predetermined exposure for fireworks or astral subjects, just adjust the shutter speed, and aperture to that exposure.

If Auto Lighting Optimizer, a feature that automatically adjusts exposures that are too dark or that have flat contrast, is turned on, the image may not reflect the actual exposure settings. I recommend turning off Auto Lighting Optimizer on the Shooting 2 menu.

The aperture and shutter speed values detailed in the preceding sections are also available in M mode, and you have full control over all the camera controls, Picture Style, and flash settings.

Bulb (B) mode

Bulb on the Mode dial enables you to keep the shutter open as long as the shutter button is fully depressed. Bulb mode is handy for some night shooting, fireworks, celestial shots, and other long exposures.

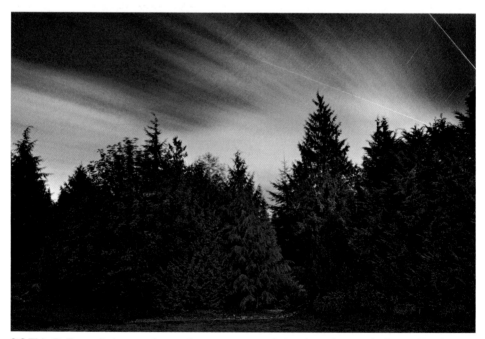

3.8 This Bulb mode image shows the movement of clouds and stars during a 45-minute exposure. I used the Canon Remote Switch RS-60E3 to keep the shutter open. Exposure: ISO 100, f/8, 45 minutes.

Bulb exposure times can be as long as 1 to 2 hours, so be sure that you have a fully charged battery before you begin an extended exposure. To ensure rock-solid stability during Bulb exposures, you can use the RS-60E3 Remote Switch to hold the shutter open. You can also enable Mirror lockup to reduce the chance of blur caused by the reflex mirror action. Mirror lockup can be chosen by setting C.Fn III-5 to Option 1: Enable.

To make a Bulb exposure, turn the Mode dial to B (Bulb). With the camera on a tripod, select the aperture you want by turning the Main or Quick Control dial, and then use a remote release to hold the shutter open or press and hold the shutter button for the length of time you want. The elapsed exposure time is shown in seconds on the LCD panel.

Because long exposures introduce digital noise and increase the appearance of grain, consider setting C.Fn II-1, Long exposure noise reduction, to Option 2: On.

Camera User Settings (C) mode

One of the handiest options the 60D offers is the option to program a shooting mode with your favorite shooting settings and preferences. The C mode on the Mode dial enables you to set up the camera with your most commonly used settings — including a shooting mode, White Balance setting, Color Space, Picture Style, Custom Function, and more — and then register those settings. Then, when you want to use those specific settings again, you simply turn the Mode dial to C.

Because C mode is customizable, it is detailed in Chapter 5.

Automatic shooting modes

The automatic modes, from Full Auto and Creative Auto (CA) to Night Portrait, enable quick shooting with few to no changes to the camera settings. Full Auto, denoted by a green rectangle icon on the Mode dial, provides point-and-shoot functionality while Creative Auto (CA) is designed to help photographers transitioning from using fully automatic cameras to dSLR cameras by providing simple descriptions and controls for traditional photographic functions. The other automatic or Basic Zone modes are based on the type of scene you're shooting and are denoted by descriptive icons indicating types of scenes. They are often referred to as Scene modes.

In Basic Zone modes except Creative Auto (CA) mode, the camera automatically sets the exposure settings, ISO, aperture, and shutter speed, as well other camera settings. You can, however, apply Creative Filters, shoot by lighting type in some modes, resize images, and rate images.

Basic Zone modes are a good choice for quick shots. In all except Creative Auto (CA) mode, the 60D automatically sets the ISO, f-stop, and shutter speed, as well as the following:

▶ Auto ISO ranging from ISO 100 to 3200.

▶ Auto selection of the Standard Picture Style except in Landscape and Portrait modes where Landscape and Portrait Picture Styles are used, respectively.

▶ Auto white balance (AWB).

▶ Auto Lighting Optimizer, an automatic adjustment that lightens images that are too dark and increases the contrast in low-contrast images.

▶ The sRGB color space. Color spaces are detailed in Chapter 4.

▶ Evaluative metering mode.

▶ Drive mode is set to Single shooting mode except in Portrait mode, where Low-speed continuous drive mode is selected. You can optionally choose the 10-sec. Self-timer/Remote control drive mode.

▶ The AF point or points.

▶ Use of the built-in flash for some Basic Zone modes, detailed later.

 In Basic Zone modes, you can set the Lighting or Scene Type, and, in all except Full Auto and Flash Off shooting modes, you can also select Ambience filters in all except Full Auto and Flash Off shooting modes. Lighting type and Ambience effects are detailed in Chapter 4.

In most Basic Zone modes, you cannot change the camera settings that the camera chooses. The following sections explain the automatic Basic Zone modes.

Full Auto mode

The Full Auto mode name describes its functionality — full automation leaving little for you to do except to point and shoot.

To change the shooting mode, be sure to press the Mode dial lock button in the center of the Mode dial as you turn the dial.

In Full Auto mode, the camera sets the following in addition to the settings listed in the previous section:

▶ AI Focus AF, which means that if the subject begins to move, the camera auto-matically switches to AI Servo AF to maintain focus on the subject as it moves.

▶ Automatic AF point selection.

▶ Single shooting drive mode, but you can choose to use the 10-sec. Self-timer/ Remote control mode.

▶ Automatic flash use, but you can choose to turn on Red-eye reduction.

You can choose to shoot in Live View or to shoot movies in Full Auto shooting mode as well. If you display the Quick Control screen by pressing the Q button on the back of the camera, you can select either Single shooting or the 10-sec. Self-timer/Remote control mode from the screen.

 Shooting movies is detailed in Chapter 7.

Flash Off mode

In Flash Off mode, the 60D does not fire the built-in flash or an external Canon Speedlite, regardless of how low the scene light is. This is a good mode to use if you're shooting in a museum or gallery where flash photography is prohibited and any time you do not want the flash to fire. In low-light scenes using Flash Off mode, be sure to use a tripod.

In Flash Off mode, the camera automatically sets

▶ AI Focus AF autofocus mode with automatic AF-point selection. This means that the camera uses One-shot AF mode, designed for still subjects, but automati-cally switches to the focus tracking mode AI Servo AF if the subject begins to move. The camera automatically selects the AF point.

▶ Single shooting drive mode.

You can easily switch to any of the Basic Zone modes. Press the lock-release button on the Mode dial and turn it so that one of the Basic Zone modes lines up with the white mark on the camera; then press the shutter button halfway down to focus, and press it completely to make the picture.

Creative Auto (CA) mode

Creative Auto (CA) mode displays visuals and text on the LCD to help you understand the results that you get from making various adjustments. This shooting mode offers

more control than Full Auto shooting mode, but less control than P, Tv, Av, and M shooting modes.

To use CA mode, press and hold the Mode dial lock-release button as you turn the Mode dial to CA and press the Q button. Press up or down on the Multi-controller to highlight an option on the Quick Control screen, and then turn the Quick Control or Main dial to adjust the setting unless otherwise noted in the following sections.

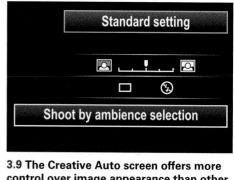

3.9 The Creative Auto screen offers more control over image appearance than other automatic modes without needing to understand photographic exposure concepts.

To see the current exposure settings, press the INFO. button one or more times to display the Shooting settings screen.

You can change the following settings:

▶ **Select Ambience setting.** You can choose one of nine Ambience options from Standard to Monochrome. Ambience options are detailed in Chapter 4.

▶ **Background blur.** You can use this control to determine whether the background is softly blurred or rendered with more distinct detail by adjusting the slide control to the left or right, respectively; in other words, it changes the aperture (f-stop) to change the depth of field. The aperture is shown on the Camera settings screen by pressing the INFO. button. You can't adjust the Background blur setting when the flash is raised.

▶ **Drive mode/Flash firing.** The Drive mode determines the speed at which the camera captures images. You can choose Single shooting mode, where each press of the shutter button makes one image; Low-speed Continuous drive mode, where pressing and holding the shutter button shoots at 3 frames per second (fps); the 10-sec. Self-timer/Remote control mode, where shooting is delayed by 10 seconds so that you can be in the picture; or you can avoid shake by pressing the shutter button when you are shooting long exposures, macro images, or using a long telephoto lens.

With the Flash control, you can choose to have the built-in flash fire automatically when the light is too low to get a sharp handheld image; have the flash fire for every image; or turn off the flash completely. If you choose to turn off the flash and the light is low, be sure to stabilize the camera on a tripod or a solid surface before shooting. Also even if you turn off the flash, the flash may pop up

so the camera can use the flash's AF-assist beam to help the camera focus in low light. Even if this happens, the flash will not fire during the exposure.

To display the Drive mode/Flash firing screen, select the Drive mode/Flash firing option, and then press the SET button. Turn the Main dial to set the drive mode, and press left or right on the Multi-controller or turn the Quick Control dial to set the Flash option.

Certainly the automatic Basic Zone modes are handy, and they produce nice exposures. But if you recall, one of the characteristics of a good image is sharp focus in the right place. In the automatic modes, the camera always sets the autofocus point automatically, and often the sharp focus is not at the point in the subject or scene where it should be. That is one of the drawbacks to using the Basic Zone modes. If you're anxious to move out of the automatic modes, I encourage you to begin using semiautomatic modes such as P, Tv, and Av; or use M mode so you can control the focus as well as the exposure and all other functions on the 60D.

Focusing is discussed in more detail later in this chapter.

Portrait mode

In Portrait mode, the 60D sets a wide aperture (small f-stop number) to create a shallow depth of field that blurs background details and prevents them from distracting the viewer's eye from the subject. The 60D also uses the Portrait Picture Style, which is designed to enhance the skin tones. Obviously, Portrait mode is great for people portraits, but it's also good for taking pet portraits and indoor and outdoor still-life shots.

In Portrait mode, the camera automatically sets

▶ One-shot AF mode and automatic AF point selection.

▶ Low-speed Continuous drive mode so that you can shoot at 3 fps. Alternately, you can choose to use the 10-sec. Self-timer/Remote control mode.

▶ Automatic flash with the option to turn on Red-eye reduction.

To enhance the Portrait mode effect of blurring the background, use a telephoto lens or move the subject farther from the background.

In Portrait mode, the camera automatically selects the AF point or points. When the camera chooses the AF point, it looks for points in the scene where lines are well

defined for the object that is closest to the lens and/or for points of strong contrast. In a portrait, the point of sharpest focus should be on the subject's eyes. However, the eyes seldom meet the camera's criteria for setting focus, and the camera often focuses on the subject's nose, mouth, or clothing instead. As you shoot, watch in the viewfinder to see which AF points the camera chooses when you half-press the shutter button. If the AF point or points aren't on the eyes, then shift your shooting position slightly to try to force the camera to reset the AF point to the eyes. If you can't force the camera to refocus on the eyes, then switch to Aperture-priority AE (Av) mode, set a wide aperture such as f/5.6, and then manually select the AF point that is over the subject's eyes. Manually selecting an AF point is detailed later in this chapter.

Landscape mode

In Landscape mode, the 60D chooses a narrow aperture to keep both background and foreground details in acceptably sharp focus, creating an extensive depth of field. The camera gives you the fastest shutter speed possible given the amount of light in the scene to help ensure sharp handheld images, and to do this, it may increase the ISO to a high setting.

Therefore, as the light fades, be sure to monitor the shutter speed in the viewfinder. If the shutter speed is 1/60 or 1/30 second or slower, or if you're using a telephoto lens, then steady the camera on a solid surface or use a tripod for shooting. This mode works well not only for landscapes but also for cityscapes and portraits of large groups of people where a flash is not needed. The flash never fires in Landscape shooting mode.

In Landscape mode, the camera automatically sets

▶ One-shot AF mode and automatic AF point selection.

▶ Single shooting mode with the option to set 10-sec. Self-timer/Remote control mode.

Close-up mode

In Close-up mode, the 60D allows a close focusing distance. As in Portrait mode, the camera sets a wide aperture to create a shallow depth of field. It also sets as fast a shutter speed as possible given the light. In Close-up shooting mode, the camera uses the Standard Picture Style. You can further enhance the close-up effect by using a macro lens. If you're using a zoom lens, zoom to the telephoto end of the lens.

All lenses have a minimum focusing distance and it varies by lens. This means that you can't get sharp focus at distances closer than the minimum focusing distance of the lens. Listen for the beep that confirms that the camera has achieved sharp focus. If you don't hear it, move back a little, focus, and listen for the beep or look for the focus confirmation light to burn continuously in the viewfinder.

In Close-up mode, the camera automatically sets

▶ One-shot AF mode with automatic AF point selection.

▶ Single shooting drive mode with the option to set 10-sec. Self-timer/Remote control mode.

▶ Automatic flash with the option to turn on Red-eye reduction.

Sports mode

In Sports mode, the 60D sets a fast shutter speed to freeze subject motion. This mode is good for capturing athletes in midaction or the antics of pets and children.

To give you a fast shutter speed, the 60D increases the ISO setting, sometimes to very high levels. High ISO settings increase the digital noise in the image as well. For high-ISO images, you may want to apply noise reduction during image editing on the computer.

In this mode, you half-press the shutter button, the camera focuses on the subject, and then it automatically tracks focus as the subject moves. The focus is set the moment you fully press the shutter button. And if you're shooting a burst of images, you can continue to hold the shutter button down and the camera maintains focus. In Sports mode, the camera automatically sets

▶ AI Servo AF mode with automatic AF point selection.

▶ High-speed Continuous drive mode. This drive mode enables you to shoot at 5.3 fps for a maximum burst rate of 58 Large/Fine JPEG images. You also have the option to use the 10-sec. Self-timer/Remote control mode.

▶ The flash does not fire.

Night Portrait mode

In Night Portrait mode, the 60D combines flash with a slow speed. The flash provides proper exposure for the subject, and the long shutter speed provides proper exposure for the background. However, because this mode uses a longer exposure, it's important that the subject remain stock-still during the exposure to avoid motion blur. Be sure to use a tripod or set the camera on a solid surface to take night portraits. Also the subject should be positioned within the range of the built-in flash.

You should use this mode when people are in the picture, rather than for general night shots, because the camera blurs the background similar to the way it does in Portrait mode. For night scenes without people, use Landscape mode or a Creative Zone mode and a tripod.

In Night Portrait mode, the camera automatically sets

▶ One-shot AF mode with automatic AF point selection.

▶ Single shooting drive mode with the option to set 10-sec. Self-timer/ Remote control mode.

Setting the ISO Sensitivity

When you're shooting in P, Tv, Av, M, or B shooting modes, you can control not only the aperture and shutter speed, but also the ISO, which is the third element of exposure. In simple terms, the ISO determines the image sensor's sensitivity to light; more specifically, increasing the ISO amplifies the output of the image sensor.

Most often, photographers increase the ISO sensitivity to get faster shutter speeds that are needed to shoot in low-light scenes. There is a tradeoff when the amplification is increased,

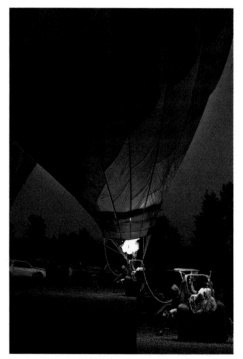

3.10 The inset in this image shows the balloon anchor team and the digital noise that is prevalent at ISO 800. This type of digital color noise becomes more apparent and objectionable when the image is sharpened in Adobe Photoshop, as it was here. Exposure: ISO 800, f/2.8, 1/400 second using −1/3 stop Exposure Compensation.

so is the digital noise in the image. The higher the amplification, the higher the ISO setting, the higher the level of digital noise in the image. Digital noise appears as unwanted colorful flecks, particularly in shadow areas of the image, and as a grain. Certainly the 60D improves performance by reducing digital noise at higher ISO sensitivity settings, but you should be aware of the effects of digital noise in your images.

Photographers have different levels of tolerance for the amount of digital noise in images. But the general standard is that if digital noise is visible and aesthetically objectionable in an 8×10- or 11×14-inch print when viewed at a distance of 1 foot or more, then the digital noise has degraded the image quality to an unacceptable level. This standard emphasizes the need to test the 60D at each of the higher ISO sensitivity settings, and then process and print images at the size you typically use. Evaluate the prints to see how far you want to take the 60D's ISO settings.

In P, Tv, Av, M, and B shooting modes, you can set the ISO sensitivity in 1/3-stop increments, or in 1-stop increments by setting C.Fn I-2 to Option 1. The 60D's standard range is ISO 100 to 6400, but you can expand the range to include ISO 12800 by setting C. Fn I-3 to Option 1: On; then ISO 12800 appears as H on camera displays.

The 60D also has an Auto ISO option that can be used in all shooting modes. In the Basic Zone modes except Portrait, the ISO is set between 100 and 3200. In P, Tv, Av, and M shooting modes, Auto ISO ranges from 100 to 6400. However, you can you set a lower maximum ISO, as detailed later in this section. With flash use, the ISO is fixed at 400 unless the image will be overexposed, and then ISO 100 or higher is set.

There are some exceptions to the Auto ISO range. In Portrait mode, Auto ISO is fixed at 100, and in Bulb (B) mode, it's fixed at 400. If you use bounce flash with an accessory Speedlite, and if you're shooting in Program AE (P) or Basic Zone modes except Night Portrait, then the ISO is automatically set between 400 and 1600. Alternatively, if you set the maximum setting for Auto ISO to 400 or 800, then the limit you set is used for bounce flash.

If you are concerned about controlling digital noise in images, and if you use Auto ISO, be sure to check the ISO setting in the viewfinder to ensure that it is acceptable based on the shooting circumstances and your tolerance for digital noise. If it is not, turn off Auto ISO and set the ISO manually. You can also turn on Standard, Low, or Strong noise reduction at high ISO settings by using C.Fn II-2.

To change the ISO on the 60D, follow these steps.

1. **Set the Mode dial to P, Tv, Av, or M shooting mode, and then press the ISO speed setting button above the LCD panel.**

2. **Turn the Main dial to the ISO sensitivity setting that you want.** If you select A for Auto, the 60D sets the ISO as described previously.

The 60D gives you the ability to set the upper ISO limit that's used with the Auto ISO setting. This is important because you get the advantage of letting the camera increase the ISO when necessary, while still retaining control over the highest ISO that it can use. Thus, you have control over the amount of digital noise in your images.

To set the maximum ISO used for Auto ISO, follow these steps.

1. **On the Shooting 3 camera menu tab, highlight ISO Auto, and then press the SET button.** The maximum ISO options appear.

2. **Press up or down on the Multi-controller to select the maximum ISO setting.** I recommend testing the camera at the higher ISO settings so you know how high to set the maximum. For my work, I set ISO 800 as the maximum.

My camera is set to ISO 100 as a matter of course, and I only use Auto ISO for shooting action scenes. Also I increase the ISO only when the light conditions force me to, and then I increase it just enough to get the shutter speed that I need to either handhold the camera with the lens I am using, or to freeze subject motion in action shooting.

Here are general recommendations for setting the ISO:

▶ In bright to moderate daylight, set the ISO to 100 unless you need a faster shutter speed to handhold the camera with a telephoto lens.

▶ At sunset, dusk, and in overcast light, set the ISO from 100 to 400. At this time of day, shadows are deep and keeping the ISO low helps minimize digital noise that is inherent in shadow areas while still providing faster shutter speeds.

▶ Indoors (including gymnasiums, recital halls, and night music concerts), and for night shooting, set the ISO from 400 to 1600. From ISO 3200 to 6400 and with the expanded 12800 setting, digital noise is evident in images. I recommend using 6400 and 12800 only when the light is dismally dark and there is no other way to get the image. Also use C.Fn II-2 to set high ISO digital noise reduction. Scene light can vary dramatically, so keep an eye on the shutter speed and raise the ISO only enough to give you the shutter speed you need to achieve your shooting needs.

Metering Light and Modifying Exposure

The starting point of all exposures, of course, is the light in the scene. To measure, or *meter* the light, the 60D uses Canon's latest onboard light meter that measures the

light reflected from the subject or scene back to the camera. The camera uses the light meter reading to determine its ideal recommended exposure.

Camera light meters are typically color blind — they see only in black-and-white brightness levels or luminosity. But the 60D's meter is no longer colorblind. The dual-layer meter measures the full spectrum of Red, Green, and Blue (RGB). As a result, the meter makes more informed decisions about metering. The metering sensor evaluates the light and color throughout 63 zones within the viewfinder. Canon has dubbed the latest autoexposure (AE) system Intelligent Focus Color Luminosity metering, or, IFCL. With IFCL, you can expect precise and consistent exposures particularly in Evaluative metering mode.

In general, when the camera meters the light in a scene, it measures the light reflected from the subject back to the camera, and it assumes that all tones average to 18 percent, or a middle gray tone. This assumes an *average scene* has a fairly even distribution of light, medium, and dark tones. And with the 60D metering system, the meter also takes into account the subject colors. But not all scenes are average because some objects reflect more or less light than others. For example, a white wedding gown reflects more light than a medium-gray dress, and a black tuxedo reflects less light. So if the camera meters a subject that reflects more or less light than average, the result can be either underexposure or overexposure, respectively.

While the metering system helps to overcome some metering challenges such as this, the meter can still be fooled by very light and very dark subjects. In those scenes, you can choose among the four metering modes to get more precise metering results, or you can opt to use any of several exposure-modification techniques, all of which are explained in the following sections.

Using metering modes

The 60D provides four metering options that you can choose from when you are shooting in P, Tv, Av, M, and B shooting modes. Here is a look at each of the four metering modes:

▶ **Evaluative metering.** This is Canon's venerable metering system that partitions the viewfinder into 63 zones. This mode evaluates each zone and considers distance, light intensity, and color. It also biases metering toward the subject position as indicated by the active AF point or points, and it takes into account back- or front-lighting. As a result of extensive evaluations, Evaluative metering mode works well in scenes with an average distribution of light, medium, and dark tones, and it functions well in backlit scenes and scenes with reflective surfaces.

► **Partial metering.** This metering mode hones in on a metering area that is approximately 6.5 percent of the viewfinder at the center. By limiting the meter reading to a small area, the exposure can be concentrated on a small area of the subject, something that is useful for metering backlit and high-contrast subjects and when the background is much darker than the subject.

► **Spot metering.** In this metering mode, the 60D meters from only 2.8 percent of the viewfinder at the center — the circle displayed in the center of the viewfinder. This mode is ideal for metering a middle gray area in the scene or a metering from a photographic gray card to calculate exposure, as described in the sidebar in Chapter 11.

► **Center-weighted Average metering.** This is an older metering mode that weights exposure calculation for the light read at the center of the frame, and then evaluates light from the rest of the viewfinder to get an average for the entire scene. The center area encompasses an area larger than the Partial metering area. As the name implies, the camera expects the subject to be in the center of the frame.

> **NOTE** In the automatic Basic Zone shooting modes, the camera uses Evaluative metering mode, and you cannot change it.

Partial, Spot, and Center-weighted Average metering all use the center AF point for metering. To meter with these modes, move the camera so that the center AF point is over the area you want to meter, such as a middle-gray photographic card or tonal value in the scene, and then use AE Lock (described later) to lock the exposure or use Manual shooting mode to dial in the exposure.

Using the Electronic Level

With the 60D, you can virtually eliminate tilted horizontal and vertical lines by using the Electronic Level to help you square up lines in the scene. You can use the Electronic Level for still shooting, as well as with Live View and Movie mode shooting.

To display the Electronic Level, press the INFO. button until the Electronic Level is displayed. If it doesn't appear, then go to the Setup 3 menu and select Electronic Level as one of the options that will be displayed when you press the INFO. button. As you're shooting, hold the camera until the line across the level turns green.

Evaluating exposures

After you make a picture, the next step is to evaluate the exposure, and the 60D's Brightness and RGB histograms are good tools for this task especially with JPEG images. With a histogram, you can immediately see if the highlights retain image detail or are blown out and whether the shadows retain detail or are blocked (go completely black with no detail). With a quick look at the histogram, you know immediately if you need to reshoot with modified exposure settings, or if you can move onto the next shot.

A *histogram* is a bar graph that shows the distribution and number of pixels captured at each brightness level. The horizontal axis shows the range of values, and the vertical axis displays the number of pixels at each location.

You can see the image with a histogram by switching to the Shooting Information display when you play back images. Simply press the INFO. button until the display shows one or more histograms.

Brightness histogram

The Brightness histogram is a snapshot of the exposure bias and the overall tonal distribution within the image. The brightness values are shown along the horizontal axis of the histogram. Values range from black (level 0 on the left side of the histogram) to white (level 255 on the right side of the histogram). Note that although the 60D captures 14-bit RAW images, the image preview and histogram are based on an 8-bit JPEG rendering of the RAW file.

The Brightness histogram shows at a glance whether the image has blown highlights or blocked-up shadows. Blown highlights are indicated by a spike of pixels against the right side of the histogram. Once the highlight detail is blown, it is gone for good. Blocked-up shadows are indicated by a spike of pixels against the left side of the histogram. If the shadows are blocked up, you can, of course, lighten them in an editing program. However, digital noise is virtually always present in the shadows, and lightening the shadows reveals the digital noise.

 The 60D's Highlight alert causes blown highlights to appear as blinking areas on the image preview during playback — a quick alert to reshoot using exposure modification. You can turn on Highlight alert in the Playback 2 menu.

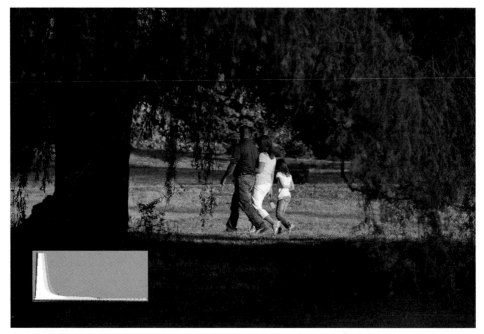

3.11 This histogram shows an excellent exposure. A spike does not appear on the right side of the histogram, which indicates that the highlights have retained good detail. No spike appears on the shadow (left) side, indicating that the shadows are open. Exposure: ISO 100, f/2.8, 1/500 second using −1/3 stop of Exposure Compensation.

Overall underexposure is shown when there is a large gap between the end of the highlight pixels and the right edge of the graph. Overexposure is indicated by a spike of pixels on the right side of the graph. If any of these exposure problems are indicated, you can reshoot using an exposure modification technique described later in this section.

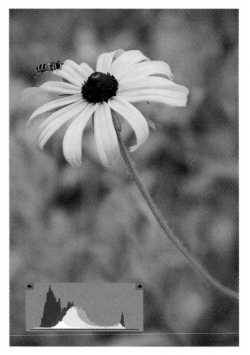

3.12 The histogram for this image shows underexposure by the empty space between where the highlight pixels end and the right side of the histogram. Exposure: ISO 100, f/4, 1/80 second.

The Brightness histogram simply reflects the tones in the image. In an average scene, the pixels are distributed fairly evenly across the histogram. In a scene with predominately light tones, such as a high-key image of a child in a white dress against a white background, the majority of the image pixels are concentrated to the right side of the histogram. Likewise in an image with predominately dark tones, or a low-key image, the pixels are concentrated toward the left side of the graph.

RGB histogram

RGB histograms show the distribution of brightness levels for the Red, Green, and Blue (RGB) color channels. Each color channel is shown separately so that you can evaluate the color channel's saturation, gradation, and bias. As with the Brightness histogram, the horizontal axis shows how many pixels exist for each color brightness level and the vertical axis shows how many pixels exist at that level.

More pixels to the left indicate that the color is darker and less prominent, while more pixels to the right indicate that the color is brighter and denser. If pixels spike on the left or right side, then color information is either lacking or oversaturated with no detail, respectively.

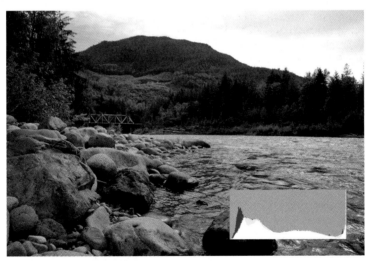

3.13 The spike on the right side of the histogram shows overexposure, reflecting the much brighter sky portion of the image. Even with the ability to recover highlight detail during RAW conversion, the overexposure here is too extensive to recover. Exposure: ISO 100, f/8, 1/100 second.

Both types of histograms are accurate for evaluating JPEG images because the histograms are based on the JPEG format. However, if you shoot RAW images, the histogram is based on a less-robust JPEG version of the RAW image. The nature of the RAW image data does not make it feasible to display a histogram, so a JPEG version of the image is used for preview histograms. Therefore, if you shoot RAW, just know that the RAW image is richer than the data you see on the histogram. Despite the JPEG rendering, the histogram is still an invaluable tool for evaluating RAW exposures in the field.

Depending on your needs, you can choose to display only the Brightness histogram during image playback, or you can display the RGB and Brightness histograms simultaneously to get a complete view of the tonal and color distribution in the image.

Differences in JPEG and RAW Exposure

When you shoot JPEG images, it is important to expose images to ensure that highlight detail is retained. You cannot recover highlight detail that is not recorded in a JPEG exposure. To ensure that images retain highlight detail, you can use exposure modification techniques such as Auto Exposure Lock (AE Lock) or Exposure Compensation, which are detailed later in this chapter.

However, for RAW exposure, the goal is to ensure that you capture the first full f-stop of image data. Image sensors are linear devices in which each f-stop records half the light of the previous f-stop. The majority of image data is recorded in the first f-stop of light. In fact, the first f-stop contains half of the total image data. Thus it is very important to capture the first f-stop and to avoid underexposure because it sacrifices image data. With RAW capture, exposure should be biased toward the right of the histogram.

A right-biased exposure results in a histogram with highlight pixels just touching or nearly touching, but not crowded against the right edge of the histogram. With a right-biased exposure, the image preview on the LCD may look a little light, but you can adjust the brightness during image conversion — and with the assurance that you have captured all the image data the 60D image sensor can deliver.

In addition, you have more latitude with RAW images because slight overexposures can be recovered during image conversion in Canon Digital Photo Professional, Adobe Camera Raw, Lightroom, or other RAW conversion programs.

To choose the type of histogram you want displayed, follow these steps.

1. **On the Playback 2 menu, select Histogram, and then press the SET button.** Two options appear.

2. **Press up or down on the Multi-controller to select Brightness or RGB, and then press the SET button.**

Modifying and bracketing exposures

Given that you can immediately review the image histogram, you know immediately whether the image exposure is correct or whether you need to modify the exposure to prevent blown highlights or to open the shadows.

The 60D offers several options to either manually or automatically modify exposure, including Auto Lighting Optimizer, Highlight Tone Priority, Auto Exposure Lock (AE Lock), and Exposure Compensation. In addition, you can use Safety Shift to help prevent exposure problems caused by sudden shifts in light, or use Auto Exposure Bracketing (AEB) to get several images at varying exposures.

3.14 This image of a rental boat house in La Conner, Washington, was taken without using Auto Lighting Optimizer. Exposure: ISO 200, f/8, 1/4000 second.

3.15 This the same scene taken with Auto Lighting Optimizer set to Strong and the same exposure settings used for the previous image.

Auto Lighting Optimizer

One of the 60D's automatic exposure adjustments is Auto Lighting Optimizer, which brightens images that are too dark and/or that have low contrast. Auto Lighting Optimizer is applied at the Standard level to all JPEG images shot in Basic Zone shooting modes such as Portrait, Landscape, and so on. In P, Tv, Av, M, and Bulb shooting modes, you can adjust the level of optimization or turn it off. The automatic correction is not applied to RAW images, although you can apply it in Canon's Digital Photo Professional program.

If you most often print images directly from the SD/SDHC card, then Auto Lighting Optimizer can help you get better prints. However, if you prefer to control exposure yourself, then turn off Auto Lighting Optimizer because it can mask the effects of exposure modifications, including Exposure Compensation, Auto Exposure Bracketing (AEB), and Auto Exposure Lock (AE Lock).

One downside of using Auto Lighting Optimizer is that as it brightens the shadow areas in the image, digital noise becomes visible, just as it does when shadows are lightened in an image-editing program. If your shooting involves long exposures and/or using high ISO settings, you can help avoid digital noise by setting C.Fn II-1, Long exposure noise reduction, to Option: 1: Auto or 2: On, and C.Fn II-2, High ISO speed noise reduction, to Option 1: Low or Option 2: Strong.

You can adjust the level of Auto Lighting Optimizer on the Shooting 2 menu. Just choose Auto Lighting Optimizer, press the SET button, and then to change the setting or disable it. Auto Lighting Optimizer is automatically disabled if you use Highlight Tone Priority, C. Fn II-3.

Highlight Tone Priority

Highlight Tone Priority is a Custom Function designed to improve and maintain highlight detail in bright elements in the scene. When you enable this Custom Function, highlight detail is improved by extending the range between 18 percent middle gray and the maximum highlight tones in the image, thus effectively increasing the dynamic range. Using Highlight Tone Priority also makes the gradations between gray tones and highlights smoother.

This option is especially useful when you are shooting very light objects, such as a wedding dress or white tuxedo, bright white sand on a beach, or shots of light-colored products. Using Highlight Tone Priority automatically limits the ISO range so that the lowest setting you can choose is ISO 200.

Highlight Tone Priority takes advantage of the higher ISO baseline so that the image sensor pixel wells do not fill, or saturate. Also, with the 60D's 14-bit analog/digital conversion, the camera sets a tonal curve that is relatively flat at the top in the high-light area to compress highlight data. The result is almost a full f-stop increase in *dynamic range* (the range from highlight to shadow tones in a scene as measured in f-stops). The tradeoff, however, is a more abrupt move from deep shadows to black — a reduced range of shadow tones that also increases the potential for digital noise in the shadows.

 If you enable Highlight Tone Priority, it is denoted in the viewfinder and on the LCD panel as D+, with the D indicating dynamic range. Highlight Tone Priority is disabled by default.

To turn on Highlight Tone Priority, follow these steps.

1. **With the camera set to P, Tv Av, M, or B shooting mode, select C.Fn II: Image on the Custom Functions menu, and then press the SET button.** The last Custom Function you chose in this group is displayed.

2. **Press left or right on the Multi-controller until the number 3 appears in the Custom Function number control in the upper-right corner of the screen, and then press the SET button.** The C.Fn II: Highlight tone priority screen appears with two options.

3. **Turn the Quick Control dial to select Option: 1 Enable.** Or to turn it off, select Option: 0 Disable. With the function enabled, the lowest ISO setting is 200. The setting remains in effect until you change it.

Safety Shift

Safety Shift also falls loosely into the category of automatic exposure modifications. Although this function is turned off by default, you can enable Safety Shift so that the camera automatically changes the exposure settings if the light changes enough to make your current exposure setting in Av or Tv shooting modes inaccurate.

Safety Shift may be annoying to photographers who have carefully set up the depth of field and/or the shutter speed they want for a shot, and having the camera change the exposure settings automatically may seem intrusive.

But there is virtue in this function in some scenarios, such as during action shooting. Sports and action shooting requires almost single-minded concentration on capturing the peak moments, and having the 60D automatically shift the exposure if a break in the clouds suddenly sheds more light on the athlete can be welcome assistance.

If you want to use Safety Shift in Tv and Av shooting modes, follow these steps:

1. **With the camera set to P, Tv Av, M, or B shooting mode, select C.Fn I: Exposure on the Custom Function menu, and then press the SET button.** The last accessed Custom Function screen appears.

2. **Press left or right on the Multi-controller until the number 6 appears in the Custom Function number control in the upper-right corner of the screen, and then press the SET button.** The first option is activated.

3. **Turn the Quick Control dial to highlight either Disable or Enable (Tv/Av), and then press the SET button.** The option you select remains in effect until you change it.

Auto Exposure Lock (AE Lock)

Normally, when you're shooting in Evaluative metering mode and you half-press the shutter button, the 60D meters the scene with a bias toward the active Autofocus (AF) point — the AF point that's lit in red in the viewfinder. This is also, of course, where the sharp focus is set. But what if you want to meter one area but focus on a different area? This is the time to use Auto Exposure Lock (AE Lock) to meter on an area while focusing on another area. For example, you can meter on a middle-gray tone in the scene, press the AE Lock button to retain the metered exposure settings, and then move the camera to recompose and focus on another area of the scene. Because the camera retains the metered exposure settings for a few seconds, you can continue using the same locked exposure settings as long as the asterisk appears at the bottom left of the viewfinder.

AE Lock works differently with different metering modes. In Evaluative metering mode, if you manually select the AF point, the 60D biases the metering toward that AF point. And if you use automatic AF point selection where the camera automatically selects the AF point(s), AE Lock is applied at the AF point that achieves focus.

However, Spot, Partial, and Center-weighted Average metering modes use the center AF point to meter. To use AE Lock in these metering modes, point the center AF point over the part of the scene or subject where you want the camera to take the meter reading, and then press the AE Lock button on the back-right top of the camera. The camera stores the meter reading for a few seconds while you move the camera to recompose the image; then you focus on the subject using the center or another AF point, and make the picture.

 You cannot use AE Lock in Basic Zone modes such as Creative Auto (CA), Portrait, Landscape, and so on.

Exposure Compensation

Another way to modify the camera's metered exposure is by increasing or decreasing the exposure by a specific amount to lighten or darken the image respectively. With Exposure Compensation, you can modify the exposure up to +/–5 stops in 1/3-stop increments.

Although the 60D offers an impressive 5 stops of compensation, the LCD panel and viewfinder can only display 3 stops of compensation. To set the full 5 stops, press the Q button on the back of the camera to display the Quick Control screen, press the Multi-controller to select the Exposure Compensation control, and then press the SET button. Then turn the Quick Control dial to set up to the full 5 stops of compensation. You can also set Exposure Compensation on the Shooting 2 menu.

3.16 To keep the white petals and white background bright white, I used +2/3-stop of Exposure Compensation. Exposure: ISO 100, f/2.8, 1/30 second.

A classic use of Exposure Compensation is to override the camera's meter so that whites and blacks in the image are truly white and black rather than gray. In scenes with large expanses of white or dark tones, the camera's onboard meter averages the tones to 18 percent gray so that both white and black objects are rendered as middle gray. To get true whites and blacks, you can use Exposure Compensation to brighten or darken the image from the camera's recommended exposure. For example, for a snow scene, a +1 or +2 stop of compensation renders snow as white. For a black train engine, a –1 or –2 stop compensation renders it as true black.

Here are some points to know about Exposure Compensation:

▶ Exposure Compensation can be used in P, Tv, Av, and C shooting modes.

▶ In Tv mode, setting Exposure Compensation changes the aperture by the specified amount of compensation. In Av mode, it changes the shutter speed. In P mode, compensation changes both the shutter speed and aperture by the exposure amount you set.

▶ The amount of Exposure Compensation you set remains in effect until you change it, regardless of whether you turn the camera off, change the lens, or replace the battery.

▶ Automatic exposure correction features such as Auto Lighting Optimizer can mask the effect of compensation. I recommend turning off Auto Lighting Optimizer before setting Exposure Compensation.

You can set Exposure Compensation by following these steps:

1. **With the camera set to P, Tv, or Av shooting mode, highlight Expo. comp./ AEB on the Shooting 2 menu, and then press the SET button.** The Exposure comp./AEB setting screen appears.

2. **Turn the Quick Control dial to the left to set negative compensation or to the right to set positive compensation, and then press the SET button.** As you adjust the amount, the tick mark on the Exposure Compensation control moves in 1/3-stop increments up to +/–5 stops.

To cancel Exposure Compensation, repeat these steps, but move the tick mark back to the center position of the Exposure Compensation control.

Auto Exposure Bracketing

Auto Exposure Bracketing (AEB) enables you to capture a series of three images at different exposures. Traditionally, the bracketing sequence is one image at the camera's standard metered exposure, one 1/3-stop above the standard exposure, and one 1/3-stop below the standard exposure up to +/–3 stops. Thus, if the scene has high contrast, highlight detail is better preserved in the darker exposure than in either the standard or lighter exposure. Conversely, the shadows may be more open in the brighter exposure than in either of the other two.

But the 60D adds flexibility to AEB by enabling you to shift the entire bracketing range to below or above zero on the Exposure Level meter. As a result, you can set all three bracketed exposures to be brighter or darker than the camera's recommended exposure and skip capturing the camera's standard exposure.

Exposure bracketing provides a way to cover the bases — to get at least one printable exposure in scenes with challenging lighting, scenes that are difficult to set up again, or scenes where there is only one opportunity to capture an elusive subject. Today, exposure bracketing is also very often used for High-Dynamic Range imaging.

High-Dynamic Range imaging (HDR) captures bracketed frames of the same scene, with one exposure set for the highlights, one for the midtones, and one for shadow detail. In some cases, five to seven bracketed frames merge into the final composite image. The images are bracketed by shutter speed rather than by aperture to avoid shifts in focal length. The final images are composited in Photoshop or another HDR

program to create a single image that has a dynamic range far beyond what the camera can capture in a single frame.

With the 60D, you can combine both Exposure Compensation and AEB to set exposure values of up to 8 stops from the metered exposure. And in practical application, this range is adequate for most HDR work.

Regardless of how you use the bracketed exposures, here are some points to keep in mind when using AEB:

▶ AEB is only available in P, Tv, and Av shooting modes.

▶ AEB cannot be used with the built-in or any accessory flash unit or with Bulb mode.

▶ Settings for AEB are retained only for the current shooting session. If you turn off the camera, attach a flash, pop up the built-in flash, or switch to Movie mode, AEB is cancelled. If you want to retain the AEB settings even after turning off the camera, you can set C.Fn I-4: Bracketing auto cancel to Option 1 to retain the settings. However, the settings are temporarily cancelled if you use a flash.

▶ In High-speed and Low-speed Continuous drive modes, pressing the shutter button once takes all three bracketed exposures. Likewise, in 10- or 2-sec. Self-timer/Remote control modes, the bracketed shots are taken in succession after the timer interval elapses.

▶ In Single shot Drive mode, you must press the shutter button three separate times to get the bracketed sequence.

▶ The order of bracketed exposures begins with the standard exposure, followed by the decreased and increased exposures. You can change the order of bracketing using C.Fn I-5: Bracketing sequence.

▶ You can change the default 1/3-stop exposure increment to 1/2 stop using C.Fn I-1: Exposure level increments.

You can combine AEB with Exposure Compensation. If you combine them, the bracketed exposures are based on the amount of Exposure Compensation that you set.

To set AEB, follow these steps:

1. **With the camera in P, Tv, or Av shooting mode, highlight Expo. comp./AEB on the Shooting 2 menu, and then press the SET button.** The Exposure comp./AEB setting screen appears.

2. **Turn the Main dial clockwise to set the bracketing amount that you want, and then press the SET button.** As you turn the Main dial, two additional tick marks appear and move outward from the center in 1/3 stop increments. If you

want to shift the bracketing sequence above or below zero, turn the Quick Control dial, and then press the SET button.

Using the 60D Autofocus System

Whether you are shooting one image at a time, or you are blasting out the maximum burst of images as players move across a soccer field, the 60D's autofocus is quick and accurate. You can choose among three autofocus modes.

The following sections help you get the best performance from the 60D's autofocus system.

Choosing an autofocus mode

The 60D's three autofocus modes are designed to help you achieve sharp focus based on the type of subject you are photographing. Here is a summary of the autofocus modes and when to use them.

▶ **One-shot AF.** This mode is designed for photographing stationary subjects that are still and will remain still. This mode is a good choice for photographing land-scapes, macro, portraits, architecture, and interiors. Unless you are shooting sports or action, One-shot AF is the mode of choice for everyday shooting. In this autofocus mode, the camera does not allow you to make the image until focus is achieved.

▶ **AI Servo AF.** This mode is designed for photographing action subjects. The camera tracks focus on the subject regardless of changes in subject distance from side to side or approaching or moving away from the camera as long as the shutter button is half-pressed. The camera begins focus tracking with the center AF point, and follows focus as long as the subject is within any of the AF points. The focus and the exposure are set at the moment the image is made.

▶ **AI Focus AF.** This mode is designed for photographing stationary subjects that may begin moving. This mode starts out in One-shot AF mode, but then auto-matically switches to AI Servo AF if the subject begins moving. Then the camera maintains focus on the moving subject as described in AI Servo AF. When the switch from One-Shot AF to AI Servo AF happens, a soft beep sounds and the focus confirmation light in the viewfinder is no longer lit. (The beeper sounds only if you have turned on the beeper on the Shooting 1 menu.) This is a good choice for photographing wildlife, children, or athletes who alternate between stationary positions and motion. In this mode, focus tracking is activated by pressing the shutter button halfway.

Improving Autofocus Accuracy and Performance

Autofocus speed depends on factors such as the size and design of the lens, the speed of the lens-focusing motor, the speed of the autofocus sensor in the camera, the amount of light in the scene, and the level of subject contrast. Given these variables, here are some tips for getting the best autofocus performance and focus.

▶ **Light.** In low-light scenes, autofocus performance depends in part on the lens speed and design. In general, the faster the lens, the faster the autofocus performs. Provided that there is enough light for the lens to focus without an AF-assist beam, lenses with a rear-focus optical design, such as the EF 85mm f/1.8 USM, focus faster than lenses that move their entire optical system, such as the EF 85mm f/1.2L II USM. Regardless of the lens, the lower the light, the longer it takes for the system to focus.

▶ **Contrast.** Low-contrast subjects and subjects in low light slow down focusing speed and can cause autofocus failure. With a passive autofocus system, auto-focusing depends on the sensitivity of the AF sensor. Autofocusing performance is always faster in bright light than in low light, and this is true in both One-shot and AI Servo AF modes. In low light, consider using the built-in flash or an accessory EX Speedlite's AF-assist beam as a focusing aid using C.Fn III-4.

▶ **Focal length.** The longer the lens, the longer the time required to focus because the range of defocus is greater on telephoto lenses than on normal or wide-angle lenses. You can improve the focus time by manually setting the lens in the general focusing range, and then using autofocus to set the sharp focus.

▶ **AF-point selection.** Manually selecting one AF point provides faster autofocus performance than using automatic AF-point selection because the camera does not have to determine and select the AF point(s) to use first.

▶ **Subject contrast.** Focusing on low-contrast subjects is slower than focusing on high-contrast subjects. If the camera cannot focus, shift the camera position to an area of the subject that has higher contrast.

▶ **EF Extenders.** EF Extenders reduce the speed of the lens-focusing drive.

▶ **Wide-angle lenses and small apertures.** Sharpness can be degraded by diffraction when you use small apertures with wide-angle or wide-angle zoom lenses. Diffraction happens when light waves pass around the edges of an object and enter the shadow area of the subject, softening fine detail. To avoid diffraction, avoid using apertures smaller than f/16 with wide-angle prime (single-focal length) and zoom lenses.

If you routinely set focus and then keep the shutter button pressed halfway, it shortens battery life. To maximize battery power, anticipate the shot and press the shutter button halfway just before making the picture.

To choose an Autofocus mode, set the lens switch to AF, and then follow these steps:

1. **Set the Mode dial to P, Tv, Av, M, or B.**

2. **Press the AF button above the LCD panel, and then turn the Main dial to select the autofocus mode you want.** Each mode is represented by text displayed on the LCD panel and on the LCD. The selected autofocus mode remains in effect until you change it.

Manually choosing an AF point

A key ingredient to creating a successful image is getting tack-sharp focus with the focus placed precisely where it should be. And the best way to ensure this is by manually choosing a single AF point yourself. It's that simple.

Granted it's faster to let the 60D automatically select the AF point or points, but if you've used the automatic shooting modes such as Portrait or Landscape, then you know that automatic AF point selection can range from getting sharp focus where it should be to the camera incorrectly identifying the subject entirely. For my work, I have neither the time nor inclination to hope that the camera correctly identifies the subject and focuses on the right place, so I *always* set the AF point manually. However, automatic AF point selection is a good choice when you're shooting action.

If the camera has trouble focusing in low light, you can use the built-in flash's focus assist beam to help establish focus without firing the flash. This technique is detailed in Chapter 8.

Finally, it's helpful to know that the AF points have different sensitivities to vertical and horizontal lines in the scene or subject. This is important because it speeds up the camera's ability to focus. The center AF point is sensitive to lenses with a maximum (widest) aperture of f/2.8. And because it's sensitive to both horizontal and vertical lines, it's called a cross-type AF point. The other AF points are cross type as well, and they are sensitive to lenses with maximum apertures of f/5.6 or faster. Canon notes that the center AF point is approximately twice as sensitive as the other eight AF points. Therefore, for fast focusing with lenses with an f/2.8 maximum aperture, the center AF point is a good technical choice, although it may not be the best choice depending on the image composition.

3.17 In this image I manually selected the AF point that was on top of the center of the flower, and the focus is not only tack sharp, but also it is where it should be for this subject. Exposure: ISO 100, f/2.8, 1/125 second.

3.18 In this image I let the camera automatically select the AF points and the sharp focus is on the petals just outside the center of the flower — close, but not close enough. Exposure: ISO 100, f/2.8, 1/125 second.

In addition to using autofocus, you can also manually focus if the lens has a Manual Focus (MF) switch on the side of the lens. Set the switch to MF, and then turn the focusing ring on the lens until the subject appears sharp in the viewfinder. Just watch for the focus confirmation light in the viewfinder to burn steadily to confirm that sharp focus is achieved.

TIP Be sure that you've set the Diopter switch for your vision. If you wear glasses for shooting, wear them as you adjust the dioptric knob until the AF points in the viewfinder are clear and sharp to your eye.

To manually select an AF point, follow these steps:

1. **In P, Tv, Av, M, or B shooting mode, press the AF-point Selection/Magnify button on the back top right side of the camera.**

2. **As you look in the viewfinder, turn the Main dial to move through AF points.** You can also press the Multi-controller in the direction of the AF point you want to select or turn the Quick Control dial. Select only one AF point — the AF point that is on top of the place in the scene or subject that should have sharp focus. If you choose the option where all the AF points light in red, the camera automatically selects the AF points for you.

3. **Press the shutter button halfway to focus using the selected AF point, and then press the shutter button completely to make the picture without moving the camera.** The camera beeps when focus is achieved, and the auto-focus light in the viewfinder is lit continuously.

The best way to verify tack-sharp focus is to press the Playback button, and then press the Magnify button on the back of the camera to zoom in on the image. If the focus isn't sharp, or if it isn't in the place where it should be, reshoot.

Selecting a Drive Mode

One of the nice aspects of the 60D is its speed and drive mode options. The EOS 60D offers drive modes for everything from capturing action shots to avoiding blur when pressing the shutter button with your finger. Just choose the appropriate drive mode: Single shooting, High-speed or Low-speed Continuous shooting, or one of the two Self-timer/Remote control modes. You can choose these drive modes when you are shooting in P, Tv, Av, M, or B shooting mode.

In automatic shooting modes, the camera automatically chooses the drive mode, but you can optionally choose the 10-sec. Self-timer/Remote control mode.

Here is a summary of each mode:

▶ **Single shooting.** In this mode, one image is captured with each press of the shutter button. This is a good choice for still subjects.

▶ **High-speed Continuous shooting.** In this mode, you can keep the shutter button depressed to shoot at 5.3 fps to capture approximately 58 Large/Fine JPEGs or 16 RAW, or 7 RAW+JPEG [Large/Fine] images. The actual number of frames in a burst depends on the shutter speed, Picture Style, ISO speed, brand and type of SD/SDHC card, battery level, lens, and light.

▶ **Low-speed Continuous shooting.** This mode delivers a maximum of 3 fps when you keep the shutter button completely depressed.

▶ **Self-timer/Remote control modes (10- and 2-sec.).** In Self-timer/Remote control modes, the camera delays taking the picture for 2 or 10 seconds after the shutter button is fully depressed. The 10-sec. mode is effective when you want to include yourself in a picture. The 2-sec. mode is useful in nature, landscape, and close-up shooting, and can be combined with Mirror lockup (C.Fn III-5) to prevent vibration from the reflex mirror action and from pressing the shutter button. You have to press the shutter button once to lock the mirror, and again to make the exposure.

 If you do not have the camera to your eye while using Self-timer/Remote control modes, slip the eyepiece cover over the viewfinder to prevent stray light from entering the viewfinder, which can alter the exposure.

When you are shooting a burst of images in High-speed Continuous mode, Canon uses *smart buffering* to enable large bursts of images. The images are first delivered to the camera's internal buffer. Then the camera immediately begins writing and offloading images to the SD/SDHC card.

The time required to empty the buffer depends on the speed of the card, the complexity of the image, and the ISO setting. JPEG images that have a lot of fine detail and digital noise tend to take more time to compress than images with less detail and low-frequency content.

Thanks to smart buffering, you can continue shooting in one-, two-, or three-image bursts almost immediately after the buffer is filled, as the camera offloads images and frees up buffer space. In the Continuous drive modes, the viewfinder displays a Busy message when the buffer is full, and the number of remaining images shown on the LCD panel blinks. You can press the shutter button halfway and look at the bottom-right area of the viewfinder to see the current number of available shots in the maximum burst.

The 60D is set to Single shooting drive mode by default in P, Tv, Av, M and B shooting modes. In automatic shooting modes such as Portrait and Landscape, the camera automatically sets the drive mode, and you can only select the 10-sec. drive mode. In Creative Auto (CA) shooting mode, you can choose Single shooting, Low-speed Continuous, or the 10-sec. Self-timer/Remote control mode.

To switch to a different drive mode, follow these steps:

1. **With the camera in P, Tv, Av, M and B shooting mode, press the Drive button above the LCD panel.** The camera activates drive mode selection in the LCD panel.

2. **Turn the Main dial to select a drive mode.** When you turn the Main dial clockwise, the mode sequence begins with Single shooting and progresses through High-speed Continuous shooting, Low-speed Continuous shooting, 10-sec. Self-timer/Remote control mode, and 2-sec. Self-timer/Remote control mode. The drive mode remains in effect until you change it. If you want to cancel a Self-timer exposure, press the Drive button above the LCD panel.

Using Color Options, Ambience Effects, and Creative Filters

The EOS 60D offers several options for ensuring accurate and visually pleasing color. The options include setting white balance, setting a color space, and selecting any of the Canon Picture Styles. The more faithful you are in setting the options for each shooting session, the better the color in your images. And the better the color, the less time you spend correcting color on the computer.

In addition, the 60D offers effects and filters that you can apply to give images a creative look. Ambience effects can be used in most of the automatic shooting modes such as Creative Auto, Portrait, and Landscape. You can adjust the filters to suit your personal taste.

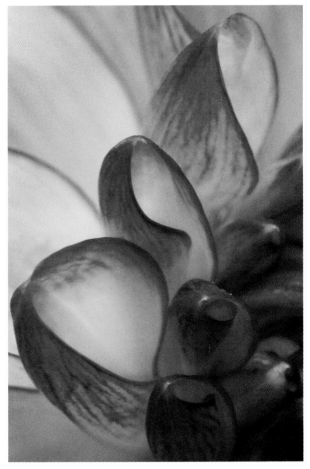

You can count on the 60D to deliver stunning color. This image is an extreme close-up using an extension tube on the EF 85mm f/1.2L II USM lens. Exposure: ISO 100, f/16, 1/4 second using a –1/3-stop of Exposure Compensation.

Working with Color

The settings on the 60D that affect image color are Color Space, White Balance, Picture Style, and for the automatic shooting modes, Ambience effects.

▶ **Color Space.** This option determines the breadth of colors that are captured in images. Some color spaces encompass a broad range of colors, and others encompass fewer colors. Choosing a color space also factors into the overall image workflow; you want to keep color space consistent from image capture through editing and printing. The Color Space option is one that most photographers set once and seldom change.

▶ **White Balance and Lighting Type.** These settings determine the accuracy of color in images. To get accurate color, the camera must know what kind of light is in the scene. The White Balance setting in P, Tv, Av, M, and Bulb shooting modes, and the Lighting Type setting in some automatic shooting modes give the camera that information so the 60D can, in turn, render colors correctly. These settings are ones that you change each time the light in the scene changes.

▶ **Picture Styles.** These settings determine whether the image colors are vivid and saturated, or less vivid and more subdued, and they affect image sharpness and contrast. How often you change the Picture Style depends on your preferences for color rendering, saturation, and contrast in the images and the type of scene or subject that you are photographing.

▶ **Ambience effects.** When you're shooting in the Basic Zone modes except for Full Auto and Flash Off shooting modes, you can apply Ambience effects that include Standard, Vivid, Soft, Warm, Intense, Cool, Brighter, Darker, and Monochrome. Much like Picture Styles, these effects enable you to control the color and rendering of images.

Each of these settings plays a unique role in determining image color. The following sections provide more detail on using these settings.

Choosing a color space

A *color space* defines the range of colors, or the gamut, that can be reproduced by a device such as a printer or computer monitor, and the way that device reproduces color. Color spaces encompass large to smaller ranges of color. The size of the color space is important because it determines the amount of shadow and highlight detail that is reproduced in the image, as well as the color saturation. The larger the space, or gamut, the more colors the device can reproduce, and vice versa.

 Color spaces also represent other aspects of color including lightness, saturation, and hue.

The 60D has two color space choices: Adobe RGB and sRGB. Adobe RGB is a color space that supports a wider gamut of colors than sRGB. As is true with all aspects of image capture, the more data you capture in the image, the richer and more robust the image is. And the more robust the image, the better it can withstand image editing.

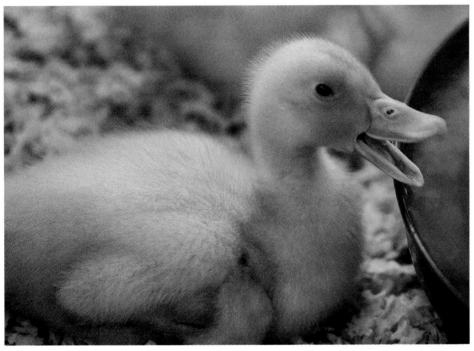

4.1 Occasionally the light source is unusual, as it was here with the warming light that illuminated the duckling. I used the Auto white balance (AWB) setting and adjusted the color during RAW image conversion. Exposure: ISO 800, f/2.8, 1/125 second.

An advantage of the 60D is that it has 14-bit files. That translates to color-rich image files that have 16,384 colors for each of the three color channels (Red, Green, and Blue) when you shoot in RAW capture. (In contrast, 8-bit files offer only 256 values per color channel.) Even if you shoot JPEG, which automatically converts 14-bit files to 8-bit files in the camera, the conversion to 8-bit files is better because it is based on color-rich, 14-bit files.

 The 60D's 14-bit RAW files can be processed in a conversion program, such as Adobe Camera Raw or Lightroom, as 16-bit files that offer robust color data, and subtle tonal gradations.

As you consider which color space to choose, try to avoid shooting in one color space, and then editing and printing in another color space. This is important because when an image is converted from a large color space to a smaller color space, the device — the camera, computer, or printer — must then decide which colors to keep and which to alter or throw out.

Because I want to get all the image data possible, I avoid settings that discard or alter color data in my images. To do that, I use the Adobe RGB color space through the entire workflow, from image capture through editing and printing. Alternately, you can use the sRGB color space for capture, editing, and printing.

To illustrate the difference between color spaces, consider Figures 4.2 and 4.3. The image histograms show the effects of changing color space.

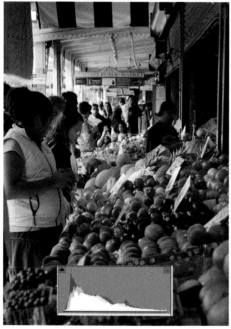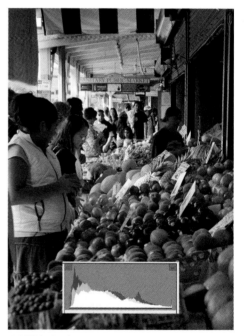

4.2 This is a RAW image with its histogram as displayed in Adobe Camera Raw. Here the image is shown in the Adobe RGB color space and there is only a small spike in the highlights. Exposure: ISO 100, f/6.3, 1/40 second using a –1/3-stop of Exposure Compensation.

4.3 This is the same image with the histogram as displayed in Adobe Camera Raw and with the color space set to sRGB. The histogram shows noticeably more highlight clipping on the right side of the graph than in the Adobe RGB color space.

Spikes on the far edges of the histogram indicate image data that is *clipped*, or discarded, from the image. The higher the spike on the left and right sides of the histogram, the more data that is clipped. Ideally, you do not want image data to clip, or at the very least, you want to reduce clipping as much as possible. Clipped data contains image detail for both highlights and shadows, detail that you want to preserve. The larger the color space, the less clipping.

Does this mean that you should always choose the larger Adobe RGB color space? Not necessarily. While Adobe RGB is a great color space for capturing a wide range of colors, it isn't the color space that provides the best image color for online display. In fact, when you view an image that's in the Adobe RGB color space outside of an image-editing program or online, the image colors look dull and flat. For online display, the sRGB color space provides the best color. In addition, some commercial printing services use only the sRGB color space for printing. So if you want images that you can display online with no image editing and without needing to convert the color space, or if your printing service requires sRGB, the sRGB color space is the best choice.

However, if you capture images in Adobe RGB and you want to display them on the Web or send them in e-mail, you can simply convert images from Adobe RGB to sRGB after the images are edited and sized in an image-editing program. For example, I use Adobe RGB for capture, editing, and printing. But when I want to display an image on my Web site, I make a copy of the image, and then convert it to the sRGB color space in Adobe Photoshop.

Here are some things to consider when choosing a color space:

▶ You can choose a color space when you are shooting in Program AE (P), Aperture-priority AE (Tv), Shutter-priority AE (Av), Manual (M), and Bulb (B) shooting modes.

▶ The 60D does not automatically include, or *embed*, the ICC profile within the image's files. The ICC profile is important because it contains information that's necessary to properly convert color data between the camera and the device that you're using, such as a computer monitor or a printer, thus helping to ensure that colors are consistent when viewed and printed on different devices. You can embed the ICC profile in Adobe Photoshop 6 or later.

> **NOTE** *ICC* is an abbreviation for International Color Consortium, an organization that "promotes the use and adoption of open, vendor-neutral, cross-platform color management systems."

 For all step-by-step instructions in this chapter, you can access the 60D camera menus by pressing the Menu button. Then press left or right on the Multi-controller to highlight the menu tab or turn the Main dial, and then press up or down on the Multi-controller to highlight a menu option or turn the Quick Control dial.

To choose a color space, follow these steps:

1. **In P, Tv, Av, M, or Bulb shooting mode, go to the Shooting 2 menu, highlight Color space, and then press the SET button.** The sRGB and Adobe RGB options appear.

2. **Press up or down on the Multi-controller to highlight the option you want and then press the SET button.** The color space you choose remains in effect until you change it.

Although the color space is your choice, try to set it based on your image capture and printing needs, and then keep it consistent as you edit and print images.

Setting the white balance

The easiest way to achieve good out-of-the-camera color is to choose the White Balance setting that matches the light in the scene. In broad terms, choosing a White Balance setting tells the camera what the color or temperature of the light in the scene is so the camera accurately reproduces the colors in the scene. In practice, a White Balance setting such as Daylight is a range of light temperatures designed to provide accurate color in daylight conditions. You can select a White Balance setting when you're shooting in P, Tv, Av, M, Bulb, and C shooting modes. In automatic shooting modes such as Portrait, Landscape, and so on, you can choose a Lighting or Scene type.

The 60D offers six preset White Balance options for common light sources, as well as a Custom white balance option that sets the light temperature to the specific light in the scene; an option to set a specific color temperature; and Auto white balance (AWB), an option where the camera makes its best guess on the light temperature in the scene.

 In Portrait, Landscape, Close up, and Sports automatic shooting modes, you can set the *Lighting type*, which is essentially the same as using a preset White Balance option. Lighting options are detailed later in this chapter.

How do you know which White Balance option to use? Here are some approaches you can use for setting white balance:

▶ **Use a preset White Balance option or Auto white balance.** The preset White Balance options are Daylight, Shade, Cloudy, Tungsten light, White fluorescent light, and Flash. If the scene you're shooting has a single light source that clearly matches one of the preset White Balance options, use a preset option. You can use the Auto white balance option in mixed light or when the light source isn't clearly defined, such as on a playing field or in a stadium. If you use the Auto white balance option, be aware that it tends to have a bluish, or cool, color tint.

If you are new to using white balance, Figures 4.4 and 4.5 illustrate the difference it makes to have the correct white balance set.

4.4 This image was taken using the Daylight white balance setting and the Neutral Picture Style. The image has accurate color. Exposure: ISO 100, f/3.5, 1/40 second.

4.5 This image is shown using the Tungsten white balance setting that shifts the color to blue. Exposure: ISO 100, f/3.5, 1/40 second.

▶ **Set a Custom white balance.** A Custom white balance sets image color for the specific light in the scene, whether it's a single light source or mixed light. This is the option to use with mixed lighting and when the light source doesn't clearly match one of the preset White Balance options. Setting a Custom white balance takes a little more time, but it provides very accurate color, and it is worth the time when you are shooting a series of images in the same light, especially if you are capturing JPEG images.

If you are shooting RAW capture, shooting a white or gray card and balancing images during RAW image conversion is often faster than setting a Custom white balance.

▶ **Set a specific color temperature.** With this option, you set the specific light temperature on the 60D. This is good for studio shooting when you know the specific temperature of the lights, such as when you're using studio lighting.

Here's how to use a preset White Balance option such as Daylight, Tungsten, Shade, and so on:

1. **Set the Mode dial to P, Av, Tv, M, or B, and then press the Q button.** The Quick Control screen appears. You can also set White Balance options in Movie mode.

2. **Press up or down on the Multi-controller to select White Balance setting, and then turn the Quick Control dial until the White Balance setting you want is displayed.** The White Balance settings are shown with icons and text at the bottom of the screen. The White Balance option that you set remains in effect until you change it or until you switch to a Basic Zone shooting mode such as Portrait, Landscape, and so on.

Changing the Lighting or Scene type in some automatic shooting modes

You can change the *Lighting or Scene type* in Portrait, Landscape, Close-up, and Sports automatic shooting modes. While these options are denoted as Lighting or Scene types, they function much like the preset White Balance settings available in P, Tv, Av, M, and B shooting modes; however, their names are slightly different in some cases. In the other automatic shooting modes, Full Auto, Flash Off, CA, and Night Portrait, the 60D automatically chooses Auto white balance, and you can't change it or select a Lighting or Scene type.

The 60D includes these Lighting or Scene types:

▶ **Default.** The 60D makes its best guess at the light and light temperature in the scene. Typically this is a good choice when you have mixed light sources.

▶ **Daylight.** This setting delivers the most accurate color under sunny skies.

▶ **Shade.** This setting corrects the blue color characteristic of cool light in the shade.

▶ **Cloudy.** Good to use when the sky is fully overcast.

▶ **Tungsten light.** This setting is ideal for traditional incandescent household light bulbs.

▶ **Fluorescent light.** This setting is best for all types of fluorescent lighting.

▶ **Sunset.** This setting renders the warm colors of sunset accurately.

Getting Accurate Color with RAW Images

If you are shooting RAW images, a great way to ensure accurate color is to photograph a white or gray card that is in the same light as the subject, and then use the card as a reference point for balancing color when you process the RAW images in a RAW conversion program such as Canon's Digital Photo Professional or Adobe's Lightroom or Camera Raw programs.

For example, when you take a portrait, ask the subject to hold the gray card under or beside his or her face for the first shot, and then continue shooting without the card in the scene. If the light changes, take another picture with the gray or white card. When you begin converting the RAW images on the computer, open the picture that you took with the card. Click the card with the White Balance tool to correct the color, and then click Done to save the corrected White Balance settings.

If you are using a RAW conversion program such as Adobe Camera Raw or Canon Digital Photo Professional, you can copy the White Balance settings from the image you just color balanced, select all the images shot under the same light, and then paste the White Balance settings to them. In a few seconds, you can color-balance 10, 20, 50, or more images.

There are a number of white and gray card products, such as the gray card included in the back of this book, the WhiBal cards from RawWorkflow.com (www.rawworkflow.com/whibal), or the Digital Calibration Target reflector from PhotoVision (www.photovisionvideo.com). The Digital Calibration Target does double duty because it has the calibration target on one side and a reflector on the other. The least-expensive option, and one that works well, is a plain, white, unlined index card.

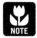 If you use a flash, the Lighting or Scene type automatically changes to the Default setting.

You can combine a Lighting type selection with an Ambience setting, detailed later in this chapter. If you do, it's important to set the Lighting type first so that the camera records the image color correctly before the camera shifts the color, as it does with some Ambience options.

In addition, if you're using a Lighting type that creates warm image colors, such as Sunset, and then choose an Ambience setting that further increases the color warmth, such as Warm, the combination may create an unnatural look. You can press the Live View button on the back of the camera to ensure that the Lighting type and Ambience setting combination creates a pleasing result.

Here is how to change the Lighting type:

1. **Set the Mode dial to Portrait, Landscape, Close-up, or Sports shooting mode, and then press the Live View shooting button on the back of the camera.** A live view of the scene appears on the LCD.

 If you don't want to use Live View mode, then skip to Step 2 without pressing the Live View button. The advantage of using Live View is you get an approximation of the Lighting or Scene type effect. The disadvantage is that it will be hard to see the effect on the LCD in bright light.

2. **Press the Q button to display the Quick Control screen, and then press the up or down on the Multi-controller to highlight Default setting.** Be sure the text at the bottom of the screen says Shoot by lighting or scene type.

3. **Press left or right on the Multi-controller to select the Lighting type you want.** You can also select the Lighting type by turning the Quick Control dial. If you're using Live View the preview scene on the LCD changes to reflect the setting you choose. If the color does not appear accurate, choose another lighting type until it does.

4. **In Live View, press the Q button, and then compose, focus, and make the picture.** If you are not using Live View, use the viewfinder to compose, focus, and make the image.

Setting a Custom white balance

Setting a Custom white balance adjusts image color precisely for the light that is in the scene. Custom white balance is the ticket for getting the most accurate color in scenes with a mix of different types of light and in scenes where the light doesn't match any of the preset White Balance settings. You can set a Custom white balance in P, Tv, Av, M, and B shooting modes, and in Movie mode.

The following steps show you how to set a Custom white balance. A word of caution is in order, though. You must complete all these steps to ensure the Custom white balance is used by the camera.

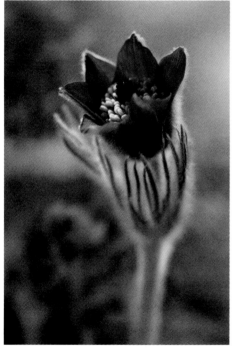

4.6 For this image, I used Auto white balance, but the color was too cool and not visually inviting. Exposure: ISO 100, f/3.4, 1/25 second using a –2/3-stop of Exposure Compensation.

4.7 In this image, I used a Custom white balance, and the color is accurate, reflecting the warmth of the light in the scene. Exposure: ISO 100, f/3.4, 1/25 second using a –2/3-stop of Exposure Compensation.

1. **Set the camera to P, Av, Tv, M, or B, and ensure that the Picture Style is not set to Monochrome and that a Creative Filter isn't applied.**

 Creative Filters are detailed later in this chapter.

2. **In the same light that is used for the subject, position a piece of unlined white paper so that it fills the center of the viewfinder, and take a picture.** If the camera cannot focus, switch the lens to Manual Focus (MF) and focus on the paper, if your lens has a MF switch. Also ensure that the exposure is neither underexposed nor overexposed, such as by having Exposure Compensation set.

3. **On the Shooting 2 menu tab press up or down on the Multi-controller to highlight Custom White Balance, and then press the SET button.** The camera displays the last image captured (the white piece of paper) with a Custom white balance icon in the upper-left corner of the display. If the image of the white paper is not displayed, turn the Quick Control dial until it is.

4. **Press the SET button again.** The 60D displays a confirmation screen asking if you want to use the white balance data from this image for the Custom white balance.

5. **Turn the Quick Control dial to choose OK, and then press the SET button.** A second screen appears, reminding you to set the white balance to Custom.

6. **Press the SET button one last time, and then press the shutter button to dismiss the menu.** The camera imports the white balance data from the selected image and returns to the Shooting 2 menu.

7. **Press the Q button, press the Multi-controller to select White Balance setting, and then turn the Quick Control dial until the Custom white balance icon is displayed.** The Custom white balance icon is denoted by two triangles on their sides with a black square between them. The Custom white balance remains in effect until you change it by or switching to a Basic Zone shooting mode.

 If you cannot use the Quick Control dial, press the Unlock button under the dial first.

When you finish shooting in the light for which you set the Custom white balance, be sure to reset the White Balance option.

Setting a specific color temperature

Anytime you know the color temperature of the light in the scene, you can set that temperature using the K White Balance option. For example, I know that the

temperature of my studio lights is 5300K, and so I use the K White Balance setting to set this temperature. I can continue shooting without further adjustments to the white balance because the light temperature remains constant. You can set the specific color temperature in the range of 2500K to 10,000K in 100K increments.

Here is how to set a specific color temperature for the K White Balance setting:

1. **With the camera set to P, Tv, Av, M, or B, press the Q button, and then press the Multi-controller to highlight White Balance.**

2. **Press the SET button.** The White Balance screen appears.

3. **Turn the Quick Control dial to highlight the K option.** If you have previously changed the temperature for the K White Balance setting, the screen reflects the last used temperature.

4. **Turn the Main dial to the left to decrease the color temperature number or to the right to increase it, and then press the SET button.** The Quick Control screen appears, with the white balance K displayed.

If you use a color temperature meter, you may need to do some testing to adjust readings to compensate for differences between the camera's temperature settings and the meter's reading.

Fine-tuning white balance

With the range of different types of lights both for household and commercial use, it is difficult to get accurate color. And even in images where the color is accurate, you may want a warmer or cooler rendering than a preset White Balance option provides. To compensate for differences in specific light temperatures and to fine-tune a preset White Balance setting, you can use one of two options: White Balance Auto Bracketing or White Balance Correction. You can adjust White Balance in P, Tv, Av, M, Bulb, and C shooting modes.

Both the bracketing and correction options enable you to bias image color in much the same way that a color-correction filter does when you are shooting film.

Using White Balance Auto Bracketing

White Balance Auto Bracketing, displayed on the camera as BKT, biases the color toward magenta/green or blue/amber. White Balance Auto Bracketing works much like exposure bracketing does: You take a set of three images that vary the color toward a blue/amber or magenta/green bias at +3 levels in one-step increments.

4.8 This and the next two images were shot outdoors in late afternoon sunlight. I used the Daylight White Balance setting and set White Balance Auto Bracketing at a +3 level. This is a standard white balance image with no color bias. Exposure: ISO 1200, f/4.5, 1/3200 second using a –1/3-stop of Exposure Compensation.

4.9 This is the image with a +3 blue bias that cools the color. The changes in White Balance Auto Bracketing are reasonably subtle, and with the commercial printing of this book, you may not be able to detect significant differences.

As you would expect, White Balance Auto Bracketing reduces the camera's maximum burst rate by one-third. You can combine exposure bracketing with White Balance Auto Bracketing. If you do this, a total of nine images are recorded for each shot. This is a way to not only fill up a memory card quickly, but also to slow down shooting to a crawl. However, in scenes that you can't re-create and where image color is critical, both exposure and White Balance Auto Bracketing can be good insurance.

 White Balance Auto Bracketing and White Balance Correction involve similar steps. See the steps in the next section to set White Balance Auto Bracketing.

Using White Balance Correction

White Balance Correction sets a single and specific color bias rather than bracketing in multiple directions as White Balance Auto Bracketing does. This is the technique to

use when you know the shift and the amount that is needed to get the image color you want. White Balance Correction is similar to using color-compensation and color-correction filters with film, with the advantage that you don't need to buy and carry multiple filters.

You can correct color in any of four directions: blue, green, amber, and magenta. Each level of color shift is equivalent of 5 mireds of a color temperature conversion filter. A *mired* is a unit of measure that indicates the density of a color temperature conversion filter.

To set either White Balance Auto Bracketing or White Balance Correction, follow these steps:

4.10 This is the image with a +3 amber bias that adds more warmth to the color.

1. **On the Shooting 2 tab, highlight WB SHIFT/BKT, and then press the SET button.** The WB correction/WB bracketing screen appears.

2. **To set White Balance Correction, press the Multi-controller to set the bias you want.** As you press the Multi-controller, a tick mark indicates the direction and amount of correction. The bracketing amount is also displayed under the Shift display.

 To set White Balance Auto Bracketing, turn the Quick Control dial in the direction of the shift you want. As you turn the dial, the tick mark changes to three tick marks indicating the amount of bracketing. The direction and amount of bracketing is displayed in the Bracket section. You can also press up, down, left, or right on the Multi-controller to bias the bracketing toward Green, Blue, Magenta, or Amber.

3. **Press the SET button.** If you change your mind and want to start over, press the INFO. button. Bracketed images are taken with the Standard white balance first, followed by the blue (or magenta) bias, and then the amber (or green) bias.

Working with Picture Styles

Picture Styles are digital versions of the different "looks" just as various films provide different looks. For example, some portrait film is characterized by its subdued color and contrast while other film is known for producing saturated blues and greens and snappy contrast. As films offer various characteristics, Picture Styles produce unique looks. You can set Picture Styles in P, Tv, Av, M, and Bulb shooting modes.

> **TIP** If you shoot RAW capture, you can't print images directly from the SD/SDHC card, but you can apply Picture Styles either in the camera using in-camera RAW conversion or during RAW image conversion on the computer using the Canon Digital Photo Professional conversion program.

Behind each Picture Style are parameters that set the tonal curve, color rendering and saturation, and sharpness for the images that you shoot with the 60D. The default Picture Style is Standard, and it is characterized by snappy contrast, vivid colors, and moderate-to-high saturation. Picture Styles are described in Table 4.1. Default settings are listed in order of sharpness, contrast, color saturation, and color tone.

Table 4.1 EOS 60D Picture Styles

Picture Style	Description	Contrast	Color saturation	Default settings
Standard	Vivid, sharp, crisp.	Higher contrast	Medium-high saturation.	3, 0, 0, 0
Portrait	Enhanced skin tones, soft texture rendering, low sharpness.	Higher contrast	Medium saturation, rosy skin tones.	2, 0, 0, 0
Landscape	Vivid blues and greens, high sharpness.	Higher contrast	High saturation for greens/blues.	4, 0, 0, 0
Neutral	Allows latitude for conversion and processing with low saturation and contrast.	Subdued contrast	Low saturation, neutral color rendering.	0, 0, 0, 0
Faithful	True rendition of colors with no increase in specific colors. No sharpness applied.	Subdued contrast	Low saturation, calorimetrically accurate.	0, 0, 0, 0
Monochrome	Black-and-white or toned images with slightly heightened sharpness.	High contrast	Yellow, Orange, Red, and Green Filter effects are available. Sepia, Blue, Purple, and Green Toning effects are also available.	3, 0, NA, NA

In the Monochrome Picture Style, only the sharpness and contrast parameters are adjustable, but you can add toning effects, as detailed in the sidebar. In Basic Zone shooting modes, the 60D automatically selects the Picture Style, which you cannot change. However, in these modes, you can apply Ambience selections to change the appearance of the image.

Using Monochrome Filter and Toning Effects

You can customize the Monochrome Picture Style, but you can only change the Sharpness and Contrast parameters. However, you can also apply a variety of Filter and Toning effects:

▶ **Monochrome Filter effects.** Filter effects mimic the same types of color filters that photographers use when shooting black-and-white film. The Yellow filter makes skies look natural with clear white clouds. The Orange filter darkens the sky and adds brilliance to sunsets. The Red filter further darkens a blue sky and makes tree leaves look crisp and bright and renders skin tones realistically. The Green filter brightens foliage in the scene.

▶ **Monochrome Toning effects.** You can choose to apply a creative toning effect when shooting with the Monochrome Picture Style. The Toning effect options are None, Sepia (S), Blue (B), Purple (P), and Green (G).

To apply a Filter or Toning effect, follow these steps:

1. **On the Shooting 2 menu tab, highlight Picture Style, and then press the SET button.** The Picture Style screen appears.

2. **Press up or down on the Multi-controller to select Monochrome, and then press the INFO. button.** The Detail set. screen appears.

3. **Press down on the Multi-controller to select Filter effect or Toning effect.**

4. **Press the SET button.** The camera displays options that you can choose.

5. **Turn the Quick Control dial to highlight the option you want and then press the SET button.** The effect is applied until you change it.

You can convert RAW images captured in Monochrome to color using the software bundled with the camera. However, in JPEG capture, you cannot convert Monochrome images to color.

Whether you modify an existing style or create one of your own, the 60D provides good latitude in setting parameters with seven adjustment levels for sharpness, and eight levels of adjustments for contrast, saturation, and color tone. Picture Styles are designed to produce classic looks that need little or no post-processing so that you can print JPEG images directly from the SD/SDHC card. If you shoot RAW capture, you can't print images directly from the SD/SDHC card, but you can apply Picture Styles either in the camera or during conversion using the Canon Digital Photo Professional conversion program. You can alternatively choose to convert RAW images in the camera, and then you can print the resulting JPEG directly from the camera.

You can also use the Picture Style Editor to modify and save changes to Picture Styles for captured images. The Picture Style Editor is included on the Canon EOS Digital Solution Disk that comes with the camera, and it is described later in this chapter.

Choosing and customizing Picture Styles

To get the color, contrast, and saturation results you want out of the camera, you can customize Picture Styles to suit your creative vision. And if one of the preset Picture Styles isn't quite to your liking, you can change the settings or parameters to modify it. You can choose Picture Styles when you're shooting in P, Tv, Av, M, and B shooting modes.

Figures 4.11 through 4.16 show the results you can expect using several different Picture Styles as compared to the Standard Picture Style. Here are the parameters that you can change for each Picture Style.

▶ **Sharpness:** 0 to 7. Level 0 (zero) applies no sharpening and renders a very soft look (due largely to the anti-aliasing filter in front of the image sensor that helps ward off various problems, including moiré, spectral highlights, and chromatic aberrations).

At high sharpness levels, images are suitable for direct printing from the memory card. However, if you edit images on the computer before printing, then use a low level and sharpen images in an image-editing program.

▶ **Contrast:** –4 to +4. The Contrast parameter represents the image's tonal curve. If the setting is too high, image pixels can be clipped (clipping discards highlight and/or shadow pixels). A negative adjustment produces a flatter look but helps to prevent clipping.

▶ **Saturation:** –4 to +4. This setting affects the strength or intensity of the color with a negative setting, producing low saturation, and vice versa. As with the Contrast parameter, a high Saturation setting can cause individual color channels to clip. A +1 or +2 setting is adequate for snappy JPEG images destined for direct printing.

4.11 This image was taken using the Standard Picture Style. Exposure: ISO 400, f/5.6, 1/60 second.

For images that you edit on the computer, a 0 (zero) setting allows ample latitude for post-capture edits.

▶ **Color Tone:** –4 to +4. This setting modifies the hue of the image. Negative settings produce tones that are more red and more blue, while positive settings produce tones that are more yellow.

4.12 This image is shown using the Portrait Picture Style. The Portrait Style delivers subdued and soft skin tones with lower contrast than the Standard style. Exposure: ISO 200, f/2.8, 1/200 second.

4.13 This image is shown using the Neutral Picture Style. This style has reduced contrast and color saturation. Exposure: ISO 400, f/18, 1/160 second.

4.14 This image is shown using the Standard Picture Style. If you print images straight from the SD card, this Picture Style produces a nice print with rich color and saturation and snappy contrast. Exposure: ISO 400, f/18, 1/160 second.

4.15 This image is shown using the Landscape Picture Style, which provides saturated greens and blues and high contrast. Exposure: ISO 400, f/18, 1/160 second.

To select a Picture Style, follow these steps.

1. **With the Mode dial set to P, Tv, Av, M, or B, press the Q button.** The Quick Control screen appears.

2. **Press the Multi-controller to highlight the Picture Style icon, and then turn the Main dial to select the style you want.** The Picture Style icon has a circular icon with the first letter of the Picture Style next to it, such an S for Standard. The Picture Style remains in effect until you change it or switch to an automatic shooting mode such as Portrait or Landscape.

After evaluating and printing with different Picture Styles, you may want to adjust the default parameters to get a rendition that is more pleasing to your eye. You can also create up to three custom Picture Styles based on an existing style.

4.16 This image was taken using the Faithful Picture Style, which works well with studio lights that are color balanced to 5200K. Exposure: ISO 100, f/20, 1/125 second.

For most of my photography, I use a modified Neutral Picture Style. I use this modified style for a couple of reasons: First, I always edit images on the computer and this style gives me latitude in interpreting the color tone and saturation of images; and, second, for portraits, the modified Neutral Picture Style creates subdued, lovely skin tones with pleasing contrast that I can adjust as necessary.

4.17 This image was taken with my modified Neutral Picture Style. This modified style gives me latitude in interpreting color tone and saturation and creates subdued, lovely skin tones in portraits. Exposure: ISO 400, f/5, 1/125 second.

Here is how I set the modified Neutral Picture Style for my work. These settings work best when the lighting isn't flat and the image isn't underexposed. The settings are Sharpness +2, Contrast +1, Saturation +1, and Color tone 0.

To modify a Picture Style, follow these steps:

1. **With the Mode dial set to P, Tv, Av, M, or B, highlight Picture Style on the Shooting 2 menu.**

2. **Press the SET button.** The Picture Style screen appears.

3. **Press the Multi-controller to select the Picture Style you want to modify, and then press the INFO. button.** The Detail set. screen for the selected style appears.

4. **Press down on the Multi-controller to select the parameter you want to adjust, and then press the SET button.** The camera activates the control.

5. **Press the Multi-controller to the left or right to change the parameter setting, and then press the SET button.** Negative settings decrease sharpness, contrast, and saturation, and positive settings provide higher sharpness, contrast, and saturation. Negative color tone settings provide reddish skin tones, and positive settings provide yellowish skin tones.

6. **Turn the Quick Control dial to select the next parameter, and then press the SET button.**

7. **Repeat Steps 5 and 6 to change additional parameters.**

8. **Press the Menu button.** The modifications are saved and remain in effect until you change them. The Picture Style selection screen appears.

Registering a new Picture Style

If you want a greater range of Picture Styles for your work on the 60D, you can create three User-Defined styles. Each style is based on one of the Canon Picture Styles, and you can modify the style to suit your preferences. With this approach, you can retain the preset Picture Styles, either unchanged or modified, and you can have three additional modified (or User-Defined) styles to extend your style choices.

You can take several approaches to create new styles. Depending on your needs, you can use the preset and User-Defined Picture Styles in several ways. You can use each of the three User-Defined styles for specific scenes or places in which you shoot often.

For example, you can set up one style for nature and landscape shooting (a modification of the Landscape or Standard style), one for studio portraits (a modification of the Portrait style), and one for a sports arena (a modification of the Standard style). Or you can use the User-Defined style for a style that you create using the Canon Picture Style Editor, a program included on the EOS Digital Solution Disk that comes with the camera. This technique is described in the next section of this chapter.

Here's how to create and register a User-Defined Picture Style:

1. **With the Mode dial set to P, Tv, Av, M, or B, highlight Picture Style in the Shooting 2 menu.**

2. **Press the SET button.** The Picture Style screen appears.

3. **Press down on the Multi-controller to select User Def. 1, and then press the INFO. button.** The Detail Set screen for the selected style appears.

4. **Press the SET button.** The camera activates the base Picture Style control.

5. **Press up or down on the Multi-controller to select a base Picture Style, and then press the SET button.** You can select any of the preset Picture Styles, such as Standard, Portrait, and so on, as the base style.

6. **Press up or down on the Multi-controller to select a parameter, such as Sharpness, and then press the SET button.** The camera activates the parameter's control.

7. **Press left or right on the Multi-controller to set the level of change, and then press the SET button.**

8. **Repeat Steps 6 and 7 to change the remaining parameters.** The remaining parameters are Contrast, Saturation, and Color tone.

9. **Press the Menu button to register the style.** The Picture Style selection screen appears. The base Picture style is displayed to the right of User Def. 1. This Picture Style remains in effect until you change it.

You can repeat these steps to set up User Def. 2 and 3 styles.

Using the Picture Style Editor

Choosing and modifying Picture Styles requires a good deal of experimentation to determine the modifications you like best. A more efficient way to fine-tune Picture Styles is by using the Picture Style Editor, a program included on the EOS Digital Solution Disk.

Canon offers a more efficient approach to fine-tuning Picture Styles: the Picture Style Editor. This program enables you to apply a Picture Style to a RAW image, and then modify the style on the computer, where you can watch the effects of the changes. Once you have perfected your modified style, you can install it in the 60D.

Because the goal of working with the Picture Style Editor is to create a Picture Style file that you can register and use in the camera, the adjustments that you make to the RAW image are not applied to the image. Rather, the adjustments are saved as a file with .pf2 extension, and then you use the EOS Utility to register the file in the camera and apply it to images. You can also apply the style in Digital Photo Professional after saving the settings as a PF2 file. Additionally, if you use more than one Canon EOS dSLR, you can register the style and use it on all your cameras. Instructions for using the Picture Style Editor are included on the EOS Solutions disk that comes with the camera. In addition to creating your own styles, you can download additional Picture Styles from the Canon Web site at web.canon.jp/imaging/picturestyle/index.html.

Adding Ambience and Creative Filter Effects

With the 60D, you have new options to apply in-camera image processing for creative color and image effects. The Ambience options are available in select automatic shooting modes. But if you want to add a Creative Filter, you can do so in any of the shooting modes, including Movie mode. And Creative Filters can be applied to RAW images, except M-RAW and S-RAW images. Then the RAW images are processed in the camera and saved as a JPEG file.

Used separately or together, these color and image effect options give you opportunities for printing creatively rendered and finished images straight from the SD card.

Using Ambience options

Ambience settings are somewhat like Picture Styles, but with a much more pronounced effect. You can apply Ambience settings only when you're shooting in CA, Portrait, Landscape, Close-up, Sports, or Night Portrait modes. Once you choose an Ambience option, you can apply it at a Low, Standard, or Strong setting.

Here are the Ambience options you can select:

▶ **Standard.** The default setting has punchy contrast and color.

▶ **Vivid.** At the Standard level, this setting punches up the colors and sharpness.

▶ **Soft.** This option decreases color saturation and intensity as well as overall contrast. This is a good choice for portraits of women and children.

▶ **Warm.** This setting adds a noticeable shift to more prominent yellows and reds.

▶ **Intense.** Just as the name implies, this setting makes saturation and contrast pronounced and the colors slightly cooler (more bluish) as compared with colors produced by Standard. This is not the option to use if you want to show good detail in the shadows.

▶ **Cool.** This option delivers extremely blue skies and a cool (bluish) tint in foliage. The contrast and color saturation are both higher than in the Standard setting.

▶ **Brighter.** This setting lightens the image overall, including opening up shadow detail. It is a reasonable option for a scene or subject with predominately light tones; in other words, a high-key scene or subject.

▶ **Darker.** This setting creates a darker image with snappy contrast.

▶ **Monochrome.** This option offers a blue, sepia, and black-and-white option. The black-and-white option delivers bright whites and deep blacks with moderate overall contrast.

If you check the exposure settings for Ambience effects, you can see how the effect is achieved in most cases. I include the exposure that the camera automatically set for Figures 18 through 26. In other Ambience effects, the 60D increases or decreases the saturation and contrast, just as can be done when using Picture Styles. A word of warning is in order. Some styles such as Brighter can cause blown highlights, so use them with care.

4.18 This image was taken using the Standard setting. Automatic Exposure: ISO 100, f/4, 1/80 second.

4.19 This image was taken using the Vivid setting. Automatic Exposure: ISO 100, f/4, 1/80 second.

4.20 This image was taken using the Soft setting. Automatic Exposure: ISO 160, f/4, 1/80 second with +2/3-stop of Exposure Compensation.

4.21 This image was taken using the Warm setting. Automatic Exposure: ISO 160, f/4, 1/80 second with +2/3-stop of Exposure Compensation.

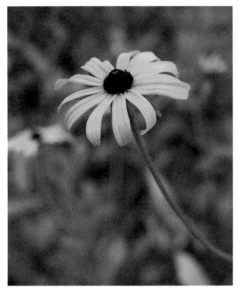

4.22 This image was taken using the Intense setting. Automatic Exposure: ISO 100, f/4, 1/125 second with –2/3-stop of Exposure Compensation.

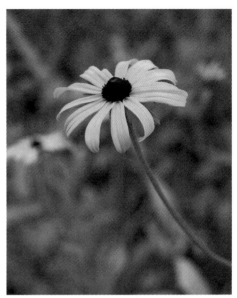

4.23 This image was taken using the Cool setting. Automatic Exposure: ISO 100, f/4, 1/125 second with –2/3-stop of Exposure Compensation.

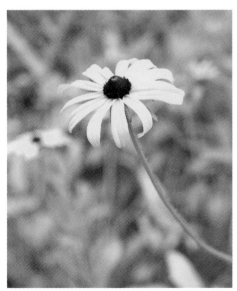

4.24 This image was taken using the Brighter setting. Automatic Exposure: ISO 160, f/4, 1/60 second with +2/3-stop of Exposure Compensation.

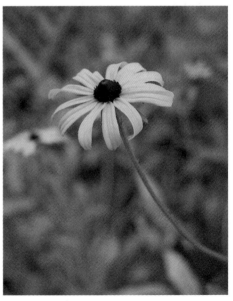

4.25 This image was taken using the Darker setting. Automatic Exposure: ISO 100, f/4, 1/100 second with –2/3-stop of Exposure Compensation.

To apply an Ambience setting, follow these steps.

1. **Set the Mode dial to CA, Portrait, Landscape, Close-up, Sports, or Night Portrait shooting mode, and then press the Live View shooting button on the back of the camera.** A live view of the scene appears on the LCD.

 If you don't want to use Live View mode to set the Ambience, then skip to Step 2 without pressing the Live View button. The advantage of using Live View is that you get an approximation of the Ambience effect. The disadvantage of using Live View is that it will be hard to see the effect on the LCD in bright light.

4.26 This image was taken using the Monochrome setting. Automatic Exposure: ISO 160, f/4, 1/60 second.

2. **Press the Q button to display the Quick Control screen, and then press up or down on the Multi-controller to highlight Standard setting.** The text Shoot by ambience selection appears at the bottom of the LCD screen.

3. **Press left or right on the Multi-controller to select the Ambience option you want.** The preview scene on the LCD changes to approximate the look of adding the Ambience effect.

4. **Press down on the Multi-controller to select Effect level, and then press left or right to set the strength: Low, Standard, or Strong.** The text at the bottom of the LCD shows the current selection.

5. **Compose, focus, and make the image.**

Applying Creative Filters

To add some fun and creative punch to your images, the 60D offers four filters: Grainy B/W (Black and White), Soft focus, Toy camera effect, and Miniature effect. The filters are applied after image capture, and then saved as a new file, leaving the original image unchanged. Because the filters are applied in the camera, you can print a finished file directly from the media card.

There are a few restrictions when applying Creative Filters. You can apply them to JPEG and full-resolution RAW images shot in all shooting modes, but you can't apply them to the smaller M-RAW and S-RAW images. If you shoot RAW+JPEG images, the filter is applied to the RAW image, and then it's converted to and it will be saved as a JPEG file. If you shoot M- or S-RAW+JPEG, the filter is applied to the JPEG image.

Here are the Creative Filters you can select:

▶ **Grainy B/W.** This filter creates a classic high-grain look of older black-and-white images. You can adjust the contrast.

▶ **Soft focus.** This filter adds a soft blur, and you can adjust the amount or strength of the blur.

▶ **Toy camera effect.** This filter replicates the popular Holga- and Diana-camera look that includes a color shift and *vignetting*, a darkening of the image corners. You can adjust the color tone and colorcast.

▶ **Miniature effect.** This filter mimics the effect of a diorama, a sort of miniature, three-dimensional visual illusion introduced in 1821 by Louis Jacques Mandé Daguerre. You can press the INFO. button to change the orientation of the white frame that indicates which area of the image will be sharp.

To apply a Creative Filter, follow these steps:

1. **On the Playback 1 menu tab, highlight Creative filters, and then press the SET button.** The last captured image appears. To move to a different image, press left or right on the Multi-controller. If you have many images on the card, press the Index button on the back right of the camera to display multiple images on the screen, which you can scroll through using the Multi-controller or Quick Control dial.

2. **Select the image you want, and then press the SET button.** The Creative Filter options are displayed at the bottom of the image preview.

3. **Press left or right on the Multi-controller to select the filter, and then press the SET button.** The filter is applied to the image and the level of the effect is displayed.

4. **Press left or right on the Multi-controller to adjust the effect, and then press the SET button.** The camera displays the option to save the image as a new file.

 With the Miniature effect, you can move the frame between horizontal and vertical orientation by pressing the INFO. button. And you can press up, down, left, or right on the Multi-controller to move the frame to the area of the image that will appear sharp. Then press the SET button.

5. **Select OK to save the image as a new JPEG.** The image is saved and the camera displays a message noting the folder and image number for the new image file.

6. **Press the SET button to confirm the message.**

4.27 This image has the Grainy B/W filter applied.

4.28 This image has the Miniature effect filter applied.

4.29 This image has the Toy camera effect filter applied.

4.30 This image has the Soft focus filter applied.

Customizing the 60D

One of the best ways to increase your shooting efficiency and enjoyment with the EOS 60D is to customize it for your everyday shooting as well as for specific shooting situations. The 60D offers three major categories of customization:

▶ **Custom Functions.** These enable you to change camera controls and behavior as well as to set up the camera for both general and venue-specific shooting situations.

▶ **Camera User Settings (C) mode.** This mode enables you to set up virtually everything on the camera and then save all the settings as C shooting mode.

▶ **My Menu.** This is a menu tab where you can place your six most frequently used menu items for quick access.

All three features will save you time and offer shooting advantages that are well worth the time it takes to make the adjustments.

Custom Functions, including Long exposure noise reduction and Mirror lockup, came in handy when I made this image of a shooting star and star trails. Exposure: ISO 100, f/5.6, 20 minutes.

Exploring Custom Functions

The major advantage of Custom Functions is that you can set up many of the camera controls and operations to suit your shooting style and to get better image quality in specific situations. As a result, they save you time, provide better image quality in some cases, and make shooting more enjoyable.

Before you begin, you should know that Custom Functions can be set only in Program AE (P), Shutter-priority AE (Tv), Aperture-priority AE (Av), Manual (M), and Bulb (B) shooting modes. Also, after you set a Custom Function option, it remains in effect until you change it.

 Canon refers to Custom Functions using the abbreviation C.Fn [group Roman numeral]-[function number]; for example, C.Fn II-3.

The 60D offers 20 Custom Functions. Some Custom Functions have a broad range of uses, and others are useful for specific shooting specialties or scenes.

Custom Function groupings

This section includes a description of each Custom Function and the options that you can set. I provide instances where the C.Fn would be useful in general, but also consider how you could use them to simplify or customize your specific shooting situations.

I encourage you to use Custom Functions to the fullest extent. I think that you will be pleasantly surprised by how much more you will enjoy the 60D after you customize it for your shooting needs.

 If you set Custom Functions and later want to return to the camera defaults, you can do that easily by using the Clear all Custom Func. (C.Fn) option on the Custom Functions camera menu.

C.Fn I: Exposure

The Exposure Custom Functions are described here followed by the options that you can choose for each function.

C.Fn I-1: Exposure-level increments

With this function, you can set the increment that is used for shutter speed, aperture, Exposure Compensation, and Auto Exposure Bracketing (AEB) changes. The exposure

increment you choose is displayed in the viewfinder and on the LCD as tick marks at the bottom of the Exposure level indicator.

▶ **Option 0: 1/3 stop.** By default, the 60D uses 1/3 stop as the exposure-level increment for changes in shutter speed, aperture, Exposure Compensation, and AEB.

▶ **Option 1: 1/2 stop.** This option sets 1/2 stop as the exposure-level increment for shutter speed, aperture, Exposure Compensation, and AEB changes. It gives you a larger exposure change and is useful when you bracket images for later compositing in an image-editing program, and any time you know that you need a larger exposure difference than the 1/3-stop offers, such as when you use positive Exposure Compensation for snow scenes. When you choose this option, the Exposure level indicator in the viewfinder and on the LCD shows a double tick mark instead of a single tick mark. This is a handy reminder that you're making 1/2-stop changes rather than 1/3-stop changes.

C.Fn I-2: ISO speed setting increments

With this function, you can set the increment level that is used when you change the ISO sensitivity setting.

▶ **Option 0: 1/3 stop.** This is the default increment. With this option set, the ISO speeds are Auto, 100, 125, 160, 200, 250, 320, 400, 500, 640, 800, 1000, 1250, 1600, 2000, 2500, and 3200, 4000, 5000, 6400, as well as H (12800) when C.Fn I-3 is set to On.

▶ **Option 1: 1 stop.** This option sets 1 f-stop as the ISO adjustment-level increment. With this option set, the ISO speeds are the traditional settings of Auto, 100, 200, 400, 800, 1600, 3200, 6400 as well as H (12800) when C.Fn I-3 is set to On.

C.Fn I-3: ISO expansion

With this function, you can choose the additional ISO sensitivity setting of H, which is equivalent to ISO 12800. To determine if you want to use this very high ISO setting, be sure to shoot test shots, and then examine the images and the prints to ensure that you get prints with acceptable noise levels at the size you most often use to make prints. And even then, to always get the highest image quality in terms of color, fine detail, and smooth tones, I recommend shooting at the lowest-possible ISO setting given light, lens, and other factors.

▶ **Option 0: Off.** At this default setting, you cannot select the expanded ISO setting of H (12800).

▶ **Option 1: On.** With this option, you can select the expanded ISO setting of H (12800). Just select H in the same way that you select other ISO settings. You can't choose ISO 12800 if you have C.Fn II-3, Highlight Tone Priority turned on.

C.Fn I-4: Bracketing auto cancel

With this function, you can choose to retain AEB and White Balance Bracketing (WB-BKT) settings even after you turn off the camera. Very often, AEB and WB-BKT are specific to a scene, and, therefore, they are not settings that you want to retain. It is also easy to forget that you have set bracketing, and you end up shooting with the bracketing inadvertently set. Unless you often shoot with AEB and WB-BKT, I recommend using the default Option 0.

▶ **Option 0: On.** Both AEB and WB-BKT are cancelled when you turn the camera power switch to Off, when the flash is ready to fire, if you clear camera settings, and if you switch to Movie shooting mode.

▶ **Option 1: Off.** Choosing this option retains AEB and WB-BKT settings. When the flash is ready, bracketing is temporarily cancelled, but the camera remembers the AEB amount and restores it after you finish using the flash.

C.Fn I-5: Bracketing sequence

Use this function when you want to change the sequence of images when you use AEB and WB-BKT. For exposure bracketing, I find that the Option 1 sequence makes it easier to identify which image is which in a series of bracketed images after I download them to the computer.

▶ **Option 0:** 0 (Standard exposure or standard white balance), – (Decreased exposure, or less blue, or less magenta white-balance bias), + (Increased exposure, or more amber, and more green white-balance bias).

▶ **Option 1:** – (Decreased exposure, or less blue, or less magenta white-balance bias), 0 (Standard exposure or standard white-balance), + (Increased exposure, or more amber, and more green white-balance bias).

C.Fn I-6: Safety shift

If you enable this function, the camera automatically shifts the aperture or shutter speed in both Shutter-priority AE (Tv) and Aperture-priority AE (Av) shooting modes if there is a shift in lighting that would cause an improper exposure at the current settings.

Although photographers are watchful of lighting changes, this function can be very helpful in stage and theater lighting venues where overhead spotlights can dramatically shift as speakers or actors move around the stage, in and out of spot-lit areas and in changeable outdoor lighting such as at a sports event.

▶ **Option 0: Disable.** This option maintains the aperture (Av shooting mode), or shutter speed (Tv shooting mode) you have set regardless of lighting changes.

▶ **Option 1: Enable (Tv/Av).** The shutter speed or aperture automatically shifts if the subject brightness suddenly changes so that the camera's standard exposure is used.

C.Fn I-7: Flash sync. speed in Av mode

This function provides options for setting the flash sync speed from the default setting of 1/250 second to 30 seconds, to either 1/250 second to 1/60 second, or to 1/250 second when you're shooting in Av mode. With these options, you can control whether the flash light balances with existing light or provides the primary illumination for the scene. And Option 2 ensures a fast-enough shutter speed to handhold the camera and prevent blur from camera shake.

▶ **Option 0: Auto.** This option automatically sets the sync speed for the built-in flash and an external Speedlite between 1/250 second and 30 seconds. This option uses both existing light and the flash to illuminate the scene for natural-looking images in many scenes. The downside is that at the slower speeds, you may cause blur if you handhold the camera.

▶ **Option 1: 1/250-1/60 sec. auto.** This provides a fast-enough sync speed to handhold the camera and get a sharp image depending on the lens you're using. This option also balances the flash with existing light, but at faster sync speeds, the background will be dark.

▶ **Option 2: 1/250 sec. (fixed).** Option 2 automatically sets the fastest flash sync speed of 1/250 second in Av mode. With this option, the flash provides the primary subject lighting. As a result, the background is very dark. But, with this option, you are assured of having a fast-enough shutter speed to handhold the camera.

C.Fn II: Image

This group of functions enables you to set noise reduction for long exposures and high ISO sensitivity settings. And you can choose to use Highlight Tone Priority as well.

C.Fn II-1: Long-exposure noise reduction

This function offers options to turn noise reduction on or off, or to set it to Auto for long exposures. With noise reduction turned on, the reduction process takes the same amount of time as the original exposure. In other words, if the original image exposure is 1.5 seconds, then noise reduction takes an additional 1.5 seconds. This means that you cannot take another picture until the noise reduction process finishes. Normally, this isn't a problem, but if you're shooting star trails at 15, 20, or 60 minutes, the noise reduction process will take an equal amount of time to finish.

For everyday shooting, I keep the 60D set to Option 1 to automatically perform noise reduction if it is detected in long exposures. I consider this to be good insurance in counteracting digital noise in longer exposures.

▶ **Option 0: Off.** No additional noise reduction beyond what the camera normally applies is performed.

▶ **Option 1: Auto.** The 60D applies noise reduction when it detects noise in exposure of 1-second or longer.

▶ **Option 2: On.** The camera performs noise reduction on all exposures of 1 second or longer. Obviously, the duration for noise reduction reduces the continuous shooting burst rate dramatically. But this is a good option for night scenes and low-light still-life subjects. If you're shooting low-light portraits or interiors, this option slows down shooting too much to be a practical option. Canon notes that this option may not be effective with ISO settings of 1600 and higher, so be sure to test before choosing this option if you often shoot at high ISO settings.

> **NOTE** If you use Live View and you have Option 2 set, then the current view on the LCD is suspended during the time that the camera performs the noise reduction and the message "BUSY" appears on the LCD.

C.Fn II-2: High ISO speed noise reduction

With this function, you can choose to apply more aggressive noise reduction to shadow areas in particular when you shoot at high ISO sensitivity settings. (The camera applies some noise reduction to all images.) If you turn this option on, noise in low-ISO images is further reduced.

Because Canon has an effective noise-reduction algorithm, using this Custom Function is a good idea, and reducing shadow noise is advantageous. However, it pays to check your images to ensure that the blurring of fine image detail resulting from noise reduction is not too heavy handed. Also plan ahead so that you have the best option for this Custom Function set before you start shooting at high ISO sensitivity settings.

▶ **Option 0: Standard.** This is the default setting that applies some color (*chroma*) and luminance noise reduction to images shot at all ISO sensitivity settings. If you seldom use high ISO settings, this is a good option to choose.

▶ **Option 1: Low.** Because the camera performs noise reduction on all images, not just high ISO images, you may not see much difference between this option and Option 0: Standard.

▶ **Option 2: Strong.** More aggressive noise reduction is applied, and a loss of fine detail may be noticeable. In addition, the burst rate (the number of images you can shoot by continuing to press the shutter button) in Continuous drive mode is significantly reduced.

▶ **Option 3: Disable.** No noise reduction is applied. If you prefer to use your favorite noise reduction program during image editing, this may be a good option to choose.

C.Fn II-3: Highlight Tone Priority

Highlight Tone Priority helps ensure good detail in bright areas such as those on a bride's gown. With the function turned on, the high range of the camera's dynamic range (the range measured in f-stops between deep shadows and highlights in a scene) is extended from 18 percent gray (middle gray) to the brightest highlights. Simply stated, it means that highlight detail blows out less often because the camera's highlight range is extended.

Further, the gradation from middle gray tones to highlights is smoother with this option turned on. The downside of enabling this option is increased digital noise in shadow areas.

But if you are shooting weddings or any other scene where it is critical to retain highlight detail, the tradeoff is worthwhile. If noise in the shadow areas is objectionable, you can apply noise reduction in an editing program.

However, if you turn on Highlight Tone Priority, the default ISO speed range is reduced to 200–6400, which means you lose the ISO 100 and H (12,800) settings. The ISO display in the viewfinder, on the LCD panel, and in the Shooting information display adds a D+ to indicate that this option is in effect.

▶ **Option 0: Disable.** This is the default setting.

▶ **Option 1: Enable.** This option turns on Highlight Tone Priority, improving the detail in bright highlights and in gradation of detail from middle gray to the brightest highlights. The lowest ISO setting available is 200 and the highest is 6400. Auto Lighting Optimizer is also turned off automatically.

C.Fn III: Autofocus/Drive

This group of functions enables you to control the lens and camera autofocusing tasks. This is also where you can enable the use of Mirror lockup.

C.Fn III-1: Lens drive when AF impossible

This is a handy function to use when the lens has difficulty achieving automatic focus. You have likely been in situations where the lens seeks focus by going back and forth and goes far out of focus range. This is common with telephoto and super-telephoto lenses. Setting this function to Option 1 helps stop the lens from seeking focus and going into an extensive defocus range.

- ▶ **Option 0: Continue focus search.** The lens continues to seek focus. If you use this option, then you manually adjust the lens's focusing ring to get the lens into general focus range.

- ▶ **Option 1: Stop focus search.** This stops the lens drive from going into extreme defocus range as it tries again to focus.

C.Fn III-2: AF-point selection method

This function enables you to reset the buttons and controls you use to manually select an AF point. Option 0 is the default method. The second option changes the functionality of two camera controls, and you should study it carefully before choosing it. With Option 1, pressing the AF-point selection button turns on automatic AF-point selection mode, the mode in which the camera chooses the AF points. To manually select an AF point, you press the Multi-controller without needing to first press the AF-point selection button. If you're in the habit of pressing the AF-point selection button first, using Option 1 throws you into automatic AF-point selection mode, and you have to remember to use the Multi-controller to manually select the AF point. I'm not a fan of automatic AF-point selection, so the default behavior works best for me.

- ▶ **Option 0: (AF-point selection button) Activate AF selection/ (Multi-controller) Select an AF point.** This is the standard method of pressing the AF-point selection button to activate the AF points, and then pressing the Multi-controller to choose the AF point you want. Note that this option disables any choices you made in C.Fn IV-2 to assign functionality to the SET button during shooting.

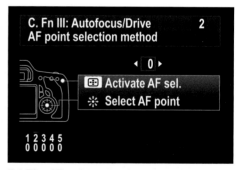

5.1 The AF point selection method screen

- ▶ **Option 1: (AF-point selection button) Auto selection/(Multi-controller) Manual selection.** This option changes the behavior of the AF-point selection button so that pressing it activates automatic AF-point selection mode. To manually

select an AF point, you press the Multi-controller. The advantage of this option is that you skip the step of pressing the AF-point selection button before you manually select an AF point. This option saves time, but if you are accustomed to first pressing the AF-point selection button, and then choosing an AF point, you can inadvertently press the AF-point selection button and be thrown into using automatic AF point selection instead of manual AF point selection.

C.Fn III-3: Superimposed display

If it bothers you to have the AF point flash in red in the viewfinder when the camera achieves focus, you can use this Custom Function to turn it off.

▶ **Option 0: On.** When you half-press the shutter button, the active AF point lights up in red in the viewfinder. This is a helpful reminder of the AF point that will be used for focusing.

▶ **Option 1: Off.** The active AF point does not light in red in the viewfinder when the camera achieves sharp focus. But when you're manually selecting the AF point to use, the AF point lights to make selection easier.

C.Fn III-4: AF-assist beam firing

With this function you control whether the 60D's built-in flash or an accessory EX Speedlite's autofocus assist light is used to help the camera establish focus in low-light scenes. The AF-assist beam fires a quick series of small flashes that are very helpful in speeding up and in ensuring sharp focus.

▶ **Option 0: Enable.** The camera uses the built-in flash or an accessory Canon EX Speedlite's AF-assist beam to establish focus. This beam helps the camera establish focus in low light or when the subject contrast is low. The flash also fires unless you have the flash firing set to Disable on the Shooting 1 camera menu.

▶ **Option 1: Disable.** The AF-assist beam isn't used.

▶ **Option 2: Enable external flash only.** Only the Speedlite's AF-assist beam is used to help establish focus. Obviously this is the option to choose if you're using a Speedlite.

▶ **Option 3: IR AF-assist beam only.** If your Speedlite has an infrared (IR) AF-assist beam, then only that beam is used with this option. The advantage is that the IR beam keeps the built-in flash or another Speedlite from firing the series of small flashes and the AF-assist beam.

C.Fn III-5: Mirror lockup

Option 1 for this function prevents blur that can be caused in macro, telephoto, and long exposure shots by the camera's reflex mirror flipping up at the beginning of an

exposure. Nature and landscape photographers who often use Mirror lockup can make this function more accessible by adding this Custom Function to My Menu. Customizing My Menu is detailed later in this chapter. Option 1 is also handy for manually cleaning the image sensor.

▶ **Option 0: Disable.** This prevents the mirror from being locked up.

▶ **Option 1: Enable.** This option locks up the camera's reflex mirror before the exposure begins. For close-up and telephoto images this prevents mirror reflex vibrations that can cause blur. When this option is enabled, you press the shutter button once to swing up the mirror, and then press it again to make the exposure. In Bulb mode with either Self-timer/Remote drive mode, you have to hold down the shutter button through the timer delay and bulb exposure time. Even if the drive mode is set to Continuous, the camera automatically uses Single shooting drive mode. Also the mirror remains locked up for 30 seconds, and then flips down unless you take the picture. It's best to use Remote Switch RS-60E3 with Mirror lockup.

When you use Mirror lockup with bright subjects such as snow, bright sand, and so on, be sure to take the picture right away to prevent the camera curtains from being scorched by the bright light. Do not point the camera toward the sun when the mirror is flipped up to avoid scorching the camera shutter curtains.

C.Fn IV: Operation/Others

This group of functions enables you to change the functionality and behavior of some camera buttons. It also includes options for adding image verification data and aspect ratio information. You can also access three of the Custom Functions in this group directly from the Quick Control screen. Just select the Custom Controls option on the Quick Control screen to access C.Fn IV-1, AF and metering buttons, C.Fn III-2, AP point selection method, and C.Fn IV-2, Assign SET button.

C.Fn IV-1: AF and metering buttons

This function gives you ten choices for modifying which camera button starts metering and autofocus functions on the 60D and which button locks the exposure. The option you choose depends entirely on what is most natural for your shooting. (The AE Lock button is located on the back right of the camera and it has a magnifying glass with a plus sign in it under it.)

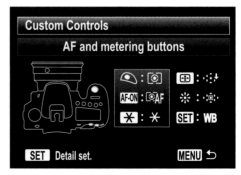

5.2 The AF and metering buttons main screen

**5.3 The AF and metering buttons
Option 2 screen**

Also some options may provide easier camera operation when you're shooting video, using Live View, or using a telephoto lens.

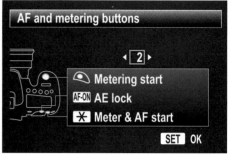

Table 5.1 C.Fn IV Options

Option	Shutter button	AF-ON button	AE Lock button
Option 0 (default setting)	Metering and focusing	Metering and focusing	Lock the exposure
Option 1	Metering	Metering and autofocusing	Lock the exposure
Option 2	Metering	AE lock	Metering and autofocusing
Option 3	AE lock	Metering and autofocusing	AE lock
Option 4	AE lock	AE lock	Metering and autofocusing
Option 5	Metering and autofocusing	AE lock	Metering and autofocusing
Option 6	Metering and autofocusing	AF stop	AE lock
Option 7	Metering and autofocusing	AE lock	AF stop
Option 8	Metering and autofocusing	No function	AE lock

C.Fn IV-2: Assign SET button

This function enables you to change the function of the SET button so that it's useful during shooting. The advantage to programming the SET button is that it provides quick access to the camera function that you use most

5.4 The Assign SET button screen

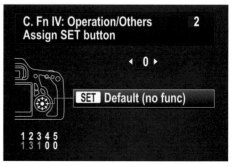

frequently. For example, if you shoot JPEG images, Option 3: White balance, is an excellent choice for getting quick access to the White Balance settings. Regardless of the option you choose, the SET button continues to perform its default functions with menus and submenus.

If you assign a function to the SET button, and then change the AF-point selection method in C.Fn III-2 using Option 1, the SET button function you choose is cancelled.

▶ **Option 0: Default (no func).** Pressing the SET button does nothing during shooting.

▶ **Option 1: Image Quality.** Pressing the SET button while shooting displays the Image recording quality menu where you can change the quality setting.

▶ **Option 2: Picture Style.** Pressing the SET button displays the Picture Style selection screen so you can change the Picture Style. Then press the SET button to confirm the selection.

▶ **Option 3: White balance.** Pressing the SET button displays the White Balance selection screen so you can change the white balance, and then press the SET button to confirm the selection.

▶ **Option 4: Flash exp. comp.** Pressing the SET button displays the Flash Exposure comp. (compensation) screen so you can set the amount of compensation. Press the SET button to confirm the selection.

▶ **Option 5: Viewfinder (Electronic level).** Pressing the SET button displays the electronic level in the viewfinder so you can ensure the horizon is square with the frame.

C.Fn IV-3: Dial direction during Tv/Av

If it seems more natural to choose a faster shutter speed by turning the Main dial to the left instead of the right, then you can choose Option 1 to do that. Likewise, with Option 1 in Av shooting mode, you turn the Main dial to the right to move to a larger f-stop rather than a smaller f-stop. And in Manual (M) mode, Option 1 reverses the dial direction of both the Quick Control and Main dials, while in other shooting modes, only the Main dial direction is reversed.

▶ **Option 0: Normal.** When you turn the Main dial clockwise in Tv or Av mode, the shutter speed increases or aperture gets narrower. In Manual mode, turning the Main dial to the right moves to a faster shutter speed and turning the Quick Control moves to a smaller aperture.

▶ **Option 1: Reverse direction.** In Tv and Av shooting modes, the Main dial direction is reversed for setting shutter speed and aperture. In Av mode, turning the

Main dial to the right moves to a wider aperture. In Tv mode, turning the Main dial moves to a slower shutter speed. In Manual mode, the directions of the Main and Quick Control dials are reversed so turning the Main dial to the right moves to a slower shutter speed and turning the Quick Control dial to the right moves to a wider aperture.

C.Fn IV-4: Focusing Screen

Use this function only if you install one of the two optional interchangeable focusing screens. Note that this is the only Custom Function that is not included if you register camera settings and recall them by switching to Camera User Settings (C) mode on the Mode dial. And if you clear all Custom Functions, this function is not cleared, which means the setting matches the currently installed focusing screen at all times.

▶ **Option 0: Ef-A.** Standard Precision Matte. This is the focusing screen that comes installed on the camera, and it offers good viewfinder brightness and good manual focusing.

▶ **Option 1: Ef-D.** Precision Matte with Grid. This screen features five vertical lines and three horizontal lines to help keep lines square during image composition.

▶ **Option 2: Ef-S.** Super Precision Matte. This screen is designed to make manual focusing easier with f/2.8 and faster lenses. The viewfinder is darker using this screen with slower lenses.

C.Fn IV-5: Add image verification data

When this option is turned on, data is appended to verify that the image is original and has not been changed. This is useful when images are part of legal or court proceedings. The optional Data Verification Kit OSK-E3 is required.

▶ **Option 0: Disable.** No verification data is appended.

▶ **Option 1: Enable.** This option appends data to verify whether the image is original or not. During image playback, a lock icon denotes verification data. To verify the image originality, the optional Original Data Security Kit OSK-E3 is required. Canon also notes that images are not compatible with the image encryption/decryption features of the Original Data Security Kit OSK-E3.

Setting Custom Functions

After reviewing the functions and options, you may be able to identify specific functions that will be helpful for your daily shooting. Other functions, such as Mirror lockup, are ones that you use for specific shooting scenarios.

You may also find that combinations of functions are useful for specific shooting situations. Whether used separately or together, Custom Functions can significantly enhance your use of the 60D.

To set a Custom Function, follow these steps:

For all step-by-step instructions in this chapter, you can access the 60D camera menus by pressing the Menu button. Then press left or right on the Multi-controller or turn the Main dial to highlight a menu tab, and then press up or down on the Multi-Controller or turn the Quick Control dial to highlight a menu option.

1. **Set the Mode dial to P, Tv, Av, M, or B, and highlight the Custom Functions (C.Fn) group you want on the Custom Functions menu, and then press the SET button.** The Custom Functions screen with the function group that you selected appears.

2. **Press left or right on the Multi-controller until the Custom Function number you want is displayed in the number control box at the top-right corner of the screen, and then press the SET button.** The first Custom Function option is activated.

3. **Press up or down on the Multi-controller to highlight the option you want, and then press the SET button.** You can refer to the descriptions earlier in this chapter to select the function and option number that you want. Repeat Steps 3 and 4 to select other Custom Function groups, functions, and options.

If you want to reset one of the Custom Functions, repeat these steps to change it to another setting or restore it to the default setting.

However, if you want to restore all the Custom Functions to the default settings, go to the Custom Functions menu, highlight Clear all Custom Functions (C. Fn), press the SET button, and then choose OK. All Custom Functions are restored to their default settings except C.Fn IV-4, Focusing screen.

Additional Customization Options

In addition to setting Custom Functions, you want to program the C (Custom User Setting) mode, and you can choose your most frequently used menu items and add them to My Menu. The next sections show you how to make additional camera customizations.

Setting up Camera User Settings (C) mode

With the Camera User Setting, denoted as C on the Mode dial, you can preset the EOS 60D with your favorite shooting mode, exposure settings, drive and autofocus modes, and Custom Functions, and then make only minimal adjustments when you are ready to start shooting. And you are not locked into the setting that you register because you can still change the settings as you shoot.

It does not take long to think of a plethora of ways to use C mode. For example, C mode could be set up for shooting nature and landscapes with the camera preset to Av mode, Exposure Bracketing, Mirror lockup, as well as to your favorite drive, autofocus, and exposure modes, and Picture Style. Alternately, it can be set up for portraits, weddings, concerts — you name it. Without question, C mode offers a way to spend less time adjusting camera settings and more time shooting.

 If you have forgotten what settings you registered for C mode, just press the INFO. button to display the current camera settings.

When you register camera settings, the following settings are saved and recalled when you set the Mode dial to the C mode under which you registered them:

▶ **Shooting settings.** These shooting settings are saved in C mode:

Shooting mode, ISO, aperture, shutter speed, AF mode, AF point, AF-point selection mode, metering and drive mode, Exposure Compensation, and Flash Exposure Compensation.

▶ **Menu settings.** These menu settings are saved in C mode:

Image quality, Beep, Red-eye setting, Release shutter without card, Review time, Peripheral illumination correction, flash control settings, Exposure Compensation, AEB, Auto Lighting Optimizer, white balance, Custom white balance, white balance shift and bracketing, color space, Picture Style, grid display, histogram, slide show, image jump settings, auto power off, auto rotate, file numbering, LCD brightness, sensor cleaning, INFO. button display, and Custom Function settings.

▶ **Live View shooting settings.** These menu settings are saved in C mode:

Live View shooting, AF mode, Grid display, Aspect ratio, exposure simulation, Silent shooting, and Metering timer.

Unfortunately, the settings you use for My Menu are not registered to the C mode settings, and you can't use the Clear all camera settings on the Setup 3 menu or the Clear all Custom Func. (C.Fn) option on the Custom Functions menu. Otherwise, all the camera menus are available, and you can change the settings you've registered while you're shooting in C mode. However, any changes you make as you're shooting in C mode are not saved as part of or changes to the registered settings.

Here is how to register Camera User Settings to C mode:

1. **With the camera set to P, Tv, Av, M, or B mode, choose all the settings on the camera that you want to register.** In addition to shooting, exposure, metering, focus, drive, and menu settings, you can set Custom Functions for specific shooting scenarios as detailed previously in this chapter.

2. **On the Setup 3 menu tab, highlight Camera user settings, and then press the SET button.** The Camera user settings screen appears.

3. **Press up or down on the Multi-controller to highlight Register settings, and then press the SET button.** The Register settings screen appears.

4. **Turn the Quick Control dial to highlight OK, and then press the SET button.** The Set-up 3 menu appears. The camera registers the settings except for the My Menu settings. Lightly press the shutter button to dismiss the menu.

5. **To shoot with the registered settings, turn the Mode dial to C.** You can change the camera settings if you want just as you would in other shooting modes.

If you want to clear the registered user settings, follow the previous steps, but in Step 3, highlight Clear Settings, and then click OK.

Customizing My Menu

Customization of the 60D includes the ability to set up My Menu with your most frequently used six menu items and Custom Functions. It takes only a few minutes to set up My Menu, and it will save you a lot of time over months to come.

In addition to adding and deleting items to and from My Menu, you can change the order of registered items by sorting them. You can also set the 60D to display My Menu first when you press the Menu button. The only drawback to My Menu is that you can only register six items. So before you begin registering, evaluate the menu items and Custom Functions and carefully choose your six favorite items.

My strategy is to include frequently used options that are not already quickly accessible using a button on the camera, or by using an option on the Quick Control screen. Here is what I have registered on My Menu: Custom WB, Format, Flash control, Grid display, Long exp. noise reduction, Highlight tone priority, and Mirror lockup. I have also set up My Menu as the first menu that is displayed when I press the Menu button.

Here is how to add items to My Menu:

1. **On the On the My Menu tab, highlight My Menu settings, and then press the SET button.** The My Menu settings screen appears.

2. **Press up or down on the Multi-controller to highlight Register to My Menu, and then press the SET button.** The Select item to register screen appears. This screen is a scrollable list of all menu items available on the camera. You can scroll through the list by turning the Quick Control dial.

3. **Turn the Quick Control dial to highlight the menu item you want to register, and then press the SET button.** The Select item to register screen appears.

4. **Turn the Quick Control dial to highlight OK, and then press the SET button.** The Select item to register screen reappears so that you can select the next item. To find individual Custom Functions, keep scrolling past the C.Fn group names, and you see the individual Custom Functions by name (the function numbers are not listed).

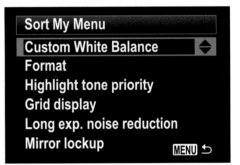

5.5 The Sort My Menu screen

5. **Repeat Steps 3 and 4 until all the menu items you want are registered, and then press the Menu button.** The My Menu settings screen appears. If you want to sort your newly added items, jump to Step 2 in the following set of steps.

To sort your registered camera Menu items and Custom Functions, follow these steps:

1. **Repeat Steps 1 and 2 in the previous list, if necessary.**

2. **On the My Menu settings screen, turn the Quick Control dial to highlight Sort, and then press the SET button.** The Sort My Menu screen appears.

3. **Press the SET button if you want to move the first menu item to a different position in the list, or press up or down on the Multi-controller to the move to the item you want to move up or down, and then press the SET button.** The camera activates the sort control represented by up and down arrows to the right side of the menu item.

4. **Press up or down on the Multi-controller to move the item's placement within the menu, and then press the SET button.**

5. **Repeat Steps 3 and 4 to move other menu items in the order that you want.**

6. **Press the Menu button twice to display your customized menu.** Or lightly press the shutter button to dismiss the menu.

You can follow these general steps to access My Menu settings where you can delete one or all items from the menu.

> **TIP** To automatically display the My Menu tab when you press the Menu button, go to the My Menu settings screen, select Display from My Menu, press Set, and then select Enable.

Now you have a good idea of how you can set up the 60D not only to make it more comfortable and efficient for your preferences, but also to have the camera ready in advance for different shooting scenes and subjects.

Shooting in Live View Mode

With Live View shooting you view, compose, and focus using a real-time view of the scene that's displayed on the 60D's 3-inch LCD monitor. If your shooting position makes it difficult to use the viewfinder to shoot, you can swivel and turn the articulated LCD to compose and make the image.

Live View offers a view you can magnify up to 10X to ensure tack-sharp automatic or manual focus; or you can use Live View's Face-detection focusing option. Live View also offers two Silent modes to reduce shutter noise. While Live View shooting is not the best choice for all shooting scenes, it is a good choice in controlled and close-up

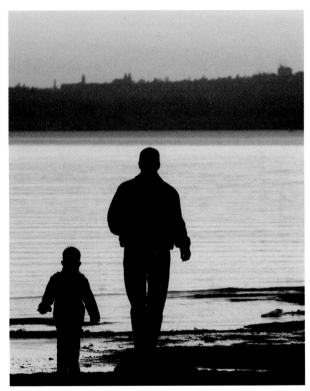

Whether you use Live View shooting for close-up images or for outdoor shooting, the ability to zoom in and ensure tack-sharp focus is one of the major benefits. Exposure: ISO 200, f/8, 1/250 second.

shooting scenarios, such as macro and still-life shooting, as well as in scenes where you cannot get the shot by looking through the viewfinder. Whatever your needs may be, you want to include Live View in your arsenal of shooting options.

Live View Shooting Pros and Cons

If you've shot using a point-and-shoot digital camera, then you're familiar with using the camera LCD to compose images. This method is now included on many digital SLRs. On a dSLR, Live View requires the camera to hold the shutter open to give you a real-time view of the scene and focus. Normally, this isn't possible because the shutter and reflex mirror block the view to the image sensor. The 60D overcomes this blind spot with a mechanical shutter that stays completely open during Live View shooting.

Live View offers some advantages that you don't get with non-Live View shooting. For example, because the first-curtain shutter is electronic, you can choose options to reduce the noise of the shutter cocking. Live View also offers face detection, which automatically identifies faces in the scene and focuses on one of them. If it focuses on the wrong face, you can shift the selection to choose the correct subject. And you can use the supplied, or an accessory cable, to connect the 60D to a TV and see Live View on the TV screen.

Although Live View shooting is undeniably cool, it has a few negative side effects:

▶ **Temperature affects the number of shots you can get using Live View.** With a fully charged LP-E6 battery, you can expect 350 shots without flash use and approximately 320 shots with 50 percent flash use in 73-degree temperatures. In freezing temperatures, expect 310 shots without flash use and 280 shots with 50 percent flash use per charge. With a fully charged battery, you get approximately 2 hours and 20 minutes of continuous Live View shooting before the battery is exhausted. Also if you've been shooting in Live View and want to take a long exposure image, turn off Live View for a few minutes to let the sensor cool down to get better image quality.

▶ **High ambient temperatures, high ISO speeds, and long exposures can cause digital noise or irregular color in images taken using Live View.** With continual use of Live View, the image sensor heats up quickly. Both high internal and external temperatures can degrade image quality and cause Live View to automatically shut down until the internal temperature is reduced.

An icon that resembles a thermometer is displayed on the LCD when internal and/or external temperatures are high enough to degrade image quality. If the icon appears, and especially if it begins blinking, stop shooting until the temperature cools down. Otherwise, the camera automatically stops shooting when the internal temperature gets too high. Additionally, high ISO settings combined

with high temperatures can result in digital noise and inaccurate image colors. The image noise created by high ISO settings may also be amplified for Live View images.

▶ **The Live View may not accurately reflect the captured image in several different conditions.** Image brightness may not be accurately reflected in low and bright-light conditions. If you move from low to a bright light and if the LCD brightness level is high, the Live View may display *chrominance* (color) *noise*, but the noise will not appear in the captured image. Suddenly moving the camera in a different direction can also throw off accurate rendering of the image brightness. If you capture an image in magnified view, the exposure may not be correct. And if you focus and then magnify the view, the focus may not be sharp.

Live View Features and Functions

While some key aspects of Live View shooting differ significantly from standard shooting, others carry over to Live View shooting. For example, you can use the LCD panel functions during Live View shooting to change the drive mode and ISO sensitivity setting. Likewise, you can press the INFO. button one or more times to change the display to include more or less shooting information along with a Brightness histogram or RGB histograms. The following sections give you a high-level view of setting up and using Live View shooting.

Live View focus

With the 60D's large and bright LCD monitor, you can use Live View shooting to get tack-sharp focus. The following overview of the Live View focusing options will help you decide in advance which option is best for the scene or subject that you are shooting in Live View.

▶ **Live mode.** With this focusing option, the camera's image sensor detects subject contrast to establish focus. This focusing mode keeps the reflex mirror locked up so that the Live View on the LCD is not interrupted during focusing. However, focusing takes longer with Live mode. To focus in this mode, press the Multi-controller to move the rectangular autofocus (AF) point over the subject, and then press the shutter button halfway to focus. You can move the AF point in the same areas as the nine AF points you see in the viewfinder in non-Live View shooting. The AF point turns green when focus is achieved.

▶ **Face Detection Live mode.** This is the same as Live mode except that the camera automatically looks for and focuses on a human face in the scene. If the camera does not choose the face of the subject you want, you can press the Multi-controller to move the focusing frame to the correct face. If the camera cannot detect a face, the AF point reverts to the center AF point, and you can manually move the

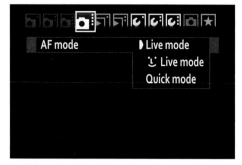

6.1 These are the focusing mode options that are available on the Shooting 4 menu.

AF point to a face. If multiple faces are detected, the focusing rectangle appears with arrows on the left and right. You can then press the Multi-controller to select another person's face.

If the person is a long way from the camera, you may need to manually turn the lens focusing ring to get the subject in focus range, and then focus by half-pressing the shutter button. Face detection does not work with extreme close-ups of a face if the subject is too far away, too bright or dark, partially obscured, or tilted horizontally or diagonally.

In Face Detection Live mode, you can't magnify the image on the LCD using the AF-point selection/Magnify button. In both Live and Face Detection Live modes, focus at the edges of the frame is not possible and the face-focusing frame is grayed out. Unlike in non-Live View shooting, the built-in flash's AF-assist beam is not fired to help the 60D establish focus.

▶ **Quick mode.** This focusing mode uses the camera's autofocus system. In this mode, the Live View on the LCD is suspended as the reflex mirror drops down long enough for the camera to establish focus. With Quick mode focusing, you can press the Q button, and then activate the nine AF points by pressing up or down on the Multi-controller. Then turn the Main dial to select an AF point.

▶ **Manual Focus.** This focusing option is the most accurate, and you get the best results when you magnify the image to focus. Another advantage is that Live View is not interrupted during focusing. The caveat is that the lens you're using needs to have a MF (Manual Focus) switch on the side. To focus manually, set the lens switch to MF, and then move the focusing frame wherever you want by tilting the Multi-controller. Turn the focusing ring on the lens to focus.

 If you use Live View with Continuous shooting, the exposure is set for the first shot and is used for all images in the burst.

Exposure Simulation and metering

Live View shooting provides Exposure Simulation that replicates what the final image will look like at the current shutter speed, aperture, and other exposure settings on the LCD during Live View display. You can turn on Exposure Simulation on the Shooting 4 menu. While simulation is nice, the image may be easier to see at standard brightness without using Exposure Simulation.

For Live View, the camera uses Evaluative metering. Unlike standard shooting, you can set how long the camera maintains the current exposure by setting the Live View metering timer from 4 seconds to 30 minutes. If the light or your shooting position changes frequently, set a shorter meter time. Longer meter times speed up the Live View shooting operation, and longer times are effective in scenes where the lighting remains constant.

 Auto Lighting Optimizer automatically corrects underexposed and low-contrast images. If you want to see the effect of exposure modifications, turn off Auto Lighting Optimizer on the Shooting 2 menu.

Silent shooting modes

Live View shooting offers two Silent shooting modes. In either Silent mode 1 or 2, the shutter noise is noticeably reduced. Following is a summary of the two Silent shooting modes and the Disable option:

▶ **Mode 1.** In this mode, the shutter cocking noise is noticeably reduced when you're using the Live focus mode. You can also use High-speed Continuous shooting at 5 fps when you hold down the shutter button completely. This mode is useful in any scenario where the noise of the shutter would scare away or disturb the subject.

▶ **Mode 2.** This mode delays shutter noise as long as you keep the shutter button pressed, thus delaying the recocking sound of the shutter. If the camera is in Continuous drive mode, only one image is made because the shutter does not recock until you release the shutter button.

▶ **Disable.** This is the setting to choose if you use a *tilt-and-shift* (TS-E) lens and make vertical shift movement, or if you use an extension tube on the lens. When you press the shutter button, it sounds like two images are being taken, but only one image is made.

Using a flash

When shooting in Live View with the built-in flash, the shooting sequence (after fully pressing the shutter button) is for the reflex mirror to drop to allow the camera to gather the preflash data. The mirror then moves up out of the optical path for the actual exposure. As a result, you hear a series of clicks, but only one image is taken. Here are some things you should know about using Live View shooting with a flash unit:

▶ With an EX-series Speedlite Flash Exposure Lock (FE Lock), modeling flash, and test firing cannot be used except for wireless flash shooting.

▶ FE Lock cannot be used with the built-in or an accessory Speedlite.

▶ If you are using a Canon Speedlite and have the camera set to Silent mode 1 or 2, the camera automatically switches to the Disable option. Non-Canon flash units do not automatically switch to Disable, so you must manually set the camera to Disable.

Setting up for Live View Shooting

The settings on the Shooting 4 menu not only activate Live View shooting, but they also enable you to set your preferences for shooting in this mode, including enabling Live View shooting, displaying a grid in the LCD, setting up Silent modes, and setting the Exposure metering timer.

> For all step-by-step instructions in this chapter, you can access the 60D camera menus by pressing the Menu button. Then press left or right on the Multi-controller to highlight the menu tab or turn the Main dial, and then press up or down on the Multi-controller to highlight a menu option or turn the Quick Control dial.

Before you begin setting up for Live View shooting, review the focusing options detailed previously, and the aspect ratio descriptions in Chapter 2. To set up the 60D for Live View shooting and to set your preferences, follow these steps:

1. **On the Shooting 4 menu tab, highlight Live View shooting, and then press the SET button.** The Live View shooting options appear.

2. **Select Enable, and then press the SET button.** The Shooting 4 menu is displayed.

3. **On the Shooting 4 menu, highlight any of the following options, and then press the SET button to display the settings you can select.**

Live View shoot.	Enable
AF mode	Live mode
Grid display	Off
Aspect ratio	3 : 2
Expo. simulation	Enable
Silent shooting	Mode 1
Metering timer	16 sec.

6.2 These are the options that you can set for Live View shooting on the Shooting 4 menu.

- **AF mode:** Select Live mode, Face Detection Live mode, or Quick mode, and then press the SET button.

- **Grid display:** Select a 3 × 3 or 4 × 6 grid to help you align horizontal and vertical lines in the scene. Or select Off if you do not want to use a grid, and then press the SET button.

- **Aspect ratio:** Select 3:2, 4:3, 16:9, or 1:1, and then press the SET button. Aspect ratios are detailed in Chapter 2.

- **Expo. (Exposure) simulation:** Choose Enable to see an approximation of the final exposure on the screen. Otherwise, choose Disable, and then press the SET button.

- **Silent shooting:** Choose Mode 1 to reduce the sound of the shutter. Choose Mode 2 to delay the sound of the shutter until you release the shutter button. Choose Disable if you are using a non-Canon flash unit, a TS-E lens, or a lens extender. Then press the SET button.

- **Metering timer:** Choose 4, 16, or 30 seconds, or 1, 10, or 30 minutes to determine how long the camera retains the exposure. If the light changes often, choose a shorter time. Then press the SET button.

Working with Live View

Now that you've chosen the focusing mode and selected the Live View options, you're ready to begin shooting. Here are a few tips to get you started:

▶ For still-life and macro shooting, manual focusing with the image enlarged to 5X or 10X helps ensure tack-sharp focus.

▶ For a really large view, tether the camera to your laptop using the supplied USB cable. Alternatively, you can hook up the camera to the TV and use the TV screen as a monitor.

▶ Just a few minutes of watching the real-time view will convince you that a tripod is necessary for Live View shooting. With any focal length approaching tele-photo, Live View provides a real-time gauge of just how steady or unsteady your hands are.

Shooting in Live View

The operation of the camera during Live View shooting differs from traditional still shooting, but the following steps guide you through the controls and operation of the camera.

To shoot in Live View using autofocus, follow these steps:

1. **With the camera set to any shooting mode except Movie mode, press the Live View shooting button on the back of the camera.** This button has a camera icon on it and is to the right of the viewfinder. A current view of the scene appears on the LCD.

2. **Press the INFO. button one or more times to display to show more or less information, and to display the histogram if Exposure Simulation or the grid is turned on.**

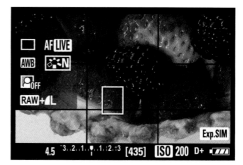

6.3 The Live View screen displays whenever Exposure Simulation is active, as well as the focus mode, white balance, current Picture Style, the Auto Lighting Optimizer setting, and the image-recording quality. Exposure information is along the bottom of the frame. Here, the large 3 x 3 grid is displayed.

3. **Press the Q button to display the settings that you can adjust.** The settings you can adjust depend on the shooting mode. In automatic modes such as

Portrait, Landscape, and so on, you can change the focus mode, drive mode, Ambience, and Lighting or Scene type. In Creative Auto (CA) mode, you can change the amount of Background blur. In Program AE (P), Shutter-priority AE (Tv), Aperture-priority AE (Av), and Manual (M) shooting modes, you can adjust the AF and drive mode, White Balance, Picture Style, Auto Lighting Optimizer level, Image-recording quality, and Exposure and Flash Exposure Compensation (FEC).

4. **Press up or down on the Multi-controller to select the setting you want to adjust, and turn the Main or Quick Control dial to adjust the setting.**

5. **Press the buttons above the LCD panel to change the drive mode and ISO.** Evaluative metering is automatically set for Live View shooting, and you can't change it. You can use the camera controls and buttons that you use in still shooting during Live View shooting. For example, to set Exposure Compensation, press the shutter button halfway, and then turn the Quick Control dial to set the amount of compensation. If you access the camera menus, then lightly press the shutter button to restore the Live View on the LCD.

6. **Compose the image.** As you move the camera and half-press the shutter button, the exposure changes and is displayed in the bottom bar under the Live View display.

7. **If you are using Quick mode to focus, press up or down on the Multi-controller, and then turn the Main or Quick Control dial to select the AF point that you want.** You can also press the Autofocus On button (AF-ON) to focus.

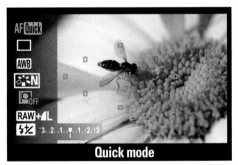

6.4 The Live View screen with the AF points displayed

If you are using Quick mode to focus, when you press the AF-ON button, you hear the sound of the reflex mirror dropping down to focus and Live View is suspended. If you are using Live focusing mode, focus takes longer, and it is a good idea to magnify the image to verify sharp focus. In all focus modes, when the camera achieves sharp focus, the AF focus rectangle turns red.

Press the AF-point Selection/Magnify button on the top-right corner of the camera to magnify the view for manual focusing. The first press of the button enlarges the view to 5X, and a second press enlarges the view to 10X.

8. **Press the shutter button completely to make the picture.** The shutter fires to make the picture, the image preview is displayed, and then Live View resumes.

To return to non-Live View shooting, press the Live View shooting button.

Using Movie Mode

The 60D opens a new dimension of creative expression with its high-quality and very versatile video shooting capabilities. The 60D has video shooting with either automatic or manual exposure control. In addition, the camera has a built-in microphone that offers automatic or manual control over the noise of the wind for outdoor shooting. You can shoot in full High-Definition, Standard-definition, or in Movie crop mode with frame rates that you can select based on the recording size.

It is also to your advantage that the 60D's movie quality is among the best available in the dSLR market. All of this is packaged in

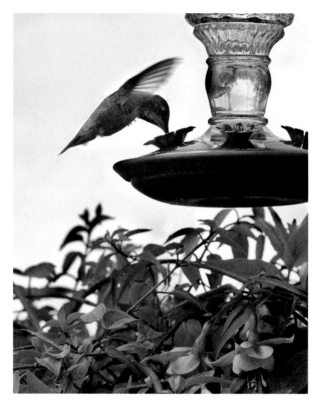

Whether you are recording the antics of children, pets, or nature, the 60D is an excellent tool for creating High-Definition or Standard-definition movies.

a lightweight camera with a vari-angle LCD monitor that gives you a large view of the scene during shooting. Further, the 60D accepts more than 60 lenses to enhance your videos in ways that traditional video cameras cannot. Last but not least, you can capture still images during video shooting.

About Video

For many still-image photographers, shooting video is like learning a new visual language. While the language is different, video, like traditional still photography, is a form of creative visual communication. And just like with still shooting, the goal of video shooting is to tell a story, a moving narrative with sound that has a beginning, middle, and an end.

As with still photography, a world of technical information and terms goes with video. So if you are new to videography, it is good to have at least a basic understanding of digital video.

Video standards

In the world of video, there are several industry standards, including the following resolutions: 720p, 1080i, and 1080p.

The numbers 720 and 1080 represent vertical resolution. The 720 standard has a resolution of 921,600 pixels, or 720 (vertical pixels) × 1280 (horizontal pixels). The 1080 standard has a resolution of 2,073,600 pixels, or 1080 × 1920. It seems obvious that the 1080 standard provides the highest resolution, and, therefore, would be preferable, but that is not the entire story.

The rest of the story is contained in the *i* and *p* designations. The *i* stands for *interlaced*. Interlacing is a method of displaying video where each frame is displayed on the screen in two passes — a first pass that displays odd-numbered lines, and a second pass that displays even-numbered lines. Each pass is referred to as a *field*, and two fields comprise a single video frame. This double-pass approach was engineered to keep the transmission bandwidth for televisions manageable. And the interlaced transmission works only because your mind automatically merges the two fields so that the motion appears smooth, with no flickering. However, interlacing is an old way of transmitting moving pictures.

The newer way of transmitting video is referred to as *progressive* scan; hence, the *p* designation. Progressive scan quickly displays a line at a time until the entire frame is displayed. And the scan happens so quickly that you see it as if it were being displayed all at once. The advantage of progressive scanning is most apparent in scenes where either the camera or the subject is moving fast. With interlaced transmission, fast camera action or moving subjects tend to blur between fields. That is not the case with 720p, which provides a smoother appearance. So while 1080i offers higher

resolution, 720p provides a better video experience, particularly when there are fast-action scenes. As a result, 1080i or 720p are the commonly used standards for major broadcast companies, with those that broadcast sports choosing the 720p standard. On the other hand, 1080p is the standard for digital movies shooting at 24 fps that at full resolution has the wide-screen aspect ratio of 16:9.

Another piece of the digital video story is the frame rate. In the world of film, a frame rate of 24 frames per second (fps) provided the classic cinematic look of old movies. But in the world of digital video, the standard frame rate is 30 fps. Anything less than 24 fps provides a jerky look to the video. The TV and movie industries use standard frame rates, including 60i, which produces 29.97 fps and is used for NTSC; 50i, which produces 25 fps and is standard for PAL, still used in some parts of the world, and 30p, which produces 30 fps, a rate that produces a smooth rendition for fast-moving subjects.

> Videographers who want a cinematic look prefer cameras that can shoot in 24p (or 24 fps), creating 24 high-quality images that can then be converted in the camera or in editing software to 30 fps by adding frames in a process called *3-2-1 pulldown*.

With this very brief background on video, it is time to look at the digital video options on the 60D.

Video on the 60D

By now, you probably have questions, such as how does the 60D compare to industry standards, how long you can record on your SD/SDHC card, and how big are the files. Following is a rundown of the digital video recording options that you can choose on the 60D:

▶ **Full HD (Full High-Definition) at 1920 x 1080p at 24fps (actual 23.976) or 30 (actual 29.97).** In PAL mode, you can use either 25 (actual 25.00), or 24 (actual 23.976) fps. You get about 12 minutes of recording time with a 4GB card and about 44 minutes with a 16GB card. The file size is 330MB per minute. Full HD enables you to use HDMI (High-Definition Multimedia Interface) output for HD viewing of stills and video.

▶ **HD (High-Definition) at 1280 x 720p at 60 (actual 59.94) and 50 (actual 50.00) fps.** You get about 12 minutes of recording time with a 4GB card, and 44 minutes with a 16GB card. The file size is 330MB per minute.

▶ **SD (Standard-definition) at 640 x 480 at 60 (actual 59.94) or actual 50 fps when set to PAL.** You get 24 minutes of recording time with a 4GB card, and 1 hour and 32 minutes with a 16GB card. The file size is 165MB per minute, and the aspect ratio is 4:3.

▶ **Crop mode at 640 x 480 at 60 or 50 fps with 7X magnification when compared to other video recording sizes.** Videos are recorded in Standard-definition at a 4:3 ratio that creates the telephoto 7X magnification by cropping the video from a small area at the center of the image sensor. This mode is good when you're shooting at a great distance from the subject, but it comes with some restrictions, including that you can't magnify the image for focusing, and focusing may be more difficult at the increased magnification. In addition, digital noise and dots of light are more noticeable. In Crop recording size, you can record for 1 hour and 32 minutes with a 16GB card at a file size of 165MB per minute.

▶ **There is a 4GB limit to single movie clips, and the clips are H.264-compressed movie files with a .mov file extension.** At 1080p and 720p, clips run approximately 12 minutes depending on ISO and movie content and movement. You can also trim the beginning and end of a clip in the camera. Videos can be viewed in Apple's QuickTime Player.

NOTE NTSC is the standard for North America, Japan, Korea, Mexico, and other countries. PAL is the standard for Europe, Russia, China, Australia, and other countries.

So you have two high-quality video options, albeit at different frame rates. The 30 fps option is the traditional recording speed for online use whereas the actual 29.97 speed is the TV standard in North America. As a result, the 30 fps option is suitable for materials destined for DVD or display on a Standard-definition or High-Definition TV. Although 24 fps may be more filmlike, it can produce jerky motion for subjects that are moving, and it requires slower shutter speeds of around 1/50 second. In addition, the actual 29.97 frame rate makes it easier to sync audio when it is recorded separately using a video-editing program.

Here are other aspects to consider when shooting video:

▶ **A fast, high-capacity SD/SDHC card.** For the best movie recording and playback performance, use a high-capacity Class 6 or higher-rated SD/SDHC card. If you're doing a lot of movie shooting, an 8GB, 16GB, or higher capacity card is a good choice. Media cards are rated for both write and read speeds. When shopping for SD cards, make sure that the card's bus interface is supported on the 60D. For example, some of the newest and fastest SDHC cards use the new and faster

UHS-1 bus interface that isn't supported on the 60D at the advertised read/write speeds. You can use these newer cards, but the read/write speed is much slower than advertised speed. If you use a slow card, an indicator appears on the screen showing how much data is waiting in the buffer to be written to the media card. Once the level reaches the top of the indicator, movie shooting automatically stops. If you don't have a fast card, you can try using a low-quality recording level to keep the buffer from backing up with unwritten data.

▶ **Audio.** You can use the 60D's built-in monaural microphone, which is adequate if you do not want to invest in a separate audio recorder and microphone. The audio is 16-bit at a sampling rate of 48 kHz and is output in mono. If you use the built-in microphone, be aware that all the mechanical camera functions are recorded, including the sound of the Image Stabilization (IS) function on the lens, and the focusing motor. With the built-in microphone, you can use either automatic or manual recording volume adjustment. With manual control, you can adjust the audio recording level in 1 to 64-step increments. The built-in microphone features a wind-cut filter to reduce wind noise during outdoor shooting. You can, of course, use an accessory stereo microphone connected to the 60D via the mike terminal on the side of the camera.

▶ **Exposure and camera settings.** Video exposure offers full manual exposure control with the slowest shutter speed being linked to the frame rate. For example, the slowest frame rate at 60 or 50 fps is 1/60 second. At 30, 25, and 24, the slowest shutter speed is 1/30 second. And at all resolutions, the maximum shutter speed is 1/4000 second. The ISO can be set automatically or manually. Manual settings range from 100 to 6400.

Alternately, you can use fully automatic exposure so that the 60D sets the aperture, shutter speed, and ISO automatically. In addition, you can set Auto Exposure (AE) Lock and set Exposure Compensation of +/–3 stops. You can change the focus and drive mode, white balance, Picture Style, setting for Auto Lighting Optimizer, still image file format and size, and recording quality before you begin shooting in Movie mode.

▶ **Battery life.** At 73-degree temperatures, you can expect to shoot for 2 hours, with the time diminishing in colder temperatures.

▶ **Video capacities.** The upper limit is 4GB of video per movie. When the movie reaches the 4GB point, the recording automatically stops. Just press the Movie button to begin recording a new movie file.

▶ **Focusing.** You have the same options for focusing as you have in Live View shooting. In Quick mode, the reflex mirror has to flip down to establish focus, and this blackout is not the best video experience. However, Quick mode focusing

can be suitable for an interview or other still subject where you can set the focus before you begin recording. You cannot use continuous focusing for moving subjects in Movie mode.

For more details on Live View focusing options, see Chapter 6.

▶ **HDMI output.** The 60D offers HDMI-CEC (Consumer Electronics Control) video output connectivity, which enables you to control many devices with one remote control. This means that when you play back movies on your HD TV, you can use the TV remote control to play back movies or to view still images. You can control image playback, display an index, display the shooting information, rotate images, and run a slide show. You can turn on HDMI on the Playback 2 camera menu. Just select Ctrl over HDMI, and then select Enable.

▶ **Still-image shots during recording.** You can capture, or *grab*, a still image anytime during video recording by pressing the shutter button completely. When you half-press the shutter button, the 60D displays the current aperture and shutter speed on the LCD, and these settings are used for the still image. This results in a 1-second pause in the video and a full-resolution still image. The still image is recorded to the card as a file separate from the video. The still image is captured at the image-quality setting that was previously set for still-image shooting or you can change it. The camera sets the aperture and shutter speed automatically, or you set it manually if you're shooting movies in Manual exposure (M) mode and the built-in flash is not used. The white balance, Picture Style, and quality settings that you have set for non-Movie shooting are used for still images. The flash is not used, and you cannot use a Self-timer mode during movie shooting for capturing the still image, but you can use it before you begin movie recording.

▶ **Frame grabs.** You can opt to pull a still image from the video footage rather than shooting a still image during movie recording. You can do a frame grab using the ZoomBrowser EX/ImageBrowser program provided on the supplied EOS Digital Solution Disk. If you shoot at 1920 × 1080, frame grabs are limited to approximately 2 megapixels, 1 megapixel at 1280 × 720, and 300,000 pixels at 640 × 480. Also because the shutter speeds during automatic exposure tend to be slow to enhance video movement, frame grabs can appear blurry.

Recording and Playing Back Movies

Some of the setup options for Movie mode are the same as or similar to those offered in Live View shooting. In particular, the focusing modes are the same in both cases.

Also when you set the Mode dial to Movie, the camera menus change to show a variety of options that you can set for recording movies.

The following sections help you set up for movie recording with the 60D. It's important to note that careful setup helps create a much smoother and more polished movie.

Setting up for movie recording

To set up for movie shooting, you can choose the movie recording size, the focusing mode, and whether to record audio using the built-in speaker. As with Live View shooting, you can also display a grid to line up vertical and horizontal lines, set the amount of time the camera retains the last metering for exposure, use the Electronic level, and choose whether to use a remote control.

| | Be sure to review Chapter 6 for details on the focusing modes, grid display, Silent shooting modes, and Metering timer because the same options are used in Movie mode shooting. |

When the Mode dial is set to Movie mode, the camera menus change to display the options that you can select during movie recording. Tables 1.1 through 1.3 provide an overview of the menus and options.

| | You can set any of the following options by pressing the Menu button, and then pressing left or right on the Multi-controller to highlight the Menu tab or turning the Main dial. Press up or down on the Multi-controller or turn the Quick Control dial to highlight an option, and then press the SET button to confirm your option selection. |

Table 1.1 Movie 1 Shooting Menu

Commands	Options
Movie exposure	Auto or Manual. Manual enables you to set the ISO, aperture, and shutter speed you want. To set the shutter speed, turn the Main dial. To set the aperture, turn the Quick Control dial. To set the ISO, press the ISO button above the LCD panel, and then press left or right on the Multi-controller to select an ISO from 100-6400.
AF mode	Live mode, Face Detection Live mode, or Quick mode. These are the same focusing modes as those used for Live View shooting, and they are detailed in Chapter 6 and later in this chapter.

continued

Table 1.1 Movie 1 Shooting Menu *(continued)*

Commands	Options
AF w/ shutter button during [Movie shooting]	Enable or Disable. Enabling allows you to half-press the shutter button to focus during shooting. Alternately, you can choose Disable and use the AF-ON button to focus.
AF and metering butt. for [Movie shooting]	Choose this option to reassign the function of half-pressing the shutter button, the AF-ON (start), and the AE Lock buttons. See Chapter 5 for details on this option.
[Movie shooting] ISO speed setting increments	In Manual exposure mode, choose this option to set the ISO sensitivity speed in 1/3 or full-stop increments.
[Movie shooting] Highlight tone priority	Disable or Enable. This is a useful option to enable, particularly when you want to preserve highlight detail in the scene. If you enable this option, the lowest ISO sensitivity setting is 200 and Auto Lighting Optimizer is automatically turned off.

Table 1.2 Movie 2 Shooting Menu

Commands		Options
Movie rec. size		1920 × 1080 at 30, or 24 fps (25 and 24 in PAL).
		1280 × 720 at 60 fps (50 in PAL).
		640 × 480 and Crop 640 × 480 at 60 fps (50 in PAL).
Sound recording	Sound rec.	Auto, Manual, or Disable. Choose Manual to control the recording audio level.
	Rec. level	Set from 1 to 64 levels by turning the Quick Control dial. To set the loudest level of recording, set level meter so it occasionally lights up at the 12 (–12dB) mark. Levels approaching and at 0 will be distorted. Select Disable if you're using an accessory stereo microphone attached to the camera.
	Wind filter	Disable or Enable. Choose Enable and adjust the filter to reduce the noise of wind during outdoor shooting. Low sounds may be muffled, so test this to find the best level. Choose Disable for shooting where wind noise is not a problem.
Silent shooting		Mode 1, Mode 2, Disable. Choose to reduce the noise of the shutter when you take a still picture during movie shooting. These modes are detailed in Chapter 6.
Metering timer		4, 16, 30 seconds, 1, 10, or 30 minutes. This option determines how long the current exposure is retained.
Grid display		Off, Grid 1, or Grid 2. Select a 3 × 3 or 4 × 6 grid to help you align horizontal and vertical lines in the scene. Or select Off if you do not want to use a grid.

The choices that you make on the Movie 3 Shooting menu are applied to both the movie and still images that you shoot during recording.

Table 1.3 Movie 3 Shooting Menu

Commands	Options
Exposure Compensation	Press the SET button to set up Exposure Compensation up to +/–5 stops. This functions for movies just as it does for still images, as described in Chapter 3.
Auto Lighting Optimizer	Disable, Low, Standard, or Strong. Setting anything except Disable automatically corrects the brightness and contrast of movies. If you use Highlight Tone Priority, this setting is automatically cancelled.
Picture Style	Standard, Portrait, Landscape, Neutral, Faithful, Monochrome, or User Def. 1, 2, or 3. Picture Styles are detailed in Chapter 4.
White balance	Daylight (Approx. 5200K), Shade (Approx. 7000K), Cloudy (Approx. 6000K), Tungsten (Approx. 3200K), White fluorescent light (Approx. 4000K), Flash, Custom, or K (2500-10000). White Balance settings are detailed in Chapter 4.
Custom White Balance	Enables you to set a Custom White Balance for movies. Custom white balance is detailed in Chapter 4.

In addition, abbreviated versions of the Shooting 1, Playback 1 and 2, and Setup 1, 2, and 3 menus are available in Movie shooting mode.

Recording movies

To get a feel for shooting, you may want to record your first movies using automatic exposure, and then move into manual exposure shooting. Preparation is also important. Here are a few things to do before you begin shooting a movie:

▶ **Focus on the subject first.** While you can reset focus during shooting, it creates a visual disconnect that isn't ideal. This is especially important if you use Quick mode where the reflex mirror flips down to establish focus.

▶ **Plan for the depth of field.** One advantage of Movie mode on any dSLR, particularly if you are recording with manual exposure, is that you can create a shallow depth of field that isn't possible with a video camera if you are recording with manual exposure. Thus, you can blur the foreground and background for creative effect. Plan ahead for the look you want and choose the lens and set the aperture accordingly.

▶ **Make camera adjustments before recording.** If you're using the built-in microphone, think through camera adjustments that you can make before you begin shooting. This helps keep the sounds such as focusing, image stabilization, and

so on to a minimum during recording. Be sure to set the Picture Style, white balance, recording quality, and so on before you begin shooting with Manual exposure mode.

▶ **Attach and test the accessory microphone.** Stereo sound recording with an accessory microphone is possible by connecting the microphone with a 3.5mm-diameter mini plug that can be connected to the camera's external microphone IN terminal.

▶ **Stabilize the camera.** Use a tripod or specialized holding device for movie shooting to ensure smooth movement. And if you stabilize the camera, turn off Image Stabilization (IS) on the lens if the lens has IS.

Once the camera is set up, you can begin recording by following these steps:

1. **Set the Mode dial to Movie, and then press the Movie shooting button on the back of the camera.** The reflex mirror flips up and a current view of the scene appears on the LCD.

2. **Press the Q button to display the settings that you can adjust.** If you didn't previously set up the camera, you can press up or down on the Multi-controller to move to the option you want to change. Then turn the Main or Quick Control dial to change the setting.

7.1 The Movie shooting Quick Control screen

3. **If you're shooting in Manual exposure mode, follow these steps to set the exposure:**

 • **Turn the Main dial to set the shutter speed.** At 50 or 60 fps, you can choose 1/4000 to 1/60 second. At 24, 25, and 30 fps, you can choose 1/4000 to 1/30 second. For smooth motion for a moving subject, shutter speeds 1/30 to 1/125 second are recommended.

 • **Turn the Quick Control dial to set the aperture.** If necessary, press the UNLOCK button below the Quick Control dial first. Shooting with the same aperture is best to avoid variations in exposure during the movie.

• **Press the ISO button above the LCD panel and turn the Main dial to set the ISO between 100 and 6400.** If you have Highlight Tone Priority enabled, the ISO range is 200 to 6400.

7.2 The Movie shooting display

4. **Focus on the subject.** Here is how to use the focusing options:

 • **Live mode.** Press the Multi-controller to move the white magnifying rectangle so that it is over the part of the subject that you want in focus, and then press the AF-ON button or half-press the shutter button. When focus is achieved, the AF-point rectangle turns green. If focus is not achieved, the AF-point rectangle turns orange. In Live mode, focus takes slightly longer than you are accustomed to.

 • **Face Detection Live mode.** The camera looks for a face or faces in the scene, and displays corner marks or corner marks with left and right arrows, respectively, over the face or faces it finds. You can press the left or right cross key to move the focusing frame to another face. To focus, press the AF-ON button or half-press the shutter button. When focus is obtained, the corner marks appear in green. If the camera cannot find a face in the scene, it displays a solid rectangle and the camera uses the center AF point for focusing.

 • **Quick mode.** If you selected Quick mode, press the Q button to display the 9 AF points. Press up or down on the Multi-controller to activate the AF points, and then select the AF point by turning the Main or Quick Control dial.

 • **Manual Focus.** You need a lens that offers manual focusing to use this option. Set the switch on the side of the lens to MF (Manual Focus). Then turn the focusing ring on the lens to focus on the subject. If you have to change focus during shooting, manual focusing avoids the noise of the AF motor being recorded, but the focusing adjustment can be intrusive to the movie.

5. **Press the Movie shooting button to begin recording the movie.** The Movie mode (red) dot appears at the top right of the screen.

6. **Press the INFO. button one or two times to display more or less shooting information.**

7. **To start recording, press the Movie shooting button.** A red dot appears in the upper right of the screen. To stop recording, press the Movie shooting button again.

 You can't focus continuously on a moving subject in Movie shooting mode.

Note that movie recording can raise the camera's internal temperature. If an icon that resembles a thermometer appears, wrap up shooting and let the camera cool. Taking still photos when the icon is displayed can cause overall image degradation.

Playing back movies

For a quick preview of your movies, you can play them back on the camera's LCD. Of course, with the High-Definition quality, you will enjoy the movies much more by playing them back on a television or computer.

To play back a movie on the camera LCD, follow these steps:

1. **Press the Playback button, and then turn the Quick Control dial until you get to a movie file.** Movies are denoted with a movie icon and the word *Set* in the upper-left corner of the LCD display.

2. **Press the SET button.** A progress bar appears at the top of the screen, and a ribbon of controls appears at the bottom of the display.

3. **Press the SET button to begin playing back the movie, or press left or right on the Multi-controller to select a playback function, and then press the SET button.** You can choose from the following:

 • **Exit.** Select this control to return to single-image playback.

 • **Play.** Press the SET button to start or stop the movie playback.

 • **Slow motion.** Press left or right on the Multi-controller to change the slow-motion speed.

 • **First frame.** Select this control to move to the first frame of the movie.

 • **Previous frame.** Press the SET button once to move to the previous frame, or press and hold the SET button to rewind the movie.

- **Next frame.** Press the SET button once to move to the next frame, or press and hold the SET button to fast-forward through the movie.

- **Last frame.** Select this control to move to the last frame or the end of the movie.

- **Edit.** Select this control to display the editing screen where you can edit out 1-second increments of the first and last scenes of a movie.

- **Volume.** This is denoted as ascending bars; just turn the Main dial to adjust the audio volume.

4. **Press the SET button to stop playing the movie.**

5. **Press Exit to exit out of the movie.**

Cutting movie scenes

During image playback, you can choose to cut the first and/or last scenes of a movie in the camera in 1-second increments, and then save the edited movie. This is handy if you used the first part of the movie for setup or testing and the last section of the movie for wrap up and scenes that are not vital or relevant to the story of the movie.

To cut scenes from a movie, follow these steps:

1. **Follow the previous steps to play back a movie, and then select Edit on the movie play-back control bar at the bottom of the movie.** A screen appears with a frame and control bar at the bottom of the display.

7.3 The Movie editing display

2. **To cut the beginning of the movie, press the SET button, or press left on the Multi-controller to select Cut end, and then press the SET button.** A selection bar with the time segment appears at the top left of the image along with an icon of a pair of scissors.

3. **Press and hold left or right on the Multi-controller to move through the section of the movie indicated on the blue bar, or turn the Quick Control dial to move to the next frame you want to cut.**

4. **Press the SET button to cut the scene.** The blue bar at the top shows what will be left in the movie.

5. **Do one of the following:**

 • Press left on the Multi-controller to select the Play (right arrow) button to see the resulting movie after cuts.

 • Press right on the Multi-controller to select the Save button, and then press the SET button. Select New file to retain the unedited version and save the edited version as a new movie file, or Overwrite to replace the existing movie file with the edited version, or Cancel. If the SD/SDHC card doesn't have sufficient space to save the movie as new file, you can't select the New file option.

 • Press left on the Multi-controller to select Exit, and then press the SET button to return to the movie playback screen.

Working with Flash

With the EOS 60D, you have the option of using the built-in flash, which is handy in a variety of scenes and lighting situations, as well as the option of using one or more Canon EX Speedlites. You can also use the 60D as a wireless transmitter to fire one or more Speedlites, creating a lightweight and versatile portable studio.

In addition, you can control the built-in flash and one or more Speedlites directly from the camera menu, making it quick and easy to set up and use flash lighting. And you can control the settings as well as the Custom Functions for accessory Speedlites such as the 580EX II, 550EX, and 430EX II from the 60D's Flash Control options (Shooting 1 menu).

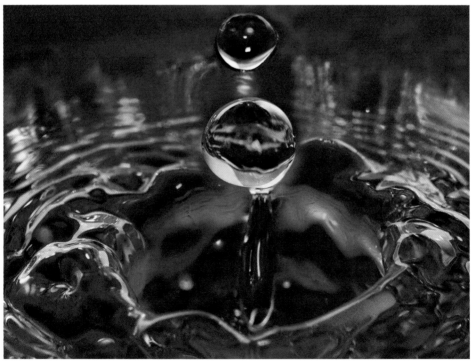

Flash photography is great for everything from portraits and product shots to fun projects such as stopping the motion of water. Exposure: ISO 100, f/10, 1/6 second using a –1-stop of Exposure Compensation.

Flash Technology and the 60D

Canon flash units, whether they're built-in flashes or accessory EX-series Speedlites, use *E-TTL II technology*. To make a flash exposure using Evaluative metering, the camera takes a reading of the light in the scene when you half-press the shutter button. When you fully press the shutter button, a preflash is fired and read by the camera. The camera compares the existing and preflash readings to determine the best flash output, and then stores that information in its internal memory. The camera also detects when there is a difference between the existing and flash light readings, and assumes that the difference is the subject. If the camera detects areas where there are large differences in readings, it attributes them to a highly reflective surface, such as glass or a mirror, and ignores them when calculating the exposure.

During this process, the flash unit also receives information from the camera, including the focal length of the lens, distance from the subject, and exposure settings, and this information confirms if the subject distance from the flash reading is correct. The flash also automatically figures in the angle of view for the 60D given its cropped image sensor size. Thus, the built-in and EX-series Speedlites automatically adjust the flash zoom mechanism to get the best flash angle and to illuminate only key areas of the scene, which also conserves power.

8.1 With one or more flash units, you can simulate studio lighting. Here I used two Speedlites to create a highlight rim on the sides of the wine bottle. Exposure: ISO 100, f/5.6, 3.2 seconds.

To make a flash image, the camera's reflex mirror flips up, the first shutter curtain opens and the flash fires, the image sensor is exposed to make the exposure, and then the second curtain closes.

NOTE The built-in flash offers coverage for lenses as wide as 17mm and a recycle time of 3 seconds.

Why Flash Sync Speed Matters

If flash sync speed isn't set correctly, only part of the image sensor has enough time to receive light while the shutter curtain is open. The result is an unevenly exposed image. The 60D doesn't allow you to set a shutter speed faster than 1/250 second, but you can set a slower flash sync speed. Using Custom Function C.Fn I-7, you can set whether the 60D sets the flash sync speed automatically (Option 0), sets the sync speed to 1/250 to 1/60 second (Option 1), or always sets the sync speed at 1/250 second (Option 2) when you shoot in Aperture-priority AE (Av) mode.

Shooting with the built-in flash

The built-in flash is handy when you need a pop of fill flash for a portrait, or when you are in low-light scenes where you might not otherwise be able to get a shot without a flash. The built-in flash offers coverage for lenses as wide as 17mm and sync speeds between 1/250 and 30 seconds, and it recycles in approximately 3 seconds. Depending on the shooting mode you choose, Tables 8.1 and 8.2 show what you can expect when you use the built-in flash and the flash range estimates.

Table 8.1 60D Exposure Settings Using the Built-in Flash

Shooting mode	Shutter speed	Aperture
Program AE (P)	The 60D automatically sets the shutter speed in the range of 1/250 second to 1/60 second.	The 60D automatically sets the aperture. With flash use, you cannot shift, or change, the exposure in P mode.
Shutter-priority AE (Tv)	You set the shutter speed from 1/250 second to 30 seconds. If you set a shutter speed faster than 1/250 second, the camera automatically readjusts it to 1/250.	The camera automatically sets the appropriate aperture.
Aperture-priority AE (Av)	The camera automatically sets the shutter speed from 1/250 second to 30 seconds. You can determine the flash sync speed by setting C.Fn I-7 to either Option 1, 1/250 to 1/60 second, or to Option 2, 1/250 second fixed. The 60D uses slow-speed flash sync in low light so that the flash exposes the subject properly while the existing light registers with the slow shutter speed. If you use slow-speed flash sync, use a tripod with slow shutter speeds.	You set the aperture and the camera sets the shutter speed.

continued

Table 8.1 60D Exposure Settings Using the Built-in Flash *(continued)*

Shooting mode	Shutter speed	Aperture
Manual (Ml)	You can set the shutter speed in the range of 1/250 second to 30 seconds.	You set the aperture manually. Flash exposure is set automatically based on the aperture.
Bulb (B)	Exposure continues until you release the shutter button.	You set the aperture.
Creative Auto (CA), Portrait, Close up, and Full Auto	The 60D automatically sets the shutter speed in the range of 1/60 second to 1/250 second.	The 60D automatically sets the aperture.
Night Portrait	The 60D sets the shutter speed between 1/250 second and 2 seconds. Given the potential for a very long exposure, use a tripod and ensure that the subject stays stock-still.	The 60D automatically sets the aperture.

Table 8.2 60D Built-in Flash Range

ISO sensitivity setting	f/3.5 (ft/meters)	f/4 (ft/meters)	f/5.6 (ft/meters)
100	12 (3.5)	11 (3)	7.5 (2.5)
200	17 (5.5)	15 (4.5)	11 (3.5)
400	24 (7.5)	21 (6.5)	15 (4.5)
800	34 (11)	30 (9)	22 (6.5)
1600	49 (15)	43 (13)	30 (9.5)
3200	69 (21)	60 (18)	43 (13)
6400	97 (30)	85 (26)	61 (19)
H (12800)	138 (42)	121 (36)	86 (26)
Information in this table provided by Canon			

From the information in Table 8.1, you can see that flash use differs based the shooting mode you choose. In Av and Tv shooting modes, the 60D balances the existing light with the flash light to provide fill flash. Fill flash uses the light in the scene for the exposure and provides just enough flash illumination to fill shadows and brighten the subject. Fill flash provides natural-looking exposures.

In Av shooting mode, you can choose the aperture you want, but because more existing light is used for much of the exposure, it's up to you to ensure that the shutter speed is fast enough to prevent the blur that can occur when you're handholding the camera. Just monitor the shutter speed in the viewfinder when you're using the flash in Av shooting mode. If the shutter speed is too slow, you can use a wider aperture, use a tripod, or use a higher ISO setting. Also, you can use Custom Function (C.Fn) I-7 to set the flash sync speed to ensure a fast-enough shutter speed to prevent that blur that comes from handholding the camera.

In Tv mode, you can set a shutter speed that is fast enough to prevent handshake. But if you set a shutter speed that is out of range for the amount of light in the scene, the aperture value flashes in the viewfinder, alerting you that the camera can't record enough of the exiting light to get a balanced fill-flash exposure. In those cases, set a slower shutter speed, use a tripod, or increase the ISO setting.

© Peter Burian

8.2 For this image, Peter used flash to fill the shadows on the left side of the model's face. Exposure: ISO 400, f/2, 1/4000 second using a –1/3 stop of Exposure Compensation.

In Manual mode, you have full control over the balance between existing and flash light. With fast shutter speeds, less of the existing light is captured — unless the existing light is very bright — and the background goes dark. If you choose a very slow shutter speed, you run the risk of camera shake if you're handholding the camera, but the background will be brighter because more of the existing light factors into the exposure.

Gauging the Power of the Built-in Flash

Understanding the power of the built-in flash is important because it helps you evaluate whether the flash will provide the coverage you need for the scene you're photographing. The classic way to gauge the relative power of the flash is by the flash unit's guide number. While the guide number is not something that you deal with each time you use the built-in flash, understanding guide numbers helps you use the flash more effectively.

A *guide number* indicates the amount of light that the flash emits, or the power of the flash. The guide number is measured at ISO 100 for a field of view of 105mm. From that number, you or the camera can determine what aperture to set given the subject distance and the ISO. The guide number for the 60D's built-in flash is 43 feet (13 meters) at ISO 100. Divide the guide number by the flash-to-subject distance to determine the appropriate aperture to set.

The relationship between the aperture and the flash-to-subject distance is Guide Number ÷ Aperture = Distance for optimal exposure and Guide Number ÷ Distance = Aperture for optimal exposure.

Thus, if the subject is 15 feet from the camera, you divide 43 (the guide number) by 15 feet (camera-to-subject distance) to get f/2.8 at ISO 100.

If you want a different aperture, you can change the camera-to-subject distance, or you can increase the ISO sensitivity setting on the camera. By increasing the ISO, the camera needs less light to make the exposure, and it simultaneously increases the range of the flash. When you increase the ISO from 100 to 200, the guide number increases by a factor of 1.4X; increasing from 100 to 400 doubles the guide number.

Working with the built-in flash

The built-in flash features options you can use to control the flash output to get natural-looking flash images. These options include Flash Exposure Compensation (FEC) and Flash Exposure Lock (FE Lock). In addition, you can set flash functions using the Flash Control options (Shooting 1 menu) when you shoot in P, Tv, Av, M, and B modes.

Flash functions include setting the flash mode, shutter synchronization with either first or second curtain, setting Flash Exposure Compensation, selecting Evaluative or Average metering, and using the Wireless function. You can also turn on Red-eye reduction on the Flash Control options (Shooting 1 menu).

 To use the flash in P, Tv, Av, M, and B shooting modes, you have to press the flash pop-up button. In automatic modes except Flash Off shooting mode, the flash pops up and fires automatically when the 60D determines that flash is needed.

When you use the built-in flash, be sure to remove the lens hood to prevent obstruction of the flash coverage. And if you use a large telephoto lens, the built-in flash coverage may also be obstructed.

Red-eye reduction

The red appearance in a person's eye is caused when the bright flash reflects off the retina, revealing the blood vessels in the reflection. The Red-eye reduction function fires a preflash, causing the pupils of the subject's eye to contract when the subject looks at the preflash.

You can turn on Red-eye reduction on the Flash Control options (Shooting 1 menu). Just highlight Red-eye reduction, press the SET button, and then choose Enable. Then press the SET button to confirm the change.

Modifying flash exposure

There are times when the flash output won't produce the image that you envisioned, and there are times when you want a slightly increased or decreased flash exposure, or to avoid a hot spot on the subject. In these situations, you can modify the flash output using either Flash Exposure Compensation (FEC) or Flash Exposure Lock (FE Lock). You can set both of these options for the built-in flash and an accessory Speedlite.

Flash Exposure Compensation

Flash Exposure Compensation (FEC) enables you to manually adjust the flash output without changing the aperture or the shutter speed in P, Tv, and Av shooting modes. This function is effective when you want to adjust the balance between the foreground and background exposure, and it can help compensate for high or nonreflective subjects. FEC is also useful for balancing lighting in unevenly lit scenes and reducing the dark background flash shadows. When you are using the flash as the primary light, FEC gives good results. If you're using the flash for fill light, then you can use FEC as a dimmer switch to turn the amount of light up or down.

With FEC, you can increase the flash output up to +/–3 stops in 1/3-increments. As a result, you can maintain the camera's original E-TTL (Evaluative Through-the-Lens) readings while manually increasing or decreasing the flash output.

If you use an accessory Speedlite, you can set FEC either on the camera or on the Speedlite. However, the compensation that you set on the Speedlite overrides any compensation that you set using the 60D's FEC function on the Shooting 1 menu. In short, set compensation either on the Speedlite or on the camera, but not on both.

FEC can also be combined with Exposure Compensation. If you shoot a scene where one part of the scene is brightly lit and another part of the scene is much darker — for example, an interior room with a view to the outdoors — then you can set Exposure Compensation to –1 and set the FEC to –1 to make the transition between the two differently lit areas more natural.

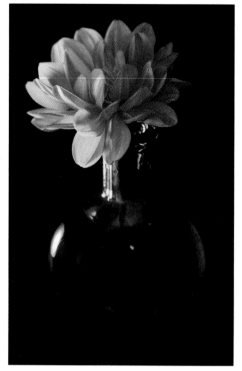

8.3 For this image, I used two Speedlites: one at full power and one with a –1-stop of Flash Exposure Compensation to light this flower. Exposure: ISO 100, f/4.5, 1/10 second using a –1/3-stop of Exposure Compensation.

NOTE Auto Lighting Optimizer can mask the effect of FEC. If you want to see the effect of the compensation, turn off Auto Lighting Optimizer by setting it to Disable on the Shooting 2 menu.

To set FEC for the built-in flash or for a Speedlite, follow these steps:

1. **Set the camera to P, Tv, Av, M, or B shooting mode, and then press the Q button.** The Quick Control screen appears on the LCD.

2. **Press up or down on the Multi-controller to select the Flash Exposure comp. icon, and then press the SET button.** The Flash exposure comp. screen appears.

3. **Turn the Quick Control dial to the left to decrease the flash output or to the right to increase it.** The FEC icon appears in the viewfinder when you half-press the shutter button.

4. **Make the picture and check the exposure. If necessary, adjust the amount of compensation by repeating these steps.** The Flash Exposure Compensation you set on the camera remains in effect until you change it. To remove FEC, repeat these steps, but in Step 3, move the tick mark on the Flash Exposure Compensation indicator back to the center point.

Flash Exposure Lock

Flash Exposure Lock (FE Lock) is a great way to control flash output for any part of the scene or subject. For example, you might set the flash exposure for a subject's skin in a portrait or for a gray card. FE Lock fires a preflash that is read from a very precise area at the middle of the frame — a Spot meter reading from 2.8 percent of the frame at the center. So be sure to point the center of the viewfinder over the part of the scene or subject from which you want to take the meter reading. This preflash meter reading is stored temporarily so that you can move the camera to recompose the scene, focus, and make the image.

If you're accustomed to using gray cards, then you can use the one provided in the back of this book, or identify a middle-gray tonal value in the scene and lock the flash exposure on it. If the area from which you take the meter reading is brighter or darker than middle gray, you can use Flash Exposure Compensation to compensate for the difference.

Regardless of your approach, FE Lock is a technique that you want to add to your arsenal for flash images.

 If you are shooting a series of images under unchanging existing light, then FEC is a more efficient approach than using FE Lock.

To set FE Lock, follow these steps:

1. **Set the camera in P, Tv, Av, M, or B shooting mode, and then press the Flash button to raise the built-in flash or attach an accessory Speedlite.** The flash icon appears in the viewfinder when you half-press the shutter button.

2. **Point the center of the viewfinder over a gray card, an area that is middle (18 percent) gray, or on the area of the subject where you want to lock the flash exposure, and then press the FE Lock button on the back of the camera.** This button has a magnifying glass with a minus sign in it. The camera fires

a preflash. FEL is displayed momentarily in the viewfinder, and the flash icon in the viewfinder displays an asterisk beside it to indicate that flash exposure is locked. If the flash icon in the viewfinder blinks, you're beyond the flash range, so move closer and repeat the process.

3. **Move the camera to compose the image, half-press the shutter button to focus, and then completely press the shutter button to make the image.** Ensure that the asterisk is still displayed to the right of the flash icon in the viewfinder before you make the picture. As long as the asterisk is displayed, you can take other images at the same compensation amount.

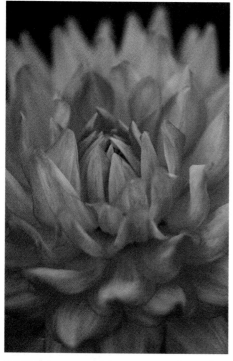 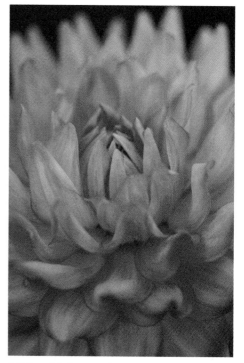

8.4 This image and the next one show the subtle improvements a bit of flash can make when you're shooting nature subjects outdoors — especially in the flat light of an overcast day. In this image, no flash was used. Exposure: ISO 100, f/2.8, 1/60 second.

8.5 For this image, I used an on-camera 580EXII Speedlite with a –1-stop of Flash Exposure Compensation to open up shadow detail and brighten the center of the flower. Exposure: ISO 100, f/2.8, 1/60 second.

Setting Flash Control options

You can set many of the onboard and accessory flash settings using the Flash Control options (Shooting 1 menu) on the 60D. This menu offers an array of adjustments for the built-in flash, including the first or second curtain shutter sync and the choice of Evaluative or Average exposure metering. This menu also enables you to change the Custom Function (C.Fn) settings for compatible Speedlites.

NOTE For all step-by-step instructions in this chapter, you can access the 60D camera menus by pressing the Menu button. Then press left or right on the Multi-controller or turn the Main dial to highlight the menu tab, and then press up or down on the Multi-controller to highlight a menu option or turn the Quick Control dial.

To change settings for the built-in or compatible accessory EX-series Speedlites, follow these steps. If you are using an accessory Speedlite, mount it on the hot shoe and turn it on.

1. **Set the camera to P, Tv, Av, M, or B shooting mode, highlight Flash Control on the Shooting 1 menu, and then press the SET button.** The Flash Control screen appears.

2. **Press up or down on the Multi-controller to highlight the setting that you want to change, and then press the SET button.** Table 8.3 details the Flash Control menu (Shooting 1 menu) and the options you can choose for both the built-in flash and/or an accessory Speedlite.

 As you review this menu, know that

 - A colon represents ratio control between the built-in and Speedlite flash units. Ratios and stops are equivalent. One stop is twice as bright as the other. With each stop being twice as bright, the formula is $2 \times 2 \times 2 = 8$. An 8:1 ratio represents a 3-stop difference.

 - A plus sign means that the built-in and Speedlite flash units act as one flash system.

 - The letters A, B, C represent groups with one or more flash units in a group.

 - Ratio control such as A:B ratio determines the relative power or brightness between two flash groups.

 I recommend visiting MichaelTheMentor on YouTube (www.youtube.com/user/MichaelTheMentor) for flash tutorials.

Table 8.3 Flash Control Menu Options

Setting	Option(s)	Suboptions/Notes
Flash Firing	Enable, Disable	Turns the flash firing on and off for shooting in P, Tv, Av, M, and B modes. You can choose Disable if you want to use the flash AF-assist beam to help the camera achieve focus in low-light scenes, a technique detailed later in this chapter.
Built-in flash func. setting	Flash mode	E-TTL II, or Manual flash.
	Shutter sync	First curtain: Flash fires at the beginning of the exposure. Can be used with a slow-sync speed to create light trails in front of the subject.
		Second curtain: Flash fires just before the exposure ends. Can be used with a slow-sync speed to create light trails behind the subject.
	E-TTL II meter.	Evaluative. This default setting sets the exposure based on an evaluation of the entire scene.
		Average: Flash exposure is metered and averaged for the entire scene. Results in brighter output on the subject and less balancing of existing background light. You may want to apply some Flash Exposure Compensation if the subject exposure is too bright.
	Wireless func.	Disable, Speedlite or built-in flash, Speedlite only, or Speedlite and the built-in flash.
	Channel	Up to four communication channels
	Flash exp. comp.	Press the SET button to activate the Flash Exposure level indicator, and then you can set up to 3 stops of Flash Exposure Compensation.
	Clear flash settings	Press the INFO. button to display a screen where you can choose to clear the built-in flash settings.

Setting	Option(s)	Suboptions/Notes
External flash func. setting	Flash mode	E-TTL II, Manual flash, MULTI flash, and depending on the Speedlite, TTL, AutoExtFlash, and Man.ExtFlash. Note that the settings may depend on Speedlite settings.
	Shutter sync	First curtain: Flash fires immediately after the exposure begins.
		Second curtain: Flash fires just before the exposure ends. Can be used with slow-sync speed to create light trails behind the subject.
		High-speed: Enables flash at speeds faster than 1/250 second. However, the flash range is shorter.
	FEB	Set Flash Exposure Bracketing of +2/–3 stops.
	E-TTL II meter.	Evaluative. This default setting sets the exposure based on an evaluation of the entire scene.
		Average: Flash exposure is metered and averaged for the entire scene. Results in brighter output on the subject and less balancing of existing background light. You may want to apply some Flash Exposure Compensation if the subject exposure is too bright.
	Zoom	Auto, or turn the Multi-controller to set the zoom setting from 24-105mm.
	Wireless func.	Enable or Disable. See the flash manual for details on additional settings.
	Master flash	Enable to have the external flash control slave flash units.
		Disable.
	Channel	Select the communications channel for multiple wireless flashes. Flash units should be on the same channel.
	Firing group	All, A:B, A:B C
	Flash exp. comp.	Set +/– 3 stops of Flash Exposure Compensation
	A:B fire ratio	2:1, 1:1, 1:2. Sets the lighting ratio of external flashes.
	Grp. C exp. comp.	Press the SET button to activate the Exposure Level meter to set +/–3 stops of compensation for the C flash or group of flash units.
External flash C.Fn setting	Custom Functions depend on the Speedlite in use	Press the SET button to display the C.Fn screen for the external Speedlite.
Clear ext. flash C.Fn set.	Highlight and press the Set button, then choose OK.	Choose this option and press the INFO. button to display a screen where you can choose to clear the built-in flash settings.

Shooting with Speedlites

A single Speedlite offers many advantages, one of which is that it is more powerful than the built-in flash. With E-TTL II technology, you can simply attach the Speedlite and begin shooting good exposures. The camera and Speedlite communicate so that the cropped sensor size and the lens you're using are automatically calculated.

However, to get better flash images, you need to remove the Speedlite from the camera. To do this, you can mount the Speedlite on a flash bracket. Alternately, you can handhold the flash while it's attached to the camera by a flash cable, or you can fire the Speedlite wirelessly by using the built-in flash. Then as you progress, you can add flash modifiers. Modifiers can be as simple and inexpensive as a Sto-Fen cap that diffuses the flash light. Alternatively, you can attach a flash softbox or mount the Speedlite on a stand and shoot it into an umbrella. With any of these options, you can position and diffuse the flash light for excellent results.

If one flash is good, it follows that more flash units would be better. While that logic doesn't hold true for everything, in the case of flash units it does. Multiple Speedlites enable you to set up lighting patterns and ratios similar to studio lighting. You also have the option of using one or more flash

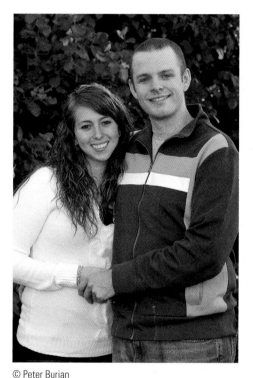

© Peter Burian

8.6 Peter used a single Speedlite to brighten the faces of the subjects while taking advantage of the lovely side rim light in the scene. Exposure: ISO 400, f/6.3, 1/160 second.

units as either the main or an auxiliary light source to balance existing light with flash to provide even and natural illumination and balance among light sources. Plus, unlike some studio lighting systems, a multiple Speedlite system is lightweight and portable.

 For detailed information on using Canon Speedlites, I recommend the *Canon Speedlite System Digital Field Guide* by Brian McLernon (Wiley, 2010).

Setting up wireless Speedlites

The 60D is compatible with EX-series Speedlites. With EX-series Speedlites, you get FP (focal-plane) Flash Sync, Flash Exposure Bracketing, and *flash modeling* (to preview the flash pattern before the image is made). And you can use the 60D's built-in flash as a wireless Speedlite transmitter to fire multiple Speedlites.

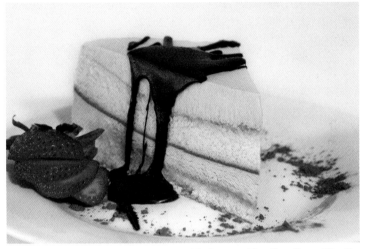

8.7 I used three Speedlites to light this image. The first Speedlite lit the white background, the second Speedlite was on the left of the camera, and the third Speedlite was on the right of the camera. Exposure: ISO 100, f/5.6, 1/6 second.

You can set up the flash units in groups and control the light output directly from the camera menu. Although this book does not provide extensive instructions for wireless flash techniques, the following sections help get you started with a wireless flash setup such as a single Speedlite with or without the built-in flash or a wireless flash with multiple Speedlites.

The first step is to mount one or more Speedlites on stands — use either the stands that come with the flash units or commercial stands — and then place them around the set or subject, and swivel the flash head toward the subject and/or the background if you are using multiple Speedlites. Just remember that the wireless sensor on the Speedlite(s) have to be pointed toward the 60D.

Setting up a single wireless Speedlite

An easy way to use the flash off the camera and gain much more control over the lighting is by using the 60D's wireless flash transmitter function to fire the Speedlite. The setup is simple and quick, and the results are much better than what on-camera flash provides.

To set up the Flash Control functions for single-Speedlite shooting, follow these steps.

1. **Set the Mode dial to P, Tv, or Av shooting mode and pop up the built-in flash.** Review the details in Table 8.1 for the sync speeds in each shooting mode.

2. **On the Setup 1 menu tab, highlight Flash Control, and then press the SET button.** The Flash Control screen appears.

3. **Select the Built-in flash func. setting, and then press the SET button.** The Built-in flash func. setting screen appears.

4. **Select the following settings, and after you make each selection, press the SET button:**

 Flash mode: E-TTL II

 Shutter sync.: 1st curtain

 E-TTL II meter.: Evaluative

 Wireless func.: Speedlite (displayed as an icon of a flash unit without a base)

 Channel: 1

 Firing Group: Speedlite (icon) All

5. **Set the Speedlite to Slave mode.** Refer to the Speedlite instruction manual for instructions.

6. **Position the Speedlite where you want it to light the subject and ensure that it has line-of-site transmission to the camera, and then focus and make the picture.**

Setting up multiple wireless Speedlites

Setting up multiple Speedlites presents many more lighting options, including the option to control the ratio of lights that are controlled as slave groups. In multiple flash photography, there is a master unit, the 60D, and one or more slave, or secondary, units that are fired wirelessly by the master unit. Slave units can be Speedlites, such as the 580EX II, 580EX, and 430EX II. In addition, you can choose whether the 60D's built-in flash fires; however, if you do not have the built-in flash fire, it still emits a low-level flash and it fires the slave Speedlites.

To light large subjects or scenes, you can set the Speedlites so they fire as a single unit, all at the same output. In that situation, you set the Firing group option on the Built-in flash func. setting screen to the Speedlite (icon) All option.

But more often, you want the Speedlites to mimic studio lighting so that you can control their output to create classic lighting patterns. And to achieve different lighting patterns, the Speedlites have to be in designated groups; this way you can control the lighting ratios.

Refer to the instruction manual for your specific Speedlite when you set it up. The following is a general checklist for setting up multiple wireless Speedlites.

▶ **Set the Speedlite(s) as slave units.** The process differs by Speedlite. Some have a switch, and on other Speedlites, you set the Slave option on the flash menu.

▶ **Set the communication channels.** Channels enable you to work in an area where other photographers are working with flash units; when you set a channel, your flashes do not trigger their flashes. You can choose any of four channels. Set the flash units to the same channel.

▶ **Set the slave unit group or ID.** You can set up groups A, B, and C and then control the ratio — the output of each group relative to the other group. Set one Speedlite to A, set the second Speedlite to B, and so on.

▶ **On the 60D's Flash control/Built-in flash func. setting screen, set the following, and press the SET button after making each selection:**

> **E-TTL II meter.:** Evaluative
>
> **Wireless func.:** Speedlite (icon)
>
> **Channel:** 1
>
> **Firing group:** Speedlite (icon) (A:B) to set a ratio or Speedlite (icon) All for the Speedlites to fire as a single unit.
>
> **A:B fire ratio:** Set the ratio you want. For example, for a portrait, a 2:1 ratio provides nice brightness on one side of the face, with a shadow on the other side of the face.

▶ **Position the camera and Speedlites.** Set up the camera and the Speedlites to get the lighting effect that you want, keeping each unit within its range of coverage. The Speedlite wireless sensors must be set facing the 60D.

As you can see, the Flash control/Built-in flash func. setting enables you to control virtually all aspects of the lighting setup. You can add the built-in flash unit as part of the overall flash setup by changing the Wireless func. to include the Speedlites and the built-in flash. And you can apply Flash Exposure Compensation to all slaves or to the slave Speedlites and the built-in flash on the same screen.

Whether you're using one or multiple Speedlites, you'll get pleasing results by using modifiers. I routinely use silver, gold, and shoot-through umbrellas, a small Photoflex LiteDome for strobes, and I also mount the Speedlites on affordable Photoflex LiteStand LS-B2211s.

In low-light scenes, the flash often illuminates the subject properly, but the background is too dark. You can switch to Av or Tv shooting mode and use a wide aperture or slow shutter speed respectively to allow more of the existing light to contribute to the exposure. With a slow shutter speed, use a tripod and ask the subject to remain still.

Using the flash AF-assist beam without firing the flash

In some low-light scenes, you may not want the built-in or an accessory flash, but the light is too low for the camera to establish focus easily. This is when you can use the flash unit's AF-assist beam to help the camera establish focus without actually firing the flash.

Before you begin, check the settings for C.Fn III-4, AF-assist beam firing. If this function is set to Option 1: Disable, then change it to Option 0: Enable. Also if the Speedlite's Custom Function is set to Disabled, the Speedlite AF-assist beam does not fire until you change the Custom Function on the Speedlite.

For details on Custom Functions, see Chapter 5.

To disable flash firing, but use the flash's AF-assist beam to help the camera focus, follow these steps:

1. **On the Shooting 1 menu, highlight Flash Control, and then press the SET button.** The Flash Control screen appears.

2. **Press up or down on the Multi-controller to highlight Flash firing, and then press the SET button.** Two options appear.

3. **Press up or down on the Multi-controller to select Disable, and then press the SET button.** Neither the built-in flash nor an accessory Speedlite will fire.

4. **Press the flash pop-up button, or mount an accessory EX-series Speedlite.**

5. **Half-press the shutter button to have the flash AF-assist beam fire to help the camera establish focus.**

The advantage of the built-in flash is that it is available anytime you need a pop of additional light. The scenarios for using the flash in P, Tv, Av, and M shooting modes vary from filling shadows in portraits to providing the primary subject illumination.

On the 60D, the E-TTL II setting automatically detects when the flash pops up. Then when the exposure for the existing light in the scene is properly set, the camera automatically provides reduced output to fill shadows in a natural-looking way as opposed to a blasted-with-flash rendering.

Exploring flash techniques

While it is beyond the scope of this book to detail all the lighting options that you can use with one or multiple Speedlites, I cover some common flash techniques that provide better flash images than using straight-on flash.

Bounce flash

One frequently used flash technique is *bounce flash*, which softens hard flash shadows by diffusing the light from the flash. To bounce the light, turn the flash head to point toward the ceiling or a nearby wall, so that the light hits the ceiling or wall and then bounces back to the subject. This technique spreads and softens the flash illumination.

If the ceiling is high, it may underexpose the image. As an alternative, I often hold a silver or white reflector above the flash to act as a ceiling. This technique offers the advantage of providing a clean light with no colorcast. A few tips will help you get the best bounce-flash results:

▶ Bounce the flash off a neutral and light color surface to reduce light loss and avoid throwing the color of the wall onto the subject.

▶ Bounce the flash off the ceiling rather from directly above the subject to avoid casting shadows on the subject's face. Better yet, bounce the flash off a side wall to create shadow patterns that add depth, or *modeling*, to the subject.

▶ Bounce the flash as far as possible. The farther the bounce distance, the softer the light (at the same flash level). However, ensure that the distance isn't so far that the flash becomes ineffective.

Adding catchlights to the eyes

Another frequently used technique is to create a catchlight in the subject's eyes by using the panel that is tucked into the flash head of some Speedlites. Just pull out the translucent flash panel on the Speedlite. At the same time, a white panel comes out;

you can use it to create catchlights. The translucent panel is called the *wide* panel and you use it with wide-angle lenses to spread the light. Push the wide panel back in while leaving the white panel out. Point the flash head up, and then take the image. The panel throws light into the eyes, creating catchlights that add a sense of vitality to the eyes. For best results be within 5 feet of the subject.

 If your Speedlite doesn't have a panel, you can tape an index card to the top of the flash to create catchlights.

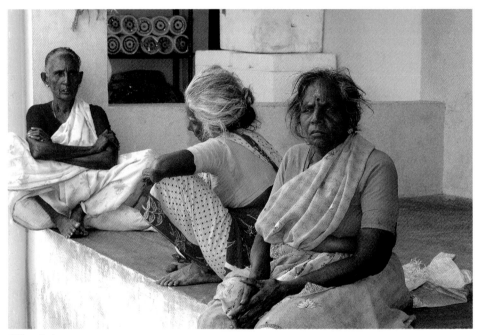

© Peter Burian

8.8 Peter used fill flash to add catchlights to the eyes of this woman. The flash also improved the image contrast. Exposure: ISO 400, f/8, 1/60 second.

Lenses and Accessories

H aving a high-quality camera like the 60D is one element of the equation in getting great images. Another element is the lenses that you use on the 60D. Excellent lenses not only deliver the sharpness and contrast that set images apart, but they also broaden your ability to express your creative vision. For most photographers, buying lenses is a gradual process, and over time, the investment in lenses far exceeds the investment in the camera body.

Your investment in a system of lenses is one that will pay excellent dividends in terms of image quality for years to come. The lenses you buy will last a long time. In fact, they will outlast one or more camera bodies. So as much you can, buy the best lenses that you can afford with an eye toward lenses that will serve your needs both now and in the future.

Lenses help you achieve the vision that you have for your images. Here a wide f/3.5 aperture combined with a 100mm telephoto focal length provided just enough blur on the background statue to add context to the daisy. Exposure: ISO 200, f/3.5, 1/1000 second using an EF 100mm f/2.8L IS II Macro USM lens.

Evaluating Lens Choices for the 60D

With more than 60 compatible Canon EF and EF-S lenses and accessories, you have a wide range of choices, and your options are even more extensive when you factor in compatible lenses from third-party companies. In fact, the sheer number of lens options can be confusing. This chapter helps you develop a strategy for building a lens system that serves you well.

Building a lens system

By now, you have your first lens, and you may be wondering which lens to buy next. A few basic strategies can help you create a solid plan for adding new lenses to your system. A practical approach is to begin with two good lenses that cover the focal range from wide-angle to telephoto. These two lenses are the foundation for your system; you can shoot 80 to 95 percent of the scenes and subjects that you encounter, ranging from landscapes with the wide-angle zoom lens to portraits and wildlife with the telephoto zoom lens.

Because you'll use these lenses often, they should be high-quality lenses that produce images with snappy contrast and excellent sharpness, and ideally they should be fast enough to allow you to shoot in low-light scenes. A *fast lens* is generally considered any lens with a maximum aperture of f/2.8 or faster. With a fast lens, you have a better chance of handholding the camera in low light and getting sharp images. And if the lens has Image Stabilization, a lens feature detailed later in this chapter, you gain more stability.

My first two Canon lenses were the EF 24-70mm f/2.8L USM lens and the EF 70-200mm f/2.8L IS USM lens — two excellent lenses that cover the focal range of 24-200mm. Today these two lenses are still the ones I use most often. And because I shoot with a variety of Canon EOS cameras, I know that I can mount these lenses on the 60D, the T2i, the 5D Mark II, or the 1Ds Mark III and get beautiful images.

If you bought the 60D as a kit with the EF-S 18-135mm f/3.5-5.6 IS lens, then you may already have learned that this lens provides a good focal range for everyday shooting. While this lens doesn't have the USM designation for the ultrasonic motor drive, it is a bit noisy during focusing, but it's a capable lens. Your next step might be to add either a longer telephoto lens to your gear bag, or a wider lens.

9.1 The EF 70-200mm f/2.8L IS USM lens is one of the first lenses I bought, and it is still one of the lenses I use most often, as I did for this scene of two ducklings in a protected wetland area. Exposure: ISO 100, f/4.5, 1/80 second using a –2/3-stop of Exposure Compensation.

Understanding the focal-length multiplier

One of the most important lens considerations for the 60D is that it has an APS-C-size image sensor. *APS-C* is simply a designation that indicates that the image sensor is 1.6 times smaller than a traditional full 35mm frame. As a result, the lenses you use on the 60D have a smaller angle of view than they have when used on a full-frame camera. A lens's angle of view is how much of the scene, side to side and top to bottom, that the lens encompasses in the image.

In short, the angle of view for Canon EF lenses that you use on the 60D is reduced by a factor of 1.6X at any given focal length. That means that a 100mm lens is equivalent to a 160mm lens when used on the 60D. Likewise, a 50mm normal lens is the equivalent to using an 80mm lens — a short telephoto lens on the 60D.

> **NOTE** With the cropped sensor on the 60D, an EF lens's focal length must be multiplied by 1.6 to determine its actual focal length on the 60D. However, in everyday conversation, photographers refer to EF lenses by their focal length on a noncropped (full 35mm frame) camera.

This focal-length multiplication factor works to your advantage with a telephoto lens because it effectively increases the lens's focal length (although technically the focal length doesn't change). And because telephoto lenses tend to be more expensive than other lenses, you can buy a shorter and less-expensive telephoto lens and get 1.6X more magnification at no extra cost.

The focal-length multiplication factor works to your disadvantage with a wide-angle lens; the sensor sees less of the scene because the focal length is magnified by 1.6. However, because wide-angle lenses tend to be less expensive than telephoto lenses, you can buy an ultrawide 14mm lens to get the equivalent of an angle of view of 22mm.

As you think about the focal-length multiplier effect on telephoto lenses, it seems reasonable to assume that the focal length multiplier would produce the same depth of field that a longer lens — the equivalent focal length — does. That isn't the case, however. Although an 85mm lens on a full 35mm-frame camera is equivalent to a 136mm lens on the 60D, the depth of field on the 60D matches the 85mm lens, not a 136mm lens. This depth of field principle also holds true for enlargements. The depth of field in the print is shallower for the longer lens on a full-frame camera than it is for the 60D.

9.2 This image shows the approximate difference in image size between a full-frame 35mm camera and the 60D. The smaller image size represents the 60D's image size.

Another important lens distinction for the 60D is that it's compatible with both EF-mount and EF-S-mount lenses. The EF lens mount is compatible across all Canon EOS cameras regardless of image sensor size, and regardless of camera type, whether digital or film. However, the EF-S lens mount is specially designed to have a smaller image circle: the area covered by the image on the sensor plane. EF-S lenses can be used only on cameras with cropped frames, such as the 60D, T2i, and 7D among others, because the rear element on EF-S lenses protrudes back into the camera body.

This also factors into how you build your lens system. As you buy lenses, think about whether you want lenses that are compatible with both a full-frame camera and a cropped sensor camera, or not. As your photography career progresses, you'll most likely buy a second, backup camera body or move from the 60D to another EOS camera body. If your next EOS camera body has a full 35mm frame sensor, you'll want the lenses you've already acquired to be compatible with it, which means you'll buy the EF-mount lenses. Of course, if you have EF-S lenses, you can sell them.

Types of Lenses

My photography students often ask me which lens they should buy next. It is virtually impossible to answer that question for someone else. If that's your question too, then you have to consider the scenes and subjects you most enjoy shooting, your budget, and your goals for expanding your photography.

Then, it is important to have a solid understanding of the different types of lenses and their characteristics. Only then can you evaluate which types of lenses best fit your needs. The following sections provide a foundation for evaluating lenses by category and by characteristics.

Lenses are categorized in many ways, and one basic categorization is whether they zoom to different focal lengths or have fixed focal lengths (known as *prime lenses*). Within these two categories, lenses are further grouped by focal length (the amount of the scene included in the frame) in three main types: wide-angle, normal, and telephoto. And macro lenses are in a subcategory, serving double duty as macro and either normal or telephoto lenses.

One categorization of lenses is *zoom* and *prime*. The primary difference is that a zoom lens offers a range of focal lengths in a single lens. By contrast, a prime lens has a fixed, or single, focal length. Additional distinctions, discussed in the following sections, come into play as you evaluate whether a zoom or prime lens is best for your shooting needs.

Zoom lenses

Because zoom lenses provide variable focal lengths when you zoom the lens to bring the subject closer or farther away, they are very versatile in a variety of scenes. Consequently, if you use them, you can carry fewer lenses. For example, carrying a Canon EF-S 17-55mm f/2.8 IS USM lens and a Canon EF 55-200mm f/4.5-5.6 II USM lens, equivalent to 88-320mm on the 60D, or a similar combination of lenses, gives you the focal range you need for most everyday shooting.

9.3 Wide-angle zoom lenses such as the Canon EF 16-35mm f/2.8L USM and EF 24-70mm f/2.8L USM lenses help bridge the focal-length multiplier gap by providing a wide view of the scene.

Zoom lenses, which are available in wide-angle and telephoto ranges, are able to maintain focus during zooming. To keep the lens size compact and to compensate for aberrations with fewer lens elements, most zoom lenses use a multi-group zoom with three or more movable lens groups.

Most midpriced and more expensive zoom lenses offer high-quality optics that produce sharp images with excellent contrast. Many Canon lenses offer full-time manual focusing by setting the button on the side of the lens to MF (Manual Focusing).

Some zoom lenses are slower than single focal-length, or prime, lenses, and getting a fast zoom lens — with a maximum aperture of f/2.8 or faster — means paying a higher price. While using zoom lenses allows you to carry around fewer lenses, they tend to be heavier than their single focal-length counterparts.

> **NOTE** Maximum aperture refers to the widest aperture of the lens. For the 70-200mm f/2.8L IS USM lens, the maximum, or widest aperture, is represented by the f/2.8 designation. Maximum aperture is also often referred to as the lens *speed*.

Some zoom lenses have a variable aperture, which means that the minimum aperture changes at different zoom settings on the lens. For example, an f/4.5 to f/5.6 variable-aperture lens means that at the widest focal length, the maximum aperture is f/4.5 and at the longer end of the focal range, the maximum aperture is f/5.6. In practical terms, this limits the versatility of the lens at the longest focal length for shooting in all but bright light or at a high ISO setting. And unless you use a tripod or your subject is stone-still, your ability to get a crisp picture in lower light at f/5.6 is questionable.

More expensive zoom lenses offer a fixed and fast, or relatively fast, maximum aperture; with maximum apertures of f/2.8, you get faster shutter speeds, enhancing your ability to get sharp images when handholding the camera. But the lens speed comes at a price: the faster the lens, the higher the price.

Prime lenses

Prime, or single focal-length, lenses, are worth careful evaluation, and they make a great addition to your lens system because they provide sharpness, speed, and excellent contrast. With a prime lens, the focal length is fixed, so you must move closer to or farther from your subject to change image composition. Canon's venerable EF 50mm f/1.4 USM and EF 100mm f/2.8L IS Macro USM lenses are only two of a lineup of Canon prime lenses and the prices range from highly affordable to very expensive.

9.4 Single focal-length lenses such as the EF 50mm f/1.4 USM and the EF 50mm f/1.2L USM are smaller and lighter and provide excellent sharpness, contrast, and resolution when used on the 60D.

Unlike zoom lenses, prime lenses tend to be fast, with maximum apertures of f/2.8 or wider. The fast maximum apertures allow fast shutter speeds, which enable you to handhold the camera in lower light and still get a sharp image. Prime lenses are lighter and smaller than zoom lenses and they also tend to be sharper than some zoom lenses.

Though most prime lenses are lightweight, you need to carry more of them to cover the range of focal lengths. Prime lenses also limit the options for on-the-fly composition changes that are possible with zoom lenses.

I've long been a fan of prime lenses, and I use prime lenses as often as zoom lenses. My prime lenses include: the EF 50mm f/1.2L USM, EF 100mm f/2.8L Macro IS USM, 85mm F/1.2L II, and 180mm f/3.5L Macro USM.

The 50mm and 85mm lenses are especially useful in low-light venues, such as music concerts, where I can't get fast-enough shutter speeds using slower zoom lenses. And the 85mm is an ideal portrait lens. On the 60D, the 50mm lens is an 80mm lens, and the 85mm lens is equivalent to 136mm. And that makes both lenses short telephoto lenses on the 60D, great for portraits and still-life subjects.

Working with Different Types of Lenses

Within the zoom and prime lens categories, lenses are grouped by their focal lengths. While some lenses fall into more than one group, the groupings are still useful when talking about lenses in general. Before going into specific lenses, it is helpful to understand a couple of concepts.

First, the lens's *angle of view* is expressed as the angle of the range that's being photographed, and it's generally shown as the angle of the diagonal direction. The image sensor is rectangular, but the image captured by the lens is circular, and it's called the *image circle*. The image that's captured is taken from the center of the image circle.

For a 15mm fisheye lens, the angle of view is 180 degrees on a full-frame 35mm camera; for a 50mm lens, it's 46 degrees; and for a 200mm lens, it's 12 degrees. Simply stated, the shorter the focal length, the wider the scene coverage, and the longer the focal length, the narrower the coverage. These focal lengths change for EF-mount lenses used on a cropped-sensor camera such as the 60D. Therefore, when I refer to an EF lens's focal length, the 1.6X multiplier must be applied to get the focal length equivalent for the 60D.

Second, the lens you choose affects the perspective of images. *Perspective* is the visual effect that determines how close or far away the background appears to be from the main subject. The shorter (wider) the lens, the more distant background elements appear to be, and the longer (more telephoto) the lens, the closer, or more compressed the elements appear.

Wide-angle lenses

Wide-angle lenses do what the name implies — they offer a wide view of a scene. Sometimes, the view is beyond human perspective, and depending on the focal length, this strong perspective creates a separation between the subject and the background or objects in a landscape scene. In addition, wide-angle lenses provide a greater sense of depth than normal or telephoto lenses provide.

Generally, lenses shorter than 50mm are commonly considered wide-angle on full-frame 35mm image sensors. On the 60D, a normal lens is closer to 30-35mm. Not including the 15mm fisheye lens, EF-mount wide-angle and ultrawide lenses range from 16-40mm.The EF-S 10-22mm f/3.5-4.5 USM lens is designed specifically for cropped sensor cameras such as the 60D. The wide-angle lens category provides angles of view ranging from 114 to 63 degrees.

On the 60D, the 1.6X focal-length multiplier works to your disadvantage. Thus, if you often shoot landscapes, cityscapes, architecture, and interiors, you can consider buying a lens that offers a true wide-angle view. Good choices include the EF 16-35mm f/2.8L II USM (approximately 26-56mm with the 1.6X multiplier), the EF-S 10-22mm f/3.5-4.5 USM, or the EF 17-40mm f/4L USM lens (approximately 27-64mm with the multiplier).

Wide-angle lenses are ideal for capturing scenes ranging from sweeping landscapes and architecture to large groups of people, and for taking pictures in places where space is cramped.

9.5 To get the wide-angle view on the 60D, you need a wide-angle lens such as the EF 16-35mm f/2.8L lens that I used here to photograph the Skykomish River near Sultan, Washington. The focal length was set to 24mm. Exposure: ISO 100, f/8, 1/320 second using −1 stop of Exposure Compensation.

Here are wide-angle lens characteristics to keep in mind:

▶ **Extensive depth of field.** Particularly at small apertures from f/11 to f/32, the entire scene, front to back, appears in acceptably sharp focus. This characteristic gives you slightly more latitude for less-than-perfectly focused pictures.

The lens's aperture range is one factor that affects the depth of field. The depth of field is also affected by the focal length and the camera-to-subject distance.

▶ **Fast apertures.** Wide-angle lenses tend to be faster (meaning they have wider maximum apertures) than telephoto lenses. For example, the EF 24mm and 35mm lenses sport a very fast f/1.4 aperture while the more economical EF 35mm offers a fast f/2 maximum aperture. As a result, wide-angle lenses are good choices for shooting when the lighting conditions are not optimal.

▶ **Distortion.** Wide-angle lenses can create perspective distortion, especially if you tilt the camera up or down when shooting. For example, if you tilt the camera up to photograph a group of skyscrapers, the lines of the buildings tend to converge and the buildings appear to fall backward (also called *keystoning*). You can minimize the distortion by keeping the camera level and parallel to the main subject. The wider the focal length, the more pronounced the distortion. For architectural subjects, a 28mm lens offers low distortion along with an ample focal range, and on a cropped sensor camera, that translates to an 18mm lens in the EF line.

▶ **Perspective.** Wide-angle lenses have a *foreshortening effect* that makes objects close to the camera appear disproportionately large, while subjects farther away quickly decrease in size. The wider the lens, the stronger the foreshortening effect. You can use this characteristic to move the closest object farther forward in the image, or you can move back from the closest object to reduce the effect. Wide-angle lenses are popular for portraits, but if you use a wide-angle lens for close-up portraiture, keep in mind that the lens exaggerates the size of facial features closest to the lens, which is unflattering.

9.6 This image and Figure 9.7 show the difference in perspective between a wide-angle and telephoto lens. Here the wide-angle lens creates a sense of separation between the tractor and the building and field. Exposure: ISO 100, f/14, 1/60 sec. using –2/3-stop of Exposure Compensation.

Telephoto lenses

When you need to make a portrait or bring a distant scene closer, reach for a good telephoto lens. Telephoto lenses offer a narrow angle of view, as well as a beautifully compressed perspective that brings the subject and background closer together while at the same time isolating the subject and bringing it visually forward in the image. Short telephoto lenses such as the EF 85mm lenses (136mm on the 60D) are ideal for portraits while telephoto lenses, including the EF 300mm (480mm on the 60D) and 400mm (640mm on the 60D), are the ticket for wildlife and sports shooting. When photographing wildlife, these lenses also enable you to keep a safe distance.

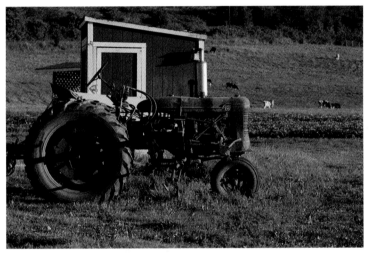

9.7 Here the telephoto lens compresses the perspective, making the building seem much closer to the tractor than it is. Exposure: ISO 200, f/8, 1/320 second using –1 2/3-stops of Exposure Compensation.

On full 35mm-frame cameras, lenses with focal lengths longer than 50mm are considered telephoto lenses. For example, 80mm and 200mm lenses are telephoto lenses. On the 60D, however, the focal-length multiplier works to your advantage with telephoto lenses. Factoring in the 1.6X multiplier, a 50mm lens is equivalent to 80mm, or a short telephoto lens. And because telephoto lenses are more expensive overall than wide-angle lenses, you get more focal length for your money when you buy telephoto lenses for the 60D.

Telephoto lenses offer an inherently shallow depth of field that is heightened by shooting at wide apertures. When you shoot with a telephoto lens, keep these lens characteristics in mind:

▶ **Shallow depth of field.** Telephoto lenses provide a limited range of sharp focus, and as the focal length increases, everything in front of and behind the focal area is thrown out of focus, even at narrow apertures. At wide apertures, you can reduce the background to a soft blur, and the longer the lens, the greater the blur. Because of the extremely shallow depth of field, it's important to get tack-sharp focus. Many Canon lenses include full-time manual focusing that you can use to fine-tune the camera's autofocus. Canon also offers an extensive lineup of Image Stabilized (IS) telephoto lenses.

▶ **Narrow coverage of a scene.** Because the angle of view is narrow with a tele-photo lens, much less of the scene is included in the image. You can use this characteristic to exclude distracting scene elements from the image.

▶ **Slow speed.** Midpriced telephoto lenses tend to be slow; the widest aperture is often f/4.5 or f/5.6, which limits your ability to get sharp images without a tripod in all but the brightest light unless they also feature Image Stabilization (IS). And because of magnification, even the slightest movement is exaggerated.

▶ **Perspective.** Telephoto lenses compress perspective, making objects in the scene appear close together. At 300mm, the compression effect goes beyond what humans naturally see. Extreme telephoto focal lengths put the subject and background next to each other, which creates visual tension in images.

Normal lenses

Normal lenses offer an angle of view and perspective that is similar to how you see the scene. Because of the normal perspective, if you are using wide apertures, you must do more in terms of balancing the subject distance, perspective, and the background blur. Using your shooting position skillfully with a narrow aperture, you can make a normal lens produce images with the same impact as a wide-angle lens would. Likewise, using a wide aperture to soften the background can produce images that mimic those shot using a medium telephoto lens.

On full 35mm-frame cameras, 50-55mm lenses are considered normal lenses. However, on the 60D, a normal lens is 28-35mm when you take into account the focal-length multiplier. When you shoot with a normal focal length, keep these lens characteristics in mind:

▶ **Natural angle of view.** On the 60D, a 28mm or 35mm lens closely replicates the sense of distance and perspective of the human eye. This means the final image will look much as you remember seeing it when you made the picture.

▶ **Little distortion.** Given the natural angle of view, the 28-35mm lens retains a normal sense of distance, especially when you balance the subject distance, perspective, and aperture.

Charlotte's Favorite Lenses

My general approach to adding lenses to my system is to buy the highest-quality lens available in the focal length that I need. If I can't afford the highest-quality lens, then I wait and save money until I can buy it. For example, my last lens purchase was an EF 50 f/1.2L USM lens, and it took me a long time to save enough money to buy it.

But for inquiring minds, the workhorse lenses in my gear bag are the first two Canon lenses I bought: the EF 70-200mm f/2.8L IS USM and the EF 24-70mm f/2.8L USM lens. Both lenses have outstanding optics and provide superb sharpness and excellent resolution and contrast on any EOS camera body. I also frequently use the EF 100mm f/2.8L IS Macro USM lens, the EF 85mm f/1.2L II USM, and the EF 100-400 f/4.5-5.6L IS USM.

Macro lenses

Macro lenses are designed to provide a closer lens-to-subject focusing distance than nonmacro lenses, which enable you to shoot extreme close-ups of all or part of a subject. Depending on the lens, the magnification ranges from half life-size (0.5X) to 5X magnification. Thus, objects as small as a penny or a postage stamp can fill the frame, and nature macro shots can reveal breathtaking details that are commonly overlooked. Using extension tubes can further reduce the closest focusing distance.

9.8 Canon offers several macro lenses, including the new Canon EF 100mm f/2.8L IS Macro USM lens (left) and the EF 180mm f/3.5L Macro USM lens right) that offers 1X (life-size) magnification and a minimum focusing distance of 0.48 m/1.6 ft.

Some normal and telephoto lenses offer macro capability. Because these lenses can be used both at their normal focal length as well as for macro photography, they do double duty focusing from close-up to infinity. And with focal lengths that range from 60–180mm (96-288mm on the 60D), macro lenses make good portrait lenses as well.

You can buy a macro lens based on focal length or magnification. One of the lenses I use most often is the EF 100mm f/2.8L IS Macro USM lens (equivalent to 160mm on the 60D), and I use it for both macro work and for portraits.

9.9 The EF 100mm f/2.8L IS Macro USM lens captured this detail shot of strawberries. Exposure: ISO 200, f/22, 1/125 second.

Tilt-and-shift lenses

Tilt-and-shift lenses, referred to as *TS-E lenses*, enable you to alter the angle of the plane of focus between the lens and sensor plane to provide a broad depth of field even at wide apertures, and to correct or alter perspective at almost any angle. This enables you to correct perspective distortion and control focusing range.

Using tilt movements, you can bring an entire scene into focus, even at maximum apertures. By tilting the lens barrel, you can adjust the lens so that the plane of focus is uniform on the focal plane, thus changing the normally perpendicular relationship between the lens's optical axis and the camera's focal plane. Alternatively, reversing the tilt has the opposite effect: It greatly reduces the range of focusing.

Shift movements avoid the trapezoidal effect that results from using wide-angle lenses pointed up; for example, when you take a picture of a building. Keeping the camera so that the focal plane is parallel to the surface of a wall and then shifting the TS-E lens to raise the lens results in an image where the perpendicular lines of the structure are rendered perpendicular and the structure is rendered as a rectangle.

TS-E lenses have a range of plus/minus 90 degrees, making horizontal shift possible, which is useful when you are shooting a series of panoramic images. You can also use shifting to prevent reflections of the camera or yourself from appearing in images that include reflective surfaces, such as windows, car surfaces, and other similar surfaces.

All of Canon's TS-E lenses are Manual Focus only. These lenses, depending on the focal length, are excellent for architectural, interior, merchandise, nature, and food photography.

Image Stabilized (IS) lenses

Most photographers can use a bit of added steadiness when shooting. And in the Canon line of cameras, that steadiness comes in the form of Image Stabilized (IS) lenses. Image Stabilization counteracts some or all of the motion that results in image blur from handholding the camera and lens.

While additional stability is nice and sometimes essential, it comes at a premium price. IS lenses are pricey compared to their nonstabilized counterparts because they give you from 1 to 4 f-stops of additional stability over non-Image Stabilized lenses — and that means that you may be able to leave the monopod or tripod at home.

With an IS lens, miniature sensors and a high-speed microcomputer built into the lens analyze vibrations and apply correction via a stabilizing lens group that shifts the image parallel to the focal plane to cancel camera shake. The lens detects camera motion via two gyro sensors — one for yaw and one for pitch. The sensors detect the angle and speed of shake. Then the lens shifts the IS lens group to suit the degree of shake to steady the light rays reaching the focal plane.

9.10 The light was very low in this natural wetland area when I captured these morning glory flowers. I used the EF 70-200mm f/2.8L IS USM lens at 70mm with Image Stabilization turned on for a handheld shot. Exposure: ISO 100, f/2.8, 1/125 second.

Stabilization is particularly important with long lenses, where the effect of shake increases as the focal length increases. As a result, the correction needed to cancel camera shake increases proportionately.

To see how the increased stability pays off, consider that the rule of thumb for hand-holding the camera and a non-IS lens is the reciprocal of the focal length, expressed as 1/[focal length]. For example, the slowest shutter speed at which you can handhold a 200mm lens and avoid motion blur is 1/200 second. If the handholding limit is pushed, then shake from handholding the camera bends light rays coming from the subject into the lens relative to the optical axis, which results in a blurry image.

Thus, if you're shooting in low light at a music concert or a school play, the chances of getting sharp images at 200mm are low because the light is too low to allow a 1/200 second shutter speed, even at the maximum aperture of the lens. You can, of course, increase the ISO sensitivity setting and risk introducing digital noise into the images. But if you're using an IS lens, the extra stops of stability help you keep the ISO low to get better image quality, and you still have a good chance of getting sharp images by handholding the camera and lens.

But what about when you want to pan or move the camera with the motion of a subject? Predictably, IS detects panning as camera shake and the stabilization then interferes with framing the subject. To correct this, Canon offers two modes on IS lenses. Mode 1 is designed for stationary subjects. Mode 2 shuts off Image Stabilization in the direction of movement when the lens detects large movements for a preset amount of time. So when you are panning horizontally, horizontal IS stops but vertical IS continues to correct any vertical shake during the panning movement.

9.11 The 70-200mm f/2.8L IS USM (left) and the EF 100-400mm f/4.5-5.6L IS USM (right) lenses offer Image Stabilization in two modes: one for stationary subjects and the second for panning with subjects horizontally.

Setting Lens Peripheral Illumination Correction

Depending on the lens that you use on the 60D, you may notice a bit of *light falloff* and darkening in the four corners of the frame. Light falloff describes the effect of less light reaching the corners of the frame as compared to the center of the frame. The darkening effect at the frame corners is known as *vignetting*. Vignetting is most likely to be evident in images when you shoot with wide-angle lenses, when you shoot at a lens's maximum aperture or when an obstruction such as the lens barrel rim or a filter reduces light reaching the frame corners. On the 60D, you can correct vignetting for JPEG shooting.

 NOTE If you shoot RAW images, you can correct vignetting in Canon's Digital Photo Professional program during RAW image conversion.

When you turn on Peripheral Illumination Correction, the camera detects the lens, and it applies the appropriate correction level if the lens is already registered in the camera. If the lens isn't already registered, then no correction is applied. The 60D can detect 25 lenses, but you can add information for other lenses by using the EOS Utility software supplied on the EOS Solutions Disk.

 NOTE In the strictest sense, vignetting is considered to be unwanted effects in images. However, vignetting is also a creative effect that photographers sometimes intentionally add to an image during editing to guide the viewer's eye inward toward the subject.

You can test your lenses for vignetting by photographing an evenly lit white subject such as a white paper background or wall at the lens's maximum aperture as well as at a moderate aperture such as f/8, and then examine the images for dark corners. Then you can enable Peripheral Illumination Correction on the camera and repeat the images to see how much difference it makes.

If you use Peripheral Illumination Correction for JPEG images, the amount of correction applied is just shy of the maximum amount. However, if you shoot RAW images, you can apply the maximum correction in Digital Photo Professional. Also, the amount of correction for JPEG images decreases as the ISO sensitivity setting increases. If the lens has little vignetting, the difference when using Peripheral Illumination

Correction may be difficult to detect. If the lens does not communicate distance information to the camera, then less correction is applied. Canon recommends that you turn off Peripheral Illumination Correction if you use a non-Canon lens.

Here's how to turn on Peripheral Illumination Correction:

> **NOTE** For all step-by-step instructions in this chapter, you can access the 60D camera menus by pressing the Menu button. Then press left or right on the Multi-controller or turn the Main dial to highlight the menu tab, and then press up or down on the Multi-controller or turn the Quick Control dial to highlight a menu option.

1. **Set the camera to the JPEG image quality setting that you want.**

2. **On the Shooting 1 menu, highlight Peripheral illumin. correct., and then press the SET button.** The Peripheral illumin. correct. screen appears with the attached lens listed, and whether or not correction data is available. If correction data is unavailable, then you can exit this screen and use the Canon EOS Utility program to register the lens.

3. **Turn the Quick Control dial to select Enable if it is not already selected, and then press the SET button.**

Doing More with Lens Accessories

Even with the lenses you currently own, you can increase the focal range on some lenses and decrease the focusing distance to add creative flexibility. Lens accessories are also relatively economical. Accessories can be as simple as a lens hood to avoid flare, a tripod mount to quickly change between vertical and horizontal positions without changing the optical axis or the geometrical center of the lens, or a drop-in or adapter-type gelatin filter holder. You can use extenders on some telephoto lenses to increase the focal range. And you can add one or more extension tubes to the lens for close focusing.

Lens extenders

For relatively little cost, you can increase the focal length of any lens by using an extender. An *extender* is a lens set in a small ring mounted between the camera body and a regular lens. Canon offers two extenders, a 1.4X III and 2X III, that are compatible only with L-series Canon lenses. Extenders can also be combined for even greater magnification.

However, one disadvantage to using extenders is that they reduce the light reaching the sensor. The EF 1.4X III extender decreases the light by 1 f-stop, and the EF 2X III extender decreases the light by 2 f-stops. But an obvious advantage is that in addition to being fairly lightweight, extenders can reduce the number of telephoto lenses you carry.

Thus, accounting for the extra reach of the extender, its light loss, and the focal length magnification, if you use the Canon EF 2X II or III extender with the EF 70-200mm f/2.8L IS USM lens, the lens becomes a 224-640mm f/5.6 lens.

In general, you can use extenders with fixed focal-length (prime) lenses 135mm and longer (except the 135mm f/2.8 Softfocus lens). The extender compatibility list is available at www.usa.canon.com/app/pdf/lens/EFLens Chart.pdf.

9.12 Extenders, such as this Canon EF 1.4X II or III mounted between the camera body and the lens, extend the range of L-series lenses. They increase the focal length by a factor of 1.4X, in addition to the 1.6X focal-length conversion factor inherent with the 60D's focal length multiplier.

Extension tubes and close-up lenses

Extension tubes are close-up accessories that provide magnification increases from approximately 0.3 to 0.7, and they can be used on many EF lenses, though there are exceptions. Extension tubes are placed between the camera body and lens and connect to the camera via eight electronic contact points. Extension tubes can be combined for greater magnification.

9.13 The Kenko DG Auto extension tube set increases the magnification, allowing close focusing with most lenses.

Canon offers two extension tubes: the E 12 II and the EF 25 II. Magnification differs by lens, but with the EF12 II and standard zoom lenses, it is approximately 0.3 to 0.5. With the EF25 II, magnification is 0.7. When combining tubes, you may need to focus manually. Extension tubes are compatible with specific lenses. Be sure to check the Canon Web site for lenses that are compatible with extension tubes.

Additionally, you can use screw-in close-up lenses. Canon offers four lenses that provide enhanced close-up photography based on the lens size, including the 52mm Close-up Lens 250D; the 77mm Close-up Lens 500D; the 52mm Close-up Lens 500D, and the 58mm Close-up Lens 500D. The 250D/500D series uses a double-element design for enhanced optical performance. The 260D/500D series features a double-element achromatic design to maximize optical performance. The 500 series has a single-element construction for economy.

Event and Action Photography

Whether you're shooting sports events, festivals, corporate gatherings, or weddings, the Canon 60D is a strong performer in the event and action shooting arenas. With a burst rate of 5.3 shots per second and a fast focusing system, the 60D has all you need to make one-of-a-kind images that capture the peak moments in action and emotion.

The 60D's wide ISO range and low digital noise at higher ISO settings provides excellent latitude for shooting in low-light venues, and when you combine this with Image Stabilized (IS) lenses, you may be able to leave the tripod or monopod at home. And with the addition of High-Definition video, you can capture the story of sports and other events with both still and moving images.

Outdoor lighting combined with rim light creates a dramatic portrait of a vocalist at an open-air concert. Exposure: ISO 200, f/2.8, 1/800 second using a –2/3-stop of Exposure Compensation.

Preparing for Event and Action Photography

There are few areas where you can hone your timing and photography skills as quickly as you can with event and action shooting. To capture the peak moments, it's important both to know the 60D well and to have the appropriate gear available. Regardless of whether you're shooting a baseball game or a couple walking down the aisle, the objective is to capture the decisive moments, and at 5.3 frames per second (fps) with up to 58 Large/Fine JPEG shots per burst, the 60D keeps up with the action.

There are at least two "givens" in event and action shooting. The first is that you have one, and only one, opportunity to capture the peak moments. Whether you're shooting a sports event or a wedding, there are

10.1 The late afternoon light was just bright enough to provide an action-stopping shutter speed of 1/400 second for this skateboarder image. Exposure: ISO 200, f/3.2, 1/400 second.

no do-overs. The second is that you'll encounter everything from the best to the worst lighting. So being prepared is especially important for event and action photography.

Selecting gear

Part of capturing decisive moments is have the gear you need so that if anything goes wrong with it, you can switch to another camera or lens and keep shooting. Be sure to include backup gear in the camera bag so you can keep shooting without a hiccup.

The gear that you select relates directly to the subjects you're shooting as well as other factors, including your distance from the action, the light and changing light, the weather, and the duration of the event.

Here are some suggestions to con-
sider as you select your gear for action
or event shooting:

▶ **Camera and backup camera.** In
an ideal world, you would have
the EOS 60D as your main cam-
era, and a backup EOS camera. If
you have two cameras, you can
mount a wide-angle lens on one
camera and a telephoto lens on
the other camera — or whatever
lenses you need for the subject
you're shooting and switch
between them as necessary.

If you don't have a second EOS
camera, then pack a capable com-
pact camera such as the Canon
G12, or, at the least, bring a point-
and-shoot camera as a backup.

▶ **Lenses.** Given that the lenses
you need depend on the subject
you're shooting and your dis-
tance from the action or sub-
jects, I've found the 24-70mm
f/2.8L USM lens (38.4-112mm
on the 60D) and the 70-200mm
f/2.8L IS II USM (112-320mm on

10.2 One way to subsume a busy
background is by using a telephoto lens,
such as I did here using the EF 70-200mm
f2.8L IS USM lens at a 200mm focal length.
I applied additional blur to the background
in Photoshop. Exposure: ISO 200, f/2.8,
1/400 second.

the 60D) lens to be a versatile combination for many action and event venues. In
good light, you can get more reach from your telephoto lens by using the
Extender EF 1.4x III or Extender EF 2x III.

Other good telephoto lens choices are the EF 28-135mm f/3.5-5.6 IS USM (44.8-
216mm), the EF 100-400mm f/4.5-5.6L IS USM (160-640mm), or the EF
70-300mm f/4.5-5.6L IS USM (112-480mm) lens. For low-light events such as
concerts, fast lenses such as the EF 50mm f/1.2L USM (80mm on the 60D)
practically shoot in the dark. For any outdoor events where dirt and wind collide,
such as motocross, be sure to use lens hoods and have lens-cleaning cloths
handy as well.

▶ **Monopod or tripod.** If the event continues through sunset and evening hours, you'll be glad to have the solid support of a tripod. I carry the TrekPod Go! PRO, a lightweight monopod that has three foldout legs that give an extra measure of stability as the light fades.

▶ **Image recording and storage media.** Any event that features action means that you'll take a lot of images. Bring a plentiful supply of SD/SDHC/SDXC cards, and have a system for keeping used cards separate from empty cards. For long events, you can offload images to a laptop or handheld storage unit during lulls in the action. Certainly you want a minimum of one spare charged battery and maybe two, depending on the duration of the event.

▶ **Camera protection.** If it rains or if you're shooting in fog or mist or blowing dirt, having a weatherproof camera jacket and lens sleeve is good insurance against camera damage and malfunctions.

Setting up the 60D for event and action shooting

Another part of preparation is setting up the camera in advance of the event. I typically scout the venue or location before the event to get a feel for the light, area, sun direction and intensity, and any challenges the venue presents. Then before leaving for the event, I set up the 60D as far as possible knowing that I have to make minor tweaks when I arrive.

I'm a big fan of the 60D's Camera User Settings (C) shooting mode. If you routinely shoot events in a specific venue such as an arena, then you can set up and register settings for the C mode specifically for that venue. Once you arrive, you have few if any camera adjustments to make before you begin shooting.

Here are some suggestions for camera settings and Custom Functions that are especially helpful for action and event photography. Again, consider these suggestions as a jumping-off point for your shooting needs.

▶ **Image quality setting.** The 60D provides image sizes tailored for everything from large files for making 11×16-inch prints to small files suitable for a digital photo frame or posting on the Web. And you can choose to shoot JPEG, RAW, or both. Certainly the plethora of options can be handy, but to ensure that you'll have the best-quality image, choose either Large/fine JPEG or full-size RAW quality setting. Then when you get that one stunning image, you have the largest file size that enables you to get the best prints. But if you want to have a JPEG handy for quickly posting to Web sites or to send in e-mail, you can choose the RAW+JPEG option and select among a variety of JPEG sizes. Alternatively,

you can choose Medium or Small RAW+JPEG image quality options if you want to conserve space on the media card. The JPEG images enable you to immediately post images to the Web site while the RAW or Medium and Small RAW images give you the option to process exceptional shots for maximum potential or tweak shots that need more attention.

▶ **Shutter-priority AE (Tv) shooting mode.** This shooting mode gives you quick control over the shutter speed so that you can stop the motion of athletes or subjects in midmotion with no motion blur, or show motion blur depending on your goal. Just remember that for non-IS lenses, the handholding guideline is 1/[focal length]. So for a 200mm lens, you need at least a 1/200 second shutter speed to be able to handhold the camera and lens and get a sharp image. And by using Tv shooting mode, you can set the camera to maintain that shutter speed unless the light is too low.

▶ **Focus options.** AI Servo AF mode is designed for action shooting because it tracks focus on a moving subject. For events such as a parade, fair, or graduation, One-Shot mode or AI Focus AF, which switches from One-shot AF mode to AI Servo AF mode, are good choices.

> **TIP** When you know you won't be focusing at the close range of the lens, you can use the focus limiter switch, which is available on many Canon lenses, to limit the range the autofocus system covers when hunting for focus. This helps speed up focusing.

▶ **Drive mode.** For sports and action shooting, High-speed Continuous shooting (5.3 fps) allows a succession of shots up to 58 Large/Fine JPEGs. When the internal camera buffer is full, you're able to continue shooting as images are offloaded to the SD/SDHC/SDXC card. When the buffer fills, you'll see a Busy warning in the viewfinder. Also, if you see Full in the viewfinder, wait until the red access lamp goes out to replace the card. The camera displays a warning if you open the media card door while images are being recorded. For events with slower action, you can opt for Low-speed continuous shooting (3 fps).

> **NOTE** If the 60D is not shooting the burst rate that you expect, check to see if you have enabled C.Fn II-2, High ISO speed noise reduction, which can reduce the burst rate depending on the option chosen.

▶ **Metering mode.** Evaluative metering mode performs well in a variety of different lighting situations, including backlighting.

10.3 With event shooting, you can't choose the subject position or lighting. In this parade image, the light was bright in the back and dark to the front. To hold highlight detail, I used a –1-stop of Exposure Compensation, and then I lightened the girl's face during image editing. Exposure: ISO 200, f/5, 1/2500 second with –1-stop Exposure Compensation using an EF 70-200m f/2.8L IS USM lens.

▶ **Picture Style.** The Standard Picture Style is a good choice, particularly if you've previously tested it and examined the prints. If the light is bright, the Neutral Picture Style helps keep images from becoming too contrasty.

▶ **Custom Functions.** For low-light action and event shooting, consider enabling ISO expansion, C.Fn I-3, but you should test the H (12800) setting for digital noise level before using it. For weddings, there is no question that using Highlight Tone Priority, C.Fn II-3, provides an increased highlight range so that the highlights are less likely to blow out.

You can also use the AF-ON button to focus in P, Tv, Av, and M shooting mode. This technique enables you to control the focus with your thumb as the subject starts, stops, and moves through the venue. Safety Shift, C.Fn I-6, automatically adjusts the exposure if the light suddenly changes enough to make the current exposure settings inaccurate. This can be helpful for outdoor events as well as for indoor events where the lighting varies across a stage.

Shooting Events and Action Images

With a fast shutter action and good burst depth, the 60D gives you versatility in shooting a broad range of events and games. Couple that with shutter speeds ranging from 1/8000 to 30 seconds (and Bulb), and you have ample opportunity to freeze or show motion, and to create interesting panned images. Action photography and the techniques used for it are by no means limited to sports. Any event — from a football game to a carnival or concert — is an opportunity to use action-shooting techniques.

Exposure approaches

A classic exposure approach is to capture the athlete or participant in midwhatever — midjump, midrun, middrop — with tack-sharp focus and no motion blur. Fast shutter speeds are required for stopping subject motion, and fast shutter speeds require ample light, or an increased ISO sensitivity setting. The shutter speed that you need to stop motion depends on the subject's direction in relation to the camera. Table 10.1 provides some common action situations and the shutter speeds needed to stop motion and to pan with the motion of the subject.

Table. 10.1 Recommended Shutter Speeds for Action Shooting

Subject direction in relation to camera	Shutter speeds in seconds
Subject is moving toward camera	1/250
Subject is moving side to side or up and down	1/500 to 1/2000
Panning with the motion of the subject	1/25 to 1/8

Depending on the light and the speed of the lens that you're using, getting a fast shutter speed often means increasing the ISO sensitivity setting. I recommend shooting test shots at the higher ISO settings, and then evaluating the images for digital noise at 100 percent enlargement on the computer to know how high you want to set the ISO.

 A *fast* lens is generally considered to be a lens with a maximum aperture of f/2.8 or faster.

10.4 For action shooting, timing the shutter release is everything. Capturing the biker in midair juxtaposed with other kids shows the context park and keeps the viewer's eye moving through the composition. Exposure: ISO 200, f/3.2, 1/800 second with a –1 stop of Exposure Compensation.

In addition to using High ISO Noise Reduction, C.Fn II-2, you can minimize digital noise, especially in high ISO images, by biasing exposures to the right of the histogram. This exposure approach increases the amount of light captured, and, thereby maximizes the signal-to-noise ratio, particularly in the shadow areas where digital noise is most prevalent. Biasing the exposure to the right means exposing so that the highlight pixels just touch the right side of the histogram without blowing the highlights. If the histogram shows some underexposure, and if you're shooting in

10.5 Events such as the Seafair Hydroplane races offer many opportunities for capturing local color, including this Seafair pirate. Exposure: ISO 200, f/2.8, 1/400 second.

Program AE (P), Shutter-priority AE (Tv), or Aperture-priority AE (Av) shooting mode, just set some positive Exposure Compensation to bias the exposure to the right without clipping highlight tones.

Getting accurate and visually pleasing color is important as well. When you shoot JPEG images at outdoor events and games, the preset White Balance settings such as Daylight, Cloudy, and so on provide excellent color, and you always get better color by using one of these settings versus setting Auto white balance (AWB). The only time I recommend using AWB is in mixed light or indoors where you aren't sure what type of lighting is used or when there is light from two or more sources.

Because I shoot RAW, I carry either a small gray card or white card and take a picture of it in the event light. If the light changes, I shoot a new picture of the card. Then I open the images taken under the same light as a group with the picture of the gray card in a RAW conversion program. I can select all the images, click the gray card, and color-balance the entire image series. Other photographers prefer using the ExpoDisc, a calibrated 18 percent gray lens filter.

Find your own gray card attached in the back of this book.

Alternate shooting approaches

Professional sports photographers have various opinions on what makes a great action shot. Some say the great shots are those that demand the attention of the viewer and keep it longer than a few seconds. Others believe that getting as close to the action — and to the emotions — of the event as possible is the key to getting great shots. But all agree that it all comes down to getting the shot and capturing the right moment that encapsulates the story of the event. These goals apply equally well to weddings, graduations, corporate events, concerts, and other events.

Most often, capturing the story involves stopping the action in midmotion by using a fast shutter speed. But while stopping subject motion is what you most often see in event and action images, there are also countless scenes where a slow shutter speed creates a rich display of motion, whether it's the blur of jumbled bodies during a tackle or the blurred lights of a Ferris wheel. And you can explore the effect in not only athletic events, but also during music concerts and some phases of weddings.

Add a Sense of Motion with Panning

If you've wondered how photographers capture images where the subject is in focus but the background details appear as colorful streaks, wonder no more. The technique they use is called *panning*, and it involves focusing on the subject and then moving the camera with the motion of the subject while using a slow shutter speed. Here is how the technique works:

1. **Find a shooting location where the background will be attractive when it is rendered as long streaks of color.**

2. **With the camera on a tripod, set the 60D to Tv shooting mode, and then set a shutter speed that is slow enough to allow you to record movement with the camera.** I typically use shutter speeds slower than 1/30 second, usually ones 1/25 to 1/8 second. And if you're shooting on a tripod with an Image Stabilized lens, turn off IS on the lens.

3. **Prefocus on a spot where the subject will eventually be in the scene and keep the shutter button half-pressed.** In this example, I focused on a spot on the field. Then I watched for the subject to come into the scene.

4. **When the subject enters the frame, move the camera to start following the subject's motion.** When the subject hits the spot where you prefocused, press the shutter button completely to make the picture *and* continue moving the camera with the subject as the subject leaves the scene.

This technique is much easier to accomplish if you are using a tripod. The tripod keeps the scene level and frees you to concentrate on a smooth panning motion. Also, you can use a cable release to fire the shutter while you use your other hand to pan the camera.

When you combine a flash with a slow shutter, you open new doors for creative renderings that include the dynamic aspect of motion. One technique that is popular with wedding photography is called *dragging the shutter*, and while it can be used with or without a flash, it's very often used in combination with flash. This technique has several components. First, the flash suspends subject motion for a sharply focused subject; second, a slow shutter speed allows the existing light to fully register during the exposure; and third, panning the camera creates blur that adds the dynamic sense of motion to the image.

You can set the Speedlite to second-curtain sync so that the flash fires at the end of the exposure rather than at the beginning. That way, the motion is recorded and the subject motion is frozen at the end of the exposure with the pop of flash. During the long exposure, you can pan the camera with or against the direction of the subject motion. You can also turn the camera to create a circular background blur, or you can zoom the lens during the exposure.

Of course, the subject should be sharply focused, so the usual lens handholding guidelines apply.

Event and Action Photography Tips

Beyond the point of selecting the correct shutter speed to capture the action, the biggest challenges of action shooting are timing shots and composing images. The first challenge is to anticipate the moments of high emotion and the decisive moment. When the mirror flips up, you hold your breath during the blackout hoping that you captured the critical moment. Because the subject is in constant motion, there is limited time to compose the image as you react to the subject's motion.

In many scenarios, action shooting often means getting a handful of keepers from 50 to 100 exposures. You can use a few approaches to increase your odds of getting good action images.

10.6 Watch for interesting composition opportunities such as the repetition of these gauchos at a festival. Exposure: ISO 200, f/3.5, 1/640 second.

▶ **In a venue with spotty lighting, find an area with good light.** Prefocus on the area, and then wait for the action to come to that spot. You might choose to prefocus on an area such as the goal line.

▶ **Know the sport or event.** Not only does knowing the sport or event sequence help you anticipate actions, it also helps you time shots to capture peak action.

▶ **Keep exposure changes to a minimum for as long as the light allows so that you can concentrate on capturing the important moments and composing images.**

▶ **Anticipate the action.** Whether the event is a football game or a wedding recessional, knowing what is likely to happen next means that you can set up for the next action sequence before the subject gets to the area.

▶ **You can switch between using a telephoto lens to photograph action and a wide-angle lens to capture establishing shots of the overall venue, the audience, and crowd reactions.** These are the shots that help create the full story and spirit of the event.

© Peter Burian

10.7 To bring the action close, Peter used the 70-200mm f/4L IS USM lens for this shot of racers coming over the crest of the hill. Exposure: ISO 400, f/7.1, 1/ 500 second.

Nature and Landscape Photography

O ne of the most rewarding and challenging areas of photography is nature and landscape shooting. Not only are subjects inspiring and abundant, providing a rich photography experience, but also the variety of light that you encounter challenges your technical prowess in getting the best exposures. As a result, nature and landscape photography blends both the technical and creative aspects of photography into a synergistic and fluid process, with each aspect complementing the other. In this chapter, you explore how to use the EOS 60D to get stunning images of the natural world and to deal with the range of light that you encounter when you photograph nature and landscape images.

One of the gifts of nature and landscape photography is that you get to spend time in the most beautiful and inspiring locations. This quiet mountain stream was only a few yards downstream from a massive roaring waterfall. The dappled forest light and crystal-clear water emphasized the stunning colors of the rocks and foliage. Exposure: ISO 100, f/8, 1/8 second.

Preparing for Nature and Landscape Photography

Few photographers can resist the lure of photographing the stunning array of beauty that nature provides. And as you photograph nature, your photographic eye becomes more precise and your appreciation for the amazing world of nature grows exponentially.

TIP You can apply many of the techniques you use for nature and landscape photography to shooting skyscrapers, cityscapes, and, in part, outdoor architectural photography.

The umbrella of landscape and nature photography is large, encompassing everything from photographs of travel, fine-art landscapes, seascapes, flora, fauna, wildlife, and birds to close-up images of the smallest subjects that occur in nature. Despite the diversity in this category, all these areas share common threads: They have a wide diversity of light, there is structure and rhythm in the scenes and subjects, and they inspire you to capture the singular beauty and interpret what you see in new and exciting ways.

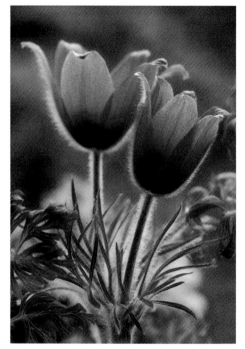

11.1 Soft backlighting of a cloudy day reveals the details in these Pasque petals, and it creates a soft rim light on the fuzzy stems. Exposure: ISO 100, f/10, 1/8 second with a –2/3-stop of Exposure Compensation.

Selecting gear

The adventure of nature photography begins by having a good selection of lenses and filters, as well as other accessories. The lenses and filters that you choose for landscape and nature photography depend on the scenes and subjects that you're shooting or that you're likely to encounter. Because nature offers such an amazing variety of subjects and because the light can change in minutes, be prepared to capture everything, from sweeping landscapes to close-ups of flora and fauna. And, of course, be prepared for sudden weather changes.

At the top of the packing list are lenses. Here are some lenses to consider packing in addition to other gear that comes in handy:

▶ **Wide-angle lenses.** To capture truly sweeping landscapes with the 60D, you need a wide-angle and ultrawide-angle lens such as the EF 16-35mm f/2.8L II USM (25.6-56mm on the 60D), EF-S 10-22mm f/3.5-4.5 USM, or the EF 17-40mm f/4L USM (27.2-64mm) lens. If you don't have a wide-angle lens, consider using the lens you have, and shoot a panorama of images that you can later stitch together using the PhotoStitch program that Canon provides on the EOS Digital Solution Disk.

If you shoot panoramas, carry along a monopod or a tripod to keep the image series level. Keeping the images level makes stitching images together easier and more precise.

▶ **Telephoto lenses.** Your choice of telephoto lenses depends to some extent on what shooting opportunities you'll most likely encounter. For example, if the area has wildlife, then pack the longest telephoto lens that you own, along with the Canon Extender EF 2x II or III or the Extender EF 1.4x II or III, to double the focal length or to multiply the focal length by 1.4X, respectively.

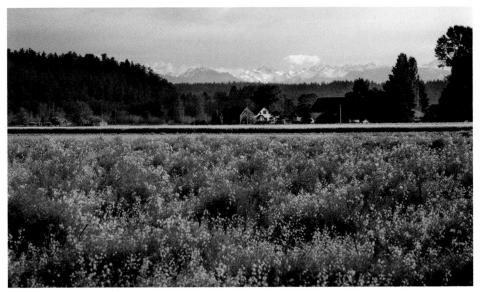

11.2 For this shot of a farm in the shadow of the Cascade Mountains, I handheld the camera with the lens zoomed to 200mm. I used Aperture-priority AE (Av) mode; and the shutter speed at 1/80 second normally would not be fast enough to ensure sharp focus, but with Image Stabilization, I was able to get tack-sharp focus. Exposure: ISO 100, f/16, 1/80 second using an EF 70-200mm f/2.8L IS USM lens.

In general, a lens in the 70-200mm (112-320mm on the 60D) or 100-400mm (160-640mm) range or longer is a good choice for birds and wildlife, and allows you to get in close to distant landscapes.

Lens extenders reduce the maximum effective aperture. The 1.4X extender reduces the effective aperture by 1 f-stop, and the 2X extender reduces it by 2 f-stops. For more information on extenders, see Chapter 9.

▶ **Macro lenses.** I seldom go anywhere without a macro lens. If I know that I'll be doing a lot of macro shooting, I take both a long and short macro lens. For macro work where you can't or don't want to get close to the subject, the EF 180mm f/3.5L Macro USM lens is ideal. For flowers and plants, the EF-S 60mm f/2.8 Macro USM (96mm on the 60D) or the EF 100mm f/2.8L Macro IS USM (160mm) les are excellent choices.

▶ **Filters.** Standard filters for outdoor shooting include a high-quality circular polarizer, and graduated neutral density filters. Filters are described in the sidebar in this section.

▶ **Weatherproof camera and lens sleeves.** The EOS 60D's weather sealing is not as extensive as other EOS cameras. Also non-L-series lenses lack extensive weather sealing. As a result, carrying a water-repellent bag is good insurance against the moisture, dust, and sand that can quickly put a camera out of commission. You can buy a wide variety of weatherproof camera protectors from Storm Jacket, Pelican, AquaTech, and OP/TECH. If your lenses are not well sealed, good lens sleeves are also advisable. I always have several large plastic bags in my camera bag to protect accessories during an unexpected shower. Most newer camera bags are water repellent and have overlapping protectors around zippers to keep moisture and dust out of the bag. But if you've left the camera bag in the car and venture out with a spare lens and some filters, the separate camera covers and lens sleeves come in handy.

▶ **Additional gear.** Because light can change quickly, depending on the time of day and the focal length of your telephoto lenses, you will likely need a sturdy tripod or a monopod. Also carry spare SD/SDHC cards, charged camera batteries, a cell phone, florist's wire (to steady plants), silver reflectors, a GPS locator, and water and snacks. If you're on an extended shooting trip, you'll want to carry a laptop or handheld drive to offload photos at the end of each day's shooting. Some parks require that you pack out what you bring in, so carry a trash bag in your gear bag.

Filters for Nature Photography

The most useful filters in outdoor photography include the circular polarizer filter, neutral density and variable neutral density filters, and warm-up filters. Here is a brief overview of each type of filter:

▶ **Polarizer.** Polarizers deepen blue skies, reduce glare on surfaces to increase color saturation, and help remove spectral reflections from water and other reflective surfaces. A circular polarizer attaches to the front of the lens, and you rotate it to reduce glare and increase saturation. Maximum polarization occurs when the lens is at a right angle to the sun. With wide-angle lenses, uneven polarization can occur, causing part of the sky to be darker than the sky closest to the sun. You can use a 1- to 2-stop neutral density (ND) gradua- tion filter to tone down the lighter area of the sky by carefully positioning the grad-ND filter. If you use an ultrawide-angle lens, be sure to get the thin polar- izing filter to help avoid *vignetting*, the darkening of corners of the frame, which can happen when thicker filters are used at small apertures. Both B+W (www.schneideroptics.com/filters/index.htm) and Heliopan (www.hpmarket- ingcorp.com) offer thin polarizing filters.

▶ **Variable neutral density filters.** Singh-Ray's Vari-ND variable neutral density filter (www.singh-ray.com/varind.html) enables you to continuously control the amount of light passing through your lens up to 8 stops, making it possible to use narrow apertures and slow shutter speeds, even in brightly lit scenes. Thus you can show the motion of a waterfall, clouds, or flying birds. This filter is pricey, but it is a good addition to your gear bag.

▶ **Graduated neutral density filters.** These filters enable you to hold back the brightness in the sky from 1 to 3 f-stops to balance a darker foreground with a brighter sky. Filters are available in hard- or soft-stop types and in different densities: 0.3 (1 stop), 0.45 (1.5 stops), 0.6 (2 stops), and 0.9 (3 stops). With these filters, you can darken the sky without changing its color; its brightness is similar to that of the landscape, and it appears in the image as it appears to your eye.

▶ **Warm-up filters.** Originally designed to correct blue deficiencies in light or certain brands of film, warm-up filters correct the cool bias of the light. You can use them to enhance the naturally warm light of early morning and late afternoon. Warm-up filters come in different strengths, including 81 (weak- est); 81A, B, C, and D; and 81EF (strongest). For the greatest effect, combine a warm-up filter with a polarizer.

I encourage you to adopt the mantra of many nature and landscape photographers to "leave only footprints." In other words, make no negative impact on the environment as you photograph it.

The 60D is a fine camera and Canon lenses are among the best on the market, but they capture only what you see. So be sure to bring your sharp and practiced photographic eye as well as your curiosity and passion.

Setting up the 60D for nature and landscape shooting

Every morning that I wake up knowing that I am going shooting, I can't get started fast enough. However, over time, I've learned to slow down long enough to check the latest weather forecast, and to set up the camera before I rush out the door. The few minutes it takes to adjust the camera not only saves me time when I get to the location, but it also helps me avoid oversights that can make a big difference in the quality of the images. This way, by the time I get to the location where I'm shooting, I can concentrate on evaluating the scene, light, exposure, and composition.

Most often, I have the Camera User Settings (C) shooting mode preset for outdoor shooting, and adjusting settings based on the weather or other conditions takes only a few minutes. With the C shooting mode, you can preset your preferences for the shooting, autofocus, drive, and metering mode, as well as Picture Style and Custom Functions.

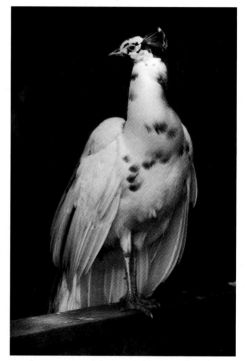

11.3 The dappled afternoon light was changing quickly on this peacock, and to ensure that the highlights retained good detail, I used –1-stop of Exposure Compensation. The compensation also darkened the background nicely. Exposure: ISO 200, f/2.8, 1/3200 second, –1-stop Exposure Compensation using an EF 100mm f/2.8L Macro IS USM lens.

Here is a checklist of camera settings that you can set in advance or register in C mode:

▶ **Shooting mode.** Nature photographers use several different approaches to choosing a shooting mode. The following sidebar covers this in depth.

▶ **Autofocus (AF) mode and AF-point selection.** For still subjects, I use One-shot AF mode with manual AF-point selection because I always want to control where the plane of sharpest focus is in the image. But with birds or wildlife, AI Focus AF mode, which automatically switches from One-shot AF mode to focus tracking (AI Servo AF mode) if the subject begins to move, is a good choice.

▶ **Drive mode.** Choose a drive mode based on the scene or subject you're shooting. For example, if I'm shooting in areas where birds and wildlife are common, then I use High-speed Continuous

11.4 This is an average scene where the onboard light meter produces an excellent exposure. Exposure: ISO 200, f/2.8, 1/4000 second using an EF 100mm f/2.8L Macro IS USM lens.

drive mode. But if I'm shooting only landscapes, flora and fauna, or macro subjects, then I use Single shooting drive mode. And for macro shooting with a tripod, the 2-sec. Self-timer/Remote control drive mode helps avoid the blur that can happen when you press the shutter button.

▶ **Metering mode.** Evaluative metering gives good exposures in many scenes. You can also use Spot metering mode and Manual (M) shooting mode and meter on a middle gray area of the scene, a technique detailed later in this chapter.

▶ **Picture Style.** Because I always edit my images on the computer before displaying them on the Web or printing them, I most often use my modified Neutral Picture Style for shooting outdoors. This style offers ample room for interpreting the color and contrast during image editing, and the colors are very true to the

scene. You can also use Landscape Picture Style with its more vivid greens and blues. If you don't edit images on the computer before printing them, then the Standard or Landscape Picture Styles produce good prints from the camera.

For more information on modifying Picture Styles, see Chapter 4.

Shooting Mode Considerations

There are different opinions about which shooting mode is best for outdoor and nature scenes. Here is a synopsis of when and why photographers use Av, Tv, and M shooting modes for landscape and nature shooting.

▶ Av mode seems like the logical choice because it enables quick control over the aperture, and thus, the depth of field, with a minimum of camera adjustments. And this mode works well as long as you keep an eye on the shutter speed to ensure it is fast enough to get a sharp image if you are handholding the camera.

▶ Some photographers prefer to use Tv shooting mode. This school of thought argues that the ability to control depth of field is useful only so long as the image has sharp focus. And to get sharp focus when you're handholding the camera, controlling the shutter speed is more important than controlling the aperture. Using Tv mode, you can lock in the shutter speed fast for handholding the camera and lens (depending on the light, of course). And if there is potential subject movement, Tv mode enables you to quickly set a fast-enough shutter speed to freeze subject motion.

▶ For photographers who determine exposure settings by metering from a gray card or from a midtone in the scene, M (Manual) mode is best because it is necessary to manually set the aperture and the shutter speed based on the midtone meter reading. You can meter a middle tone in Tv or Av mode using AE lock as well, but the locked exposure settings are temporary.

▶ **Custom Functions.** Your choices depend on the scene and subject, but in general, here are some Custom Functions to consider. If you want to make larger or smaller changes in aperture and shutter speed, you can set exposure level increments, C.Fn I-1, to 1/2 stop instead of the default 1/3 stop increment. Safety shift (C.Fn I-6) offers some insurance to automatically change the exposure setting if the light suddenly changes. Long exposure and High ISO noise reduction (C.Fn II: 1 and 2) are good choices if you are shooting low light at a high ISO

setting and/or using long exposures. Finally, you can set C.Fn III-5 to lock up the reflex mirror to prevent blur when you are making long exposures or macro shots, or using a long lens.

Shooting Nature and Landscape Images

As with shooting any subject, one of the compelling considerations is getting a great exposure. But what does that mean, and what should you for look for in terms of a good exposure? Technically, a good exposure is one that retains detail in the highlights and shadows, and that has a full range of tones between the brightest highlight and the deepest shadow. In addition, the late photographer Monte Zucker added this caveat: "A properly exposed digital file is one in which the [tonal range] fits within the range that can be printed on photographic paper and still show the same detail."

The place where good exposures happen is in the camera, not on the computer. Too often, photographers see an exposure problem and think, "I'll fix it in Photoshop." Certainly you can improve many image problems with skillful editing, but your goal should be to get the best in-camera exposure that the 60D is capable of delivering.

The exposure sections that follow help you get the best exposures from the 60D. At first glance, the advanced exposure approach may seem too complex or too much trouble. In that case, use the basic exposure technique knowing that the 60D will give you consistently good exposures. However, the advanced technique explained in the sidebar is a classic approach for ensuring good exposure and one that you can try as you continue working with the 60D.

11.5 The challenge in this image was to retain highlight detail on the bright areas of the water and in the woman's hair without blocking up the shadow areas under the bridge. I used a –2/3-stop of Exposure Compensation and lost only a bit of detail in the water highlights. Exposure: ISO 100, f/9, 1/100 second with –2/3-stop Exposure Compensation using the EF 24-70mm f/2.8L USM lens.

For the basic exposure approach, you can expect the 60D's onboard reflective light meter, along with Canon's new and improved Evaluative metering, to provide excellent exposures for most scenes. However, in some scenes, you'll want to override the camera's suggested exposure by using Exposure Compensation, AE Lock, or Auto Exposure Bracketing.

The exposure approach described first in the next section is bolstered by the 60D's new metering sensor. The camera takes into account focus, luminance, and color from the 63 zones throughout the viewfinder, and each layer of the dual-layer sensor is sensitive to different wavelengths of light. This provides very accurate meter readings.

Exposure approaches

For the majority of nature and landscape images, the primary consideration is controlling the depth of field — whether you visualize a final image with an extensive depth of field for a stunning sweep of flower-covered hills, or with a shallow depth of field. In any case, the shortest route to controlling the depth of field via aperture changes is by using Aperture-priority AE (Av) shooting mode. And for metering, Evaluative metering mode is dependable and accurate, even for backlit subjects.

11.6 Scenes such as this one of Mt. Baker in Washington State are tailor-made for the basic exposure technique using the Evaluative metering mode. Exposure: ISO 200, f/8, 1/800 second using an EF 100mm f/2.8 Macro USM lens.

Here is the sequence for the basic exposure approach. Set the ISO, set the aperture based on the depth of field you want, and then check the shutter speed. If you're shooting handheld and the shutter speed is too slow to handhold, increase the ISO

incrementally until you have a fast-enough shutter speed to handhold the camera, use a wider aperture, or use a tripod. Then make the first exposure using the camera's recommended settings. Evaluate the image histogram to see if exposure modifications are needed. In some scenes, the camera's recommended exposure needs to be modified to maintain highlight detail or to open blocked shadows. Exposure modification is detailed in a later section.

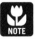 In low-light scenes, Tv shooting mode is preferable because you can lock in a **NOTE** fast-enough shutter speed to handhold the camera (as long as the light allows).

A spike on the right side of the histogram indicates blown highlights, and a **CROSS REF** spike on the left side indicates blocked shadows — shadows that transition too quickly to black. For more details, see Chapter 3.

Dealing with High Dynamic Range Scenes

Very often, photographers have to deal with High Dynamic Range (HDR) scenes. In practical terms, an HDR scene is one where the range from highlights to shadows as measured in f-stops is greater than the camera's imaging sensor can handle. As a result, the camera sacrifices detail in the highlights, resulting in blown highlights, although the shadows may also be *blocked* — go to solid black too quickly. If you're not sure whether the scene falls into the HDR category, you can quickly assess the scene brightness range. Just switch to Spot metering mode and take a meter reading on a highlight and another on a shadow area. Then calculate the difference between the two readings. If the difference in f-stops is greater than the dynamic range of the 60D, you can consider using HDR imaging.

In HDR scenes, many photographers use HDR imaging that involves shooting five to eight images bracketed by shutter speed, and then combining them in an HDR-imaging program. To aid in this type of imaging, the 60D enables you to set the bracketing range up to +/–3 stops. However, you can increase this range by combining Auto Exposure Bracketing (AEB) with Exposure Compensation. Exposure Compensation offers 5 stops of compensation, so combining them gives a range of 8 stops from the metered exposure. It's beyond the scope of this book to detail the HDR processing steps, but many new books are available that describe both the steps and the specialty software for this imaging approach.

continued

continued

Alternately, you can shoot a single RAW image, and then convert the image multiple times in a RAW conversion program, saving the different versions. For example, you process the image once with an eye toward recovering or retaining highlight detail, then another time to maximize midtone rendering, and yet another time to provide good shadow detail. You then composite the three individual files in Photoshop and manipulate them to reveal the best details from each version of the image.

You can realize the highest dynamic range of the 60D by shooting at lower ISO sensitivity settings such as 100 and 200 and by shooting RAW capture. In addition, using Highlight Tone Priority can increase the highlight range by approximately one stop although shadows block up more quickly as well.

Web sites such as www.dpreview.com and www.imaging-resource.com have 60D reviews that provide test results on the dynamic range of the 60D.

A goal of exposure is to retain highlight detail within the subject, and if possible, to maintain highlight detail throughout the entire scene. This is especially important if you are shooting JPEG capture because if you don't capture the highlight detail, you cannot add it later. If you're shooting RAW capture, you can recover varying amounts of highlight detail when you convert the image in a RAW conversion program.

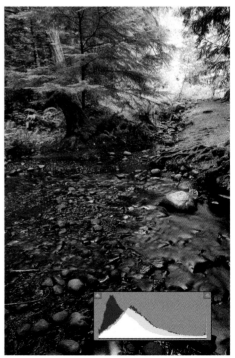

11.7 I knew that it would be difficult to retain details in the bright background in this scene, so I began by using –1/3-stop of Exposure Compensation to retain the details. The inset histogram shows that the highlight clipping is too extensive to recover the blown highlight details, even in a RAW conversion program. Exposure: ISO 100, f/22, 6 second using a –1/3-stop of Exposure Compensation.

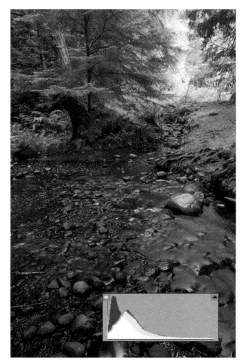

11.8 Eventually, I settled on using –1 1/3-stops of Exposure Compensation to preserve highlight detail, and with RAW conversion, I recovered even more detail. I also knew that I would have to brighten the river area in Photoshop during the editing process. Exposure: ISO 100, f/22, 3.2 seconds using an EF 16-35mm f/2.8L IS USM lens.

11.9 The exposure for this image was set by metering on a gray card with Spot metering mode. The exposure was ISO 100, f/4.5, 1/800 second. I also took a meter reading using Evaluative metering, and the suggested exposure was f/5.6 at 1/640 second. The histogram for the image exposed using the gray-card technique provided a very nice RAW exposure with a slight bias toward the highlights.

If the highlights are blown when using the camera's suggested exposure, then use the exposure modification techniques, such as Exposure Compensation, detailed in the next section.

Exposure modification techniques

Because the camera expects all scenes to have an average distribution of tonal values, it follows that scenes with a predominance of light or dark tones throw off the camera's suggested exposures. Thus it's important to recognize these types of scenes. *Nonaverage scenes* are those that have large areas of white or black or dark subjects, such as large expanses of snow, white sand, or large expanses of dark water or a black train engine.

Advanced Exposure Technique

The advanced exposure approach for landscape and nature scenes is to set the exposure by taking a meter reading on a gray card or on a midtone area in the scene. This approach is based on knowing that the camera expects all scenes tones to average to 18 percent, or middle gray. Thus, when the midtones in the scene are properly exposed, it follows that the other tones will also be properly exposed in many scenes.

To use this exposure technique, set the Mode dial to Manual (M) shooting mode, and then place a photographic gray card in the same light as the subject. If you can't do this, then identify an area in the scene that has the same brightness value as middle gray, or 18 percent reflectance. The area color likely will not be gray, but the tonal value should be the same as middle gray.

Set the ISO, and then set the metering mode to Spot metering. Set the aperture you want. Point the lens so that the center AF point is on top of the gray card or is on top of a middle gray tone within the scene. Press the shutter button half-way, and then set the shutter speed until the tick mark is at the center of the Exposure Level indicator shown at the bottom of the viewfinder. If the light doesn't allow the aperture you've set, then change the aperture or the ISO or both. Also, if you're handholding the camera, be sure that the shutter speed is fast enough to get a sharp image. Then select the AF point you want, compose the image, focus, and make the picture.

When you're presented with a snowy landscape or an expanse of white sandy beach, you know by now that if you don't make an exposure modification, the camera will average all the tones in the scene to middle gray. As a result, the final image will have gray snow and gray water using the basic exposure approach.

This is when you should set positive Exposure Compensation for light-toned scenes and negative Exposure Compensation for dark-toned scenes to get true whites or true blacks.

Generally, a +1 or +2 Exposure Compensation for scenes with a predominance of light tones, or –1 to –2 compensation for scenes with a predominance of dark tones produces true whites and blacks. But be sure to check the histogram to ensure that highlights are not blown or the shadows are not blocked. You need to experiment to find the precise amount of compensation that the scene needs.

When you set Exposure Compensation in Av shooting mode, the camera changes the shutter speed to achieve the compensation. So always monitor the shutter speed, and use a tripod if the shutter speed is too slow for handholding the camera and lens.

11.10 For this image of Mount Index, I used the advanced exposure technique and metered on the patch of blue sky that is a middle gray tonal value. Exposure: ISO 100, f/14, 1/80 second using an EF 24-70mm f/2.8L USM lens.

NOTE With any exposure approach, you may not see any difference in images where you make exposure changes if you have Auto Lighting Optimizer on the Shooting 2 menu set to any setting except Disable. Auto Lighting Optimizer automatically brightens pictures that it detects as being too dark and corrects low contrast. Auto Lighting Optimizer can mask the effect of any exposure modifications that you make.

11.11 For this shot of the iconic ski resort clock at Steven's Pass in Washington State, I used a touch of positive Exposure Compensation to keep the whites truly white. Exposure: ISO 100, f/9, 1/250 second with +1/3-stop of Exposure Compensation using the EF 24-70mm f/2.8L USM lens.

Another exposure modification option is Auto Exposure Bracketing (AEB). Normally, you use AEB to shoot three exposures: one at the camera's recommended exposure, one with more exposure, and one with less exposure. But if the challenge you're trying to solve is overexposed highlights, shooting the frame with more exposure is pointless. Fortunately, the 60D enables you to shift AEB so that all frames are in the negative exposure range.

11.12 Exposure Compensation of +2/3-stop helped render this daisy petal white instead of middle gray. Exposure: ISO 200, f/2.88, 1/160 second, using an EF 50mm f/1.4L USM lens.

Looking for the Light

All the tips in the world cannot make great images if the photographer doesn't constantly practice seeing and appreciating everything in nature. I've irritated more people on the highway than I can count because I routinely slow down to appreciate a stunning mountain lit by that rare and incomparable light that happens only occasionally. Slowing down helps you get great landscape and nature shots.

Keep these tips in mind as you begin exploring nature and landscape photography:

▶ **Look for the light.** Light, especially beautiful light, is transitory and fleeting, and this is the light you want to capture. Maybe the light illuminates a mountainside forest with gold and purple hues, or maybe a small shaft of light pierces through

11.13 Nature offers an endless variety of abstract shapes and forms, such as this aged tree trunk. Exposure: ISO 100, f/8, 1/4 second using an EF 24-70mm f/2.8L USM lens.

the forest trees to spotlight a tiny frog or wild mushroom, but whatever the light, look for it with an acute eye. And be ready to shoot, regardless of whether or not you have the right lens on your camera. Don't let the magical light opportunities pass you by.

▶ **Keep your eye in practice.** Photography is like any other skill: The more you practice it, the more finely tuned your eye becomes and the more you will look for unique and unusual scenes and approaches. For example, when I spend long stretches writing at the computer, and then go out shooting, it takes a while to see with a practiced eye again.

▶ **Image composition is very important.** Many books have been written on composition, but you'll do well to study nature itself. For my work, nature itself is the ultimate field guide to good composition.

11.14 Some nice images can be found in your own yard, as was the case with this deer. Exposure: ISO 200, f/5.6, at 1/320 second using an EF 100mm f/2.8L IS Macro USM lens

Maximizing Depth of Field

Maximizing depth of field is especially important in landscape photography. Certainly a narrow aperture is part of maximizing depth of field, but you can also use hyperfocal focusing to maximize the acceptably sharp focus from near to far in the frame. With hyperfocal focusing, the depth of field extends from half the hyperfocal distance to infinity at any given aperture.

The easy way to set hyperfocal distance focusing is if you have a lens that has both a distance scale and a depth of field scale. If you have this type of lens, first focus the lens on infinity, and then check the depth of field scale to see what the nearest point of sharp focus is at the aperture you've set. Then focus the lens on the hyperfocal distance. For example, with the aperture set to f/11 and using the EF 28mm lens, the hyperfocal distance is just more than 2 meters. That means you would refocus the lens at a point in the scene just more than 2 meters from the camera to get acceptable sharpness from half the hyperfocal distance, or approximately 5 feet, to infinity.

If your lens does not have a depth of field scale, and most newer lenses do not, you can buy a hyperfocal focusing calculator. Or you can calculate the distance using a formula. The formula takes into account the *circle of confusion*, or the maximum size of points on an image that are well defined; that is, to 3 feet. For the 60D with a cropped sensor, that circle size is approximately 0.018mm.

To calculate the hyperfocal distance, use this equation:

$H = (F \times F)/(f \times c)$

Where H is the hyperfocal distance, F is the lens focal length, f is the aperture, and c is the circle of confusion.

So a 28mm lens set to f/16 produces

$H = (28 \times 28)/(16 \times 0.018)$, or $H = 2{,}722$mm or 2.72m.

To ensure maximum depth of field, you focus the lens on a point in the scene that is 2.7 meters from the camera.

11.15 In this image, the layering of the elements provides a good sense of depth.
Exposure: ISO 200, f/10, 1/50 second using an EF 100mm f/2.8L IS Macro USM lens.

Portrait Photography

Whether you set out to be a portrait photographer or not, there's no escaping the times when you want or need to photograph people. These are some of the most valuable opportunities you have to capture truly memorable images — images that are treasured by the people you photograph and by their family and friends.

If portrait photography is your calling, you are blessed with a never-ending source of fascinating subjects. In addition, you can unleash your creativity in designing sets, scouting interesting locations, and perfecting a variety of lighting techniques.

But more to your advantage is the priceless opportunity to work with people — to get to know them, to coax out the best in them, and to make images that they will enjoy for years to come.

Whether it's a private or commercial portrait, taking the time to make a strong connection with the subject reflects in the subject's eyes and makes a much stronger portrait. Exposure: ISO 400, f/3.2, 1/200 second.

Preparing for Portrait Photography

The goal of making a portrait is to capture the spirit of the person or people. When you capture the spirit of the person, it's evident because the subject's eyes are engaged, vibrant, expressive, and energetic, drawing the viewer into the image. No amount of skillful lighting, posing, or post-capture editing can substitute for this. So the first goal is to establish a good and continuing rapport with the subject or subjects so that you can draw out and capture their spirit.

In this specialty area more than in any other area, you must have command of your camera, the lighting, and the accessories to the level that using them is second nature. You need this level of expertise because the majority of your time is spent working with the people you're photographing. Before you even bring the camera to the tripod or out of the gear bag, your first goal is to connect with the person or people you're photographing. Establishing rapport takes time and work on your part. By comparison, in nature and landscape shooting, you work with uninhibited subjects that sit silently and submissively so that you can set the pace and face snafus with equanimity. In people photography, whether you're doing a structured portrait session or street portraits, you work with people who may have a lot of previous "I-hate-pictures-of-me" baggage, often have many things to say, and worry sometimes excessively about what they are wearing and how they look. People, unlike trees and streams, have little patience for technical delays and camera adjustments.

12.1 For this assignment, I needed a narrow aperture to get extensive depth of field. In addition, I asked the people in the back rows to lean slightly forward and the subjects in front to lean back slightly to get everyone closer to being on the same plane. Exposure: ISO 400, f/7, 1/25 second using an EF 24-70mm f/2.8L USM lens.

Photographing people involves maintaining an ongoing conversation, providing specific directions, and, in a structured portrait session, coordinating clothing, lighting, and background changes. Given these demands on your time and attention, the last thing you have time to worry about is the camera's performance, and with the 60D, you can depend on the camera to perform without a hiccup.

If you plan carefully, your odds of having a smooth and trouble-free session are greatly increased. Set up the camera in advance with the lenses and accessories that you want to use within easy reach, and out of the reach of children. Know the range of setups or locations you want and the lighting that you'll use, whether it's flash units or the skillful use of reflectors.

Selecting gear

A number of variables affect the gear that you need for photographing people. Those variables include whether you shoot in your studio or home where your gear is conveniently close by, or if you shoot at a location where you bring gear with you. Another aspect that influences gear selection is whether you're photographing a single person or a group, and, if a group, how large the group is.

Here are some suggestions for camera, lenses, and accessories. These are a good starting point from which you can make adjustments to suit your portrait session.

▶ **Two 60Ds or a 60D and a backup EOS camera body.** In almost all shooting situations, a backup camera is the one element that keeps the session moving should you encounter camera problems. At the very least, have a backup compact or point-and-shoot camera.

▶ **One or more fast wide-angle and short telephoto lenses.** For portraits, I most often use the EF 24-70mm f/2.8L USM (38.4-112mm on the 60D), the EF 70-200mm f/2.8 IS USM (112-320mm), and the EF 85mm f/1.2L II USM (136mm) lens. In particular, the 24-70mm is very versatile — you can shoot individual subjects at the 70mm focal length or at a wider focal length for groups of up to five or six people. But the EF-S 18-135 kit lens provides a good focal range for portraits, and it is a reasonably fast lens with Image Stabilization, which pays off when you have to shoot in low-light scenes.

The EF 70-200mm f/2.8L IS USM or the lighter-weight but slower EF 70-200mm f/4L IS USM is also a good choice to increase background softness, particularly at wide apertures. As well, a short telephoto between 70-85mm creates the classic shallow depth of field and provides a comfortable working distance from the subject.

▶ **Reflectors.** I can't imagine shooting a portrait session indoors or outdoors without using one, two, or more silver, white, or gold reflectors. Reflectors are small, lightweight, collapsible, and indispensable for everything, from redirecting the main light or filling shadow areas to adding catchlights to the subject's eyes. Reflectors are easier to manipulate than flash (and much less expensive), and silver and white reflectors retain the natural color of the ambient light. A gold reflector adds appealing warmth to skin tones.

▶ **EX-series flashes, light stands, umbrellas, or softboxes.** You can create a nice portrait with a single flash unit mounted off-camera on a flash bracket. But you have more creative control if you use one or more Speedlites off the camera. You can use a flash bracket, or you can mount the Speedlites on stands with either umbrellas or softboxes. In any case, you can fire the flash units wirelessly from the 60D thanks to its built-in wireless Speedlite transmitter. The light ratios can be controlled, while the Speedlites can be placed around the set to replicate almost any classic lighting pattern. A multiple Speedlite lighting system is portable and lightweight and, with it, you can replicate studio lighting.

▶ **Tripod, monopod, extra SD cards, and spare batteries.** These are obvious items to have on hand, but they bear mentioning. I keep spare SD (Secure Digital) cards in cases, and designate one case for filled SD cards and another for empty cards.

▶ **Brushes, combs, cosmetic blotters, lip gloss, concealer, safety pins, kids' toys, and anything else you can think of.** The subject will likely forget to bring one of these items, a garment will tear, or a button will pop off. Have a small emergency kit ready. The kit will often contain just what you need to keep the session going with minimal stress and interruption. And a simple toy will keep a child occupied while you make camera and lighting changes. It can also be a good prop in some images.

Setting up the 60D for portrait shooting

If you primarily shoot portraits, then devoting the Camera User Settings (C) mode to your portrait settings saves you time setting up for the session. In portrait photography, you often use the same types of exposure settings as well as lighting, particularly for indoor shooting. Because of this, you can set up the C mode in advance of the session and test the lighting before the subject arrives. The camera settings change as you move through the session, of course, but starting with the camera preset helps get the session moving quickly. With the camera set up for the first part of the session, you can devote more time to working with your subject or subjects.

Here are suggestions for setting up the 60D for portrait shooting.

▶ **Aperture-priority AE (Av) or Manual (M) shooting mode.** Av shooting mode combined with Evaluative metering mode is a good choice because it offers quick control over the depth of field by changing the aperture with a single camera adjustment. If you use Av shooting mode, *always* keep an eye on the shutter speed to ensure it's fast enough to handhold the camera and stop blur if the subject moves during the exposure. Alternately, Manual mode is the best choice if you meter from a gray card or a digital calibration target such as the one from PhotoVision (www.photovisionvideo.com), or if you use studio strobes.

Regardless of the shooting mode you choose, I recommend giving yourself a comfortably fast shutter speed — one that takes into consideration that the subject may also move during the exposure. So if you err, err on the side of a faster rather than a slower shutter speed.

12.2 Window light to the right of the subjects provided a classic lighting pattern for this father and son portrait. I used a large silver reflector on the left to bounce light into the shadow areas of the faces. I added a vignette in Photoshop and used Nik Color Efex Pro's Dynamic Skin Softener filter during editing. Exposure: ISO 400, f/10, 1/25 second with –1/3-stop of Exposure Compensation.

As a rule of thumb, the minimum shutter speed at which you can handhold a non-IS lens is the reciprocal of the focal length. Thus, if your lens is set to 100mm, the minimum shutter speed at which you can handhold the camera and get a sharp image is 1/100 second. That's the *minimum* shutter speed. I also factor in the potential that the subject may move, so a safer shutter speed is 1/200 second or faster.

▶ **One-shot AF mode or AI Focus AF.** Unless the portrait subject is a young child who moves unexpectedly, One-shot AF mode is a good choice. If you are photographing a young child, then you can use AI Focus AF. In AI Focus AF mode, you can focus on the child, and if the child begins to move, the 60D switches automatically and tracks the child to maintain focus. A portrait isn't successful if the point of sharpest focus is anywhere except on the subject's eyes, and the best way to ensure sharp focus on the eyes is to manually set the AF point.

▶ **Low-speed Continuous drive mode.** This mode allows a succession of shots at a reasonably fast 3 fps shooting speed for JPEG images. If you are photographing children in existing light, consider switching to High-speed Continuous mode to keep shooting fast-moving youngsters.

▶ **Evaluative metering mode.** Evaluative metering is both fast and accurate for portraits. If you're shooting outdoors using a middle gray card for metering, then Spot or Partial metering mode are good choices. Spot and Partial metering use 2.8 and 6.5 percent of the viewfinder at the center, respectively. You have to point the lens so that the center AF point is on the gray card when you take a meter reading. Then set the indicated exposure using the Exposure level indicator in the viewfinder.

Manual shooting mode is detailed in Chapter 3.

▶ **Picture Style.** The Portrait Picture Style produces lovely skin tones and renders colors faithfully and with subdued saturation, which is appropriate for portraits. I also use a modified Neutral Picture Style. If you are shooting where the lighting is flat, then Standard Picture Style produces a snappier rendering.

12.3 Evaluative metering mode provided an excellent exposure for the subjects as well as the background. Exposure: ISO 400, f/5, 1/125 second using an EF 24-70mm f/2.8L USM lens.

▶ **Custom Functions.** For flash portraits in low light using Av shooting mode, consider using a fixed 1/250-second sync speed to make flash the primary illumination but ensure a fast handholding speed. If you do this, move the subjects as far from walls and backgrounds as possible. Alternately, you can sync the flash at slower shutter speeds to allow more of the ambient light to figure into the exposure for much more natural-looking lighting, but at slower shutter speed in low light. You can set the flash sync speed for Av shooting mode using C.Fn I-7. If you're shooting scenes with bright tones, such as a bride in a white dress, you can enable C. Fn II-3, Highlight tone priority, to help keep highlights from blowing out.

Making Natural-Light Portraits

Whether you're shooting outdoors or by window light indoors, the 60D offers a full complement of exposure options that deliver stunning exposures and accurate, visually appealing color. This is when it pays to skillfully use the metering modes, Picture Styles and White Balance options to get images that need a minimum of post-capture editing. And the less time you spend editing images, the more time you have to make new portraits.

Outdoor portraits

There are many times during the day, and many types of outdoor light, that create lovely portrait light that flatters the subject and allows for great exposures.

The following list provides considerations for outdoor portrait lighting:

▶ **The least-flattering outdoor portrait light.** Before I discuss good portrait light, it's worth mentioning that the worst portrait light is bright, overhead, unmodified midday sunlight. Bright sunlight flatters no one, and no one is comfortable squinting into direct sunlight. If you cannot reschedule the portrait session, then move the subject to an area that is shaded from the top, such as by a roof, an awning, or a tree, being careful to avoid areas with dappled light. If you move the subject into the shade, use a reflector to direct light onto the face. Then you can use the reflectors to create and control highlights and shadows. Also remember to adjust the white balance for the shade light.

If you must shoot in an open area with overhead sunlight, hold a diffuser or *scrim* — fabric or other material stretched over a frame — over the subject to diffuse the strong sunlight.

12.4 This picture was made just before dusk, when there was just enough remaining light to create good catchlights in the subjects' eyes, and to create a soft and pleasing shadow pattern on the faces of the father and mother. Exposure: ISO 400, f/4.5, 1/200 second using an EF 24-70mm f/2.8L USM lens.

▶ **The most-flattering outdoor portrait light.** The most-flattering outdoor portrait light is just before, during, and just after sunrise, as well as just before and during sunset. The colors of light during these times of day imbue the subject with warm color and a glow that can't be replicated with any other type of light. Because the intensity of light can be very high, use reflectors to fill facial shadows. You may need a diffuser to reduce the light intensity. For head-and-shoulders portraits, have the subject hold a reflector at waist level, tilted upward toward his or her face, to fill deep shadow areas on the face.

In outdoor light, the Portrait or Neutral Picture Styles can keep contrast to a manageable level and provide natural-looking color. Depending on the scene, you can generally use the Evaluative metering mode to get a good exposure on both the subject and the background. Alternately, you can take a meter reading off a gray card that is placed next to the subject's face using Spot metering mode. Just move in close to the gray card, and use the center AF point as you half-press the shutter button. Then use that exposure reading by either pressing the AE Lock button, or by dialing in the exposure settings in Manual (M) mode.

▶ **Overcast light.** The light of an overcast day can also give you nice portrait light if you use reflectors or fill flash to create the highlight and shadow patterns that provide facial modeling. Because overcast light can create deep contrast and color saturation, consider using the Portrait Picture Style, which has lower contrast and color saturation, to create a pleasing portrait. Because the light is flat throughout the scene, Evaluative metering mode gives an overall excellent exposure.

▶ **Back light and rim light.** Backlighting can provide dramatic portrait lighting, especially for male subjects. While Evaluative metering is adequate for backlit subjects, you get a more-precise exposure on the subject by taking a meter reading from a gray card placed next to the subject's face using Spot or Partial metering. Backlighting with some side lighting creates rim light. Rim lighting creates a bright outline around the subject or on one side of the subject. Generally, because the rim light is *specular* — a direct reflection of the light source — rim highlights are completely or mostly blown out.

In any type of outdoor light, watch how the shadows fall on the face. Bounce fill light into those areas using a silver or gold reflector. I prefer a silver reflector for the neutral light that it reflects. If I want to diminish the light from the reflector, then use a white reflector because it scatters light and decreases the intensity.

Reflectors also help ensure that catchlights appear in the subject's eyes. In overcast light, in particular, you may need to use a reflector to create the catchlights. Ideally catchlights are at the 10 and 2 o'clock positions and appear in the iris of the eye rather

than on the pupil. The size and shape of the catchlight reflects the light source. If you use the built-in flash for fill light and to create catchlights, the catchlights will be unattractive pinpoints of white. I prefer the larger size and shape of catchlights created by the skillful use of a reflector or a Speedlite mounted on a stand as it shoots into an umbrella or a softbox.

12.5 This shot of a mother and baby is an example of the spontaneous freedom provided by shooting in subdued outdoor light. The same shot in a studio would necessitate changing the position of the studio strobes as the subjects move position. Exposure: ISO 400, f/6.3, 1/100 second using an EF 24-70mm f/2.8L USM lens.

To get the best color in any type of light, use a Custom white balance. If you don't have time to set a Custom White Balance, then at sunrise or sunset, you can use either the Daylight or Cloudy White Balance setting. Or if you're shooting RAW, you can shoot a gray card in one frame and use that image to color-correct images as a batch during RAW image conversion, as described in Chapter 4. Then you can adjust the temperature and tint controls during RAW image conversion to warm up or cool down the color to your liking.

Window light portraits

Without question, window light is one of the most beautiful types of light for portraits, and it offers exceptional versatility. This diffuse light is flattering to all subjects. And if the light is too bright, you can simply move the subject farther from the window or put a fabric over the window. Window light can be used to create the classic half-lit and half-shadow lighting pattern on the subject. Alternately you can bounce light into the shadow side of the subject using a silver reflector. For window-light portraits, try to shoot when the sun is at a low angle. However, strong midday sunlight can also be usable if you cover the window with a lightweight fabric, such as a sheer curtain.

A good starting point for window light portraits is to place the subject so that one side of the face is lit and the other side is in shadow. Then position a silver or white reflector so that it bounces light into the shadow side of the face and creates a catchlight in the eye on the shadow side.

For portrait editing, I use Nik Color Efex Pro filters, especially the Dynamic Skin Softener filter to create flattering yet natural-looking skin renderings. The Classical Soft Focus and Brilliance/Warmth filters are also excellent for portraits. You can learn more about Nik software at www.niksoftware.com.

Evaluative metering and Spot metering both produce excellent results. Evaluative metering takes the reading from the entire scene with a bias toward the active autofocus point. If you use Spot metering, move in close or zoom in on a gray card held next to the subject's face and meter from it. Then you use Manual shooting mode to shoot with the resulting exposure settings. In Manual shooting mode, you

12.6 This portrait of a young boy was taken using window light to the right of the subject and a large silver reflector on the left to fill the shadows on the side and under the chin. Exposure: ISO 400, f/5, 1/200 second using an EF 24-70mm f/2.8L USM lens.

can maintain the metered exposure, even if you change the image composition — but not the lighting — slightly. In other modes, such as Aperture-priority AE (Av), Shutter-priority AE (Tv), or Program AE (P), the shutter speed changes as you vary the image composition slightly.

Exposure approaches

For portrait shooting, you can often get excellent exposures out of the camera with no exposure modifications using Evaluative metering. However, if there are very bright spots, or *hot spots*, on the subject's skin that you can't eliminate with lighting modifications, or if there are blocked shadows, you can use exposure modification to get a better exposure.

> To set the exposure, I use a PhotoVision Digital Calibration Target and Manual (M) mode. You can order and learn how to use the calibration target on the PhotoVision Web site at www.photovisionvideo.com.

Some portraits pose exposure challenges. For example, if you're photographing a man in dark clothing against a dark background, the camera renders the dark tones as middle gray. The same exposure error can happen when you photograph a subject such as a bride in a white dress against a light background. When you're using Evaluative metering mode, you can use Exposure Compensation to get true blacks and whites. These techniques are detailed in Chapter 3.

Another element of exposure is the ISO setting. My preference for portraits is to ensure very fine detail and

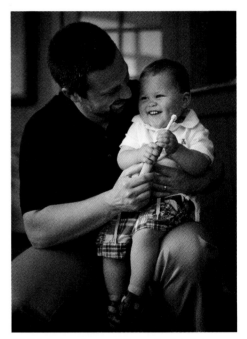

12.7 A baby plays with an electronic toothbrush with his father, a dentist, enjoying the moment. To control the background, I shot wide open at f/2.8 using a short 70mm focal length, both of which help subsume the busy background elements of the dentist's office. Exposure: ISO 400, f/2.8, 1/320 second using an EF 24-70mm f/2.8L USM lens.

the lowest level of digital noise possible in the images. And that means shooting between ISO 100 and 400, 99 percent of the time.

If you're shooting in low-light scenes, increasing the ISO to 800 provides good prints; however, you need to examine the shadow areas carefully for noise. If the noise is obvious, apply noise reduction during either RAW image conversion or JPEG image editing, particularly on facial shadow areas. Nothing spoils an otherwise beautiful portrait more quickly than seeing a colorful scattering of digital noise in facial shadows and in skin areas.

To control depth of field, many photographers rely solely on f-stop changes. Certainly, aperture changes are a major factor in controlling the depth of field, and wide apertures from f/5.6 to f/2 are common in portraiture. However, you can also use the other factors that affect depth of field:

▶ **Lens.** A telephoto lens provides shallow depth of field, and a wide-angle provides extensive depth of field. That's one of the reasons that short telephoto lenses in the range of 85-200mm are popular portrait focal lengths for their shallow depth of field.

▶ **Camera-to-subject distance.** The closer you are to the subject, the shallower the depth of field, and vice versa.

▶ **Subject-to-background distance.** The farther the subject is from the background, the softer the background details appear, and vice versa.

Making Studio Portraits

Whether you have one or multiple studio lights, such as strobes, continuous lights, or Speedlites, you have the opportunity to make portraits using classic lighting patterns. And if you combine the lighting with modifiers such as umbrellas, softboxes, reflectors, and other accessories, you can adjust the light to get just about any type of lighting that you envision.

12.8 For this studio portrait, I used four Photogenic strobes: two lit the background and two lit the baby. I also used a large silver reflector to camera right to fill shadows. Exposure: ISO 100, f/16, 1/125 second, using an EF 85mm f/1.2L II USM lens.

If you have studio lights such as continuous light, it takes only one or two sessions to determine the correct light temperature, if you don't already know it. For my studio system, I use the K White Balance setting, and set it to 5300. This setting gives me a clean, neutral white with no further adjustments during shooting or in image conversion or editing. In addition, if I'm shooting JPEG, which is seldom, I use the Portrait Picture Style. This style produces the subdued color and pleasing skin tones of classic portraiture. If you think that the color rendition and contrast are too subdued, you can modify the style parameters by bumping both settings to a higher level.

12.9 If I had this portrait to do over, I'd move the strobes to avoid the shadows cast by the dress straps and to lighten the shadows under the mother's chin. It's a reminder for me to step back and check every detail of the image before shooting. Exposure: ISO 100, f/16, 1/125 second using an EF 24-70mm f/2.8L USM lens.

12.10 When photographing children, I capture the classic expressions as well as the fun expressions because I know that parents often buy these images as well. Here I used the Nik Color Efex Pro softfocus filter and applied sepia toning in Photoshop. Exposure: ISO 400, f/5, 1/125 second using an EF 24-70mm f/2.8L USM lens.

Portraits with a One-Light Setup

If you're just starting to build a studio lighting system, it is important to know that you can make great portraits with a single light, or even a Speedlite, and an umbrella or softbox combined with silver reflectors. For example, set up the single light or Speedlite on a stand shooting into an umbrella or fitted with a softbox. Then place the light at a 45-degree angle to the right of the camera with the light pointed slightly down onto the subject. This creates a shadow under the subject's nose and lip. Now place a silver reflector to the left of the camera and adjust its position to soften the shadow created by the light.

continued

> *continued*
>
> For classic loop lighting, the shadow under the nose should follow the lower curve of the cheek on the opposite side of the light. The shadow from the light should cover the unlit side of the nose without the shadow extending onto the subject's cheek. Also ensure that the eyebrows and the top of the eyelids are well lit. You can also adjust the height of the main, or *key*, light to change the shadow curve under the cheekbone.

Keeping It Simple

A library of books has been written on people photography. If you want to specialize in people photography, read the books, practice the classic techniques, and keep practicing until they become second nature.

But when the time comes to start shooting, relax and keep it simple. At a minimum, here are the basic guidelines that I keep in mind for every portrait session.

▶ **Connect with the person, couple, or group.** Engage them in conversation about themselves. When you find a topic that lights up a subject's eyes, start shooting and keep up the chit-chat.

▶ **Focus on the eye that is closest to the camera.** If the subject's eyes are not in tack-sharp focus, reshoot. I do not use the focus-and-recompose technique where you lock focus by half-

12.11 This commercial portrait conveys the kind and open demeanor of the doctor — something that should resonate with potential patients who receive his mailer. Exposure: ISO 400, f/4, 1/50 second using an EF 24-70mm f/2.8L USM lens.

pressing the shutter button, and then move the camera to recompose the image. I manually select the AF point that is on top of the subject's eye, and then I do not move the camera after setting focus.

▶ **Keep the subject's eyes in the top half or third of the frame to give the subject more power in the image.**

▶ **The best pose is the pose in which the subject feels comfortable and relaxed.** You may need to tweak the pose a bit to add polish, but generally, let the subject determine the overall pose.

▶ **Check exposure settings as you shoot.** It's easy to get so involved in talking to and directing subjects that you forget to ensure you have a fast-enough shutter speed to stop subject movement. Recheck the shutter speed periodically and increase the ISO or open up to a wider aperture if the shutter speed is too slow.

▶ **Compliment and encourage the subject.** Many people are predisposed to hate having their photos taken and to hate the actual pictures. Generous and sincere praise can help put your subjects at ease and enable them to look at images of themselves in a new light.

▶ **Be prepared.** Be unflappable. Back up everything. And check the histograms as you shoot.

12.12 This type of candid spontaneous shot is typically a favorite with portrait customers. I used the Nik Efex Soft Focus filter during editing. Exposure: ISO 400, f/4.5, 1/200 second.

The Elements of Exposure

If you haven't used a dSLR before, then the options for controlling exposure on the 60D may seem foreign to you, and knowing when to use them to get specific results may seem overwhelming. But once you know how the elements of exposure work together, the camera will make much more sense. In this appendix, you learn how aperture (f-stop), shutter speed, and ISO affect your images, as well as how they work together. And if you are returning to photography after time away, the information in this appendix serves as a refresher on the elements of exposure.

The Four Elements of Exposure

Making a good picture begins with your creative eye and personal expression. The unique way that you see a subject or scene is the first step in making engaging and unique pictures. Then you use the camera to express how you see the scene or subject. While creativity is first and foremost in making images, you also need to have essential technical skills to use the camera effectively to express your vision.

While the technical aspects may not seem as exciting as the creative aspects of picture making, the more you understand what goes into making a photographic exposure, the more creative control you have. And creative control moves you out of the realm of getting a few happy-but-accidental images and into the realm of building a portfolio of beautiful-and-intentional images. A solid understanding of exposure also prepares you for when you need to find creative workarounds for challenging lighting, scenes, subjects, or limitations of the camera itself.

A.1 Learning to use the 60D exposure controls means that you can control the aperture, and, thus, the depth of field. In this image, I chose a wide f/4.5 aperture to bring the flower visually forward in the frame. Exposure: 1S0 200, f/4.5, 1/250 second using –1/3 stop of Exposure Compensation.

Photographic exposure is the combination of four elements:

▶ **Light.** The starting point of exposure is the amount of light that is in the scene. Before making any image, the 60D first measures, or meters, the amount of light in the scene, and only then can it calculate its suggested exposure settings. Your range of creative control with the 60D is often determined by the amount of light you have to work with or the amount of light that you can add using a flash or other lights.

▶ **Sensitivity.** Sensitivity refers to the amount of light that the camera's image sensor needs to make an exposure or to the sensor's sensitivity to light. Sensitivity is controlled by the ISO setting. At high ISO settings, the camera needs less light to make an image than it does at low ISO settings.

▶ **Intensity.** Intensity refers to the strength or amount of light that reaches the image sensor. Intensity is controlled by the aperture, or f-stop. The aperture controls the lens diaphragm, an adjustable opening within the lens that opens or closes to allow more or less light into the camera.

▶ **Time.** Time refers to the length of time that light is allowed to reach the sensor. Time is controlled by setting the shutter speed, which determines how long the camera's shutter stays open to let light reach the sensor.

This language may sound unfamiliar, so it may be easier to think of exposure as filling the image sensor with light, just as you would fill a glass with water. The goal is to fill the image sensor with just the right amount of light to get a good exposure, as you would fill the glass with the perfect amount of water.

In photography, you start with the amount of light that's in the scene and use that amount to determine the correct exposure. In the water glass analogy, that equates to the level to which you want to fill the glass with water. Then you have several choices. You can use a strong or weak stream of water, analogous to a large or a small aperture or f-stop. Then you can choose how long the water flows into the glass, analogous to setting the shutter speed. Finally, you can choose the size of the glass to fill. The size of the glass represents the ISO, or the sensitivity of the sensor. A small glass fills faster than a large glass, as a high ISO requires less light than a low ISO.

So starting with the goal of reaching the perfect level of water (the perfect amount of light reaching the sensor), you can choose to use a fast or slow water flow (aperture), and can let the water run a long or short time (shutter speed) depending on the size of the glass (the ISO). Further, there are many combinations of these variables that all result in getting just the right amount of water into the size glass that you're filling.

The following sections look at each exposure element in more detail. As you read, know that every exposure element is related to the other elements. If one exposure element changes, one or all of the other elements must also change proportionally.

Light

The first element in any image is the light that you have to make the picture. And that's the first thing the camera looks at — it first measures the light in the scene using the onboard light meter. Every time that you half-press the shutter button, the camera measures the light.

 The 60D uses a reflective light meter that measures the amount of light that is reflected from the subject back to the camera.

The light meter reading is biased toward the active autofocus (AF) point. The active AF point tells the camera where the subject is so that the camera can evaluate the subject light relative to the rest of the light in the scene. The camera factors in the current ISO setting, and then calculates how much light (determined by the aperture) is needed and for how long (determined by the shutter speed setting) to make a good exposure. Then the camera gives you its recommended exposure.

Once the exposure settings are calculated, the 60D applies the aperture, shutter speed, and the ISO automatically in the Basic Zone modes, such as Portrait, Landscape, Sports, and so on. But in the semiautomatic shooting modes such as Shutter-priority AE (Tv) and Aperture-priority AE (Av), you have more control over the exposure by setting the shutter speed in Tv shooting mode, or the aperture in Av shooting mode. When you do that, the camera takes your aperture or shutter speed into account and calculates the aperture in Tv mode, or the shutter speed in Av mode based on the ISO that you've set.

Sensitivity: The role of ISO

In broad terms, the ISO setting determines how sensitive the image sensor is to light. ISO settings work this way: The higher the ISO number, the less light that's needed to make a picture; and the lower the ISO number, the more light that's needed to make a picture. In the analogy of filling a glass with water, the size of the glass corresponds to the ISO. If the glass is small (more sensitive to light), less water is needed, and vice versa.

In practical terms, high ISO settings such as ISO 800 to 1600 give you faster shutter speeds. That's important to know because if you're handholding the camera, shooting at slow shutter speeds in low light results in blurry pictures, caused by the slight shake of your hands. Fast shutter speeds in low light increase the chance that you can handhold the camera and get a sharp image. On the other hand, in bright to moderately bright scenes, low ISO settings from 100 to 400 provide fast shutter speeds because there is enough light in the scene that the camera can give you a fast-enough shutter speed to handhold the camera and get a sharp image.

Each higher ISO setting is twice as sensitive to light as the previous setting. For example, ISO 800 is twice as sensitive to light as ISO 400. As a result, the sensor needs half as much light to make an exposure at ISO 800 as it does at ISO 400 and vice versa.

In P, Tv, Av, and M shooting modes, the ISO sequence encompasses Auto (ISO 100 to 6400, which is set automatically by the camera, although you can set an upper limit) and ISO 100, 200, 400, 800, 1600, 3200, and 6400. The ISO can also be expanded to include ISO 12800 using Custom Function (C.Fn) I-3. In the automated Basic Zone modes, the 60D automatically sets the ISO between 100 and 3200, depending on the light. In P, Tv, Av, and M shooting modes, the Auto ISO setting ranges from 100 to 6400.

NOTE The International Organization for Standardization (ISO) measures, tests, and sets standards for many photographic products, including the rating or speed for film, which has, in turn, been applied to equivalents for the sensitivity of digital-image sensors.

But ISO does more than affect the amount of light that's needed to make a good exposure. ISO also impacts the overall image quality in several areas, including sharpness, color saturation, contrast, and digital noise or lack thereof.

In situations where you must use a high ISO setting, you can use Custom Function (C.Fn) II-2: High ISO speed noise reduction to minimize digital noise. The higher levels of noise reduction can reduce the fine detail in images, so you may want to test each level at high ISO settings to see which works best for your photography. You can also use C.Fn II-1: Long exposure noise reduction to reduce digital noise in exposures of 1 second or longer. This option slows down shooting, but it is very effective in reducing the level of noise in the image.

 See Chapter 5 for details on setting Custom Functions.

Intensity: The role of aperture

The lens aperture (the size of the lens diaphragm opening) determines the intensity of light that reaches the image sensor. Going back to the water glass analogy, aperture represents the strength or size of the water flow. A strong flow, or a large aperture (f-stop), fills the glass (the image sensor) faster than a weak stream of water.

Aperture is indicated as f-stop numbers, such as f/2.8, f/4.0, f/5.6, f/8, and so on. Small aperture numbers such as f/5.6, f/4, and f/2.8 correspond to a strong water flow because the lens opening, or diaphragm, is large. Large aperture numbers such as f/8, f/11, f/16, and so on correspond to a weak water flow because the lens diaphragm is small.

A.2 The left image shows the lens diaphragm at f/22, the smallest or minimum aperture for this lens. The right image shows the lens opened up to f/5.6. On a lens that has a maximum aperture of f/2.8, the diaphragm opens completely letting in the maximum amount of light.

When you increase or decrease the aperture by a full f-stop, it doubles or halves the exposure, respectively. For example, f/5.6 provides twice as much light as f/8 provides, while f/5.6 provides half as much light as f/4.0.

🌷 **NOTE** The apertures that you can choose depend on the lens that you're using. And with a variable aperture lens such as the Canon EF-S 18-55mm f/4.5-5.6 lens, the maximum aperture of f/4.5 can be used when the lens is zoomed to 18mm and f/5.6 can be used when the lens is zoomed to 55mm.

Wide aperture

Smaller f-stop numbers, such as f/5.6, f/4, f/3.5, and f/2.8, set the lens diaphragm to a large opening that lets more light reach the sensor. A large lens opening is referred to as a *wide aperture*. Based on the ISO and in moderate light, a wide aperture (a large diaphragm opening) such as f/5.6 delivers sufficient light to the sensor so that the amount of time the shutter has to stay open to make the exposure decreases. Thus you get a faster shutter speed than you would by using a narrow aperture of f/8 or f/11. In general terms, this means that wide apertures of f/5.6 to f/1.2 enable you to shoot in lower-light scenes with a reasonably fast shutter speed (depending on the existing light and the ISO setting). And that combination helps you get sharp handheld images in lower light.

Narrow aperture

Larger f-stop numbers, such as f/8, f/11, f/16, and narrower, set the lens diaphragm to a small opening that allows less light to reach the sensor. A small lens opening is referred to as a narrow aperture. Based on the ISO and in moderate light, a small diaphragm opening such as f/11 delivers less light to the sensor — or fills the glass slower — so the amount of time that the shutter has to stay open increases, resulting in a slower shutter speed. Because narrow apertures of f/8 to f/32 require longer shutter speeds, you need a lot of light to shoot with narrow apertures, or you need to use a tripod and have a scene or subject that remains stock still.

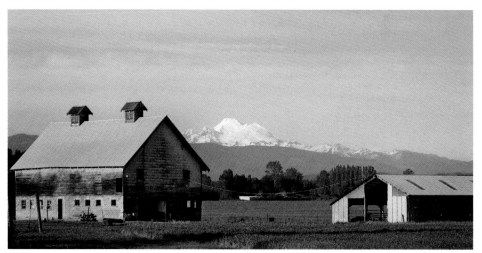

A.3 In this image of a barn in the shadow of Mt. Baker in Washington State, a narrow f/11 aperture keeps acceptably sharp focus through the entire frame. Exposure: ISO 100, f/11, 1/200 second.

 Aperture also plays a starring role in the depth of field of images.

Choosing an aperture

In everyday shooting, photographers most often select an aperture based on how they want the background and foreground to look — either showing acceptably sharp detail or blurred detail. This is called controlling the depth of field, discussed next. But you may also need to choose a specific aperture for practical or creative reasons. For example, if the light is low and you want to avoid blur from camera shake, then choosing a wide aperture (smaller f-number) provides faster shutter speeds. Or if you want to use selective focus, where only a small part of the image is in sharp focus, choose a wide aperture. But if you're shooting a group of people or a landscape, then choose a narrow aperture to render sharper detail throughout the entire frame.

You can control the aperture by switching to Av or M shooting mode. In Av shooting mode, you set the aperture, and the camera automatically sets the correct shutter speed based on the selected ISO. In M shooting mode, you set both the aperture and the shutter speed based on the reading from the camera's light meter. The Exposure level indicator is displayed in the viewfinder as a scale and it indicates over-, under-, and correct exposure based on the aperture, shutter speed, and ISO.

You can use Program AE (P) mode to make one-time changes to the aperture and shutter speed from the camera's recommended exposure. Unlike Av mode where the aperture you choose remains in effect until you change it, in P mode, changing the aperture is temporary. After you take the picture, the camera reverts to its suggested aperture and shutter speed.

What is depth of field?

Depth of field is the zone of acceptably sharp focus in front of and behind a subject. In simple terms, depth of field determines if the foreground and background are rendered as a soft blur or with distinct detail. Depth of field generally extends one-third in front of the plane of sharp focus and two-thirds behind it. Aperture is the main factor that controls depth of field, although camera-to-subject distance and focal length affect it as well.

Depth of field is both a practical matter — based on the light that's available in the scene to make the picture — and a creative choice to control the rendering of background and foreground elements in the image. For example, if you are shooting at a music concert and you've set the ISO where you want it, you might creatively prefer

to shoot using f/8 so that the midstage props are in acceptably sharp focus. But on a practical level, you might glance at the f/8 shutter speed and quickly decide that you need to use a wide aperture to get as fast a shutter speed as possible. A goodly number of scenes involve practical and creative tradeoffs, and the more you know about exposure, the better prepared you are to make judicious decisions.

Shallow depth of field

Images where the background is a soft blur and the subject is in sharp focus have a shallow depth of field. As a creative tool, shallow depth of field is typically preferred for portraits, some still-life images, and food photography. As a practical tool, choosing a wide aperture that creates a shallow depth of field is necessary when shooting in low light. To create a shallow depth of field, choose a wide aperture ranging from f/5.6 to f/1.2 depending on the lens. The subject will be sharp, while the background and foreground will be soft and less distracting. Lenses also factor into depth of field, with a telephoto lens offering a shallower depth of field than a normal or wide-angle lens. Figure A.1 shows a shallow depth of field.

Extensive depth of field

Extensive depth of field maintains acceptably sharp focus in front of and behind the plane of sharpest focus. It is preferred for images of landscapes, large groups of people, architecture, and interiors. When you want an image with extensive depth of field, choose a narrow aperture, such as f/8, f/11, f/16, f/22, or smaller. Figure A.3 shows an extensive depth of field.

Once again, you may have to make creative and practical tradeoffs when your goal is to create an extensive depth of field. Narrow apertures require a lot of light because the lens diaphragm opening is very small. This is analogous to using a weak water stream to fill the water glass. In photography, narrow apertures require longer shutter speeds than wide apertures at the same ISO.

Other factors affecting depth of field

While aperture is a key factor in determining the depth of field — range of acceptably sharp focus in a picture — other factors also affect depth of field:

▶ **Camera-to-subject distance.** At any aperture, the farther you are from a subject, the greater the depth of field is and vice versa. Additionally, the farther the subject is from the background the greater the background blur and vice versa.

▶ **Focal length.** Focal length, or angle of view, is how much of a scene the lens "sees." From the same shooting position, a wide-angle lens produces more extensive depth of field than a telephoto lens.

Time: The role of shutter speed

Shutter speed controls how long the shutter stays open to let light from the lens strike the image sensor. The longer the shutter, or curtain, stays open, the more light reaches the sensor (at the aperture and ISO that you've set). In the water glass example, the amount of time that you let the water flow into the glass is analogous to shutter speed.

When you increase or decrease the shutter speed by one full setting, it doubles or halves the exposure. For example, twice as much light reaches the image sensor at 1/30 second as at 1/60 second. Shutter speed is also related to the following:

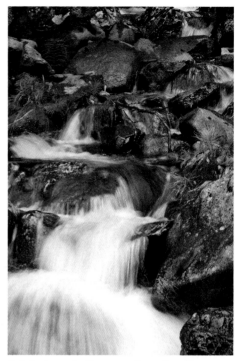

A.4 A slow shutter speed renders the motion of the water as a blur in this series of waterfalls. Exposure: ISO 200, f/32, 1/10 second using a –1/3-stop of Exposure Compensation.

▶ **The ability to handhold the camera and get sharp images, particularly in low light.** The general rule for handholding a non-image stabilized lens is that you need a minimum shutter speed that is the reciprocal of the focal length, or 1 over the focal length. For example, if you're shooting at 200mm, then the slowest shutter speed at which you can handhold the lens and get a sharp image is 1/200 second.

▶ **The ability to freeze motion or show it as blurred in a picture.** For example, you can set a fast shutter speed to show a basketball player's jump in midair with no blur. As a general rule, set the shutter speed to 1/125 second or faster to stop motion. Or set a slow shutter speed to show the motion of water cascading over a waterfall as a silky blur. To show motion as a blur, use a 1/30 second or slower shutter speed and use a tripod.

You can control the shutter speed in Tv or M shooting mode. In Tv shooting mode, you set the shutter speed, and the camera automatically sets the correct aperture. In M shooting mode, you set both the shutter speed and the aperture based on the reading from the camera's light meter and the ISO. The light meter is displayed in the viewfinder as a scale — the Exposure level indicator — and it shows over-, under-, and correct exposure based on the shutter speed, aperture, and ISO.

Equivalent Exposures

As you have seen, after the camera meters the light and factors in the selected ISO, the two remaining factors determine the exposure — the aperture and the shutter speed. Just as when filling the glass with water, you can fill it slowly over a longer time, quickly, or any variation between.

Likewise, many combinations of aperture (f-stop) and shutter speed produce exactly the same exposure given the same ISO setting. For example, f/22 at 1/4 second is equivalent to f/16 at 1/8 second, as is f/11 at 1/15, f/8 at 1/30, and so on. This is based on the doubling and halving effect discussed earlier. For example, if you are shooting at f/8 and 1/30 second, and you change the aperture (f-stop) to f/5.6, then you have doubled the amount of light reaching the image sensor, so the time that the shutter stays open must change proportionally to 1/60 second.

While these exposures are equivalent, the way the image looks and your shooting options change noticeably. An exposure of f/22 at 1/4 second produces extensive depth of field in the image, but the shutter speed is slow, so your ability to handhold the camera and get a sharp image is dubious and a tripod becomes a necessity. However, if you switch to an equivalent exposure of f/5.6 at 1/60 second, you are more likely to be able to handhold the camera, but the depth of field will be shallow.

As with all aspects of photography, evaluate the tradeoffs as you make changes to the exposure. And again, it all comes back to light. Your creative options for changing the exposure setting are ultimately limited by the amount of light in the scene.

Putting It All Together

ISO, aperture, shutter speed, and the amount of light in a scene are the essential elements of photographic exposure. On a bright, sunny day, you can select from many different f-stops and still get fast shutter speeds to prevent image blur. You have little need to switch to a high ISO for fast shutter speeds at small apertures.

As it begins to get dark, your choice of f-stops becomes limited at ISO 100 or 200. You need to use wide apertures, such as f/4 or wider, to get a fast shutter speed. Otherwise, your images will show some blur from camera shake or subject movement. Switch to ISO 400 or higher, however, and your options increase and you can select narrow apertures, such as f/8 or f/11, for greater depth of field. The higher ISO enables you to shoot at faster shutter speeds to reduce the risk of blurred images, but it also increases the chances of digital noise.

Exploring RAW Capture

If you want the highest-quality images from the EOS 60D, choosing to capture RAW images is the way to get them. Of course, you can have RAW images processed in the camera, but in more traditional terms, processing RAW images on the computer gives you more control and the highest-quality images. During RAW conversion on the computer, you have the opportunity to determine how the image data from the camera is interpreted. While RAW capture offers significant advantages, it isn't for everyone. If you prefer images that are ready to print straight out of the camera, JPEG capture is the best option. However, if you enjoy working with images on the computer and having creative control over the quality and appearance of the image, RAW is the best option.

This appendix provides an overview of RAW capture, as well as a brief walk-through on converting RAW image data into a final image.

Learning about RAW Capture

One way to understand RAW capture is by comparing it to JPEG capture, which most photographers are familiar with already. When you shoot JPEG images, the camera edits, or processes, the images before storing them on the media card. This processing includes converting images from 14-bit files to 8-bit files; setting the color, saturation, and contrast; and generally giving you a finished file. The same is true if you shoot RAW and have it converted to JPEG format in the camera. JPEG images can be printed with no editing. But in other cases, you may encounter images where you want more control over how the image is rendered — for example, you may want to recover blown highlights, tone down high-contrast images, or correct the color of an image.

Of course, you can edit JPEG images in an editing program and make some corrections, but the amount of latitude for editing is limited. With JPEG images, large amounts of image data are discarded when the images are converted to 8-bit mode in the camera, and then the image data is further reduced when JPEG algorithms compress

image files to reduce the size. As a result, the image leaves little, if any, wiggle room to correct the tonal range, white balance, contrast, and saturation during image editing. Ultimately, this means that if the highlights in an image are overexposed, or blown, they're blown for good.

If the shadows are *blocked up* (meaning they lack detail), then they will likely stay blocked up. It is possible to make improvements in Photoshop, but the edits make the final image susceptible to *posterization*, or banding, that occurs when the tonal range is stretched and gaps appear between tonal levels. This stretching makes the tonal range on the histogram look like a comb. And digital noise is revealed as the shadows are lightened during editing.

By contrast, RAW capture enables you to work with the data that comes off the image sensor with virtually no internal camera processing. The only camera settings that the camera applies to a RAW image are ISO, shutter speed, and aperture. Because many of the key camera settings have been noted but not applied in the camera, you have the opportunity to make changes to settings, including image brightness, white balance, contrast, and saturation, when you convert the RAW image data into a final image using a conversion program such as Canon's Digital Photo Professional (DPP), Adobe Camera Raw, Adobe Lightroom, or Apple Aperture.

NOTE In addition to the RAW image data, the RAW file also includes information, called *metadata*, about how the image was shot, the camera and lens used, and other description fields.

An important characteristic of RAW capture is that you have more latitude and stability when editing converted RAW files than you do with JPEG files. RAW images have rich data depth and provide significantly more image data to work with during conversion and subsequent image editing. In addition, RAW files are more forgiving if you need to recover overexposed highlight detail during conversion of the RAW file. These differences in data richness translate directly to editing leeway. And maximum editing leeway is important because after the image is converted, all the edits you make in an editing program are destructive. Another advantage of RAW conversion is that as conversion programs improve, you can go back to older RAW image files and convert them again using the improved features and capabilities of the conversion program.

Proper exposure is important with any image, and it is very important with RAW images. With RAW images, proper exposure provides a file that captures rich tonal data that withstands conversion and editing. For example, during conversion, you must map image brightness levels so that the levels look more like what we see with

our eyes — a process called *gamma encoding*. In addition, you will also likely adjust the contrast and midtones and move the endpoints on the histogram. For an image to withstand these conversions and changes, a correctly exposed and data-rich file is critical.

Proper exposure is also critical, considering that digital capture devotes the lion's share of tonal levels to highlights while devoting far fewer levels to shadows. In fact, half of all the tonal levels in the image are assigned to the first f-stop of brightness. Half of the rest of the tonal levels account for the second f-stop, and half into the next f-stop, and so on.

> **NOTE** With digital cameras, dynamic range depends on the image sensor. The brightest f-stop is a function of the brightest highlight in the scene that the sensor can capture, or the point at which the sensor element is saturated with photons. The darkest tone is determined by the point at which the noise in the system is greater than the comparatively weak signal generated by the photons hitting the sensor element.

Clearly, capturing the first f-stop of image data is critical because fully half of the image data is devoted to that f-stop. If an image is underexposed, not only is important image data sacrificed, but also the file is more likely to have more digital noise in the shadow areas.

Underexposure also means that during image conversion, the fewer captured levels must be stretched across the entire tonal range. Stretching tonal levels creates gaps between levels that reduce the continuous gradation between levels.

The general guideline when shooting RAW capture is to expose with a bias to the right so that the highlight pixels just touch the right side of the histogram. Thus, when tonal mapping is applied during conversion, the file has significantly more bits that can be redistributed to the midtones and darker tones, where the human eye is most sensitive to changes.

If you've always shot JPEG capture, the exposing-to-the-right approach may seem wrong. When shooting JPEG images, the guideline is to expose so that the highlights are not blown out because if detail is not captured in the highlights, it's gone for good. This guideline is good for JPEG images where the tonal levels are encoded and the image is essentially pre-edited inside the camera. However, with RAW capture, adjustments are made during conversion with a good bit of latitude. And if highlights are overexposed, conversion programs such as Adobe Camera Raw or Digital Photo Professional (DPP) can recover varying amounts of highlight detail.

In summary, RAW capture produces files with the most image data that the camera can deliver, and you have a great deal of creative control over how the RAW data is converted into a final image. Most important, you get strong data and color-rich files that withstand image editing and can be used to create lovely prints.

However, if you decide to shoot RAW images, you also sign on for another step in the process from capturing images to getting finished images: RAW conversion. With RAW capture, the overall workflow sequence is to capture the images, convert the RAW data in a RAW-conversion program, edit images in an image-editing program, and then print them. You may decide that you want to shoot in RAW+JPEG so that you have JPEGs that require no conversion, but you have the option to convert exceptional or problem images from the RAW files with more creative control and latitude.

Canon's RAW Conversion Program

Unlike JPEG images, RAW images are stored in proprietary format, and they cannot be viewed on some computers or opened in some image-editing programs without first converting the files to a more universal file format such as TIFF, PSD, or JPEG. Canon includes a free program, Digital Photo Professional (DPP), on the EOS Digital Solution Disk that you can use to convert 60D RAW files, and then save them as TIFF or JPEG files.

Images captured in RAW mode have a .CR2 file extension.

DPP is noticeably different from traditional image-editing programs. It focuses on image-conversion tasks, including correcting, tweaking, or adjusting white balance, brightness, shadow areas, contrast, saturation, sharpness, noise reduction, and so on. It doesn't include some familiar image-editing tools, nor does it offer the ability to work with layers.

Sample RAW Image Conversion

Although RAW image conversion adds a step to image processing, this important step is well worth the time. To illustrate the overall process, here is a high-level workflow for converting an EOS 60D RAW image using Canon's DPP.

Be sure to install the DPP application provided on the EOS Digital Solution Disk before following this task sequence.

1. **Start DPP.** The program opens. If no images are displayed, you can select a directory and folder from the Folder panel.

2. **Double-click the RAW (.CR2) image you want to process.** The image preview opens with the RAW image tool palette displayed with the RAW tab selected. If the Tool palette isn't displayed, choose View→Tool palette. In the editing mode, you can

 - **Drag the Brightness adjustment slider to the left to darken the image or to the right to lighten it.** To return quickly to the original brightness setting, click the curved arrow above and to the right of the slider.

 - **Use the White Balance adjustment control to adjust color.** You can click the Eyedropper tool, and then click an area that is white or gray in the image to quickly set white balance, choose one of the preset White Balance settings from the Shot Settings drop-down menu, or click Tune to adjust the white balance using a color wheel. After you correct the color, you can click Register to save the setting, and then use it to correct other images.

 - **Change the Picture Style by clicking the down arrow next to the currently listed Picture Style and selecting a different Picture Style from the list.** The Picture Styles offered in DPP are the same as those offered on the menu on the 60D. When you change the Picture Style in DPP, the image preview updates to show the change. If you don't like the results, you can click the curved arrow to the right of Picture Style to switch back to the original Picture Style.

 - **Adjust the tonal curve. Sliders enable you to target the image Contrast, Highlights, and Shadows for adjustments.** You can also adjust the black and white points on the image histogram by dragging the bars at the far left and right of the histogram toward the center. Then you can also adjust the color, saturation, and sharpness.

 - **Adjust the Color tone, Color saturation, and Sharpness by dragging the sliders.** Dragging the Color tone slider to the right increases the green tone, and dragging it to the left increases the magenta tone. Dragging the Color saturation slider to the right increases the saturation, and vice versa. Dragging the Sharpness slider to the right increases the sharpness, and vice versa. You can further refine the sharpness level with the Strength, Fineness and Threshold sliders.

3. **Click the RGB tab.** Here you can apply an RGB curve and also apply separate curves in each of the three color channels: Red, Green, and Blue. You can also

- **Click one of the tonal curve options to the right of Tone curve assist to set a classic S-curve without changing the black and white points.** If you want to increase the curve, click the Tone curve assist button marked with a plus (+) sign one or more times to increase the curve. Or you can click the linear line on the histogram, and then drag the line to set a custom tonal adjustment curve. If you want to undo the curve changes, click the curved arrow to the right of Tone curve adjustment, or the curved arrow to the right of Tone curve assist.

- **Click the R, G, or B buttons next to RGB to make changes to a single color channel.** Working with an individual color channel is helpful when you need to reduce an overall colorcast in an image.

- **Drag the Brightness slider to the left to darken the image or to the right to brighten the image.** The changes you make appear on the RGB histogram as you make them.

- **Drag the Contrast slider to the left to decrease contrast or to the right to increase contrast.**

- **Drag the Hue, Saturation, and Sharpness sliders until the image looks right to your eye.**

4. **Click the NR/Lens/ALO tab.** Controls on this tab enables you to do the following:

- **Set Auto Lighting Optimizer.** Auto Lighting Optimizer automatically corrects overexposed images and images with flat contrast. This option can be applied automatically to JPEG images in the camera, but the only way to apply it to RAW images is in DPP. You can choose Low, Standard, or Strong settings, or turn off Auto Lighting Optimizer by selecting the check box.

- **Control digital noise if it is problematic in the image.** There are controls for both RAW and TIFF/JPEG images. Be sure to enlarge the preview image to 100 percent and scroll to a shadow area to set noise reduction for Luminance and/or Chrominance.

- **Correct lens aberration.** Click the Tune button to display another dialog box where you can view and adjust the Shooting distance information, correct vignetting using Peripheral illumination, Distortion, chromatic aberration, and Color blur.

5. **In the image preview window, choose File → Convert and save.** The Convert and save dialog box appears. In the dialog box, you can specify the file type and bit depth at which you want to save the image. Just click the down arrow next to Kind of file and choose one of the options, such as TIFF 16-bit. Then you can set the Image Quality setting if you are saving in JPEG or TIFF+JPEG format, set the Output resolution, choose to embed the color profile, or resize the image. In addition, you can resize the image and specify the width and height.

 The Edit menu also enables you to save or copy the current image's conversion settings, and then you can apply it to other images in the folder.

6. **Click Save.** DPP displays the Digital Photo Professional dialog box until the file is converted. DPP saves the image in the location and format that you choose.

How to Use the Gray Card and Color Checker

Have you ever wondered how some photographers are able to consistently produce photos with such accurate color and exposure? It's often because they use gray cards and color checkers. Knowing how to use these tools helps you take some of the guesswork out of capturing photos with great color and correct exposures every time.

The Gray Card

Because the color of light changes depending on the light source, what you might decide is neutral in your photograph isn't neutral at all. This is where a gray card comes in very handy. A gray card is designed to reflect the color spectrum neutrally in all sorts of lighting conditions, providing a standard from which to measure for later color corrections or to set a Custom white balance.

By taking a test shot that includes the gray card, you guarantee that you have a neutral item to adjust colors against later if you need to. Make sure that the card is placed in the same light that the subject is for the first photo, and then remove the gray card and continue shooting.

 When taking a photo of a gray card, de-focus your lens a little; this ensures that you capture a more even color.

Because many software programs enable you to address color-correction issues by choosing something that should be white or neutral in an image, having the gray card in the first of a series of photos allows you to select the gray card as the neutral point. Your software resets red, green, and blue to be the same value, creating a neutral midtone. Depending on the capabilities of your software, you might be able to save the adjustment you've made and apply it to all other photos shot in the same series.

If you'd prefer to make adjustments on the spot, for example, and if the lighting conditions will remain mostly consistent while you shoot a large number of images, it is

advisable to use the gray card to set a custom white balance in your camera. You can do this by taking a photo of the gray card filling as much of the frame as possible. Then, use that photo to set the Custom white balance.

The Color Checker

A color checker contains 24 swatches that represent colors found in everyday scenes, including skin tones, sky, foliage, etc. It also contains red, green, blue, cyan, magenta, and yellow, which are used in all printing devices. Finally, and perhaps most importantly, it has six shades of gray.

Using a color checker is a very similar process to using a gray card. You place it in the scene so that it is illuminated in the same way as the subject. Photograph the scene once with the reference in place, and then remove it and continue shooting. You should create a reference photo each time you shoot in a new lighting environment.

Later on in software, open the image containing the color checker. Measure the values of the gray, black, and white swatches. The red, green, and blue values in the gray swatch should each measure around 128, in the black swatch around 10, and in the white swatch around 245. If your camera's white balance was set correctly for the scene, your measurements should fall into the range (and deviate by no more than 7 either way) and you can rest easy knowing your colors are true.

If your readings are more than 7 points out of range either way, use software to correct it. But now you also have black and white reference points to help. Use the levels adjustment tool to bring the known values back to where they should be measuring (gray around 128, black around 10, and white around 245).

If your camera offers any kind of custom styles, you can also use the color checker to set or adjust any of the custom styles by taking a sample photo and evaluating it using the on-screen histogram, preferably the RGB histogram if your camera offers one. You can then choose that custom style for your shot, perhaps even adjusting that custom style to better match your expectations for color.

Glossary

720p/1080i/1080p High-definition video recording standards that refer to the vertical resolution, or the number of horizontal lines on the screen — either 720 or 1080 lines. Seven-hundred twenty horizontal lines translate to a width of 1280 pixels, and 1080 lines translate to 1920 pixels of horizontal resolution. The *p* stands for progressive scan, which displays the video frame all at once. The *i* stands for interlaced, an analog compression scheme that allows 60 frames per second (fps) to be transmitted in the same bandwidth as 30 fps by displaying 50 percent of the video frame at a time.

Adobe RGB A color space that encompasses most of the gamut of colors achievable on commercial printers, or approximately 50 percent of the visible colors specified by the International Commission on Illumination (CIE).

AE Automatic exposure.

AE Lock (Automatic Exposure Lock) A camera control that enables the photographer to lock the exposure at a point in the scene other than where the focus is set. AE Lock enables the photographer to set the exposure for a critical area in the scene.

angle of view The amount or area seen by a lens or viewfinder, measured in degrees. Shorter or wide-angle lenses and zoom settings have a wider angle of view. Longer or telephoto lenses and zoom settings have a narrower angle of view.

aperture The lens opening that adjusts the diameter of the group of light rays passing through the lens to the image sensor. The mechanism is an iris diaphragm of several blades that can be continuously adjusted to vary the diameter of the opening. Aperture is expressed in f-numbers such as f/8, f/5.6, and so on.

artifact An unwanted element in an image caused by an imaging device, or resulting as a byproduct of image processing such as compression.

artificial light The light from an electric light or flash unit.

autofocus A function where the camera focuses on the subject using the selected autofocus point or points. Pressing the shutter button halfway down sets the focus using the selected autofocus point.

automatic exposure (AE) A function where the camera sets all or some of the exposure elements automatically. In automatic shooting modes, the camera sets all exposure settings. In semiautomatic shooting modes, the photographer sets the ISO and either the Aperture-priority AE (Av) mode or the Shutter-priority AE (Tv) mode, and the camera automatically sets the shutter speed or aperture, respectively.

available light The natural or artificial light within a scene. This is also called existing light.

axial chromatic aberration A lens phenomenon that bends different-colored light rays at different angles, thereby focusing them on different planes, which results in color blur or flare.

barrel distortion A lens aberration resulting in a bowing of straight lines outward from the center.

bit depth The number of bits used to represent the color information in each pixel in an image. Higher bit depths translate to more accurate color representation and more colors available for displaying or printing images. In monochrome images, it defines the number of unique shades of gray that are available.

blocked up A description of shadow areas that lack detail.

blooming Bright edges or halos in digital images around light sources, and bright reflections caused by an oversaturation of image sensor photosites.

bokeh The shape and illumination characteristics of the out-of-focus area in an image.

bounce light Light that is directed toward an object, such as a wall or ceiling, so that it reflects (or bounces) light back onto the subject.

brightness The perception of the light reflected or emitted by a source; the lightness of an object or image. See also *luminance.*

buffer Temporary storage for data in a camera or computer.

bulb A shutter speed setting that keeps the shutter open as long as the shutter button is fully depressed.

cable release An accessory that connects to the camera and allows you to trip the shutter by using the cable instead of pressing the shutter button.

chroma noise Extraneous, unwanted color artifacts in an image.

chromatic aberration A lens phenomenon that bends different-colored light rays at different angles, thereby focusing them on different planes. Two types of chromatic aberration exist: axial and chromatic difference of magnification. The effect of chromatic aberration increases at longer focal lengths. See also *axial chromatic aberration* and *chromatic difference of magnification.*

chromatic difference of magnification A lens phenomenon that bends different-colored light rays at different angles, thereby focusing them on different planes; this appears as color fringing where high-contrast edges show a line of color along their borders.

CMOS (complementary metal-oxide semiconductor) The type of imaging sensor used in the 60D to record images. CMOS sensors are chips that use power more efficiently than other types of recording media.

color balance The color reproduction fidelity of a digital camera's image sensor and of the lens. In a digital camera, color balance is achieved by setting the white balance to match the scene's primary light source or by setting a Custom white balance. You can also adjust color balance in RAW conversions and image-editing programs.

color/light temperature A numerical description of the color of light measured in Kelvin. Warm, late-day light has a lower color temperature. Cool, early-day light has a higher temperature. Midday light is often considered to be white light (5000K). Flash units are often calibrated to 5000K.

color space In the spectrum of colors, a subset of colors that is encompassed by a particular space. Different color spaces include more or fewer colors. See also *RGB (Red, Green, Blue)* and *sRGB*.

compression A means of reducing file size. Lossy compression permanently discards information from the original file. Lossless compression does not discard information from the original file and allows you to re-create an exact copy of the original file without any data loss. See also *lossless* and *lossy*.

contrast The range of tones from light to dark in an image or scene.

contrasty A term used to describe a scene or image with great differences in brightness between light and dark areas.

crop To trim or discard one or more edges of an image. You can crop when taking a picture by moving closer to the subject to exclude parts of a scene, by zooming in with a zoom lens, or via an image-editing program.

daylight balance A general term used to describe the color of light at approximately 5500K, such as midday sunlight or an electronic flash. A white balance setting on the camera calibrated to give accurate colors in daylight.

depth of field The zone of acceptable sharpness in a photo that extends in front of and behind a focused subject. Depth of field varies by the lens's focal length, aperture, and shooting distance. The depth of field in front of the focused subject is shallower than the depth of field behind the focused subject.

diaphragm An iris mechanism consisting of blades that open and close to adjust the diameter of the light rays passing through the lens to the image sensor. Setting the f-number or aperture controls the diaphragm diameter. In full increments, each successive diaphragm setting increases or decreases the amount of light passing through the lens by half.

diffuser Material such as fabric or paper that is placed over the light source to soften the light.

dpi (dots per inch) A measure of printing resolution.

dynamic range The difference between the lightest and darkest values in a scene as measured by f-stops. A camera that can hold detail in both highlight and shadow areas over a broad range of f-stops is said to have a high dynamic range.

exposure The amount of light reaching the image sensor. At a given ISO, exposure is the result of the intensity of light multiplied by the length of time the light strikes the sensor.

exposure meter A general term referring to the built-in light meter that measures the light reflected from the subject back to the camera. EOS cameras use reflective meters. The exposure is shown in the viewfinder and on the LCD panel as a scale, with a tick mark under the scale that indicates ideal exposure, overexposure, and underexposure.

extender An attachment that fits between the camera body and the lens to increase the focal length of the lens.

extension tube A hollow ring attached between the camera lens mount and the lens that increases distance between the optical center of the lens and the sensor, and decreases minimum focusing distance.

fast A term that refers to film, ISO settings, and photographic paper that have high sensitivity to light. This also refers to lenses that offer a wide aperture, such as f/2.8 or f/1.4, and to a short shutter speed.

filter A piece of glass or plastic that is usually attached to the front of the lens to alter the color, intensity, or quality of the light. Filters are also used to alter the rendition of tones, reduce haze and glare, and create special effects such as soft focus and star effects.

flare Unwanted light reflecting and scattering inside the lens, causing a loss of contrast and sharpness, and/or artifacts in the image.

flat A term that describes a scene, light, photograph, or negative that displays little difference between dark and light tones. This is the opposite of contrasty.

f-number A number representing the maximum light-gathering capability of a lens, or the aperture setting at which a photo is taken. It is calculated by dividing

the focal length of the lens by its diameter. Wide apertures are designated with small numbers, such as f/2.8. Narrow apertures are designated with large numbers, such as f/22. See also *aperture*.

focal length The distance from the optical center of the lens to the focal plane when the lens is focused on infinity. The longer the focal length is, the greater the magnification.

focal point The point in an image where rays of light intersect after reflecting from a single point on a subject.

focus The point at which light rays from the lens converge to form a sharp image. This is also the sharpest point in an image.

fps (frames per second) In still shooting, fps refers to the number of frames either in One-shot or Continuous Drive modes that the camera can capture in one second. In video film recording, the digital standard is 30 fps.

frame A term used to indicate a single exposure or image. This also refers to the edges around the image.

f-stop See *f-number* and *aperture*.

ghosting A type of flare that causes a clearly defined reflection to appear in the image symmetrically opposite to the light source, creating a ghostlike appearance. Ghosting is caused when the sun or a strong light source is included in the scene, and a complex series of reflections occurs among the lens surfaces.

gigabyte The usual measure of the capacity of digital mass storage devices; a gigabyte is slightly more than 1 billion bytes.

grain See *noise*.

gray-balanced The property of a color model or color profile where equal values of red, green, and blue correspond to a neutral gray value.

gray card A card that reflects a known percentage of the light that falls on it. Typical gray cards reflect 18 percent of the light. Gray cards are standard for taking accurate exposure-meter readings and for providing a consistent target for color balancing during the color-correction process using an image-editing program.

grayscale A scale that shows the progression from black to white using tones of gray. This also refers to rendering a digital image in black, white, and tones of gray. It is also known as monochrome.

HDV and AVCHD High Definition Video and Advanced Video Codec High Definition refer to video compression and decompression standards.

highlight A term describing a light or bright area in a scene, or the lightest area in a scene.

histogram A graph that shows the distribution of tones or colors in an image.

hue The color of an object. When you describe a color using the words *green, yellow,* or *red,* you're describing its hue.

infinity The distance marked on the lens between the imaging sensor or film and the optical center of the lens when the lens is focused on the farthest position on the distance scale of a lens (approximately 50 feet and beyond).

ISO (International Organization for Standardization) A rating that describes the sensitivity to light of film or an image sensor. ISO in digital cameras refers to the amplification of the signal at the photosites. ISO is expressed in numbers such as ISO 100. The ISO rating doubles as the sensitivity to light doubles. For example, ISO 200 is twice as sensitive to light as ISO 100.

JPEG (Joint Photographic Experts Group) A lossy file format that compresses data by discarding information from the original file to create small image file sizes.

Kelvin A scale for measuring temperature based around absolute zero. The scale is used in photography to quantify the color temperature of light.

LCD (liquid crystal display) The image screen on digital cameras that displays menus and images during playback and Live View shooting.

LCD panel A panel located on the top of the 60D camera; the LCD panel displays exposure information and buttons above the LCD panel enable you to change the drive mode, ISO, metering mode, and AF mode.

lightness A measure of the amount of light reflected or emitted. See also *brightness* and *luminance.*

linear A relationship where doubling the intensity of light produces double the response, as in digital images. The human eye does not respond to light in a linear fashion. See also *nonlinear.*

lossless A term that refers to file compression that discards no image data. TIFF is a lossless file format.

lossy A term that refers to compression algorithms that discard image data in the process of compressing image data to a smaller size. The higher the compression rate, the more data that is discarded and the lower the image quality. JPEG is a lossy file format.

luminance The light reflected or produced by an area of the subject in a specific direction and measurable by a reflective light meter. See also *brightness.*

megabyte Slightly more than 1 million bytes.

megapixel One million pixels. This is used as a measure of the capacity of a digital image sensor.

memory card In digital photography, removable media that stores digital images, such as the SD/SDHC media used to store 60D images.

metadata Data about data, or more specifically, information about a file. This information, which is embedded in image files by the camera, includes aperture, shutter speed, ISO, focal length, date of capture, and other technical information. Photographers can add additional metadata including copyright information on the 60D.

middle gray A shade of gray that has 18 percent reflectance.

midtone An area of medium, or average, brightness; a medium-gray tone in a photographic print.

neutral density filter A filter attached to the lens to reduce the required exposure.

noise Extraneous visible artifacts that degrade digital image quality. In digital images, noise appears as unwanted multicolored flecks and as grain that is similar to grain seen in film. Both types of noise are most visible in high-speed digital images captured at high ISO settings.

nonlinear A relationship where a change in stimulus does not always produce a corresponding change in response. For example, if the light in a room is doubled, the human eye does not perceive the room as being twice as bright. See also *linear*.

normal lens or zoom setting A lens or zoom setting whose focal length is approximately the same as the diagonal measurement of the film or image sensor used. In full-frame 35mm format, a 50-60mm lens is considered to be a normal lens.

On the 60D, normal is about 28mm. A normal lens more closely represents the perspective of normal human vision.

open up To switch to a larger f-stop, such as f/5.6, f/4, or f/2.8, to increase the size of the lens diaphragm opening.

overexposure Giving an image sensor more light than is required to make an acceptable exposure. The resulting picture is too light.

panning A technique of moving the camera horizontally to follow a moving subject, which keeps the subject sharp but blurs and/or streaks background details.

photosite The place on the image sensor that captures and stores the brightness value for one pixel in the image.

pincushion distortion A lens aberration causing straight lines to bow inward toward the center of the image.

pixel The smallest unit of information in a digital image. Pixels contain tone and color that can be modified. The human eye merges very small pixels so that they appear as continuous tones.

plane of critical focus The most sharply focused part of a scene. This is also referred to as the point or plane of sharpest focus.

polarizing filter A filter that reduces glare from reflective surfaces such as glass or water at certain angles.

ppi (pixels per inch) The number of pixels per linear inch on a monitor or image file that are used to describe overall display quality or resolution. See also *resolution*.

RAW A proprietary image file in which the image has little or no in-camera processing. Because image data has not been processed, you can change key camera settings, including brightness and white balance, in a conversion program (such as Canon Digital Photo Professional, Adobe Camera Raw, or Adobe Lightroom) after the picture is taken.

reflective light meter A device — usually a built-in camera meter — that measures light emitted by a photographic subject back to the camera.

reflector A silver, white, or gold surface used to redirect light into shadow areas of a scene or subject.

RGB (Red, Green, Blue) A color model based on additive primary colors of red, green, and blue. This model is used to represent colors based on how much of red, green, and blue is required to produce a given color.

resolution The number of pixels in a linear inch. Resolution is the amount of data used to represent detail in a digital image. Also, the resolution of a lens that indicates the capacity of reproduction. Lens resolution is expressed as a numerical value such as 50 or 100 lines, which indicates the number of lines per millimeter of the smallest black-and-white line pattern that can be clearly recorded.

saturation As it pertains to color, a dominant, pure hue undiluted by the presence of white, black, or other colors. The higher the color purity is, the more vibrant the color.

sharp The point in an image at which fine detail is clear and well defined.

shutter A mechanism that regulates the amount of time during which light is let into the camera to make an exposure. Shutter time or shutter speed is expressed in seconds and fractions of seconds, such as 1/30 second.

slave A flash unit that is synchronized to and controlled by another flash unit.

slow A reference to film, digital camera settings, and photographic paper that have low sensitivity to light, requiring relatively more light to achieve accurate exposure. This also refers to lenses that have a relatively wide aperture, such as f/3.5 or f/5.6, and to a long shutter speed.

speed The relative sensitivity to light of photographic materials such as digital camera sensors, film, and photographic paper. This also refers to the ISO setting and the capability of a lens to let in more light by opening to a wider aperture. See also *fast*.

spot meter A device that measures reflected light or brightness from a small portion of a subject.

sRGB A color space that approximates the gamut of colors of the most common computer displays. sRGB encompasses approximately 35 percent of the visible colors specified by the International Commission on Illumination (CIE).

stop See *aperture*.

stop down To switch to a smaller f-stop, such as f/8, f/11, and narrower, thereby reducing the size of the lens diaphragm opening.

telephoto A lens or zoom setting with a focal length longer than 50-60mm in full-frame 35mm format. On cropped sensor cameras, telephoto is a focal length longer than approximately 28mm.

TIFF (Tagged Image File Format) A universal file format that most operating systems and image-editing applications can read. Commonly used for images, TIFF supports 16.8 million colors and offers lossless compression to preserve all the original file information.

tonal range The range from the lightest to the darkest tones in an image.

TTL (Through the Lens) A system that reads the light passing through a lens that strikes an image sensor.

tungsten lighting Common household lighting that uses tungsten filaments. Without filtering or adjusting to the correct white balance settings, pictures taken under tungsten light display a yellow-orange colorcast.

underexposure The effect of exposing an image sensor to less light than is required to make an accurate exposure. The resulting picture is too dark.

viewfinder A viewing system that allows the photographer to see all or part of the scene that will be included in the final picture.

vignetting Darkening of edges on an image that can be caused by lens distortion, using a filter, or using a lens hood. This is also used creatively in image editing to draw the viewer's eye toward the center of the image.

white balance The relative intensity of red, green, and blue in a light source. On a digital camera, white balance compensates for light that is different from daylight to create correct color balance.

wide angle A lens with a focal length shorter than 50-60mm in full-frame 35mm format. On cropped sensor cameras, wide angle is a focal length wider than approximately 24mm.

Index

Guides to go.

Colorful, portable *Digital Field Guides* are packed with essential tips and techniques about your camera equipment. They go where you go; more than books—they're *gear*. Each $19.99.

Free Gray/Color Checker Card Inside! Brian McLernon
Canon® PowerShot G11
Digital **Field Guide**

978-0-470-56508-7

Free Gray/Color Checker Card Inside! J. Dennis Thomas
Nikon® Creative Lighting System
Digital **Field Guide**
SECOND EDITION

978-0-470-45405-3

Free Gray/Color Checker Card Inside! J. Dennis Thomas
Nikon® D300s
Digital **Field Guide**

978-0-470-52127-4

Free Gray/Color Checker Card Inside! Alan Hess
Exposure
Digital **Field Guide**

978-0-470-53490-8

Free Gray/Color Checker Card Inside! J. Dennis Thomas
Nikon® D3000
Digital **Field Guide**

978-0-470-58207-7

Free Gray/Color Checker Card Inside! Charlotte K. Lowrie
Canon® EOS Rebel T2i/550D
Digital **Field Guide**

978-0-470-64863-6

Also available

Canon EOS Rebel XSi/450D Digital Field Guide • 978-0-470-38087-1
Nikon D40/D40x Digital Field Guide • 978-0-470-17148-6
Sony Alpha DSLR A300/A350 Digital Field Guide • 978-0-470-38627-9
Nikon D90 Digital Field Guide • 978-0-470-44992-9
Nikon D300 Digital Field Guide • 978-0-470-26092-0
Canon 50D Digital Field Guide • 978-0-470-45559-3

Available wherever books are sold.

Wiley and the Wiley logo are registered trademarks of John Wiley & Sons, Inc. and/or its affiliates.
All other trademarks are the property of their respective owners.

WILEY
Now you know.